Janson's History of Art

PORTABLE EDITION

Janson's History of Art

THE WESTERN TRADITION · *Seventh Edition*

The Middle Ages

PENELOPE J. E. DAVIES
The Ancient World

DAVID L. SIMON
The Middle Ages

WALTER B. DENNY
Islamic Art

ANN M. ROBERTS
The Renaissance through the Rococo

FRIMA FOX HOFRICHTER
The Renaissance through the Rococo

JOSEPH JACOBS
The Modern World

Prentice Hall
Upper Saddle River, London, Singapore, Toronto,
Sydney, Hong Kong, and Mexico City

LIBRARY OF CONGRESS CATALOGING-IN-PUBLICATION DATA

Janson, H. W. (Horst Woldemar),
 Janson's history of art: the western tradition/Penelope J. E. Davies . . . [et al.]—7th ed.
 p.cm
 Includes bibliographical references and index.
 ISBN 10: 0-205-69741-0 | ISBN 13: 978-0-205-69741-0
 1. Art—History. I. Title: History of art. II. Davies, Penelope J. E., 1964-III.
Janson, H.W. (Horst Woldemar), 1913–History of art. IV. Title

N5300.J3 2007
709—dc22 2005054647

Editor-in-Chief: **SARAH TOUBORG**
Sponsoring Editor: **HELEN RONAN**
Editor in Chief, Development: **ROCHELLE DIOGENES**
Senior Development Editor: **ROBERTA MEYER**
Development Editors: **KAREN DUBNO, CAROLYN VIOLA-JOHN**
Editorial Assistant: **JACQUELINE ZEA**
Editorial Intern: **AIZA KEESEY**
Media Project Manager: **ANITA CASTRO**
Director of Marketing: **BRANDY DAWSON**
Assistant Marketing Manager: **ANDREA MESSINEO**
Marketing Assistant: **VICTORIA DeVITA**
AVP, Director of Production and Manufacturing: **BARBARA KITTLE**
Senior Managing Editor: **LISA IARKOWSKI**
Senior Production Editor: **HARRIET TELLEM**
Production Assistant: **MARLENE GASSLER**
Manufacturing Manager: **NICK SKLITSIS**
Manufacturing Buyer: **SHERRY LEWIS**
Creative Design Director: **LESLIE OSHER**
Art Directors: **NANCY WELLS, AMY ROSEN**
Interior and Cover Design: **BTDnyc**
Design Layout: **GAIL COCKER-BOGUSZ**
Line Art Coordinator: **MARIA PIPER**
Line Art Studio: **ARGOSY PUBLISHING INC.**
Cartographer: **CARTOGRAPHICS**
Text Research and Permissions: **MARGARET GORENSTEIN**
Pearson Imaging Center
 Manager: **JOSEPH CONTI**
 Project Coordinator: **CORIN SKIDDS**
 Scanner Operators: **RON WALKO AND CORIN SKIDDS**
Picture Editing, Research and Permissions:
 LAURIE PLATT WINFREY, FAY TORRES-YAP
 MARY TERESA GIANCOLI, CRISTIAN PEÑA, CAROUSEL RESEARCH, INC.
Director, Image Resource Center: **MELINDA REO**
Manager, Rights and Permissions: **ZINA ARABIA**
Manager, Visual Research: **BETH BRENZEL**
Image Permission Coordinator: **DEBBIE LATRONICA**
Copy Editor: **STEPHEN HOPKINS**
Proofreaders: **BARBARA DEVRIES, NANCY STEVENSON, PATTI GUERRIERI**
Text Editor: **CAROL PETERS**
Composition: **PREPARÉ**
Cover Printer: **PHOENIX COLOR CORPORATION**
Printer/Binder: **RR DONNELLEY**
Portable Edition Composition & Management: **SANDRA REINHARD, BLACK DOT**
Portable Edition Production Editor: **BARBARA TAYLOR-LAINO**
Portable Edition Cover Design: **PAT SMYTHE**

COVER PHOTO: Baptistery, begun 1153, Pisa, Italy. Dorling Kindersley Media Library

Credits and acknowledgements borrowed from other sources and reproduced, with permission, in this textbook appear on the appropriate page within text or on the credit pages in the back of this book.

Prentice Hall
is an imprint of

10 9 8 7 6 5 4 3 2 1

ISBN 10: 0-205-69741-0
www.pearsonhighered.com ISBN 13: 978-0-205-69741-0

Contents

PART THREE

THE RENAISSANCE THROUGH THE ROCOCO

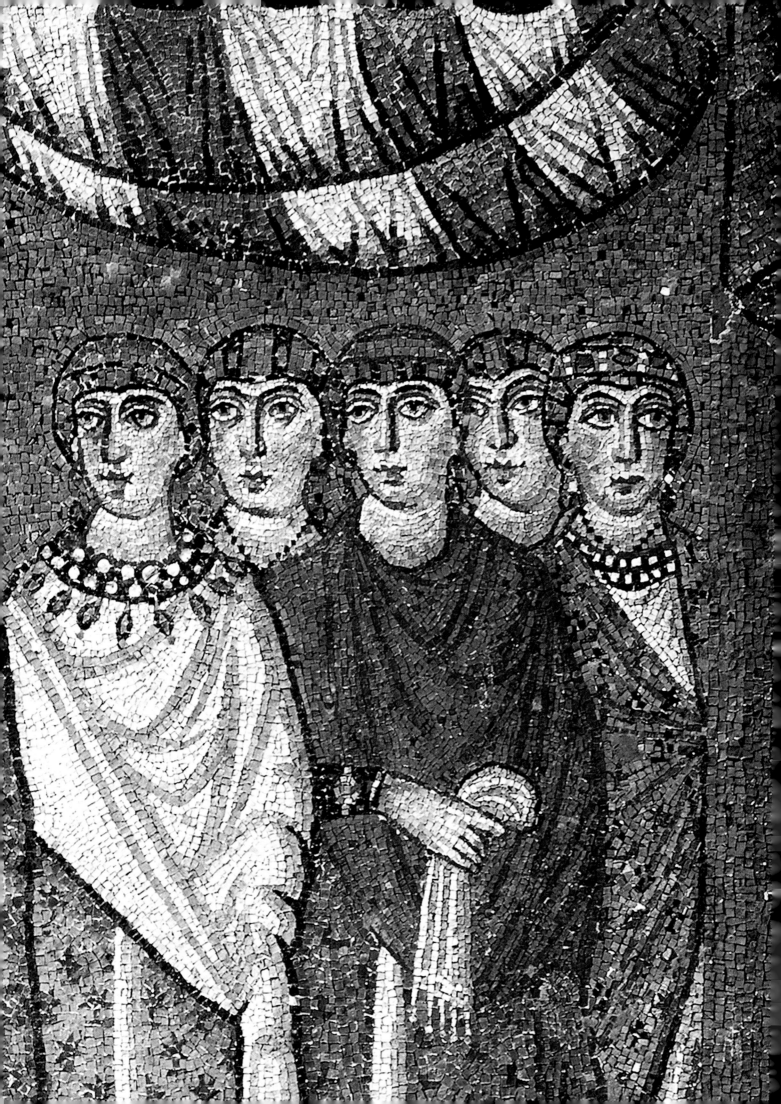

Early Christian and Byzantine Art

A S ROMAN AUTHORITY WANED, A NEW SOCIETY—WITH A VERY different outlook and set of values—took root in the soil of Rome. This new culture was formed in part by Roman traditions, but also by the energies and customs of many indigenous non-Roman groups. The values and institutions of this new culture were largely shaped by a single

religious movement that began in the ancient Near East: Christianity.

This culture of Early Christianity—shaped by Rome, by migrations of Northern European peoples, and by Christian faith and institutions—lasted a thousand years. Later historians, looking back from the Renaissance, when Roman forms were deliberately being revived, called this civilization medieval; they saw the Middle Ages as an epoch between themselves and the ancient world. (The term "medieval" is derived from the Latin *med(ium) aev(um)*, thus a synonym for the Middle Ages.) The chronological limits of the Middle Ages are somewhat fluid, but for many historians, the conversion of Constantine the Great in 312 marks the beginning of the Middle Ages, while the Renaissance in the 1400s marks its end.

The unified political structure that Rome had created in the Mediterranean began to break apart by the fourth century CE, with the result that separate imperial centers were established for the eastern half of the Empire (mostly North Africa and western Asia, but also the Balkans) and the western half (Italy and the rest of western Europe). (See map 8.1.) While for much of the medieval period, the Eastern Empire, or Byzantine Empire, retained its central authority, the West had no such centralized power. Until the seventh century, the Eastern Empire attempted to control the West, however ineffectively,

but by the end of the seventh century, the Eastern Empire itself was being challenged by the militant force of Islam. The Western Empire then fractured further into smaller kingdoms.

New religious expressions arose to address the spiritual crisis that accompanied the instability of Late Roman political institutions. The Late Roman Empire was home to a vast melting pot of creeds—including the ancient faith of Judaism, Christianity, Mithraism, Manichaeism, and Gnosticism, to name a few. These competing faiths shared several features, including an emphasis on divine revelation through a chief prophet or messiah and the hope of salvation. Of these religions, Christianity—centering on the life and teachings of Jesus of Nazareth—became the most widespread and influential. It spread first to Greek-speaking communities, notably to Alexandria, in Egypt, then reached the Latin-speaking world by the end of the second century. The Gospels of Matthew, Mark, Luke, and John, our principal source of information about Jesus' life, were probably written in the late first century, some decades after Jesus' death. The Gospels present him as a historical person and as the Son of God and Messiah or the "Anointed One." The eloquence and significance of Christ's teachings, the miracles attributed to him, and his innate goodness were considered signs of his divinity. The Roman authorities, viewing Jesus' teaching as subversive, had him arrested, tried, and ultimately punished and executed by crucifixion. As the faith spread, the Romans believed Christians

Detail of figure 8.26, *Empress Theodora and Her Attendants*

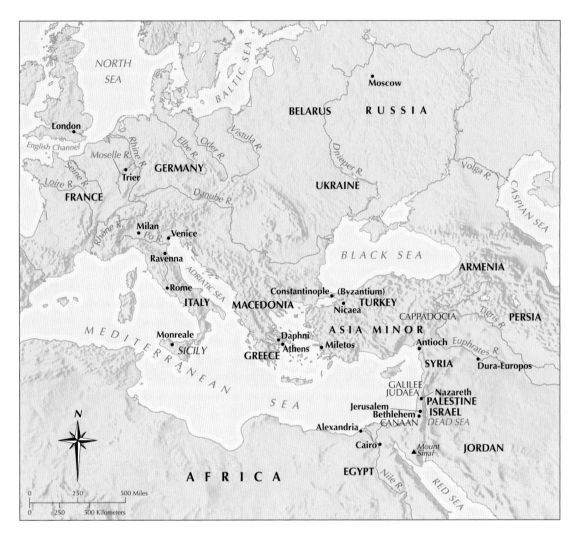

Map 8.1. The Early Christian and Byzantine Worlds

threatened the status quo, and intermittently persecuted them. Still, by 300 CE, nearly one-third of Rome was Christian, though the new faith continued to have little standing until the conversion of Constantine the Great in 312.

In that year, Constantine was battling his fellow Tetrarch, Maxentius, for control of the Western Empire. According to his biographer, Bishop Eusebius of Caeserea, Constantine claimed to have had a dream in which Christ himself assured him of his victory over Maxentius, which took place at the Milvian Bridge in Rome in 312. This is the triumph commemorated by the Arch of Constantine (see fig. 7.63). After this, Constantine accepted the Christian faith and, having consolidated imperial power, promoted Christianity throughout the Empire. Constantine began building important structures and convening Church councils. He claimed that his political authority was granted by God, and placed himself at the head of the Church as well as of the state. His choice to accept and promote Christianity was a turning point in history, as it resulted in the union of Christianity with the legacy of the Roman Empire. The charac-

ter of the Middle Ages—and thus of the rest of European history—depended directly on Constantine's decision.

Constantine also decided to build a new capital for the Roman Empire at the strategically located Greek town of Byzantium, which was renamed Constantinople (present-day Istanbul). Distant from the ancient pagan centers of Rome, the new capital in the rich Eastern provinces was in the heart of the most thoroughly Christianized region of the Empire. Constantine certainly did not anticipate it, but within a century of this event, Rome had divided into two halves: an Eastern Empire, of which Constantinople was the capital, and a Western Empire centered at Rome. Yet imperial might and wealth were concentrated in Constantinople, enriching and protecting the Eastern Empire. In the West, imperial authority was less effective in the face of new challenges, as non-Roman groups first invaded and then settled in Europe. The two empires grew apart, in their institutions and in the practice of their common faith.

Into the vacuum of power left by the decline of imperial institutions in the West stepped the Bishop of Rome. Deriving

his authority from Saint Peter, the Pope, as the Bishop of Rome became known, claimed to be the head of the universal Christian Church, although his Eastern counterpart, the patriarch of Constantinople, disputed this claim. Differences in doctrine and liturgy continued to develop until eventually the division of Christendom into a Western or Catholic Church and an Eastern or Orthodox Church became all but final. The Great Schism, or final break, between the two churches occurred in the eleventh century.

The religious separation of East and West profoundly affected the development of Christian art in the Late Roman Empire. *Early Christian* does not, strictly speaking, designate a style. It refers, rather, to any work of art produced by or for Christians during the time prior to the splitting off of the Eastern Church from the Western Church, that is, roughly during the first five centuries after the birth of Jesus. *Byzantine*, on the other hand, designates not only the art of the Eastern Roman Empire but also its specific culture and style, which was linked to the imperial court of Constantinople.

Both Early Christian and Byzantine art have their origins in Rome. But the art forms of Early Christian art differ from those of the Greek and Roman world. Whereas the ancients expressed the physical presence of their gods in naturalistic sculpture and paintings, early Christian artists explored a different vision. In the service of their new faith, Early Christian artists concentrated on symbolic representation, using physical means to express a spiritual essence. Early Christian art refined the increasingly stylized and abstracted art forms of the Late Roman Empire into a visual language that could express both profoundly spiritual and unmistakably secular power. It became the basis for later art forms in both Western Europe and Byzantium during the Middle Ages.

EARLY CHRISTIAN ART

Christian Art before Constantine

We do not know when or where the first Christian works of art were produced. None of the surviving paintings or sculptures can be dated earlier than about 200 CE. In fact, we know little about Christian art before the reign of Constantine the Great. This is hardly accidental. It is in Rome that we have the greatest concentration of the earliest surviving works, yet before Constantine, Rome was not yet the center of the faith. Older and larger Christian communities existed in the great cities of North Africa and the Near East, such as Alexandria and Antioch, but we only have hints of what Christian places of worship there and in centers such as Syria and Palestine might have looked like.

THE ART OF THE CATACOMBS The painted decoration of the Roman **catacombs**, underground burial places, is the only sizable body of material we have from which to study the earliest Christian art. The burial rite and the safeguarding of the tomb were of vital concern to early Christians, whose faith rested on salvation, the hope of eternal life in paradise. As such,

paintings in catacombs tell us a good deal about the spirit of the communities that commissioned them.

The ceiling of one of the more elaborate chambers in the catacomb of Santissimi Pietro e Marcellino (fig. **8.1**), in Rome, is decorated in a style that is at once formal and uncomplicated. Fixed borders control the overall organization; a central medallion or circle contains the figure of a shepherd, who is flanked by sheep and carries a lamb across his shoulders. The circle is connected to four **lunettes** (semicircular spaces), and in the four corners are single figures with outstretched, raised arms. The style of painting reflects Roman murals, both in the landscape settings and in the use of linear devices to divide the scenes into compartments (see the Villa of Livia at Primaporta, fig. 7.55, or the Ixion Room of the House of the Vettii, fig. 7.57). But the representations seem sketchier, less grounded in natural observation than their Roman relatives. The differences are partly due to the nature of the subterranean spaces, their use, and their meaning.

Catacombs would have been used only occasionally beyond the actual circumstance of burial, perhaps for a commemorative celebration. This is one reason why the wall paintings do not show much detail and care of execution. Another reason for the sketchiness of these paintings is that their primary value is symbolic. Consistent with the biblical prohibition against image making, as specified in the Second Commandment of the Old Testament (see end of Part II *Additional Primary Sources*), Christ is generally not represented in the catacombs, except by metaphor. The shepherd with a sheep on his shoulder is a potent allusion to Christ, since in a number of biblical accounts Christ refers to himself as the Good Shepherd, concerned for the well-being of his flock and willing to sacrifice himself in order to guarantee the salvation of those who follow him (Luke 15: 4–6; John 10: 1–18). This Good Shepherd metaphor also builds on Old Testament references, as in Psalm 23:

> The Lord is my shepherd, I shall not want.
> He makes me lie down in green pastures;
> he leads me beside still waters;
> he restores my soul.…
> Surely goodness and mercy shall follow me
> all the days of my life,
> and I shall dwell in the house of the Lord
> for ever.

The Old Testament correlation reflects the fact that many of the converts to the new faith were Jewish.

The four lunettes around the Good Shepherd form a cycle dedicated to the Old Testament prophet Jonah. Here too, the symbolic references to Christian beliefs about Christ are clear: Just as it is a principle of faith that Jonah spent three days within the belly of the whale, so Christ is supposed to have spent three days in the tomb, and just as Jonah was released with unharmed body, so Christ was resurrected from his tomb in physical wholeness. Recent converts would probably have felt comfortable knowing that didactic aspects of their old faith could find a sympathetic response in the new religion. Jonah's

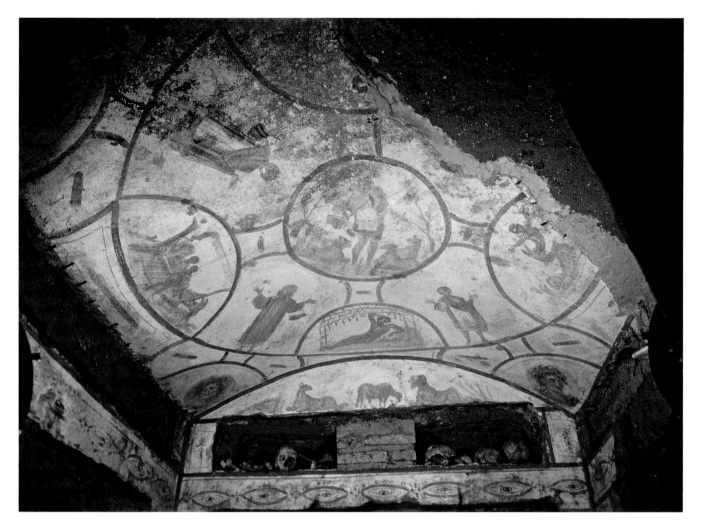

8.1. Painted ceiling. 4th century CE. Catacomb of Santissimi Pietro e Marcellino, Rome

story is presented as a **prefiguration** (foreseeing) of events in Christ's life, thus assigning the Old Testament story the role of prophecy and the New Testament one its fulfillment. As Christian thinkers increasingly analyzed the prophetic relationship of the Old Testament to the New, they developed a virtual system of concordances, called **typology**, that was to have far-reaching significance.

The painted ceiling in Santissimi Pietro e Marcellino also borrows imagery from classical sources. The Good Shepherd himself is a reminder of pagan symbols of charity in the form of ancient sculptures of men carrying sacrificial animals on their shoulders. The posture of Jonah, reclining under the gourd bush, benefiting from God's beneficence, derives from Roman pagan mythological representations of Endymion, a youth so beautiful that he was rewarded with eternal and undisturbed sleep. So, as with their Jewish counterparts, former practitioners of pagan religions who had converted to Christianity would also have been familiar with some of the images and ideas expressed in Early Christian art.

Both the Good Shepherd and Jonah are associated with messages of comfort, reminding us that Early Christian art develops during the turmoil of Rome's decline, a time of political, social, and economic instability. The allure of the new

religion must have been profound indeed, suggesting that things of this world were of less significance than those of a future world, which offered the hope of eternal peace. The four standing figures between the lunettes are **orants** (worshipers), represented in what had long been the standard pose of prayer, signifying the virtues of faith and piety that will make personal salvation possible.

One might question the extent to which the Christian use of pagan and Jewish subjects had a political agenda. After all, on some level, to borrow forms from other cultures and religions and to use them for new purposes are acts of appropriation. By adopting forms used by an older, more established culture, Christians expressed their ambition to dominate that culture—indeed, to supplant it. Such appropriation becomes more systematic as the new religion of Christianity becomes increasingly powerful.

SCULPTURE Sculpture seems to have played a secondary role in Early Christian art. The biblical prohibition of graven images was thought to apply with particular force to large cult statues, idols worshiped in pagan temples. In order to avoid the taint of idolatry, therefore, Christian sculpture had to shun life-

size representations of the human figure. Sculpture thus developed in an antimonumental direction: away from the spatial depth, naturalism, and massive scale of Graeco-Roman sculpture and toward shallow, small-scale forms and lacelike surface decoration.

The earliest works of Christian sculpture are **sarcophagi**, stone coffins, which from the middle of the third century on were produced for the more important members of the Church. They evolved from the pagan examples that had replaced cinerary urns in Roman society around the time of Hadrian. Before the time of Constantine, their decoration consisted mostly of a repertory of familiar themes from the catacombs. Examples of these can be seen on the marble sarcophagus of the mid-third century from Santa Maria Antiqua in Rome (fig. 8.2). On the left are the scenes of Jonah: the ship, the sea monster, and the reclining prophet. Jonah's well-chiseled anatomy and the elegance of his pose remind us of the Classical sources that must have served as a model for the artist. So too, the Good Shepherd, though stylized, reminds of us of Classical statuary in that he is able to distribute weight well enough to manage with some comfort the burden of the sheep he carries. Again, the orant in the center, with hands upraised in prayer, is a subject we have seen in catacomb painting. The seated figure holding a scroll derives from antique representations of writers or philosophers and is another of the metaphoric references to Christ, in this case to his role as teacher. On the right is a scene of baptism. The figure being baptized may be Christ himself. If so, this might indicate an increased movement toward narrative, since baptism was an event in the life of Jesus (see *Informing Art*, page 240), and a willingness to represent him directly. On the other hand, the figure appears to be generic, nonindividualized, virtually childlike in its proportions. This generic representation could be a result of both a fear of making an idolatrous image and an interest in expressing the more essential nature of the scene, from which a portrait of the person of Christ would detract.

ART IN TIME

ca. 29 — Crucifixion of Jesus of Nazareth

200—Earliest datable Christian art

256—Dura-Europos falls to Persians

ca. 270—Sarcophagus at Santa Maria Antigua

312—Roman emperor Constantine converts to Christianity

THE HOUSE CHURCH Although we have little archeological evidence of the places where Early Christians gathered, literary accounts, including biblical references, suggest that Christians met regularly to celebrate their shared belief in Christ as the Son of God and Savior and to observe some type of Eucharist, or spiritual union, with him by the partaking of consecrated bread and wine (representing Christ's flesh and blood) in remembrance of the Last Supper, at which Jesus and his disciples enjoyed a final communal meal. Such gatherings of Christians probably originally took place in private homes and were only later replaced by public spaces designed specifically for Christian worship. This situation is perhaps to be expected, both because Christianity was something of an underground religion and because other religions seem also to have used private houses as gathering places, for instance the Villa of the Mysteries in Pompeii (see fig. 7.53).

A remarkable archeological find of the 1920s in the Syrian town of Dura-Europos allows us to see what must have been a typical Christian meeting place. Dura-Europos was a Roman town on the upper Euphrates. In 256 CE, in order to protect itself from imminent attack by the Persians under Shapur I, who was trying to expand the territories he controlled by means of conquest (see Chapter 2), the town strengthened its protective walls, which involved filling in some streets adjacent to those walls in order to form a defensive bunker. Buried as a result, and thus preserved, were a number of buildings, including a Jewish synagogue and a house that was used for Christian rituals.

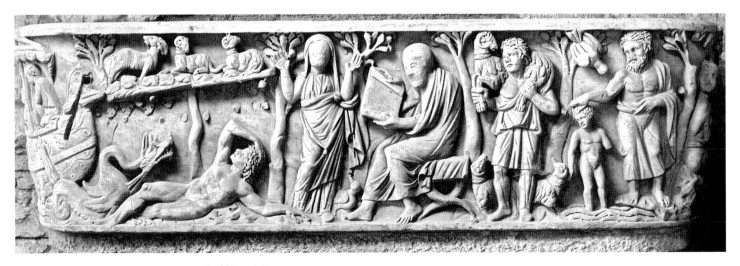

8.2. Sarcophagus. ca. 270 CE. Marble, 1'11¼" × 7'2" (5.45 × 2.2 m). Santa Maria Antiqua, Rome

The Life of Jesus

Events in the life of Jesus, from his birth through his ascension to heaven, are traditionally grouped in cycles, each with numerous episodes. The scenes most frequently depicted in European art are presented here.

Incarnation Cycle and The Childhood of Jesus

These episodes concern Jesus' conception, birth, infancy, and youth.

Annunciation. The archangel Gabriel tells Mary that she will bear God's son. The Holy Spirit, shown usually as a dove, represents the Incarnation, the miraculous conception.

Visitation. The pregnant Mary visits her older cousin Elizabeth, who is to bear John the Baptist and who is the first to recognize the divine nature of the baby Mary is carrying.

Nativity. At the birth of Jesus, the Holy Family—Mary, his foster father, Joseph, and the Christ Child—is usually depicted in a stable or, in Byzantine representations, in a cave.

Annunciation to the Shepherds and Adoration of the Shepherds. An angel announces the birth of Jesus to shepherds in the field at night. The shepherds then go to the birthplace to pay homage to the child.

Adoration of the Magi. The Magi, wise men from the East (called the Three Kings in the Middle Ages), follow a bright star for 12 days until they find the Holy Family and present their gifts to Jesus.

Presentation in the Temple. Mary and Joseph take the infant Jesus to the Temple in Jerusalem, where Simeon, a devout man, and Anna, a prophetess, foresee Jesus' messianic mission (his mission as Savior) and martyr's death.

Massacre of the Innocents and Flight into Egypt. King Herod orders all male children under the age of two in and around Bethlehem to be killed in order to preclude his being murdered by a rival newborn king spoken of in a prophecy. The Holy Family flees to Egypt.

Public Ministry Cycle

Baptism. John the Baptist baptizes Jesus in the Jordan River, recognizing Jesus' incarnation as the Son of God. This marks the beginning of Jesus' ministry.

Calling of Matthew. The tax collector Matthew becomes Jesus' first disciple (apostle) when Jesus calls to him, "Follow me."

Jesus Walking on the Water. During a storm, Jesus walks on the water of the Sea of Galilee to reach his apostles in a boat.

Raising of Lazarus. Jesus brings his friend Lazarus back to life four days after Lazarus's death and burial.

Delivery of the Keys to Peter. Jesus names the apostle Peter his successor by giving him the "keys" to the Kingdom of Heaven.

Transfiguration. As Jesus' closest disciples watch, God transforms Jesus into a dazzling vision and proclaims him to be his own son.

Cleansing the Temple. Jesus clears the Temple in Jerusalem of money changers and animal traders.

Passion Cycle

The Passion (from passio, Latin for "suffering") cycle relates Jesus' death, resurrection from the dead, and ascension to heaven.

Entry into Jerusalem. Welcomed by crowds as the Messiah, Jesus triumphantly rides an ass into the city of Jerusalem.

Last Supper. At the Passover seder, Jesus tells his disciples of his impending death and lays the foundation for the Christian rite of the Eucharist: the taking of bread and wine in remembrance of Christ. (Strictly speaking, Jesus is called Jesus until he leaves his earthly physical form, after which he is called Christ.)

Jesus Washing the Disciples' Feet. Following the Last Supper, Jesus washes the feet of his disciples to demonstrate humility.

Agony in the Garden. In Gethsemane, the disciples sleep while Jesus wrestles with his mortal dread of suffering and dying.

Betrayal (Arrest). The disciple Judas Iscariot takes money to identify Jesus to Roman soldiers. Jesus is arrested.

Denial of Peter. As Jesus predicted, Peter, waiting outside the high priest's palace, denies knowing Jesus three times as Jesus is being questioned by the high priest Caiaphas.

Jesus before Pilate. Jesus is questioned by the Roman governor Pontius Pilate regarding whether or not he calls himself King of the Jews. Jesus does not answer. Pilate reluctantly condemns him.

Flagellation (Scourging). Jesus is whipped by Roman soldiers.

Jesus Crowned with Thorns (The Mocking of Christ). Pilate's soldiers mock Jesus by dressing him in robes, crowning him with thorns, and calling him King of the Jews.

Carrying of the Cross (Road to Calvary). Jesus carries the wooden Cross on which he will be executed from Pilate's house to the hill of Golgotha, which means "the place of the skull."

Crucifixion. Jesus is nailed to the Cross by his hands and feet, and dies after great physical suffering.

Descent from the Cross (Deposition). Jesus' followers lower his body from the Cross and wrap it for burial. Also present are the Virgin Mary, the apostle John, and in some accounts, Mary Magdalen.

Lamentation (*Pietà* or *Vesperbild*). The grief-stricken followers gather around Jesus' body. In the *Pietà*, his body lies in the lap of the Virgin.

Entombment. The Virgin Mary and others place the wrapped body in a sarcophagus, or rock tomb.

Descent into Limbo (Harrowing of Hell or Anastasis in the Orthodox Church). Christ descends to hell, or limbo, to free deserving souls who have not heard the Christian message—the prophets of the Old Testament, the kings of Israel, and Adam and Eve.

Resurrection. Christ rises from the dead on the third day after his entombment.

The Marys at the Tomb. As terrified soldiers look on, Christ's female followers (the Virgin Mary, Mary Magdalen, and Mary, mother of the apostle James the Greater) discover the empty tomb.

Noli Me Tangere, Supper at Emmaus, and the Doubting of Thomas.

In three episodes during the 40 days between his resurrection and ascent into heaven, Christ tells Mary Magdalen not to touch him (*Noli me tangere*), shares a supper with his disciples at Emmaus, and invites the apostle Thomas to touch the lance wound in his side.

Ascension. As his disciples watch, Christ is taken into heaven from the Mount of Olives.

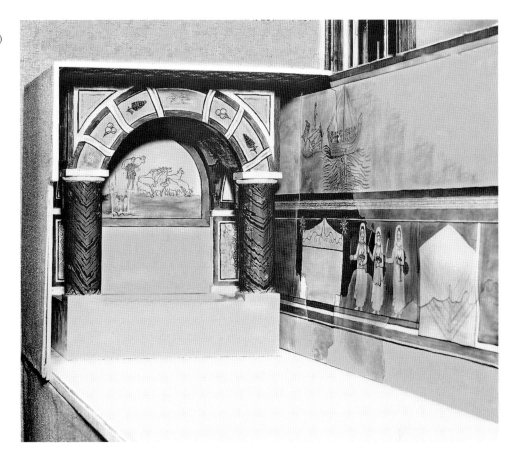

8.3. Model of the Baptistery, the Christian Meeting House (*domus ecclesiae*) at Dura-Europos, Syria. Before 256 CE. Yale University Art Gallery, New Haven, Connecticut

The house is in most ways a typical two-story Roman *domus*. A large room opened onto the atrium and would have served as a community assembly room, while another space was apparently reserved for baptism, judging by a font that takes up an entire wall of the room (fig. **8.3**). The font is covered by a stone canopy, and frescoed scenes decorate the lunette on the end wall under the canopy and also the side walls. Some of the subjects represented are familiar: In the lunette is a Good Shepherd balancing a sheep on his shoulders with his flock before him, and, at the bottom left, now barely visible, are figures of Adam and Eve. Represented on the side wall are three women holding candles who proceed toward a stone sarcophagus: This scene represents the three Marys at the Tomb (see *Informing Art*, page 240) who, when approaching the tomb of Christ (as described in Matthew 28:1–10), meet an angel who tells them that the tomb is empty because the entombed Christ has risen.

The representations on the wall of the Dura-Europos house can be connected with those found in Early Christian catacombs and on sarcophagi through shared imagery, such as the depictions of the Good Shepherd and Adam and Eve. Such images indicate a general concern for issues of death and retribution, resurrection and salvation. The inclusion here of Adam and Eve reminds the viewer of the Original Sin, committed by Adam and passed from one generation to the next, from which humankind will be redeemed as a result of Christ's sacrificial death and his resurrection, which the scene of the Marys visiting his empty tomb emphasizes. The association of these funerary subjects with baptism was a logical pairing for Christians, who

view baptism as a rebirth into the new faith, just as they see physical death as a rebirth into everlasting life. Even when artists were experimenting with how best to depict entirely new subject matter, those responsible for its creation, whether artists or patrons, applied an overwhelming conceptual consistency to Christian art during the first several centuries of the Christian era. This was perhaps a result of the new religion's need for didactic representations that could be readily understood.

Christians in other areas of the Empire also used the type of *domus ecclesiae*, or **house church**, seen at Dura-Europus. In Rome itself we know of 25 private houses—and undoubtedly there were more—reserved as places of Christian worship, although most of them were destroyed by the later building of churches on their sites.

Christian Art after Official Recognition of Christianity

The building of churches on the sites of what once were private houses used for Christian worship reflects a change in the nature of Christianity during the fourth century from an alternative religion to the official religion endorsed by the emperor Constantine. Almost overnight, an impressive architectural setting had to be created for the new official faith, so that the Church might be visible to all. Constantine himself devoted the full resources of his office to this task. Within a few years an astonishing number of large, imperially sponsored churches arose, not only in Rome but also in Constantinople, in the Holy Land, and at other important sites.

THE CHRISTIAN BASILICA The most important Constantinian church structures were a type of **basilica**, and this form provided the basic model for the development of church architecture in Western Europe. The Early Christian basilica owes its essential features to imperial basilicas, such as the Basilica Ulpia (see fig. 7.33). As with the imperial basilicas, it is characterized by a long **nave** flanked by side aisles and lit by **clerestory** windows, with an **apse** (though only at one end) and a trussed wooden roof. The Roman basilica was a suitable model since it combined the spacious interior needed to accommodate a large number of people with (perhaps most important) imperial associations that proclaimed the privileged status of Christianity. As the largely civil functions of the Roman basilica were quite different from its new uses as a house of worship, the Roman-style basilica had to be redesigned to acknowledge these changes. Therefore, the longitudinal plan of the basilica was given a new focus: the **altar** was placed in front of the semicircular apse, normally at the eastern end of the nave. The significance of the altar's placement in the east, where the sun rises, reminds us that Christianity inherited many divine attributes from other religions. In this case, Christ shares an imagery with the Roman god Apollo, in his manifestation as sun-god.

The greatest Constantinian church was Old St. Peter's Basilica in Rome (figs. **8.4** and **8.5**). It was torn down and replaced by the present St. Peter's Basilica, in the Vatican, during the sixteenth and seventeenth centuries, but its appearance is preserved in a seventeenth-century album of copies of earlier drawings (fig. **8.6**), and there are literary descriptions as well. Together these sources give us a clear idea of the original plan for the church. Begun as early as 319 and finished by 329, Old St. Peter's was built on the Vatican Hill next to a pagan burial ground. It stood directly over the grave of St. Peter, which was marked by a shrine covered with a **baldacchino**, a canopy that designates a place of honor. As such, Old St. Peter's served as the apostle's **martyrium**, a building that housed sacred relics or the remains of a holy person. The location of St. Peter's burial spot was the focus of the church, and due to site restrictions, its apse was at the west end of the church, an unusual feature. Rituals were conducted from a portable altar placed before the shrine, using gold and silver implements donated by the emperor himself. (See *Primary Source*, page 244.)

To enter the church the congregation first crossed a colonnaded court, the **atrium**, which was added toward the end of the fourth century; this feature derived from the Roman basilica. Congregants then passed through the **narthex**, an entrance hall, into the church itself. The steady rhythm of the nave colonnade would have pulled them toward the **triumphal arch**, which framed the shrine of St. Peter and the apse beyond. The shrine stood at the junction of the nave and the **transept**, a separate space placed perpendicular to the nave and aisles. Spaces at the end of the transept, marked off by columns, might have served to prepare items used during church rites and to hold offerings brought by the faithful.

The main focus of Christian liturgy, a body of rites prescribed for public worship, was, and is, the Mass, which includes the sacrament of Communion, the symbolic reenactment on the altar of Jesus' sacrifice. The Early Christian basilica encouraged attention to the altar, making it the focal point of the church by placing it opposite the entrance and at the end of a long nave. Even beyond this general emphasis on the altar, Old St. Peter's gave special prominence to the altar zone through this church's special, additional function as a martyrium.

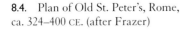

8.4. Plan of Old St. Peter's, Rome, ca. 324–400 CE. (after Frazer)

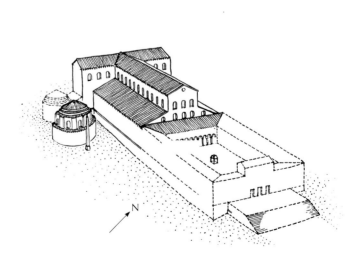

8.5. Reconstruction of Old St. Peter's, Rome, as it appeared ca. 400. (after Krautheimer)

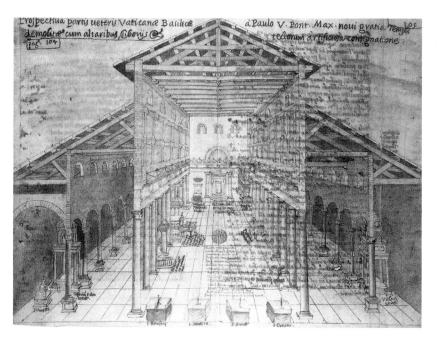

8.6. Jacopo Grimaldi. *Interior of Old St. Peter's, Rome.* 1619. Drawing, MS; Barbarini Lat. 2733 fols. 104v 105r. Vatican Library, Rome

Although today we think of the practice of religion as an open one, in the early church only those who had proven themselves full-fledged Christians could witness the complete performance of the liturgy. It was through baptism that *catechumens*, those receiving instruction in preparation for their initiation into the new religion, became full-fledged Christians. Before baptism, they could hear, but not see, parts of the Mass. Even today, Christians refer to this as the "mystery" of the Mass.

CENTRAL-PLAN STRUCTURES Buildings of round or polygonal shape capped by a dome entered the tradition of Christian architecture in Constantine's time. Roman emperors had built similar structures to serve as monumental tombs or mausoleums, such as the one Diocletian had built for himself at his palace at Spalato (see fig. 7.71). Not surprisingly, therefore, the Early Christian **central-plan building** was often associated with funerary functions, as was Santa Constanza, in Rome, the mausoleum of Constantine's daughter Constantia (figs. **8.7** and **8.8**). Built over a catacomb, it was originally attached to the now-ruined basilican church of St. Agnes Outside the Walls. The focus of the building is on the central space, illuminated by clerestory windows, over which rises a dome supported by twelve pairs of columns. Four of the arches of this colonnade stand slightly higher than the others and suggest a cross

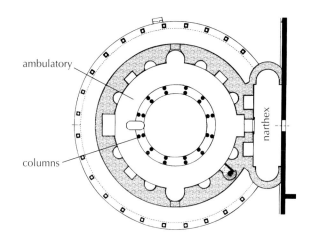

ambulatory

columns

narthex

8.7. Plan of Santa Costanza, Rome. ca. 350 CE

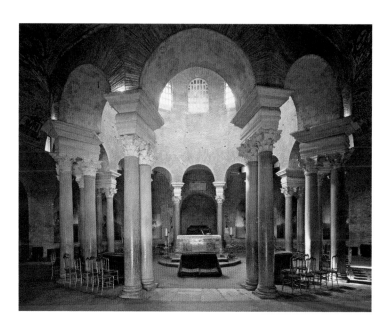

8.8. Interior (view through ambulatory into rotunda), Santa Costanza, Rome

The Book of the Popes (Liber Pontificalis)

From the Life of Pope Sylvester I

This text is an official history of the Roman papacy from St. Peter (d. ca. 64 CE) to the twelfth century. Its biographies of the early popes were compiled from archival documents. What follows, for example, is a list of gifts to Old St. Peter's by Emperor Constantine in the time of Pope Sylvester I (314–335 CE). Lavish imperial donations such as these set a standard that subsequent popes and other prelates continued to match.

Constantine Augustus built the basilica of blessed Peter, the apostle, and laid there the coffin with the body of the holy Peter; the coffin itself he enclosed on all sides with bronze. Above he set porphyry columns for adornment and other spiral columns which he brought from Greece. He made a vaulted apse in the basilica, gleaming with gold, and over the body of the blessed Peter, above the bronze which enclosed it, he set a cross of purest gold. He gave also 4 brass candlesticks, 10 feet in height, overlaid with silver, with figures in silver of the acts of the apostles, 3 golden chalices, 20 silver chalices, 2 golden pitchers, 5 silver pitchers, a golden paten with a turret of purest gold and a dove, a golden crown before the body, that is a chandelier, with 50 dolphins, 32 silver lamps in the basilica, with dolphins, for the right of the basilica 30 silver lamps, the altar itself of silver overlaid with gold, adorned on every side with gems, 400 in number, a censer of purest gold adorned on every side with jewels.

SOURCE: CAECILIA DAVIS-WEYER, *EARLY MEDIEVAL ART 300–1150*, (UPPER SADDLE RIVER, NJ: PRENTICE HALL, 1ST ED., 1971)

inscribed within a circle. The significance of the cross in a funerary context results from its association with Christ, who, though martyred on a cross, rose victorious over death. The Cross was meaningful to all Christians but particularly to the family of Constantine, whose personal conversion was a result of his vision of the Cross, which had signaled his victory at the Battle of the Milvian Bridge in 312. The sarcophagus of Constantia was originally placed under the eastern, more-elevated arch. Encircling the building is an **ambulatory**, a ring-shaped aisle, covered by a barrel vault (see fig. 7.3).

Central-plan and basilican structures are not as different as would first seem. In fact, a section of a central-plan building parallels a section of a basilican church in that both have a high central space with a clerestory flanked by a lower aisle. While the basilica plan stretches this form so that emphasis is on the end of the building, the central plan, as seen in Santa Costanza, spins the section on axis, accentuating the center. You can see this clearly by comparing figures 8.6 and 8.8.

MERGING THE BASILICAN AND CENTRAL PLANS
Since Constantine continued to follow Roman imperial traditions even as he accepted the tenets of Christianity, it is not surprising that when he supported the construction of buildings in the Holy Land to mark places significant in the life of Jesus, he chose plans based on Roman imperial building types, thus accentuating his ambitions for his new religion. The basilican Church of the Holy Sepulchre (fig. **8.9**), in Jerusalem, marked the location where St. Helena, mother of Constantine, had found the True Cross (that is, the cross on which Jesus was crucified as opposed to those crosses on which the thieves who were sentenced to death along with Christ were crucified). Beyond the basilica was the Rotunda of the Anastasis (Greek for "resurrection"), built over the tomb where Christ's body is reputed to have lain for the three days before his resurrection. Although the Constantinian building was subsequently destroyed and later rebuilt in a somewhat different form, this

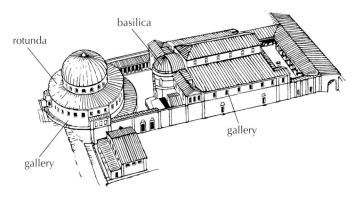

8.9. Reconstruction, Church of the Holy Sepulchre, Jerusalem, as it appeared ca. 350 CE (after Conant). 3′10½″ × 8′ (1.2 × 2.4 m)

aisled basilica included a **gallery**, a second story placed over the side aisles of a church, increasing the space available for the throngs of pilgrims that flocked to key sites. The apse was ringed with twelve columns, which Eusebius, Constantine's confidant and biographer, equated with Jesus' twelve apostles. In the Anastasis rotunda, too, there would have been a gallery, but in all other ways this rotunda has the same silhouette as Santa Constanza. Both have ambulatories formed by columns arranged around a domed central space, although unlike Santa Constanza's masonry dome, the dome of the Anastasis rotunda was probably made of wood. The similarity of form is not surprising. Both were products of the benefaction of the imperial family and both served funereal functions. As such, their roots in imperial mausoleums are appropriate, even as their forms become conveyers of new meaning. The Church of the Holy Sepulchre complex shares with Old St. Peter's a desire to combine the congregational aspects of a Roman basilica with a martyium in a monument that eulogizes the deceased whom it commemorates—Christ himself.

ARCHITECTURAL DECORATION: WALL MOSAICS

The rapid growth of large-scale Christian architecture had a revolutionary effect on Early Christian pictorial art. All of a sudden, huge wall surfaces had to be covered with images worthy of their monumental framework. Out of this need emerged a great new art form, the Early Christian wall mosaic, which to a large extent replaced the older and cheaper medium of mural painting (see *Materials and Techniques*, page 246). The challenge of inventing a body of Christian imagery produced an extraordinary creative outpouring. Great pictorial cycles of subjects selected from the Old and New Testaments were spread over the nave walls, the triumphal arch, and the apse. These cycles must have drawn on sources that reflected the whole range of Graeco-Roman painting as well as the artistic traditions that surely had developed in the Christian communities of North Africa and the Near East.

Decoration of fourth-century churches is largely fragmentary or known only from literary accounts; it is only in fifth-century churches that we can see the full development of mosaic-decorated Christian structures. Three structures in which the mosaic program is largely complete are the Mausoleum of Galla Placidia and the Orthodox Baptistry, both in Ravenna, and the church of Santa Maria Maggiore, in Rome.

During the fifth century the late Empire was threatened at all its borders by migrating tribes. Even the capital of the Western Empire at Rome was vulnerable. So the emperor Honorius moved it north, first to Milan, and when that city was besieged in 402, to Ravenna on the Adriatic coast, thought to be more easily defendable than inland sites.

The Mausoleum of Galla Placidia (fig. **8.10**) was named after Honorius' sister (who ruled the Empire as regent) because it was believed that she was buried there, though it is likely that it was begun as a chapel dedicated to the martyr St. Lawrence. Its central plan takes the form of a **Greek cross**, that is, a cross with arms of equal length. The exterior brick walls of the building, although perhaps originally covered, were always much simpler than the rich interior. Having left the everyday world behind, the visitor would encounter a shimmering realm of light and color where precious marble surfaces and glittering mosaics evoke the spiritual splendor of the Kingdom of God. To some extent the building is analogous to the ideal Christian, simple in external body and glorious in inner spirit, an analogy certainly not missed by Early Christians.

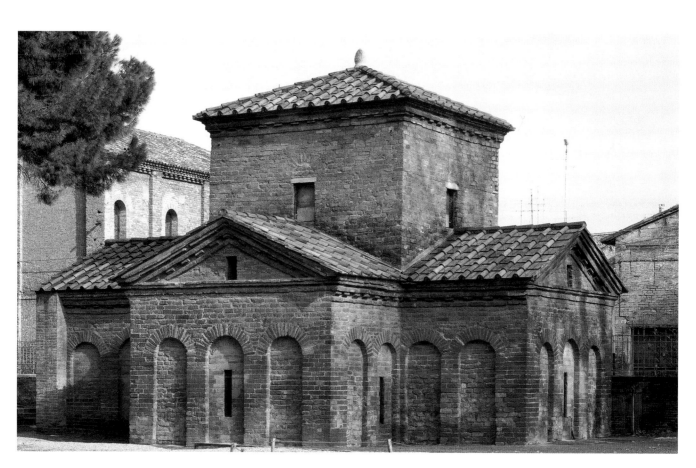

8.10. Mausoleum of Galla Placidia, Ravenna. 425–450 CE

Mosaics

Mosaics—designs composed of small pieces of colored material set in plaster or mortar—had been used by the Sumerians as early as the third millennium BCE to decorate architectural surfaces. The Hellenistic Greeks used pebbles and the Romans, using small cubes of marble called **tesserae**, had refined the technique to the point that it could be used to copy paintings, as seen in *The Battle of Alexander* (see fig. 5.79). Although most Roman mosaics were for floors, the Romans also produced wall mosaics, but these were usually reserved for special purposes, for example in fountain rooms or outdoor spaces where fresco would be vulnerable to deterioration.

The extensive and complex wall mosaics of Early Christian art are essentially without precedent. The color scale of Roman mosaics, although rich in gradations, lacked brilliance, since it was limited to the kinds of colored marble found in nature. Early Christian mosaics, by contrast, consist of tesserae made of colored glass, which the Romans had known but never fully exploited. Glass tesserae offered colors, including gold, of far greater range and intensity than marble tesserae. Moreover, the shiny, somewhat irregular faces of glass tesserae, each set slightly askew from its neighbor, act as tiny reflectors, so that the overall effect is like a glittering, immaterial screen rather than a solid, continuous surface. All these qualities made glass mosaic the ideal material for the new architectural aesthetic of Early Christian basilicas.

Glass for tesserae was made by combining sand, soda or potash, and lime with metallic oxides, which determined the resultant hues. Hardened sheets of glass were marked off and cut into tesserae of approximately cubic shape. For gold mosaics, gold leaf was placed on a sheet of glass, then glass, still in liquid form, was applied over it and heat applied to bond the glass layers, effectively embedding the gold leaf within glass.

The mosaic process was labor intensive, not only to create the design, but also to set the tesserae. Hundreds of thousands of tesserae were needed to cover a church interior, and setting them required skill and training. The process typically began by applying multiple layers of plaster (about 3 inches thick in all) to a wall. Recent investigations have shown that mosaics were generally prepared *in situ*. A drawing was done directly on the surface to be decorated, which was then painted in order to create a guide for the design. Red was used in areas that were to be covered with gold, since red added richness to the gold ground.

Tesserae were then laid into still-fresh plaster, which was sufficiently soft so that at least half the surface of the tesserae could be submerged; a secure attachment was thus guaranteed. The process required deliberate planning, since only the section of wall that could be finished in a day, roughly the time it would take for plaster to dry, would receive the final coat of plaster into which the tesserae were set.

Some medieval treatises distinguish between *pictores imaginarii* (mosaic painters) and *musearii* (mosaic workers), suggesting a hierarchy in the division of labor. Under any circumstances, mosaic production was a costly enterprise; it has been estimated that it was at least four times more expensive than wall painting. Clearly the aesthetic advantages of mosaics, as well as their durability, were thought sufficient to justify the expense.

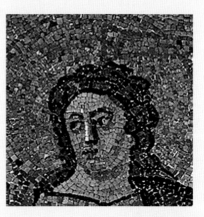

Detail of Good Shepherd, figure 8.12

The barrel vaults and dome of the Mausoleum of Galla Placidia (fig. **8.11**) are covered with luxurious leaflike decoration and fields of stars. Above the vaults, apostles flank a pair of doves and fountains, symbolic of souls drinking from the waters of paradise. In one lunette, St. Lawrence is beside the flame-racked grill on which he was martyred. A cabinet holding books, identified as the four Gospels, reminds us that Lawrence was martyred for refusing to surrender the riches of the Church, here represented as books, to Roman authorities. That books would be equated with treasure is perhaps not surprising, for, as we shall see, they were luxurious objects that played a vital function within the Church. The books also remind us that Christians referred to themselves as people of the Book, a designation they shared with the earlier Hebrew and later Moslem faiths.

Another lunette contains a mosaic of the Good Shepherd seated in a fully realized landscape (fig. **8.12**), expanding the central subject of so many catacomb paintings by its more elaborate and more formal treatment. Here the Good Shepherd is a young man with many of his attributes adopted from imperial art. His

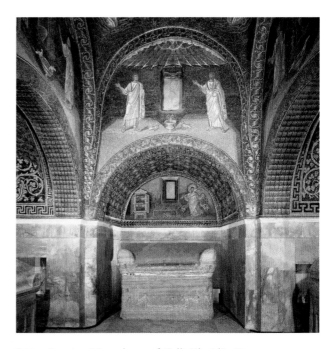

8.11. Interior, Mausoleum of Galla Placidia, Ravenna

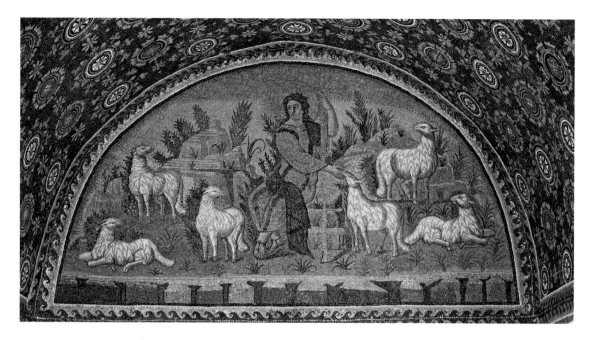

8.12. *Good Shepherd.* Mosaic. Mausoleum of Galla Placidia, Ravenna

halo comes from representations of the emperor as sun-king, and his gold robes and purple scarf are traditional signifiers of royal stature. These attributes are appropriate to a commission by the imperial family, but equally significant is the way formal features further the message, and perhaps here there is a paradox. While Christ, with realistically modeled face and flowing hair and garments, sits comfortably in a lush landscape with sky-blue background, the prevalence of gold denies naturalism to the scene. The paradox is that Christ is at once human, imperial, and of this world, and yet also beyond it, existing within a glimmering ethereal realm of which he is a natural part. Roman mural painting used illusionistic devices to suggest a reality beyond the surface of the wall (see fig. 7.55), whereas Early Christian mosaics used the glitter of gold tesserae to create a luminous realm filled with celestial beings, symbols, or narrative action. Thus, Early Christian mosaics transform the illusionistic tradition of ancient painting with the new Christian message.

The Early Christian architecture we have examined thus far suggests that vital forces enlivened preexisting forms in order to make them serve new functions. Such is also the case with the **baptistery**, which from its early roots in the rather improvisory adaptation of a room in the Christian House of Dura-Europos developed into a distinctive and significant architectural form. The Orthodox Baptistery in Ravenna (fig. **8.13**) is an octagonal building erected about 400 CE, which was heightened and domed about fifty years later. The central plan of the Orthodox Baptistery recalls antique mausoleums, while the eight sides of the building symbolically embody the connection between baptism and death: The world began on the eighth day following the Creation, and Christ was resurrected on the eighth day of the Passion. In the early Church, baptism occurred only once a year, at midnight on Easter Sunday, the day of the Resurrection, and only after the new Christian had endured a long period of indoctrination as a

catechumen. Even at Dura-Europos (see fig. 8.3), the confluence of death and resurrection is evident in the subjects represented, many of them, it will be recalled, appearing in the catacombs.

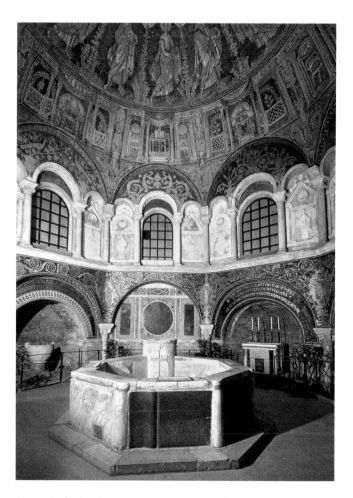

8.13. Orthodox Baptistery, Ravenna. ca. 400–458 CE

Like the interior of the Mausoleum of Galla Placidia, the interior of the Orthodox Baptistery is exultant in the marble walls of its lower reaches and in the stuccowork and mosaics above (fig. **8.14**). Old Testament prophets in stucco look down at the visitor from around the drum of the building, while above, gold-clad apostles proceed across an unnaturally blue background offering their crowns of martyrdom. In the center of the dome and within a gold medallion, Christ is baptized; to the right a pagan river god acknowledges Christ's divinity. The decorations, glittering in the candlelit night, must have made a profound impression on the converts being baptized in the font beneath the dome, for they saw depicted immediately above them the link between their own experiences and that of the Son of God.

Central in both rank and decoration among the Early Christian churches in which a full mosaic program can be described is the basilica of Santa Maria Maggiore in Rome (fig. **8.15**). Built between 432 and 440, this was the first church dedicated to Mary, begun only a year after she was declared the *Theotokos* (Greek for "the bearer of god") by the Council of Ephesus.

The apse is a later replacement, but the general outline of the original building and much of the mosaic decoration survive. These mosaics include the triumphal arch decoration and more than half of the 42 mosaic panels that were placed above the classically inspired entablature of the nave colonnade. These panels were framed by pilasters and colonettes. Sadly, much of this architectural decoration is now missing.

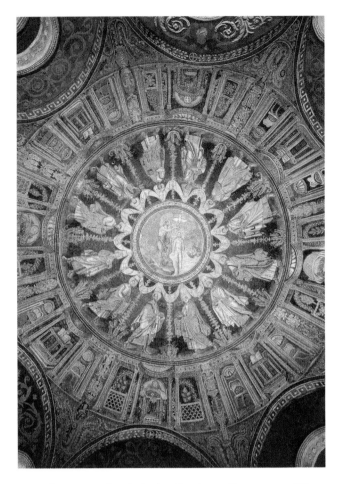

8.14. Dome mosaics, Orthodox Baptistery, Ravenna. ca. 458

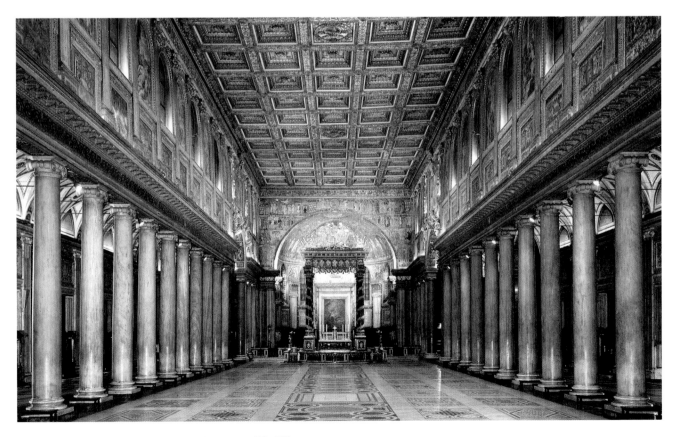

8.15. Interior, Santa Maria Maggiore, Rome. ca. 432–440 CE

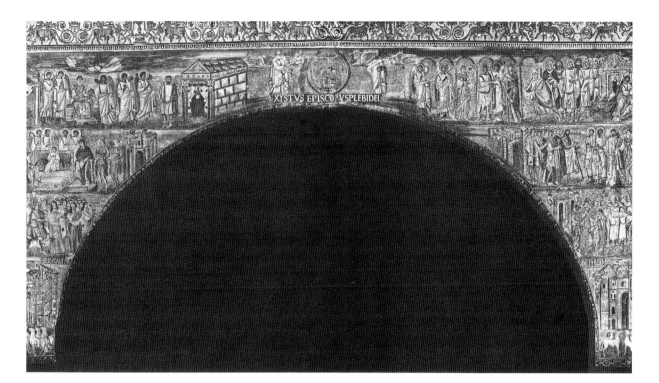

8.16. Triumphal arch. Mosaic. Santa Maria Maggiore, Rome

An enthroned Virgin in the original apse was framed by the triumphal arch, which contains stories from Jesus' infancy, an appropriate introduction to Mary's astonishing person because of her involvement in those episodes (fig. **8.16**). On one side is the Annunciation of Jesus' birth, the Adoration of the Magi, and the Massacre of the Innocents, which is when Herod, the Roman-designated ruler of Palestine, ordered the killing of first-born boys in Bethlehem, after the birth of Jesus, since it had been predicted that one of them would usurp his power. Included on the right side are scenes from the Flight into Egypt and the Magi before Herod, explaining their hope of visiting the Christ child.

The panels above the nave colonnade illustrate scenes from the Old Testament. They combine narration with a concern for structured symmetry. For instance, in the left half of *The Parting of Lot and Abraham* (fig. **8.17**), Abraham, his son Isaac, and the rest of his family depart for the land of Canaan. On the right, Lot and his clan, including his two small daughters, turn toward the city of Sodom. The artist who designed this scene from Genesis 13 faced the same task as the ancient Roman sculptors of the Column of Trajan (see fig. 7.28). He needed to condense complex actions into a form that could be read at a distance. In fact, he employed many of the same shorthand devices, such as the formulas for house, tree, and city, and the device of showing a crowd of people as a cluster of heads, rather like a bunch of grapes.

In the Trajanic reliefs, these devices were used only to the extent that they allowed the artist to portray actual historical events. The mosaics in Santa Maria Maggiore, by contrast,

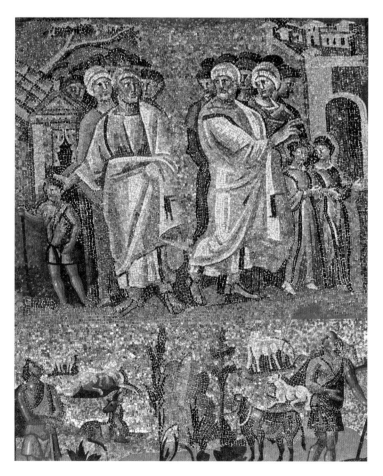

8.17. *The Parting of Lot and Abraham* and *Shepherds in a Landscape.* Santa Maria Maggiore, Rome. Mosaic

depict the history of human salvation, beginning with the Old Testament scenes along the nave and ending with the life of Jesus as the Messiah on the triumphal arch. For those who read the Bible literally, the scheme is not only a historical cycle but also a symbolic program that presents a higher reality—the Word of God. Hence the artist was not concerned with the details of historical narrative. Glances and gestures were more important than realistic movement or three-dimensional form. In *The Parting of Lot and Abraham*, the symmetrical composition, with its gap in the center, makes clear the significance of this parting. Abraham represents the way of righteousness, while Sodom, which was destroyed by the Lord, signifies the way of evil. Beneath *The Parting of Lot and Abraham* is a classically inspired but thoroughly transformed landscape, its shepherds placed on a green ground, while their sheep, as if on little islands, float in gold surroundings.

What were the visual sources of the mosaic compositions at Santa Maria Maggiore and other churches like it? These were certainly not the first depictions of scenes from the Bible. For certain subjects, such as the Last Supper, models could have been found among the catacomb murals, but others, such as the story of Joshua, may have come from illustrated manuscripts, to which, since they were portable, art historians have assigned an important role as models.

ILLUSTRATED BOOKS Because Christianity was based on the Word of God as revealed in the Bible, early Christians, the self-designated people of the Book, sponsored duplication of sacred texts on a large scale. What did the earliest Bible illustrations look like? Because books are frail things, we have only indirect evidence of their history in the ancient world. It begins in Egypt with scrolls made from the papyrus plant, which is like paper but more brittle (see pages 73–74; fig. 3.40). Papyrus scrolls were produced throughout antiquity. Not until the second century BCE, in late Hellenistic times, did a better material become available. This was **parchment** (bleached animal hide) or **vellum** (a type of parchment noted for its fineness), both of which last far longer than papyrus. They were strong enough to be creased without breaking and thus made possible the kind of bound book we know today, technically called a **codex**, which appeared sometime in the late first century CE.

Between the second and the fourth centuries CE, the vellum codex gradually replaced the papyrus roll. This change had an important effect on book illustration. Scroll illustrations seem to have been mostly line drawings, since layers of pigment would soon have cracked and come off during rolling and unrolling. Although parchment and vellum were less fragile than papyrus, they too were fragile mediums (see *The Art Historian's Lens*, page 251). Nevertheless, the codex permitted the use of rich colors, including gold. Hence it could make book illustration—or, as we usually say, **manuscript illumination**—the small-scale counterpart of murals, mosaics, and panel pictures. Some questions are still unanswered. When, where, and how quickly did book illumination develop? Were most of the subjects biblical, mythological, or historical? How much of a carryover was there from scroll to codex?

One of the earliest surviving books that illustrate the Bible is an early fifth-century fragment, the so-called *Quedlinburg Itala* (fig. **8.18**). The fragment is from an illustrated Book of Kings (one of the 39 books of the Old Testament) that has been calculated to have originally contained some 60 illustrations, each image probably comprising multiple scenes. On the **folio** (manuscript leaf) reproduced here, four scenes depict Saul's meeting with Samuel after the defeat of Amalekites (I Samuel 15:13–33), each scene framed so as to accentuate the overall unity of the composition. The misty landscape, architectural elements, and sky-blue and pink background recall the antique Roman tradition of atmospheric illusionism of the sort we met at Pompeii (see fig. 7.55).

Visible under the flaking paint in this badly damaged fragment are written instructions to the artist, part of which read, "You make the prophet speaking facing King Saul sacrificing." Apparently the artist was left free to interpret pictorially these written instructions, suggesting the lack of an illustrated model.

Particularly intriguing is the fact that the artist of the Quedlinburg fragment worked together in a Roman **scriptorium** (a workshop for copying and illustrating manuscripts) with an artist who illustrated Vergil's *Aeneid* and *Georgics*, the so-called *Vatican Vergil*, named after the collection in which it is housed today (fig. **8.19**). We might well ask if this is evidence of non-Christian artists working for Christian patrons and to what

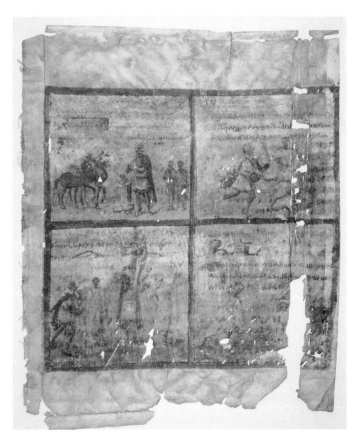

8.18. Scenes from the Book of Kings, *Quedlinburg Itala*, ca. 425–450 CE. Tempera on vellum, 12 × 18″ (30.5 × 45.8 cm). Staatliche Bibliothek, Berlin

The Cotton Library Fire

Manuscripts are fragile works of art. Executed on parchment or vellum, which are organic materials, they are subject to damage by either overly dry or overly humid conditions and by insects. Manuscripts that are popular and receive a great deal of use can tear or wear thin. Dealers, even today, often cut up manuscripts, since they can sell individual pages more easily than a whole manuscript and for more money. And it is not uncommon to find old manuscript parchment reused for a variety of purposes, including lampshades and other decorative items. Given their fragility, it is remarkable that so many precious manuscripts survive.

No event demonstrates the vulnerability of manuscripts more poignantly than the fire that damaged the collection of Sir Robert Bruce Cotton (1571–1631), a founder of the Society of Antiquaries, who, in addition to manuscripts, collected books, other works of art, and coins. Included in Cotton's manuscript collection was a unique example of the Anglo-Saxon poem *Beowulf* (see page 314), written around 1000 CE, the *Lindisfarne Gospels* (see fig. 10.6), and the *Utrecht Psalter* (see fig. 10.15).

Cotton's heirs donated his library to the English nation in 1700, and in 1729 it was moved to another location because the building in which it had been housed was considered unsafe. Ironically, two years later many of the manuscripts were destroyed in a tragic fire at the new location. An account written in the following year records that of the original 952 manuscripts, 114 were "lost, burnt, or entirely spoiled," while 98 others were severely damaged. Included in the latter category was a fifth-century manuscript, written in Greek and probably made in Alexandria, of the Old Testament book of Genesis, notable both for the number of its illustrations and for their high quality. It was one of the most significant works of the Early Christian period. Only fragments of 129 folios survive from the manuscript's original 221 folios, which included about 339 illuminations. Art historians Kurt Weitzmann and Herbert Kessler have undertaken an exhaustive and convincing descriptive reconstruction of the manuscript, but brilliant as their analysis might be, the loss of so many original illuminations is incalculable.

Art historians feel a particular anguish for the fate of the *Cotton Genesis* because it was one of only two known manuscripts dedicated to Genesis alone. The other is the *Vienna Genesis* (see fig. 8.35). Why Genesis received such exhaustive treatment is the subject of some controversy, fueled by suppositions that are difficult to prove without the evidence of the missing folios from the *Cotton Genesis*. (The *Vienna Genesis* also survives as a mere fragment containing some 24 single leaves.) John Lowden has suggested that the two Genesis manuscripts were very unusual, indeed experimental trials undertaken at a time when the Church's early interest in confronting paganism was beginning to shift to a greater concern for supporting orthodox Christian teaching. For Lowden, the *Cotton Genesis* might have been a guide for the instruction of Christian orthodoxy.

A further loss for art historians is information about what role manuscripts played in the transmission of images and motifs. We know the *Cotton Genesis* was in Venice in the early thirteenth century, when it served as a model for a series of mosaics in the Church of San Marco in Venice. The manner and process used to transfer ideas that had their origins in the Early Christian period to later generations might be easier to understand if the *Cotton Genesis* could be seen in its original form.

Virtually from the moment the charred manuscripts cooled, attempts have been made to restore some of the Cotton manuscripts and conserve those fragments not suitable for restoration. These attempts were intensified after 1753 when the Cotton Library became one of the first collections to be housed in the newly established British Museum. Recently scholars have applied modern scientific techniques to study some of the Cotton manuscripts. By illuminating individual folios from behind with a fiber-optic light, letters formerly obscured have become visible. And computer imaging has been used to replace the missing letters of some manuscripts. However, no system is likely to be devised that can restore the aesthetic vitality or artistic integrity of a manuscript such as the *Cotton Genesis*. It is one thing to know what subjects were depicted in the manuscript; it is another thing altogether to be able to see and appreciate the products of scribes and artists who worked more than 1,600 years ago.

extent pagan motifs might have been carried over to Christian subjects, or perhaps even the other way around.

Like the Quedlinburg fragment, the *Vatican Vergil* reflects the Roman tradition of illusionism and is closely linked in style to the mosaics of the contemporaneous Santa Maria Maggiore. The picture, separated from the rest of the page by a heavy frame, is like a window, and in the landscape—similar to that in the *Quedlinburg Itala* on being set off by the pink and blue sky—we find the remains of deep space, perspective, and the play of light and shade. The illustration is balanced by beautifully executed letters, which hover over the page like a curtain.

Perhaps it is not accidental that the illusionism in both the *Quedlinburg Itala* and the *Vatican Vergil* reminds us so much of

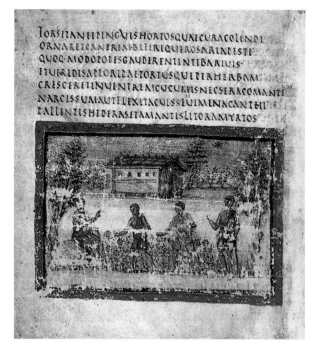

8.19. Miniature from the *Vatican Vergil*. Early 5th century CE. Tempera on vellum, 8⅝ × 7¼″ (21.9 × 19.6 cm). Biblioteca Apostolica Vaticana, Rome

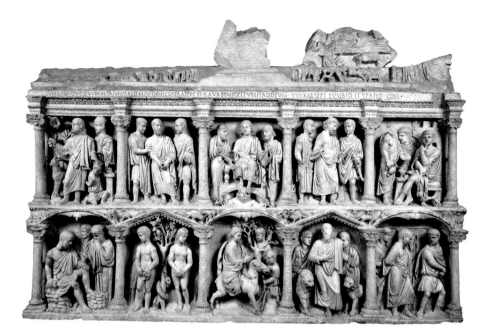

8.20. *Sarcophagus of Junius Bassus.* ca. 359 CE. Marble, 3′10½″ × 8′ (1.2 × 2.4 m). Museo Storico del Capitolino di San Pietro, Rome

the art of Rome during its glory days, nor that so many architectural features of the contemporaneous Santa Maria Maggiore are so classicizing. All of these works were produced in Rome just when that city was under direct threat; the emphasis on Rome's historic splendor might well have proven comforting during difficult times. However, the political reality was far different from the lofty ambitions of artists and patrons. Rome was sacked by the Visigoths in 410 and, as noted, the capital of the Western Empire was moved farther north, settling first in Milan, then finally in Ravenna.

SCULPTURE As we have seen, the increase in standing of Christianity had a profound effect on artistic production, moving Christian art from a modest and private sphere to a public and official arena. As Early Christian architecture and its decoration began to demonstrate increasing monumentality as a result of its dependence on Roman imperial traditions, so too Early Christian sculpture became more impressive. This is apparent in a fine Early Christian stone coffin, the *Sarcophagus of Junius Bassus*.

The richly carved *Sarcophagus of Junius Bassus* (fig. **8.20**) was made for a prefect of Rome who died in 359 at age 42 and who, an inscription tells us, had been "newly baptized." The front, divided by columns into ten compartments, contains a mixture of Old and New Testament scenes. In the upper register we see (from left to right) the Sacrifice of Isaac, St. Peter Taken Prisoner, Christ Enthroned between Saints Peter and Paul, and Jesus before Pontius Pilate (this last scene composed of two compartments). In the lower register are the Suffering of Job, the Temptation of Adam and Eve, Jesus' Entry into Jerusalem, Daniel in the Lions' Den, and St. Paul Led to his Martyrdom.

Clearly the status of Christianity has changed when a major state official proclaims, both in inscription and through representation, his belief in Christianity. The depictions of Peter and Paul, the veritable official saints of the city of Rome—each saint is commemorated by a major basilica in the city—can be

related to Junius Bassus' role as a high-ranking government official. Authoritative as well is Christ's place in the central scenes of each register. In the top register, Christ is enthroned with his feet treading on a personification of Coelus, the Roman pagan god of the heavens, as he dispenses the law to his disciples. Thus, he appropriates one of the emperor's formal privileges and the prefect's as his surrogate. Below this compartment, he enters Jerusalem in triumph. As compared to the earliest Christian representations, such as the Santa Maria Antiqua sarcophagus, Christ is now depicted directly, not through allusion alone, and his imperial nature is thereby accentuated. Daniel in the Lions' Den, the Sacrifice of Isaac, and Adam and Eve are subjects that appeared in earlier representations in catacombs. Daniel's salvation is a type for Christ as well as for all Christians who hope for divine salvation; Abraham's willingness to sacrifice his beloved son Isaac parallels God's sacrifice of his only begotten son and at the same time speaks of salvation by divine grace; Adam and Eve refer to the Original Sin that led to Christ's sacrificial death and his resurrection. Thus old methods of explication are combined with new manifestations of Christianity's important role in society, particularly by stressing Christ's imperial nature.

The style of the sarcophagus also relies on imperial convention. This is most evident in the elements of classicism that are expressed, such as the placement within deep, space-filled niches of figures that recall the dignity of Greek and Roman sculpture. Other classicizing features include the way that the figures seem capable of distributing weight, the draperies that reveal the bodies beneath them, and the narrative clarity. However, beneath this veneer of classicism we recognize doll-like bodies with large heads and a passive air in scenes that would otherwise seem to call for dramatic action. It is as if the events and figures are no longer intended to tell their own story but to call to mind a larger symbolic meaning that unites them.

The reliance on classicizing forms on the *Sarcophagus of Junius Bassus* reminds us that Early Christian art appears

throughout the Mediterranean basin in what we think of as the Classical world. During the first five centuries after Jesus' death, the art of the entire area was more or less unified in content and style. Increasing political and religious divisions in the region, however, began to affect artistic production so that it is appropriate to recognize the appearance, or perhaps better stated, the growth of another branch of Christian art that we label Byzantine.

BYZANTINE ART

Early Byzantine Art

There is no clear-cut geographical or chronological line between Early Christian and Byzantine art. West Roman and East Roman—or as some scholars prefer to call them, Western and Eastern Christian—traits are difficult to separate before the sixth century. Until that time, both geographical areas contributed to the development of Early Christian art. As the Western Empire declined, however, cultural leadership tended to shift to the Eastern Empire. This process was completed during the reign of Justinian, who ruled the Eastern Empire from 527 to 565. Under the patronage of Justinian, Constantinople became the artistic as well as the political capital of the Empire. Justinian himself was a man of strongly Latin orientation, and he almost succeeded in reuniting Constantine's domain. The monuments he sponsored have a grandeur that justifies the claim that his era was a Golden Age, as some have labeled it.

The political and religious differences between East and West became an artistic division as well. In Western Europe, Celtic and Germanic peoples inherited the civilization of Late Antiquity, of which Early Christian art had been a part, but they transformed it radically. The East, in contrast, experienced no such break. Late Antiquity lived on in the Byzantine Empire, although Greek and other Eastern Mediterranean elements came increasingly to the fore at the expense of the Roman heritage. Even so, a sense of tradition played a central role in the development of Byzantine art.

ARCHITECTURE AND ITS DECORATION Ironically, the greatest number of early Byzantine monuments survives today not in Constantinople, where much has been destroyed, but on Italian soil, in Ravenna. That town, as we have seen, had become the capital of the West Roman emperors at the beginning of the fifth century. At the end of the century it was taken by Theodoric, king of the Ostrogoths, whose tastes were patterned after those of Constantinople, where he had lived for an extended period. The Ostrogothic rule of Ravenna ended in 540, when the Byzantine general Belisarius conquered the city for Justinian. Ravenna became an exarchate, or provincial capital, the main stronghold of Byzantine rule in Italy. Thus, Ravenna serves as a kind of microcosm of the transformation and divisions of the later Roman Empire.

The most important building of the early Byzantine period, begun in 526 under Ostrogothic rule, was the church of San Vitale. Built chiefly during the 540s and completed in 547, it

ART IN TIME

319–329—Old St. Peter's Basilica constructed
 330—Constantinople becomes capital of Roman Empire
 390s—The *Confessions* of St. Augustine
 395—Roman Empire divides into Eastern and Western halves
 402—Honorius moves capital of Western Roman Empire to Ravenna
400s—Construction in Ravenna of Mausoleum of Galla Placidia and Orthodox Baptistery

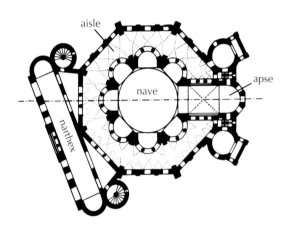

8.21. Plan of San Vitale, Ravenna. 526–547 CE

represents a Byzantine building of a type derived mainly from Constantinople. The octagonal plan (figs. **8.21** and **8.22**) with a circular core ringed by an ambulatory is a descendant of the mausoleum of Santa Costanza in Rome (see fig. 8.7), but other aspects of the building show the influence of the Eastern Empire, where domed churches of various kinds had been built during the previous century. Compared to Santa Costanza, San Vitale is both larger in scale and significantly richer in

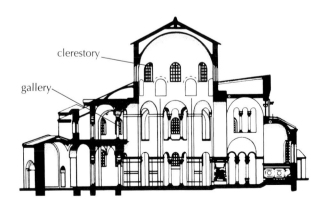

8.22. Section of San Vitale, Ravenna

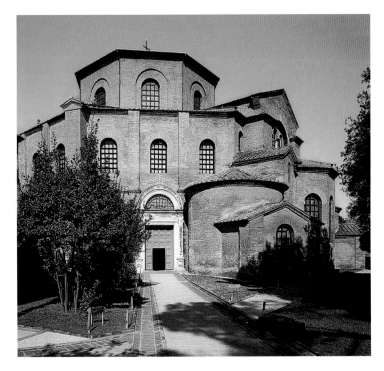

8.23. Exterior, San Vitale, Ravenna

spatial effect (fig. 8.23). In particular, below the clerestory, the nave wall turns into a series of semicircular niches that penetrate the ambulatory and thus link that surrounding aisle to the nave in a new and intricate way (fig. 8.24). The movement around the center space is thus enlivened so that the decorated surfaces seem to pulsate. The aisle itself has a second story, the galleries, which may have been reserved for women. This reflects a practice in a number of Eastern religions, including some forms of Judaism, where it is current even today. Large windows on every level are made possible by a new economy in the construction of the vaulting—hollow clay tubes allowing for a lighter structure—and the interior is flooded with light.

The plan of San Vitale shows only remnants of the longitudinal axis of the Early Christian basilica: toward the east, a cross-vaulted compartment for the altar, backed by an apse; and on the other side, a narthex. How did it happen that the East favored a type of church building (as distinct from baptisteries and mausoleums) so different from the basilica and—from the Western point of view—so ill adapted to Christian ritual? After all, had not the design of the basilica been backed by the authority of Constantine himself? Scholars have suggested a number of reasons: practical, religious, and political. All of them may be relevant, but none is fully persuasive. In any event, from the time of Justinian, domed, central-plan churches dominated the world of Orthodox Christianity as thoroughly as the basilican plan dominated the architecture of the medieval West.

At San Vitale the odd, nonsymmetrical placement of the narthex, which has never been fully explained, might be a key to helping us understand how the building functioned. Some have suggested that the narthex is turned to be parallel to an atrium, the axis of which was determined by site limitations. Others see it as a conscious design feature that accentuates the transition between the exterior and interior of the church. Whatever the reason, in order to enter the building visitors were forced to change axis, shifting to the right or left in order to align themselves with the main apse. The alteration of the journey into the building is unsettling, almost disorienting, an effect heightened by passing from the lighted area of the narthex to the shaded ambulatory, and then into the high and luminous domed center space. The passage from physical to spiritual realms so essential to worship is manifest as a separation between the external world and the internal space of the building.

The complexity of the architecture of the interior is matched by its lavish decoration. San Vitale's link with the Byzantine court can be seen in two prominent mosaics flanking the altar (figs. 8.25 and 8.26). They depict Justinian and his empress,

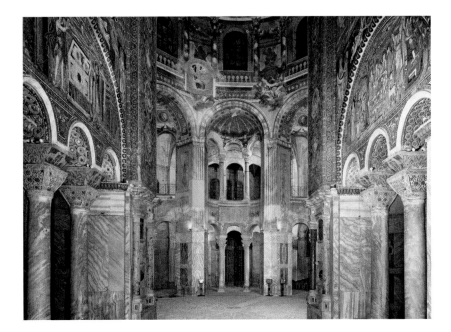

8.24. Interior (view from the apse), San Vitale, Ravenna

Theodora, accompanied by officials, the local clergy, and ladies-in waiting, about to enter the church, as if it were a palace chapel. In these large panels, the design of which most likely came from an imperial workshop, we find an ideal of beauty that is very different from the squat, large-headed figures we met in the art of the fourth and fifth centuries. The figures are tall and slim, with tiny feet and small almond-shaped faces dominated by huge eyes. They seem capable only of making ceremonial gestures and displaying magnificent costumes. There is no hint of movement or change. The dimensions of time and earthly space, suggested

ART IN TIME

451—Europe invaded by Attila the Hun

476—Fall of Ravenna to Ostrogoths

525–565—Justinian rules Eastern Roman Empire

540—End of Ostrogothic rule of Ravenna

558—Taller dome built for Hagia Sophia in Constantinople

726—Iconoclastic Controversy begins

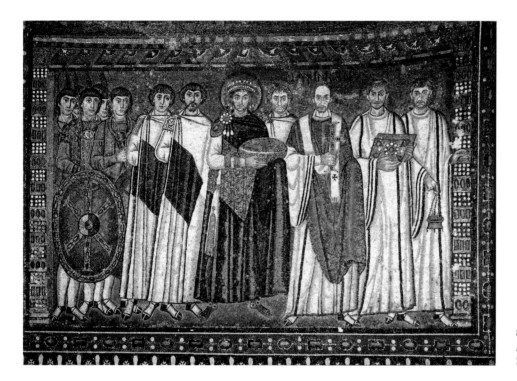

8.25. *Emperor Justinian and His Attendants.* ca. 547 CE. Mosaic. San Vitale, Ravenna

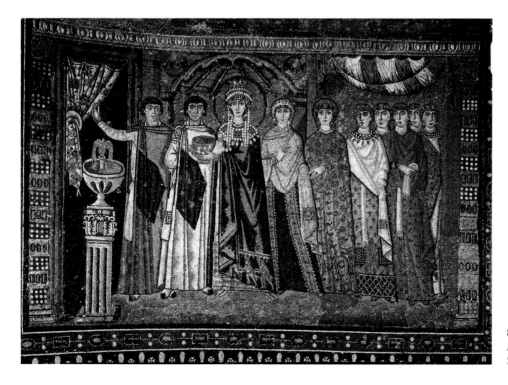

8.26. *Empress Theodora and Her Attendants.* ca. 547 CE. Mosaic. San Vitale, Ravenna

by a green ground, give way to an eternal present in the form of a golden otherworldly setting. Hence, the solemn, frontal images seem to belong as much to a celestial court as to a secular one. The quality of soaring slenderness that endows the figures with an air of mute exaltation is shared by the mysterious interior space of San Vitale, which these figures inhabit.

The union of political and spiritual authority expressed in these mosaics reflects the "divine kingship" of the Byzantine emperor and honors the royal couple as donors of the church. It is as though the mosaic figures are in fact participating in the liturgy, even though the empress and emperor are actually thousands of miles away. The embroidery on the hem of Theodora's mantle shows the three Magi carrying their gifts to Mary and the newborn King, and like them the imperial couple bring offerings. Justinian brings bread and Theodora a chalice, undoubtedly references to the Eucharist and Jesus' sacrifice of his own flesh and blood to redeem humanity. The emperor is flanked by 12 companions, the imperial equivalent of the 12 apostles. Moreover, Justinian is portrayed in a manner that recalls Constantine, that first Christian emperor: The shield with Christ's monogram equates Justinian's conquest of Ravenna with the divinely inspired Constantinian triumph that ultimately led to the founding of Constantinople, the court to which Justinian was heir.

Among the surviving monuments of Justinian's reign in Constantinople, the most important by far is Hagia Sophia (Church of Holy Wisdom) (figs. **8.27** and **8.28**). The first church on that site was commissioned by Constantine but destroyed in 532 during rioting that almost deposed the emperor, who immediately rebuilt the church, a sign of the continuity of his imperial authority. Completed in only five years, Hagia Sophia achieved such fame that the names of the architects, too, were remembered: Anthemius of Tralles, an expert in geometry and the theory of statics and kinetics; and Isidorus of Miletus, who taught physics and wrote on vaulting techniques. The dome collapsed in the earthquake of 558, and a new, taller one was built from a design by Isidorus' nephew. After the Turkish conquest in 1453, the church became a mosque. The Turks added four minarets and extra buttresses to the exterior at that time (see fig. 8.28), as well as large medallions with Islamic invocations on the interior (fig. **8.29**). In the twentieth century, after the building was turned into a museum, some of the mosaic decoration that was largely hidden under whitewash was uncovered.

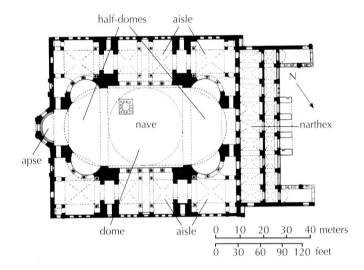

8.27. Anthemius of Tralles and Isidorus of Miletus. Plan of Hagia Sophia, Istanbul. 532–537 CE. (after V. Sybel)

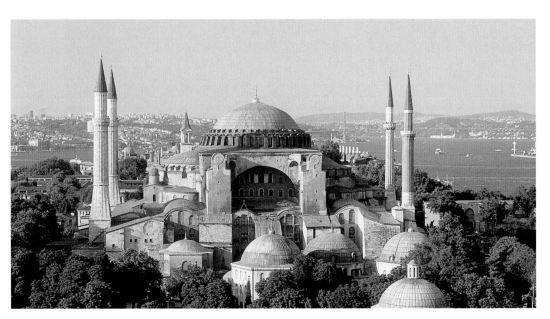

8.28. Exterior, Hagia Sophia, Istanbul

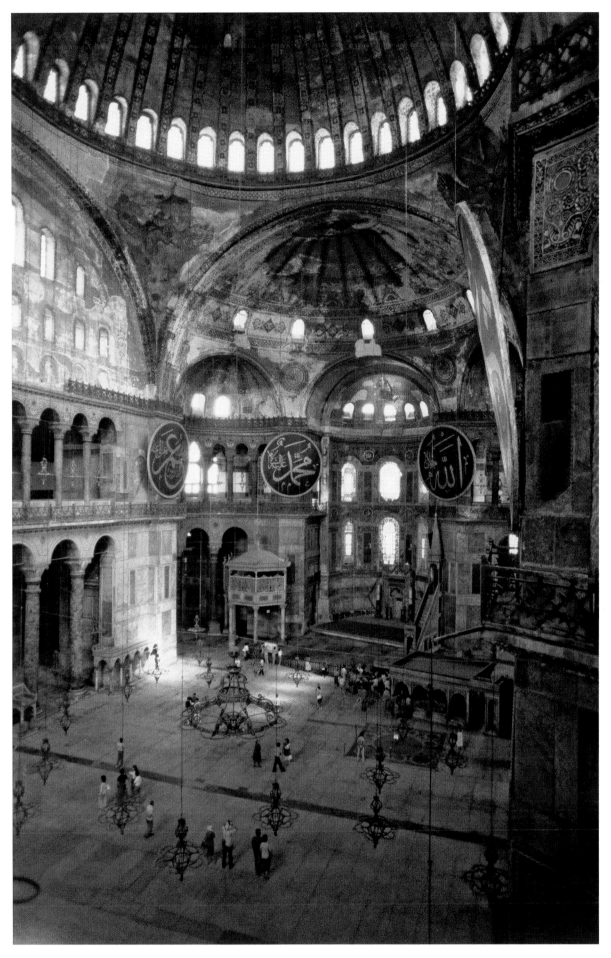

8.29. Interior, Hagia Sophia, Istanbul

Procopius of Caesarea (6th Century)

From *Buildings*

Procopius was a historian during the reign of Emperor Justinian. He wrote an entire book (ca. 550 CE) about the fortifications, aqueducts, churches, and other public buildings constructed by Justinian throughout the Byzantine Empire. The book begins with the greatest of these, Hagia Sophia (see figs. 8.27–8.32).

The emperor, disregarding all considerations of expense, raised craftsmen from the whole world. It was Anthemius of Tralles, the most learned man in the discipline called engineering, that ministered to the emperor's zeal by regulating the work of the builders and preparing in advance designs of what was going to be built. He had as partner another engineer called Isidore, a native of Miletus.

So the church has been made a spectacle of great beauty, stupendous to those who see it and altogether incredible to those who hear of it. It subtly combines its mass with the harmony of its proportions, having neither any excess nor any deficiency, inasmuch as it is more pompous than ordinary [buildings] and considerably more decorous than those which are huge beyond measure; and it abounds exceedingly in gleaming sunlight. You might say that the [interior] space is not illuminated by the sun from the outside, but that the radiance is generated within, so great an abundance of light bathes this shrine all round. In the middle of the church there rise four man-made emi-nences which are called piers, two on the north and two on the south, each pair having between them exactly four columns. The eminences are built to a great height. As you see them, you could suppose them to be precipitous mountain peaks. Upon these are placed four arches so as to form a square, their ends coming together in pairs and made fast at the summit of those piers, while the rest of them rise to an immense height. Two of the arches, namely those facing the rising and the setting sun, are suspended over empty air, while the others have beneath them some kind of structure and rather tall columns. Above the arches the construction rises in a circle. Rising above this circle is an enormous spherical dome which makes the building exceptionally beautiful. It seems not to be founded on solid masonry, but to be suspended from heaven by that golden chain and so covers the space. All of these elements, marvellously fitted together in mid-air, suspended from one another and reposing only on the parts adjacent to them, produce a unified and most remarkable harmony in the work, and yet do not allow the spectators to rest their gaze upon any one of them for a length of time, but each detail readily draws and attracts the eye to itself. Thus the vision constantly shifts round, and the beholders are quite unable to select any particular element which they might admire more than all the others. No matter how much they concentrate their attention on this side and that, and examine everything with contracted eyebrows, they are unable to understand the craftsmanship and always depart from there amazed by the perplexing spectacle.

SOURCE: *THE ART OF THE BYZANTINE EMPIRE, 312–1453:* SOURCES AND DOCUMENTS BY CYRIL MANGO (UPPER SADDLE RIVER, NJ: PRENTICE HALL, 1ST ED., 1972)

Hagia Sophia has the longitudinal axis of an Early Christian basilica, but the central feature of the nave is a vast, squarish space crowned by a huge dome (see fig. 8.27). At either end are half-domes, so that the nave takes the form of a great ellipse. Attached to the half-domes are semicircular apses with open **arcades**, series of arches, similar to those in San Vitale. One might say, then, that the dome of Hagia Sophia has been placed over a central space and, at the same time, inserted between the two halves of a divided central-plan church. The dome rests on four arches that carry its weight to the piers, large, upright architectural supports, at the corners of the square. Thus the brilliant gold-mosaic walls below these arches, pierced with windows, have no weight-bearing function at all and act as mere curtains. The transition from the square formed by the arches to the circular rim of the dome is achieved by spherical triangles called **pendentives** (fig. **8.30**). Hence we speak of the entire unit as a dome on pendentives. This device, along with a new technique for building domes using thin bricks embedded in mortar, permits the construction of taller, lighter, and more economical domes than the older method of placing the dome on a round or polygonal base as, for example, in the Pantheon (see fig. 7.39).

Where or when the dome on pendentives was invented we do not know. Hagia Sophia is the earliest example we have of its use on a monumental scale, and it had a lasting impact. It became a basic feature of Byzantine architecture and, later, of Western architecture as well. Given the audacity of Hagia Sophia's design, it is not surprising that its architects were not described as builders, but rather as theoretical scientists, renowned for their knowledge of mathematics and physics. Its massive exterior, firmly planted upon the earth like a great mound, rises by stages to a height of 184 feet—41 feet taller than the Pantheon—and therefore its dome, though its diameter is somewhat smaller (112 feet), stands out far more boldly in its urban setting.

Once we are inside Hagia Sophia (see fig. 8.29), all sense of weight disappears. Nothing remains but a space that inflates, like so many sails, the apses, the pendentives, and the dome itself. The first dome, the one that fell in 558, was less steep than the present one, and one imagines that the sense of swelling form and heaving surface would originally have been even more intense than it is today. Here the architectural aesthetic we saw taking shape in Early Christian architecture has achieved a new, magnificent dimension.

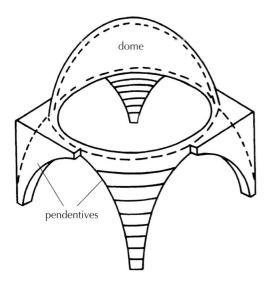

8.30. Dome on pendentives

8.31. Northwest exedra, Hagia Sophia, Istanbul

Even more than before, light plays a key role. The dome seems to float—"like the radiant heavens," according to a contemporary description—because it rests upon a closely spaced row of windows; light, both real and reflected, virtually separates the dome from the arches on which it rests. So many openings pierce the nave walls that the effect is akin to the transparency of lace curtains. The golden glitter of the mosaics must have completed the "illusion of unreality." Its purpose is clear. As Procopius, the court historian to Justinian, wrote: "Whenever one enters this church to pray, he understands at once that it is not by any human power or skill, but by the influence of God, that this work has been so finely turned. And so his mind is lifted up toward God and exalted, feeling that He cannot be far away, but must especially love to dwell in this place that He has chosen." (See *Primary Source*, page 258.) We can sense the new aesthetic even in ornamental details such as moldings and capitals (fig. 8.31). The scrolls, acanthus leaves, and similar decorations are motifs derived from classical architecture, but their effect here is radically different. The heavily patterned butterfly-marble facing of the piers denies their substantiality, and instead of actively cushioning the impact of heavy weight on the shaft of the column, the capital has become like an open-work basket of starched lace, the delicate surface pattern of which belies the strength and solidity of the stone. The contrast between the decoration of these structural members and their weight-bearing function accentuates the viewer's disorientation, an effect that would only have been increased if the interior of the building were viewed from aisle or gallery (fig. 8.32). In fact, it is from there that most congregants would have experienced the building during religious services, with no opportunity to take in or understand the entire structure.

The guiding principle of Graeco-Roman architecture had been to express a balance of opposing forces, rather like the balance within the contrapposto of a Classical statue. The result was a muscular display of active and passive members. In comparison, the material structure of Byzantine architecture, and to some extent of Early Christian architecture as well, is subservient to the creation of immaterial space. Walls and vaults seem like weightless shells, their actual thickness and solidity hidden rather than emphasized. And the glitter of the mosaics must have completed the illusion of unreality, fitting the spirit of these interiors to perfection.

8.32. Interior (view from south aisle facing northwest), Hagia Sophia, Istanbul

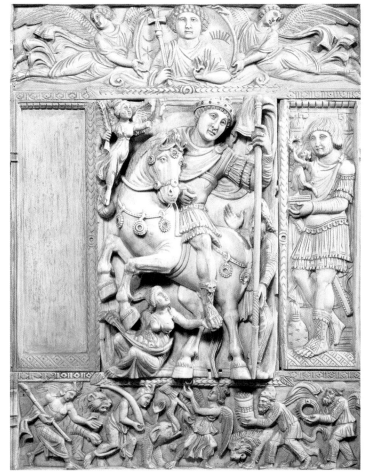

8.33. *Justinian as Conqueror.* ca. 525–550 CE. Ivory, $13\frac{1}{2} \times 10\frac{1}{2}''$ (34.2 × 26.8 cm). Musée du Louvre, Paris

8.34. *The Archangel Michael.* Leaf of a diptych. Early 6th century CE. Ivory, 17 × 5½″ (43.3 × 14 cm). The British Museum, London

SCULPTURE Beyond architectural decorations and some sarcophagi, early Byzantine sculpture consists mainly of reliefs in ivory and silver, which survive in considerable numbers. Vestiges of classicism are apparent in the beautifully carved diptych of *Justinian as Conqueror*, which celebrates the emperor's victories in Italy, North Africa, and Asia (fig. **8.33**). The subject restates in Christian terms the allegorical scene on the breastplate of the *Augustus of Primaporta* (see fig. 7.16). The figure of Victory appears twice: above the emperor, to his right, and as a statuette held by the Roman officer at the left, who no doubt was mirrored in the missing panel at the right. Scythians, Indians, even lions and elephants, representing the lands conquered by Justinian, offer gifts and pay homage, while a figure personifying Earth supports Justinian's foot to signify the emperor's dominion over the entire world. His role as triumphant general and ruler of the empire is blessed from heaven (note the sun, moon, and star) by Christ, whose image is in a medallion carried by two heraldically arranged angels. The large head and bulging features of Justinian brim with the same energy as his charging steed. He is a far cry from the calm philosopher portrayed on the equestrian statue of Marcus Aurelius (fig. 7.21) from which the image is derived.

An ivory relief of *The Archangel Michael* (fig. **8.34**), also from the time of Justinian, looks back to earlier classical ivories. It may have been paired with a missing panel showing Justinian, who, it has been suggested, commissioned it. The inscription above has the prayer "Receive these gifts, and having learned the cause …," which would probably have continued on the missing leaf with a plea to forgive the owner's sins, apparently a reference to the emperor's humility. In any event, this ivory must have been done around 520–530 by an imperial workshop in Constantinople.

The majestic archangel is a descendant of the winged Victories of Graeco-Roman art, down to the rich drapery revealing lithe limbs (see fig. 5.49), and recalls the Victories on the ivory plaque of *Justinian as Conqueror* (see fig. 8.33). Here classicism has become an eloquent vehicle for Christian content. The power the angel heralds is not of this world, nor does he inhabit an earthly space. The niche he occupies has lost all three-dimensional reality. The angel's relationship to it is purely symbolic and ornamental, so that, given the position of the feet on the steps, he seems to hover rather than stand. From the ankles down he seems to be situated between the columns, while his arms and wings are in front of them. It is this disembodied quality, conveyed through harmonious forms, that makes the Archangel Michael's presence so compelling. The paradox of a believable figure represented naturalistically but existing within an ambiguous, indeed impossible, setting connects this work with other products of Justinian's court, such as those buildings where solid structures serve to create ephemeral spaces.

ILLUSTRATED BOOKS Illustrated books of the early Byzantine period also contain echoes of Graeco-Roman style adapted to religious narrative. The most important example,

the *Vienna Genesis* (fig. **8.35**), containing a Greek text of the first book of the Bible, has a richness similar to the mosaics we have seen. White highlights and fluttering drapery that clings to the bodies animate the scene. The book was written in silver (now tarnished black) and decorated with brilliantly colored miniatures on dyed-purple vellum, that color being reserved for the imperial court. Although some scholars have suggested that an imperial scriptorium in Constantinople produced the manuscript, recent research points to Syria as the more likely source because there are parallels to manuscripts produced in Syria and to some mosaics that survive there as well.

Our page shows a number of scenes from the story of Jacob. In the center foreground Jacob wrestles with the angel and then receives the angel's blessing. Hence the picture does not show just a single event but a whole sequence. The scenes take place along a U-shaped path, so that progression in space becomes progression in time. This method, known as **continuous narration**, goes back as far as ancient Egypt and Mesopotamia. Its appearance in miniatures such as this may reflect earlier illustrations made in scroll rather than book form, although this hypothesis has been highly contested. The picture certainly looks like a frieze turned back upon itself. For

8.35. *Jacob Wrestling the Angel,* from the *Vienna Genesis.* Early 6th century CE. Tempera and silver on dyed vellum, 13¼ × 9½″ (33.6 × 24.1 cm). Österreichische Nationalbibliothek, Vienna

manuscript illustration, continuous narrative makes the most economical use of space. The painter can pack a maximum number of scenes into a small area, and the picture as a running account can be read like lines of text, rather than as a window that requires a frame.

ICONS The religious **icon** (from the Greek word *eikon*, meaning "image") provided another focus for representation at the time of Justinian. Icons generally took Christ, the Enthroned Madonna, or saints as their principal subjects and were objects of personal as well as public veneration. From the beginning they were considered portraits, for such pictures had developed in Early Christian times out of Graeco-Roman portrait panels. The issue that they might be considered idols led to arguments about their appropriateness and their power. (See *Primary Source*, page 266.) These discussions related to the contemporaneous debates on the dual nature of Christ as God and man, at once both spiritual and physical—debates that Byzantine emperors had no qualms about joining. One of the chief arguments in favor of image production was the claim that Christ had appeared with the Virgin to St. Luke and permitted him to paint their portrait together, and that other portraits of Christ or of the Virgin had miraculously appeared on earth by divine command. These "true" sacred images were considered to have been the sources for the later ones made by human artists, permitting a chain of copies and copies of copies, which has often made it difficult for art historians to date them.

Icons functioned as living images to instruct and inspire the worshiper. Because the actual figure—be it Christ, Mary, a saint, or an angel—was thought to reside in the image, icons were believed to be able to intercede on behalf of the faithful. They were reputed to have miraculous healing properties, and some were carried into battle or placed over city gates, effectively offering totemic protection to their communities. In describing an icon of the archangel Michael, the sixth-century poet Agathias writes: "The wax remarkably has represented the invisible. ... The viewer can directly venerate the archangel [and] trembles as if in his actual presence. The eyes encourage deep thoughts; through art and its colors the innermost prayer of the viewer is passed to the image."

Little is known about the origins of icons, since most early examples were intentionally destroyed by those who believed they led to idolatry; hence icons are scarce. The irony of this is particularly poignant, since early icons were painted in **encaustic**, the medium in which pigment is suspended in hot wax, chosen for its durability.

Many of the surviving early examples come from the Monastery of Saint Catherine at Mount Sinai, Egypt, the isolated desert location of which aided the survival of numerous objects. An icon of *Christ* (fig. **8.36**), generally dated to sometime in the sixth century but with later repainting, is magnificent for its freshness of color and vibrancy of brushstroke. Its link with Graeco-Roman portraiture is clear not only from the use of encaustic but also from the gradations of light and shade in Christ's face and on his neck, reminiscent of the

8.36. *Christ.* 6th century CE. Encaustic on panel, $34 \times 17^7/_8''$ (84 × 45.5 cm). Monastery of St. Catherine, Mount Sinai, Egypt

treatment of the woman in our Roman Fayum portrait, also in encaustic (see fig. 7.49). The combination of a frontal, unflinching gaze, establishing a direct bond with the viewer, with the lively and lifelike modeling of the face suggests the kind of dichotomy between spiritual and physical that we have seen in so much early Byzantine art. That dichotomy is accentuated here by the enormous gold halo hovering over an architectural background. It is as if the walls retreat into the background in response to the halo and in order to allow space for Christ.

An icon of the *Virgin and Child Enthroned Between Saints and Angels* (fig. **8.37**) is striking for the variety of styles used to represent the different figure types. The Virgin and Christ are large,

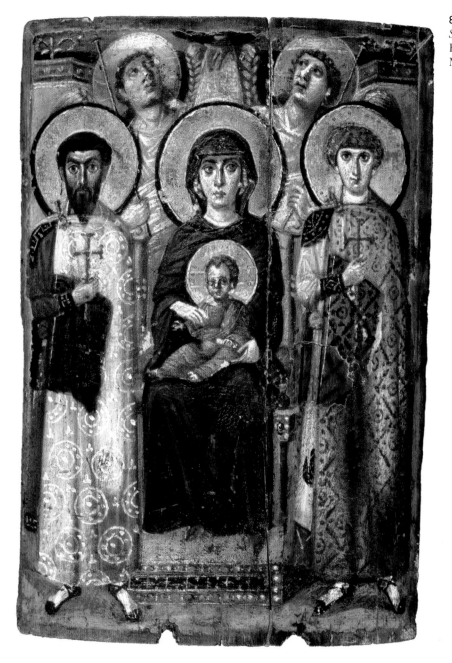

8.37. *Virgin and Child Enthroned Between Saints and Angels.* Late 6th century CE. Encaustic on panel, 27 × 19⅜″ (68.5 × 49.2 cm). Monastery of St. Catherine, Mount Sinai, Egypt

their modeled faces help convey with some delicacy their solidity, while the two warrior saints, probably Theodore on the left and George (or Demetrios) on the right, recall the stiff figures that accompany Justinian in San Vitale (see fig. 8.25). Typical of early icons, however, their heads are too large for their doll-like bodies. Behind are two almost ethereal angels looking skyward; both resemble Roman representations. It is typical of the conservative icon tradition that an artist would remain faithful to his varied sources in order to preserve the likenesses of the holy figures; yet it is also possible that different styles in the same work are considered appropriate for the differing religious roles the portrayed personages play. For example, the Virgin's pose signals that for the Byzantines the Madonna was the regal mother, the Theotokos, while the stiff formality of the soldier saints is appropriate to represent stalwart defenders of the faith.

The Iconoclastic Controversy

After the time of Justinian, the development of Byzantine art—not only painting but sculpture and architecture as well—was disrupted by the Iconoclastic Controversy. The conflict, which began with an edict promulgated by the Byzantine emperor Leo III in 726 prohibiting religious images, raged for more than a hundred years between two hostile groups. The image destroyers, *Iconoclasts*, led by the emperor and supported mainly in the eastern provinces, insisted on a literal interpretation of the biblical ban against graven images because their use led to idolatry. They wanted to restrict religious art to abstract symbols and plant or animal forms. Their opponents, the *Iconophiles*, were led by the monks and were particularly centered in the western provinces, where the imperial edict remained ineffective for the most part. The strongest argument

in favor of icons was Neo-Platonic: Because Christ and his image are inseparable, the honor given to the image is transferred to him. (See *Primary Source*, page 266.)

The roots of the argument went very deep. Theologically, they involved the basic issue of the relationship of the human and the divine in the person of Christ. Moreover, some people resented that for many, icons had come to replace the Eucharist as the focus of lay devotion. Socially and politically, the conflict was a power struggle between Church and State, which in theory were united in the figure of the emperor. The conflict came during a low point in Byzantine power, when the Empire had been greatly reduced in size by the rise of Islam. Iconoclasm, it was argued, was justified by Leo's victories over the Arabs, who were themselves, ironically, Iconoclasts. The controversy caused an irreparable break between Catholicism and the Orthodox faith, although the two churches remained officially united until 1054, when the pope excommunicated the Eastern patriarch for heresy.

If the edict barring images had been enforced throughout the Empire, it might well have dealt Byzantine religious art a fatal blow. It did succeed in greatly reducing the production of sacred images, but it failed to wipe it out entirely, so there was a fairly rapid recovery after the victory of the Iconophiles in 843. The *Khludov Psalter* (fig. 8.38) was produced soon after that date, perhaps in Constantinople and for use in the Hagia Sophia; its illustrations not only make the case for why images should be permitted, they also liken the Iconoclasts, identified by inscription, with the crucifiers of Jesus, whose vinegar-soaked sponge is equated with the implements used to whitewash icons.

Middle Byzantine Art

While we know little for certain about how the Byzantine artistic tradition managed to survive from the early eighth to the mid-ninth century, iconoclasm seems to have brought about a renewed interest in secular art, which was not affected by the ban. This may help to explain the astonishing appearance of antique motifs in the art of the Middle Byzantine period, sometimes referred to as the Second Golden Age. Hence there was a fairly rapid recovery after the victory of the Iconophiles. A

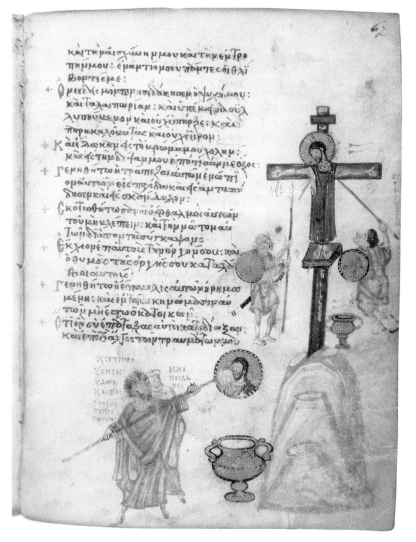

8.38. *The Crucifixion and Iconoclasts,* from the *Khludov Psalter.* After 843 CE. Tempera on vellum, $7\frac{3}{4} \times 6''$ (19.5 × 15 cm). State Historical Museum, Moscow

St. Theodore the Studite (759–826 CE)

From Second and Third Refutations of the Iconoclasts

Theodore of the Stoudios Monastery in Constantinople was a principal defender of icons against the Iconoclasts. St. Theodore refuted their charges of idolatry by examining how an image is and is not identical to its prototype (the person portrayed). Some of his arguments reflect the Neo-Platonic theory expounded by Plotinus that the sense-world is related to the divine by emanation.

The holy Basil [St. Basil the Great, ca. 329–379 CE] says, "The image of the emperor is also called 'emperor,' yet there are not two emperors, nor is his power divided, nor his glory fragmented. Just as the power and authority which rules over us is one, so also the glorification which we offer is one, and not many. Therefore the honor given to the image passes over to the prototype." In the same way we must say that the icon of Christ is also called "Christ," and there are not two Christs; nor in this case is the power divided, nor the glory fragmented. The honor given the image rightly passes over to the prototype.

Every image has a relation to its archetype; the natural image has a natural relation, while the artificial image has an artificial relation. The natural image is identical both in essence and in likeness with that of which it bears the imprint: thus Christ is identical with His Father in respect to divinity, but identical with His mother in respect to humanity. The artificial image is the same as its archetype in like-

ness, but different in essence, like Christ and His icon. Therefore there is an artificial image of Christ, to whom the image has its relation.

It is not the essence of the image which we venerate, but the form of the prototype which is stamped upon it, since the essence of the image is not venerable. Neither is it the material which is venerated, but the prototype is venerated together with the form and not the essence of the image.

If every body is inseparably followed by its own shadow, and no one in his right mind could say that a body is shadowless, but rather we can see in the body the shadow which follows, and in the shadow the body which precedes: thus no one could say that Christ is imageless, if indeed He has a body with its characteristic form, but rather we can see in Christ His image existing by implication and in the image Christ plainly visible as its prototype.

By its potential existence even before its artistic production we can always see the image in Christ; just as, for example, we can see the shadow always potentially accompanying the body, even if it is not given form by the radiation of light. In this manner it is not unreasonable to reckon Christ and His image among things which are simultaneous.

If, therefore, Christ cannot exist unless His image exists in potential, and if, before the image is produced artistically, it subsists always in the prototype: then the veneration of Christ is destroyed by anyone who does not admit that His image is also venerated in Him.

SOURCE: *ON THE HOLY ICONS*. TR. CATHERINE P. ROTH. (CRESTWOOD, NY: ST. VLADIMIR'S SEMINARY PRESS, 1981)

revival of Byzantine artistic traditions, as well as of classical learning and literature, followed the years of iconoclasm and lasted from the late ninth to the eleventh century. This revival, spearheaded by Basil I the Macedonian, was underscored by the reopening of the university in Constantinople.

ILLUSTRATED BOOKS A rather remarkable example of the antique revival is the *Joshua Roll* (fig. **8.39**), illustrated in Constantinople in the middle of the tenth century. Some art historians have seen these illustrations of the Old Testament hero Joshua's victories in the Holy Land as alluding to recent Byzantine military successes against the Muslims there. But there are problems correlating the historical events with the date of the manuscript based on stylistic criteria. It is possible that the manuscript projects aspirations more than it reflects accomplishments. That the manuscript takes the form of a scroll, that archaic type of manuscript that had been replaced by the codex a full eight centuries earlier (see pages 250–251), is remarkable. Whether or not scholars who argue that the manuscript is an accurate copy of an earlier scroll are correct, the drawn rather than painted style and the elegantly disposed figures in landscapes and against cityscapes give us some idea of what antique examples must have looked like. That such an obsolete, indeed impractical, vehicle as the scroll, whether an original or a copy, was chosen for such a lavish enterprise illustrates why scholars have referred to this period as a renaissance, crediting much of its vigor to Constantine VII.

Emperor in name only for most of his life, he devoted his energies instead to art and scholarship.

David Composing the Psalms (fig. 8.40) is one of eight full-page scenes in the mid-tenth century *Paris Psalter*. Illustrating David's life, these scenes introduce the Psalms, which David was thought to have composed. Not only do we find a landscape that recalls Pompeian murals (see fig. 7.55), but the figures, too, clearly derive from Roman models. David himself could well be mistaken for Orpheus charming the beasts with his music. His companions are even more surprising, since they are allegorical figures that have nothing to do with the Bible. The young woman next to David is the personification of Melody, the one coyly hiding behind a pillar is the mountain nymph Echo, and the male figure with a tree trunk personifies the mountains of Bethlehem.

Once again style promotes meaning in the way consciously Classical forms herald the revival of image making after iconoclasm. But despite the presence of revivalist aspects, the late date of the picture is evident from certain qualities of style, such as the crowded composition of space-consuming figures and the abstract zigzag pattern of the drapery covering Melody's legs. In truth, one might well ask to what extent and how, despite Iconoclasm, antique methods and forms survived—that is, how much of what we see is the result of continuities rather than revivals.

SCULPTURE Monumental sculpture, as we saw earlier, disappeared from the fifth century on. In Byzantine art, large-scale

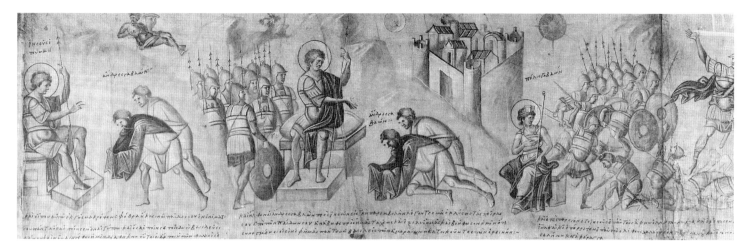

8.39. Page with *Joshua and the Emissaries from Gibeon*, from the *Joshua Roll*. ca. 950 CE. Tempera on vellum. Height 12¼" (31 cm). Biblioteca Apostolica Vaticana, Rome. (Cod. Palat. grec. 431)

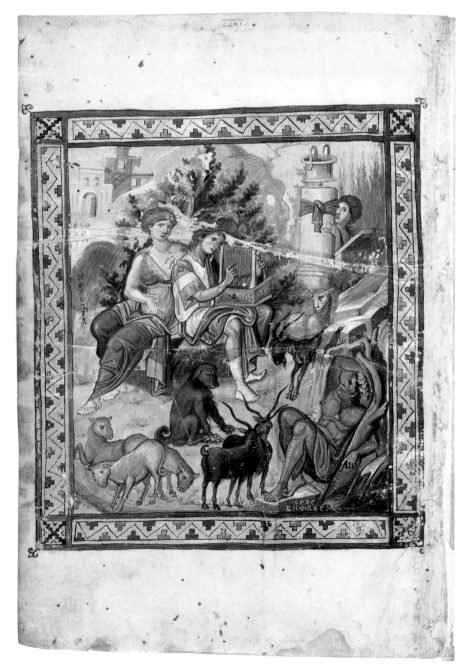

8.40. *David Composing the Psalms,* from the *Paris Psalter*. ca. 950 CE. Tempera on vellum, 14⅛ × 10¼" (36 × 26 cm). Bibliothèque Nationale, Paris

statuary died out with the last imperial portraits, and stone carving was confined almost entirely to architectural ornament. But small-scale reliefs, especially in ivory and metal, continued to be produced in large numbers with a variety of content, style, and purpose. The *Harbaville Triptych* (fig. **8.41**), named after a recent owner, is a portable shrine in ivory with two hinged wings of the kind a high official might carry for his private worship while traveling; despite its monumental presence, it is less than 10 inches high. In the upper half of the center panel we see Christ Enthroned. Flanking him are John the Baptist and the Virgin, who plead for divine mercy on behalf of humanity. This scene, the so-called **deësis**, is a theme of relatively recent Byzantine invention. Below are five apostles arranged in strictly frontal view. Only in the upper tier of each wing of the triptych is this formula relaxed. There we find an echo of Classical contrapposto in the poses of the military saints in the top registers of the lateral panels. It is possible that we are

looking at a continuity of the approach we saw in the early icon of the *Virgin and Child Enthroned between Saints and Angels* from Mount Sinai (see fig. 8.37), whereby different figure types require different representational modes. Here, the active poses of the military saints contrast with the elegant restraint of the other holy figures, whereas in the Mount Sinai icon the angels have the active poses and the military saints are static.

Refinement and control also mark the attitude of the figures on the ivory of *Christ Crowning Romanos and Eudokia* (fig. **8.42**), where the authority of the two haloed figures is confirmed by their divine election as emperor and empress. Once again there is some stylistic opposition, perhaps even tension: The body-revealing drapery of Christ contrasts with the stiff, patterned garments of the imperial figures; and the ample space that surrounds Christ contrasts with the ambiguous one between the flanking figures and the elevated podium on which Christ stands. Unequivocal, however, and as with the *Justinian as Conqueror* ivory (see fig. 8.33), is the message of a relationship between a pious emperor and his god, beneficial to both parties. The imperial couple's elevated relationship to Christ recalls that of John the Baptist and Mary on the *Harbaville Triptych* (see fig. 8.41).

ARCHITECTURE AND ITS DECORATION Byzantine architecture never produced another structure to match the scale of Hagia Sophia. The churches built after the Iconoclastic Controversy were initially modest in scale and usually monastic, perhaps reflecting the fact that monks had been important in arguing against iconoclasm; later monasteries erected in

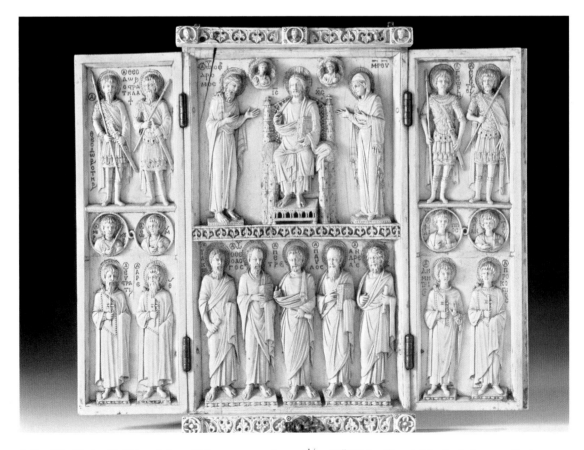

8.41. *The Harbaville Triptych.* Late 10th century CE. Ivory, $9\frac{1}{2} \times 11''$ (24.1 × 28 cm). Musée du Louvre, Paris

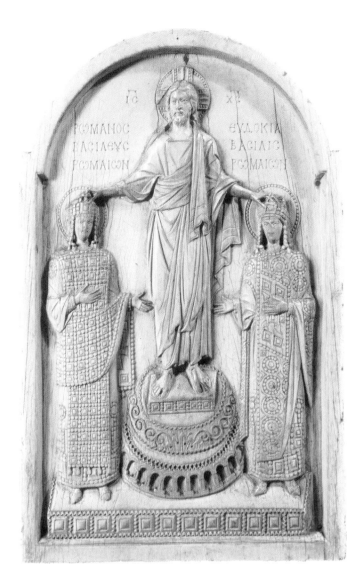

8.42. *Christ Crowning Romanos and Eudokia* ("Romanos Ivory"). 945–949 CE. Ivory, 9³⁄₄ × 6¹⁄₈″ (24.6 × 15.5 cm). Cabinet des Médailles, Bibliothèque Nationale, Paris

Constantinople under imperial patronage were much larger and served social purposes as schools and hospitals. The monastic Church of the Dormition at Daphni, in Greece, follows the usual Middle Byzantine plan of a Greek cross contained within a square, but with a narthex added on one side and an apse on the other (fig. **8.43**). The central feature is a dome on a cylinder, or **drum**. The drum raises the dome high above the rest of the building and demonstrates a preference for elongated proportions. The impact of this verticality, however, strikes us fully only when we enter the church. The tall, narrow compartments produce both an unusually active space and a sense almost of compression (fig. **8.44**). This feeling is

8.44. Interior (facing west), Church of the Dormition, Daphni, Greece

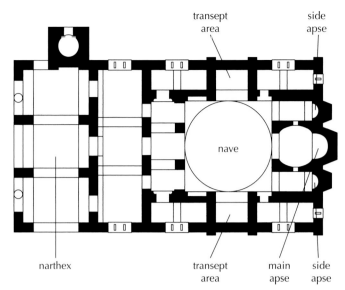

8.43. Plan of Church of the Dormition, 11th century CE. Daphni, Greece.

dramatically relieved as we raise our glance toward the luminous pool of space beneath the dome, which draws us around and upward (fig. **8.45**). The suspended dome of Hagia Sophia is clearly the conceptual precedent for this form.

The mosaics inside the church at Daphni are some of the finest works of the Second Golden Age. They show a classicism that merges harmoniously with the spiritualized ideal of

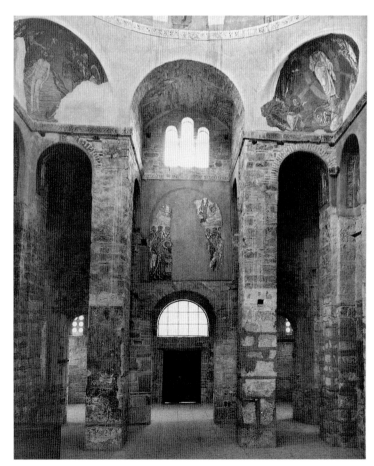

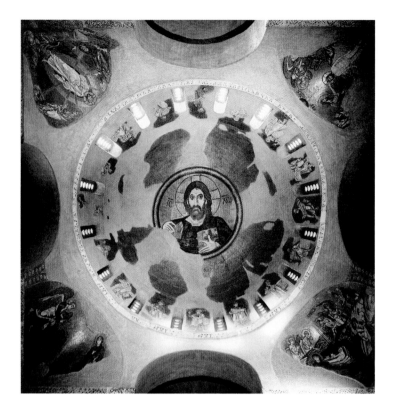

restored) mosaic image of which stares down from the center of the dome at Daphni against a gold background (see fig. 8.45). The Pantocrator is Christ as both Judge and Ruler of the Universe, the All-Holder who contains everything. The type descends from images of the bearded Zeus. The bearded face of Jesus first appears during the sixth century, and we have already seen an early example in the icon from Mount Sinai (see fig. 8.36). Once again tradition and innovation mark Middle Byzantine achievements.

These two mosaic images are part of a larger comprehensive program that served a special spiritual function. (See end of Part II *Additional Primary Sources*). Otto Demus, writing in 1948, felicitously described Middle Byzantine churches such as the one at Daphni as a cosmos, the dome representing the heavens, while the vaults and the **squinches**, those devices, similar to pendentives, used to cut the corners of the square space below to make a transition to the cylinder above, signify the Holy Land (see fig. 8.44). The walls and supports below form the earthly world. Thus, there is a hierarchy of level, increasing verticality being equated with degrees of holiness, a sense of which is reinforced by the physical experience of the building's upward spiral pull. The beholder is on the lowest level; the

human beauty we encountered in the art of Justinian's reign. For instance, the classical qualities of the *Crucifixion* mosaic (fig. **8.46**), on the east wall of the north transept arm of the church, are deeply felt, yet they are also completely Christian. There is no attempt to create a realistic spatial setting, but the composition has a balance and clarity that are truly monumental. Classical, too, is the heroic nudity of Christ and the statuesque dignity of the two flanking figures, which make them seem extraordinarily organic and graceful compared to the stiff poses in the Justinian and Theodora mosaics at San Vitale (see figs. 8.25 and 8.26).

The most important aspect of the classical heritage in Middle Byzantine depiction, however, is emotional rather than physical. This is evident in the new interest in depicting the crucified Christ, that is, the Christ of the Passion. In the Daphni *Crucifixion* mosaic, Christ is flanked by the Virgin and St. John. The gestures and facial expressions of all three figures convey a restrained and noble suffering. We cannot say when and where this human interpretation of the Savior first appeared, but it seems to have developed in the wake of the Iconoclastic Controversy. There are, to be sure, a few earlier examples of it, but none of them appeals to the emotions of the viewer so powerfully as the Daphni *Crucifixion*. To have introduced this compassionate view of Christ into sacred depiction was perhaps the greatest achievement of Middle Byzantine art. Early Christian art lacked this quality entirely. It stressed the Savior's divine wisdom and power rather than his sacrificial death. Hence, Early Christian artists depicted the Crucifixion only rarely and without pathos, though with a similar simplicity.

Alongside the new emphasis on the Christ of the Passion, the Second Golden Age gave importance to the image of Christ the Pantocrator, an oversize, awesome (though heavily

8.46. *The Crucifixion*. Mosaic. Church of the Dormition, Daphni, Greece

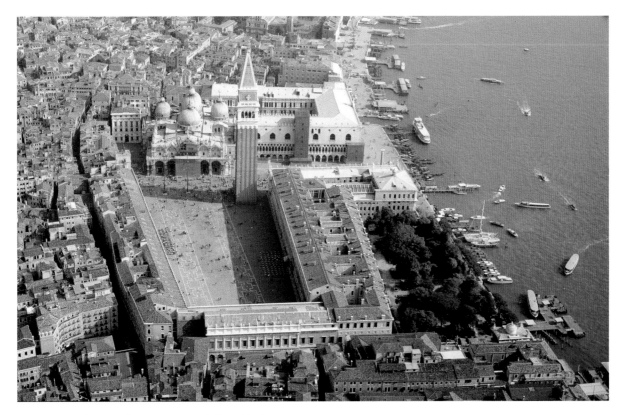

8.47. St. Mark's (aerial view). Begun 1063 CE. Venice

saints are on the walls and supports (visible in fig. 8.44); events in the life of Jesus that took place in the Holy Land, including the Annunciation, Nativity, Baptism, and Transfiguration, are on the vaults and squinches (fig. 8.45 shows the Annunciation in the lower left squinch, while the other scenes move around in a counterclockwise direction); and the Pantocrator is in the dome above (see fig. 8.45). Taken together, these representations illustrate the Orthodox belief in the Incarnation as the redemption of original sin and the triumph over death.

The movement around the building to witness the Christological cycle, which depicts the events of Christ's life, makes viewers, in effect, symbolic pilgrims to the Holy Land and is combined with a vertical momentum, a virtual journey heavenward. The impression is quite different from the experience of viewers in a Western basilica, even if both attempt to define a spiritual journey through architectural means and in aesthetic terms. In both, passage through space is a means to a goal, but when Orthodox and Western churches are compared, the manner and direction of movement is very different indeed. The largest and most lavishly decorated church of the period that still survives is St. Mark's in Venice (figs. **8.47** and **8.48**), begun in 1063, only nine years after the official schism between the Western (Catholic) and Eastern (Orthodox) churches. The church was so extensive, employing five domes in place of Daphni's single dome, that the classical system used at Daphni had to be expanded here. The present structure replaced two earlier churches of the same name on the site; it is modeled on the Church of the Holy Apostles in Constantinople, which had been rebuilt by Justinian after the riot of 532 and was later

8.48. Interior, St. Mark's, Venice

ART IN TIME

1180–1190—Apse mosaics, Cathedral Moreale

 1204—Fourth Crusade captures and sacks Constantinople

 1215—King John of England signs *Magna Carta*

 1261—Constantinople regains independence

 1453—End of Byzantine Empire

destroyed. The Venetians had long been under Byzantine rule, and they remained artistically dependent on the East for many years after they had become politically and commercially powerful in their own right. Their wish to emulate Byzantium, and Constantinople in particular, is evidence of the great sway that culture and city still held.

At St. Mark's the Greek-cross plan is emphasized, since each arm of the cross has a dome of its own. These domes are not raised on drums. Instead, they are encased in bulbous wooden helmets covered by gilt copper sheeting and topped by ornate **lanterns** (small structures often used to admit light into the enclosed spaces below), so that the domes appear taller and more visible at a distance. (They make a splendid landmark for seafarers.) The spacious interior shows that St. Mark's was meant for the people of a large city rather than a small monastic community such as Daphni.

The Byzantine manner, transmitted to Italy, was called the "Greek style" there. Sometimes it was carried by models from Constantinople, but most often it was brought directly by visiting Byzantine artists. At St. Mark's, Byzantine artists and the locals trained by them executed the mosaics. The "Greek style" appears in a number of magnificent churches and monasteries in Sicily, a former Byzantine holding that was taken from the Muslims by the Normans in 1091 and then united with southern Italy. The Norman kings considered themselves the equals of the Byzantine emperors and proved it by calling in teams of mosaicists from Constantinople to decorate their splendid religious buildings. The mosaics at the Cathedral of Monreale (fig. **8.49**), the last Byzantine mosaics to be executed, are in a thoroughly Byzantine style, although the selection and distribution of their subjects are largely Western. The wall surfaces these

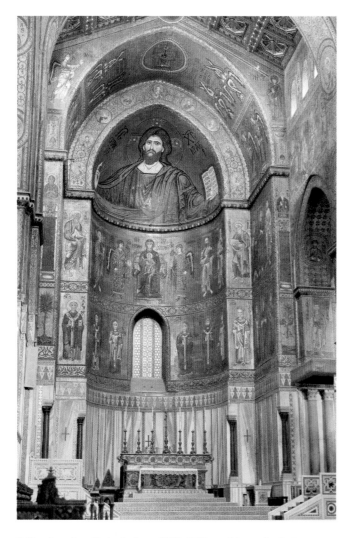

8.49. Interior, Cathedral. ca. 1180–1190 CE. Monreale, Italy

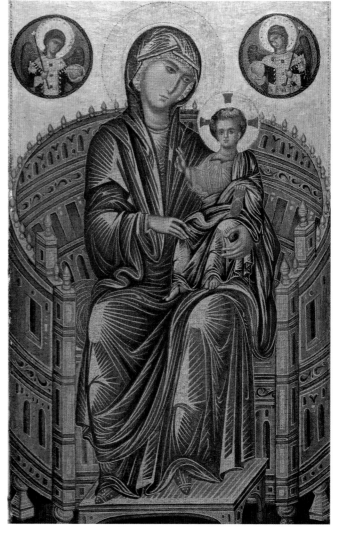

8.50. *Madonna Enthroned*. Late 13th century. Tempera on panel, $32\frac{1}{8} \times 19\frac{3}{8}''$ (81.9 × 49.3 cm). National Gallery of Art, Washington, D.C. Andrew Mellon Collection. 1937.1.1

Biblical and Celestial Beings

Much of Western art refers to biblical persons and celestial beings. Their names appear in titles of paintings and sculpture and in discussions of subject matter. The following is a brief guide to some of the most commonly encountered persons and beings in Christian art.

Patriarchs. Literally, patriarchs are the male heads of families, or rulers of tribes. The Old Testament patriarchs are Abraham, Isaac, Jacob, and Jacob's 12 sons. The word *patriarch* may also refer to the bishops of the five chief bishoprics of Christendom: Alexandria, Antioch, Constantinople, Jerusalem, and Rome.

Prophets. In Christian art, the word *prophets* usually refers to the Old Testament figures whose writings were seen to foretell the coming of Christ. The so-called major prophets are Isaiah, Jeremiah, and Ezekiel. The minor prophets are Hosea, Joel, Amos, Obadiah, Jonah, Micah, Nahum, Habakkuk, Zephaniah, Haggai, Zechariah, and Malachi.

Trinity. Central to Christian belief is the doctrine of the *Trinity* which states: that One God exists in Three Persons: Father, Son (Jesus Christ), and Holy Spirit. The Holy Spirit is often represented as a dove.

Holy Family. The infant Jesus, his mother Mary (also called the Virgin or the Virgin Mary), and his foster father, Joseph, constitute the *Holy Family.* Sometimes Mary's mother, St. Anne, appears with them.

John the Baptist. The precursor of Jesus Christ, John the Baptist is regarded by Christians as the last prophet before the coming of the Messiah, in the person of Jesus. John baptized his followers in the name of the coming Messiah; he recognized Jesus as that Messiah when he saw the Holy Spirit descend on Jesus when he came to John to be baptized. John the Baptist is not the same person as John the Evangelist, one the the 12 apostles.

Evangelists. There are four: Matthew, Mark, Luke, and John—each an author of one of the Gospels. Matthew and John were among Jesus' 12 apostles. Mark and Luke wrote in the second half of the first century CE.

Apostles. The apostles are the 12 disciples of Jesus Christ. He asked them to convert the "nations" to his faith. They are Peter (Simon Peter), Andrew, James the Greater, John, Philip, Bartholomew, Matthew, Thomas, James the Less, Jude (or Thaddaeus), Simon the Canaanite, and Judas Iscariot. After Judas betrayed Jesus, his place was taken by Matthias. St. Paul (though not a disciple) is also considered an apostle.

Disciples. See **Apostles.**

Angels and Archangels. Beings of a spiritual nature, angels are spoken of in the Old and New Testaments as having been created by God to be heavenly messengers between God and human beings, heaven, and earth. Mentioned first by the apostle Paul, archangels, unlike angels, have names: Michael, Gabriel, and Raphael. In all, there are seven archangels in the Christian tradition.

Saints. Persons are declared saints only after death. The pope acknowledges sainthood by canonization, a process based on meeting rigid criteria of authentic miracles and beatitude, or blessed character. At the same time, the pope ordains a public cult of the new saint throughout the Catholic Church. A similar process is followed in the Orthodox Church.

Martyrs. Originally, the word *martyr* (from the Greek meaning "witness") referred to each of the apostles. Later, it signified those persecuted for their faith. Still later, the term was reserved for those who died in the name of Christ.

mosaics covered are vast, the largest to be decorated in this technique, and the artists adapted their figure types and subjects to a Western building and Western subjects. Masterful indeed is the way the Pantocrator of a Byzantine domed church now controls the space of the apse and the way registers of figures lining the walls define, indeed clarify in a very un-Byzantine way, the basilica form. Christ's open book contains the text "I am the light of the world … " in Greek on one page and in Latin on the other, the schism of language being united through art.

Late Byzantine Art

In 1204 Byzantium suffered an almost fatal defeat when the armies of the Fourth Crusade, instead of warring against the Turks, captured and sacked the city of Constantinople. For more than 50 years, the core of the Eastern Empire remained in Western hands. Byzantium, however, survived this catastrophe. In 1261 it regained its independence, which lasted until the Turkish conquest in 1453. The fourteenth century saw a last flowering of Byzantine painting under a series of enlightened rulers.

ICONS The Crusades decisively changed the course of Byzantine art through bringing it into contact with the West. The impact is apparent in the *Madonna Enthroned* (fig. **8.50**), which unites elements of East and West, so that its authorship has been much debated. Because icons were objects of veneration, and because they embodied sacredness, they had to conform to strict rules, with fixed patterns repeated over and over again. As a result, most icons are noteworthy more for exacting craftsmanship than artistic inventiveness. Although painted at the end of the thirteenth century, our example reflects a much earlier type (see fig. 8.37). There are echoes of Middle Byzantine style in the graceful pose, the play of drapery folds, and the tender melancholy of the Virgin's face. But these elements have become abstract, reflecting a new taste and style in Late Byzantine art. The highlights on the drapery that resemble sunbursts are not a new development, yet they seem more rigid and stylized than in Middle Byzantine examples. Faces are carefully modeled with gentle highlights and suave shading. The linear treatment of drapery in combination with the soft shading of hands and faces continues the long-established Byzantine pattern of having naturalistic and antinaturalistic aspects play off each other in the same work.

The total effect is neither flat nor spatial, but transparent—so that the shapes look as if they were lit from behind. Indeed, the gold background and highlights are so brilliant that even the shadows never seem wholly opaque. This all-pervading radiance, we will recall, first appears in Early Christian mosaics (see, for example, fig. 8.17). Panels such as

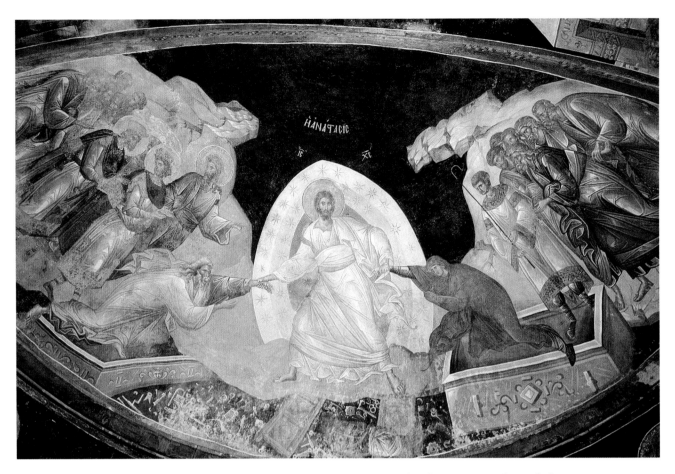

8.51. *Anastasis*. ca. 1310–1320 CE. Fresco. Kariye Camii (Church of the Savior in the Chora Monastery), Istanbul

the *Madonna Enthroned* may therefore be viewed as the aesthetic equivalent of mosaics and not simply as the descendants of the panel-painting tradition. In fact, some of the most precious Byzantine icons are miniature mosaics attached to panels, and our artist may have been trained as a mosaicist rather than as a painter.

Although many details relate this icon to Byzantine works, particularly from Constantinople, there is growing evidence that it was produced by a Western artist in emulation of Byzantine painting. For example, the manner in which the Enthroned Virgin presents the Christ Child is Byzantine, while the blessing gesture of Christ is Western. The red background of the angels in medallions is also a feature not found in Byzantium, but rather in the West. An origin in Cyprus, then ruled by the French, has been suggested, but where this work might have been painted remains a very open question. Whatever its origin, the *Madonna Enthroned* points to a profound shift in the relation between the two traditions: After 600 years of borrowing from Byzantium, Western art has begun to contribute something in return.

MOSAICS AND MURAL PAINTING The finest surviving cycles of Late Byzantine mosaics and paintings are found in Istanbul's Kariye Camii, the former Church of the Savior in the Chora Monastery. (*Kariye* is the Turkish adaptation of the

ancient Greek word *chora*, which refers to the countryside, that is, outside the city walls; *camii* denotes a mosque, to which the building was converted after the Turkish conquest, although the site is now a museum.) These particular mosaics and paintings represent the climax of the humanism that emerged in Middle Byzantine art. Theodore Metochites, a scholar and poet who was prime minister to the emperor Andronicus II, restored the church and paid for its decorations in the beginning of the fourteenth century.

The wall paintings in the mortuary chapel attached to Kariye Camii are especially impressive. Some have suggested that because of the Empire's greatly reduced resources, murals often took the place of mosaics, but at Kariye Camii they exist on an even footing and may even have been designed by the same artist. The main scene depicts the traditional Byzantine image of the *Anastasis* (fig. **8.51**), the event just before the Resurrection, which Western Christians call the Descent into Limbo or the Harrowing of Hell, clearly a fitting subject for the funerary setting. Surrounded by a **mandorla**, a radiant almond shape, Christ has vanquished Satan and battered down the gates of Hell. (Note the bound Satan at his feet, in the midst of a profusion of hardware; the two kings to the left are David and Solomon.) The central group of Christ raising Adam and Eve from the dead has tremendous dramatic force; Christ

moves with extraordinary physical energy, tearing Adam and Eve from their graves, so that they appear to fly through the air—a magnificently expressive image of divine triumph.

Such dynamism had been unknown in the Early Byzantine tradition, although the emotional force of Middle Byzantine painting might well have prepared the way for the vivacity of the Kariyi Camii representations. Coming in the fourteenth century, this Late Byzantine style shows that 800 years after Justinian, when the Anastasis first appeared as a subject, Byzantine art still had all its creative powers. Thus, despite the diverse uses it served, its long chronological spread, and the different cultures and wide geographic areas it spanned, Byzantine art continued to preserve long-established traditions. Indeed, its durability verges on the immutable.

SUMMARY

A weakened Roman Empire faced threats along its borders and during this time of turmoil many people sought solace in a variety of new religions. Principal among them was Christianity. It enjoyed special status during the rule of Constantine, a Christian convert who created a new capital for the Roman Empire at Constantinople. Eventually this move led to a split of the empire into separate Western and Eastern regions.

There is no clear-cut geographical, chronological, or stylistic line between Early Christian and Byzantine art before the sixth century. Among the earliest surviving works of Christian art are sarcophagi, wall mosaics, and illustrated books. Significant Christian architecture appears only when **Christianity** became an officially sanctioned religion. Byzantine artists shared many of the concerns of their Early Christian colleagues in the Western empire, particularly for nonnaturalistic, symbolic representations. However, Classical systems of representation continued to be admired and employed.

EARLY CHRISTIAN ART

Although early centers of the Christian faith included cities along the eastern Mediterranean, the greatest concentration of surviving works is found in Rome. These include painted decorations from the catacombs, the underground burial places of early Christians. After the conversion of Emperor Constantine, many new and impressive Christian structures were built. Particularly significant was the transformation of the Roman basilica form so that it was suitable for Christian worship, as can be seen in Old St. Peter's Basilica. Also important is the development of central-plan buildings. Two examples are the Mausoleum of Galla Placidia and the Orthodox Baptistery, both in Ravenna, which became the capital of the Western Empire in 402. Although often relying on Roman artistic forms and subjects, Early Christian artists used them for new purposes that were in keeping with the values and goals of the new religion.

BYZANTINE ART

During Justinian's rule, Constantinople became the artistic and political capital of the Eastern Empire. The grand monuments of this time, such as Hagia Sophia, are a reflection of what some have called a Golden Age. Many outstanding works also survive in Ravenna, such as the church of San Vitale, which is decorated with a famed series of mosaics. A sense of tradition played a strong role in the development of Byzantine art, and even works from later centuries—whether icons, illustrated books, or small-scale reliefs—reflect a concern for continuity as much as for change.

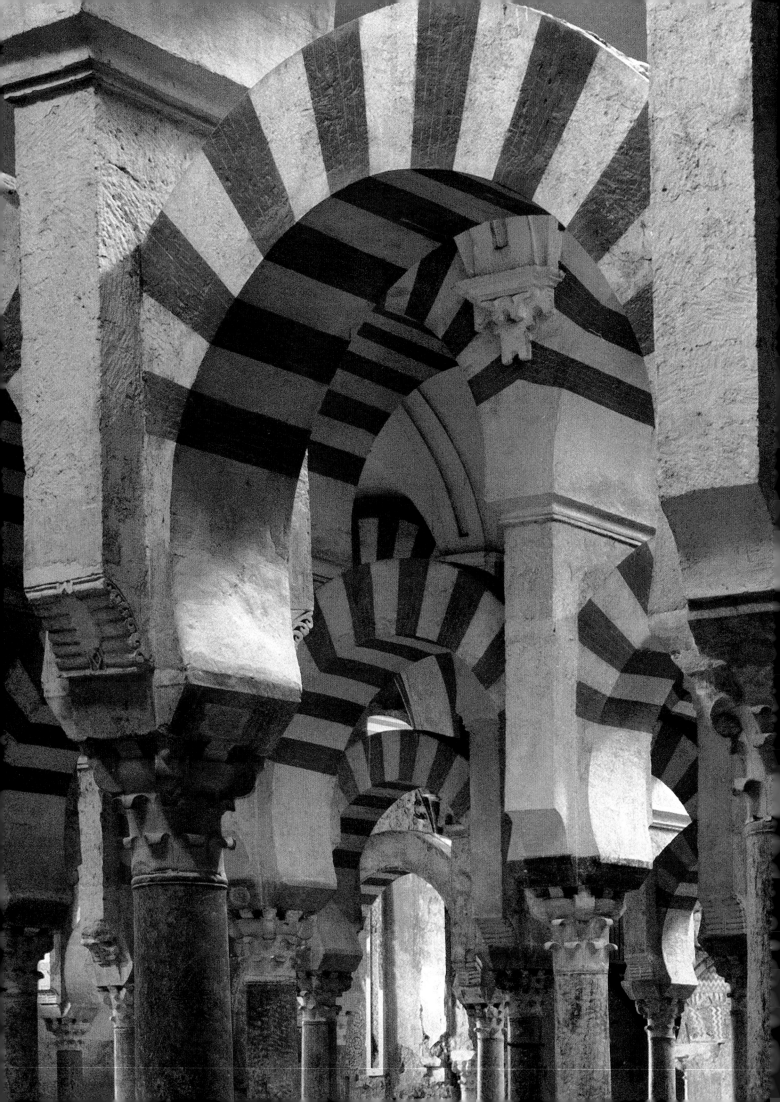

Islamic Art

THE RELIGION KNOWN AS ISLAM TOOK FORM IN THE EARLY SEVENTH century on the Arabian peninsula (see *Informing Art*, page 278). A scant 30 years after the death of its founder, the Prophet Muhammad (also known as the Messenger), in 632, Arab warriors had carried the new faith into much of today's Middle East. A century after the death of

the Prophet, Islam had spread across Africa into Spain in the west, and into the Indus valley and Central Asia in the east (map 9.1). The original Arab adherents of Islam were eventually augmented by Berbers, Visigoths, Turks, and Persians, and the complexity of today's Islamic world existed almost from the beginning. As this phenomenal expansion took place, the inevitable clashing and combining of old cultures with the new religion gave birth to what was to become a vibrant tradition of Islamic art.

Examining the formation of Islamic art gives us an intriguing look at the phenomenon of *syncretism* in art history, the process whereby a new artistic tradition emerges as a creative combination of previously existing artistic ideas under the impetus of a new ideology. Just as the first Christian art developed out of a mixture of various preexisting Classical and Near Eastern artistic ideas adapted to serve the needs of religious and then princely patrons (see Chapter 8), so the new Islamic art first took form as a series of appropriations of preexisting Graeco-Roman, Byzantine Christian, and Sasanian forms molded into a new synthesis, in the service both of the new Islamic religion and Islamic princes.

The vast geographical and chronological scope of Islamic art means that it cannot be encompassed in simple definitions. Islam, the religion, is a significant element in Islamic culture,

Detail of Figure 9.8, Great Mosque of Córdoba

but Islamic art is far more than a religious art; it encompasses secular elements and elements frowned upon, if not actually forbidden, by some Islamic theologians. As with all art, Islamic art encompasses and reflects the consistencies and the contradictions of the society and culture that give it life.

With all of its individual styles of time and place, and with the various sectarian differences within Islam, Islamic art has certain unifying themes. The first of these is reverence for the Word—the Qur'an—and for the language of the Word—Arabic—as reflected in the art of beautiful writing. From the angular, horizontal **kufic** alphabet of early Islam (fig. **9.1**) to complex cursive styles developed in later times, Islamic art, both secular and religious, shows a remarkable affinity for the written word, be it scripture or secular narrative poetry (see *Primary Source*, page 280). A second theme is the development of artistic expression independent of the human figure. Given the mistrust of figural images in many Islamic religious traditions, we see in Islamic art sophisticated and complex vocabularies of vegetal, floral, and geometric designs used in conjunction with beautiful writing. A third theme is the equality of genres. To understand and appreciate Islamic art we need to discard the notion of the primacy of (figural) painting and (figural) sculpture in the European tradition. In the Islamic world, the arts of ceramics, metalware, weaving, and carving in precious materials rank with other mediums in an artistic spectrum devoid of the formal hierarchy that in the West led to a distinction between "fine

Islam and Its Messenger

Islam (an Arabic word denoting submission to God's will) is the predominant religion of a vast area of the world extending across Africa, Europe, and Asia, with many different ethnicities, cultures, languages, and forms of social and political organization. *Muslims* (those who submit) believe that Muhammad (ca. 570–632), an orphaned member of a major tribal group from the city of Mecca in the western Arabian peninsula, was chosen by God (in Arabic, *Allah*) to serve as God's Messenger, or Prophet, to humanity. Muhammad is said to have received the Word of God as a series of poetical recitations (in Arabic, *Qur'an*), brought to him by the archangel *Jibra'il* (Gabriel). Muhammad memorized and recited these poetic verses, and taught them to his followers. Organized into *sura* (chapters) and finally written down after the death of Muhammad in 632, these prayers, stories, exhortations, and commandments constitute the Qur'an, Islam's sacred book. The Qur'an, together with official collections of *hadith* (remembrances) of the exemplary life of Muhammad as the Messenger, form the basis of Islamic religious practice and law.

While the Prophet quickly gained adherents, those in power in Mecca were threatened by the challenges the new faith posed to their political and economic power, and in 622 he was forced to leave Mecca with a few of his followers, moving to the city of Medina some 190 miles to the north. Muhammad's community, in constant conflict with the Meccans to the south, continued to grow, and more revelations were received. The Prophet's house in Medina, constructed in the form of an open square, became the prototype for countless mosques in subsequent centuries.

Islam was defined by Muhammad as the culmination of a prophetic tradition that began with God's covenant with Ibrahim (Abraham). The Qur'an prominently mentions many of the major figures of the Hebrew Bible, such as Ibrahim, Musa (Moses), and Sulayman (Solomon), as well as the prophet 'Isa (Jesus) and his mother Maryam (Mary). Islamic belief is fundamentally very simple: To become a Muslim, one repeats with conviction the phrase, "There is no God but God; Muhammad is the Messenger of God." This Affirmation of Faith is the first of the so-called Five Pillars of Islam. The others are prayer (the five daily prayers and the major weekly prayer at noon on Friday, the Muslim Day of Congregation), fasting (abstention from food and drink during daylight hours during the lunar month of Ramadan), pilgrimage (in Arabic, *hajj*, a journey to Mecca during the lunar month of Dhu'l Hijja), and charity (institutionalized as a formal system of tithing, intended to benefit the sick and needy of the Islamic community).

In addition, Islam proclaimed three other tenets that were to have a major impact on art. The first was the protected status of the "People of the Book"—Jews and Christians—in Muslim society, as ordained by God in the Qur'an. The second, based on several anecdotes from the Prophet's life, is a profound mistrust of certain images—pictures and statues of humans and animals—as potentially idolatrous, a point of view Islam shares with Judaism, and which occasionally influences the history of Christian art as well. The third, held in common with Judaism and contrasting markedly with the Christianity of that time, was a high regard for literacy and the individual's reading and study of scripture, coupled through most of Islamic history with a reverence for the written alphabet—in the case of Islam, the Arabic alphabet, which in early Islam used an angular form of script known as *kufic* (see fig. 9.1). The beauty of the script, with its contrasting thin and thick lines, written from right to left in an almost rhythmic visual cadence, was deemed appropriate for the poetic words of God himself. These three factors, taken in the general context of Islamic belief and early Islamic political history, were to have a profound effect on the molding of the Islamic artistic tradition.

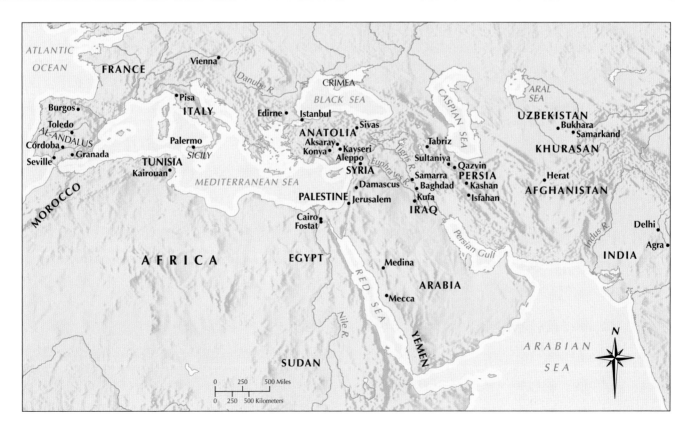

Map 9.1. The Islamic World

9.1. Page with kufic script from an Abbasid Qur'an, probably from Tunisia. 9th century. Ink, color, gold and silver on dyed blue vellum, $11\frac{1}{4} \times 14\frac{3}{4}$" (28.6 × 37.5 cm). Courtesy of the Arthur M. Sackler Museum. Harvard University Museums, Cambridge, MA, Francis Burr Memorial Fund, 1967.23

arts" and "decorative arts." In this sense, looking at Islamic art can be both enlightening and liberating.

THE FORMATION OF ISLAMIC ART

Islamic art first took form as a series of appropriations of pre-existing Graeco-Roman, Byzantine Christian, and Sasanian forms. These were molded into a new synthesis to serve the needs of the new Islamic religion and the desires and political goals of Islamic princes. The appropriation and adaptation of preexisting forms in the service of the emerging Islamic culture is particularly apparent in architecture.

Religious Architecture

The new religion required certain types of distinctive buildings, such as a place for community prayers that was visually identified with the new faith. The new Islamic rulers required dwellings appropriate to their power and wealth. Eventually the faith required commemorative buildings that memorialized great rulers, holy men, or historic events. Ultimately,

Islamic architecture developed a rich variety of forms and genres, and a distinctive repertoire of decoration that became emblematic of the faith itself.

DOME OF THE ROCK The earliest major Islamic building to have survived into our time, the Dome of the Rock in Jerusalem (fig. **9.2**), is a case in point. After the Arabian cities of Mecca and Medina, Jerusalem was the holiest Islamic site. For the first Muslims, the Temple Mount in Jerusalem marked the place where God tested Ibrahim's faith by demanding the sacrifice of his first-born son Ismail. From the same site, according to later Islamic legend, the Prophet was taken by Gabriel on a *mi'raj* (spiritual journey) to experience both Heaven and Hell, Muhammad being the only mortal allowed to see these places before death.

It is far from coincidence that the Dome of the Rock is built on Mount Moriah in Jerusalem, a place that originally was the site of the First (Solomon's) and Second (Herod's) Temples, the geographic center of the Jewish faith. It is also far from coincidence that the domed silhouette and ringlike plan of the Dome

Muhammad Ibn Mahmud Al-Amuli (Iran, 14th Century)

From *Nafâ'is al-Funûn* (The Beauty of Knowledge)

Countless Islamic adages and anecdotes testify to the importance and beauty of elegant writing, the only art form to which Islamic theologians gave their unqualified approval. Al-Amuli's encyclopedic treatise on knowledge praises the art of beautiful writing as the fulfillment of God's will, bringing respect and honor to the practictioner.

The art of writing is an honourable one and a soul-nurturing accomplishment; as a manual attainment it is always elegant, and enjoys general approval; it is respected in every land; it rises to eminence and wins the confidence of every class; being always held to be of high rank and dignity, oppression cannot touch it, and it is held in remembrance in every country, and every wall is adorned by its hand. Honour enough for it in this connexion is that the Lord of Lords, whose names are hallowed in His incontrovertible Revelation, swore—"By the pen, and what they write (Qur. lxviii.1), and He spake these words: "Recite! Thy Lord is the most generous, who hath taught by means of the pen, Hath taught man what he knew not" (Qur. xcvi. 3–5).

 It is honour and exaltation enough for the writing pen
 For ever, that it was by the pen that God swore

The Prophet (peace be upon him!) said: "Beauty of handwriting is incumbent upon you, for it is one of the keys of man's daily bread." A wise man has said: "Writing is a spiritual geometry, wrought by a material instrument."

SOURCE: SIR THOMAS W. ARNOLD *PAINTING IN ISLAM: A STUDY OF THE PLACE OF PICTORIAL ART IN MUSLIM CULTURE,* (NY: DOVER, 1965)

of the Rock (fig. **9.3**) echo the form of the sixth-century Byzantine shrine of the Holy Sepulcher, marking the burial place of Jesus, just a few hundred yards to the west. The Dome of the Rock was constructed by artists and craftspeople, many of whom were undoubtedly local Christians or new converts to Islam, probably under orders from the Muslim caliph (from the Arabic *khalifa*, meaning "successor") Abd al-Malik sometime around the year 690. Erected on a holy place that was also one of the highest points in the city, it eloquently proclaimed that Jerusalem was under the control of Islam.

A closer look at the building shows both the nature of early Islamic syncretism and the impact of the Messenger's views on the visual arts. The ground plan of the building (see fig. 9.3), with its two ambulatories around the central bare rock, ideal for organizing visits of large numbers of pilgrims to the shrine, recalls not only the Holy Sepulcher but also central-plan domed churches from late Roman times. Just to the south of the Dome of the Rock, providing a place for prayer directly next to the shrine, was an equally venerable and revered Islamic structure, the communal prayer hall known

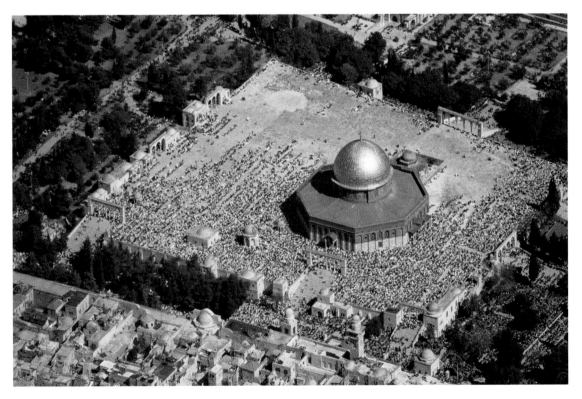

9.2. The Dome of the Rock, Jerusalem. ca. 690 and later

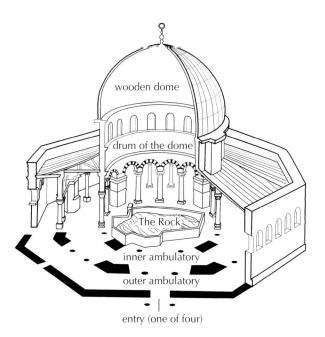

Labels on diagram:
wooden dome
drum of the dome
The Rock
inner ambulatory
outer ambulatory
entry (one of four)

9.3. Cutaway drawing, Dome of the Rock, Jerusalem

THE HYPOSTYLE MOSQUE Of all of the pillars of Islam, the religious duty of prayer proved the most important in the development of Islamic architecture. In major cities such as Damascus, the Arab Umayyad caliphs of early Islam either built or converted from preexisting structures the first great buildings for Muslim public worship called **mosques** in English (from the Arabic *masjid*, meaning "place of prostration"). These first mosques, designed to contain the entire male population of a city during the noonday prayer on Friday, recall the form of the Messenger's house in Medina, with a rectangular courtyard, usually surrounded by covered arcades, and a larger hypostyle (many-columned) hall on the **qibla**, the side facing Mecca. The architecture emphasized the equality of all Muslims before God and the absence in Islam of ordained clergy: There is little *axiality* in the early Arab mosques—no long straight pathway leading to an architectural focus visible throughout the structure. With prayer occurring directly between each worshiper and God, and no ordained clergy or canonized saints to provide intercession, the interior space of the early mosque was essentially determined by practicality, not by ceremony. Thus there was no place for music or processions; many doors were placed

today as the al-Aqsa Mosque. The dome of the shrine itself was a well-established symbol for the vault of heaven, especially appropriate given the ultimate goal of the Messenger's mystical and spiritual journey. The columns and capitals, recycled from Classical monuments, convey an impression of tradition and permanence, wealth and power, to Muslim and non-Muslim alike.

The original mosaic decoration (fig. **9.4**) consisted of Arabic script, repeating geometric motifs, and highly stylized vegetal and floral elements. Eventually, these design elements would form a distinctively Islamic repertoire of decoration. One was Arabic script used in the many religious inscriptions. Two others were a vocabulary of scrolling vines, leaves, and flowers distantly based on nature, and another a repertoire of repeating geometric patterns. Both vocabularies were staples of late Classical and Sasanian art. A fourth set of motifs consisted of jewels and jeweled objects, symbols of royalty. But in marked contrast to the Graeco-Roman and Christian religious art traditions, nowhere in the Dome of the Rock do the forms of humans or animals appear. The inscriptions in the Dome of the Rock, taken from the Qur'an, were carefully chosen to underline the importance of the building itself, its symbolic location in a city holy to Jews and Christians as well as Muslims, and its place within a religion and society that saw itself as the culmination of the two earlier scriptural traditions, and which accorded tolerance and acceptance of both Christians and Jews.

9.4. Interior, Dome of the Rock, Jerusalem

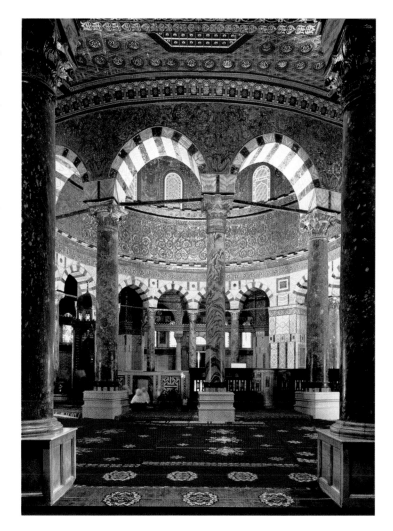

for maximum convenience of the daily coming and going of worshipers; and a large centralized or axial space, so important for the drama of the Christian Mass, was deemed unnecessary. A simple **minbar** (pulpit) served for the delivery of sermons after the Friday noon prayer, and an empty **mihrab** (niche) in the qibla wall was added to indicate the direction of Mecca (fig. **9.5**). Mats of grass or rushes, and later woolen carpets, often covered the floors. These provided a clean place for the standing, bowing, kneeling, and prostration, with the brief touching of the forehead to the ground, while reciting prayers, that constitute the essence of Islamic worship. Oil lamps provided illumination for the dawn and late evening prayers. Pools or fountains in the courtyard allowed for the ceremonial washing of hands and feet required before prayers. In later times, a tower, known in English as a **minaret**, advertised the presence of the mosque and served as a place from which to broadcast the call to prayer given five times a day by a *muezzin,* an individual usually selected for the beauty and power of his voice. And in some mosques a small platform called a **dikka** provided a place for the muezzin to chant prayers aloud.

Secular Architecture

The advent of Islam did not mean the end of secular art in the Near East. The early Islamic princely patrons, Arabs from the Umayyad ruling house, in addition to establishing the canonical form of the Islamic house of prayer, were also quickly seduced by the splendor of Sasanian and Graeco-Roman princely art. Although their urban palaces have not survived, they also constructed luxurious and secluded palaces out in the desert, away from the metropolitan centers, and some of these have been rediscovered in relatively recent times. In addition to walled residences for ruler and courtiers in the traditional hollow square form of the Roman military encampment, the Umayyads built large and sumptuous bathhouses with halls for entertainment, often lavishly furnished with mosaic floors in a late Roman style and decorated with pictorial and sculptural images of luxury. Among the subjects depicted were the royal hunt, court musicians (fig. **9.6**), the enjoyment of Roman-style baths, dancing courtesans, scenes from everyday life, and images of ancient derivation denoting fertility, sexuality, and kingly prowess. The puritanical demands of religion thus immediately came into conflict with the age-old symbols of royal wealth, luxury, and entertainment. So great was the embedded power of the artistic imagery of kingship in the Middle East that it quickly made an impact on the material culture of the new Islamic ruling elite.

THE DEVELOPMENT OF ISLAMIC STYLE

By 750, the Umayyad dynasty based in Roman Syria had been supplanted by the Abbasid dynasty centered in Mesopotamia. Here the new caliphs built their capital, called Baghdad, on the Tigris River, and later a vast palace city to the north of Baghdad at Samarra. The original Round City of Baghdad, the site of

9.5. Schematic of a generic Arab hypostyle mosque

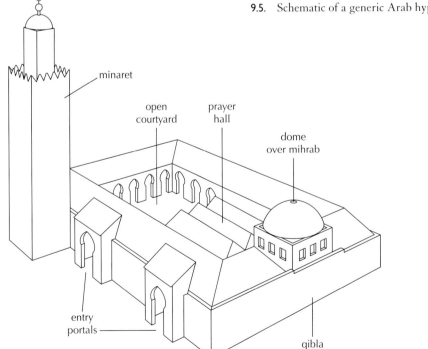

minaret

open
courtyard

prayer
hall

dome
over mihrab

entry
portals

qibla
wall

9.6. Floor fresco depicting two court musicians and a mounted hunter, from Qasr al-Hayr (West). ca. 730. National Museum, Damascus

which lies under the present-day city, was largely abandoned and destroyed long before the Mongols sacked the city in 1258, but its powerful memory lived on in Arabic poetry and prose literature. Samarra's impressive mud-brick ruins still stretch for miles along the Tigris. Under Abbasid rule over the now-extensive Islamic empire the building of mosques in newly conquered areas proceeded apace.

Religious Architecture

Chief among the new structures were the large Abbasid congregational mosques that both practically and symbolically served as religious gathering places for prayers, sermons, and religious education. Large examples, many now in ruins, were built all over Iraq, and in Egypt and elsewhere. An archetypal example is the largely ninth-century congregational mosque at Kairouan, a city in what is now Tunisia established under the Abbasids.

GREAT MOSQUE OF KAIROUAN Based like all major Arab mosques on the house of the Prophet in Medina and the four-square Mediterranean courtyard house, examples of which today still surround the structure, the Great Mosque of Kairouan consists of a rectangular courtyard surrounded by covered halls, a large hypostyle prayer hall, and a towering minaret (fig. **9.7**). Two domes mark the area: in front of the mihrab and

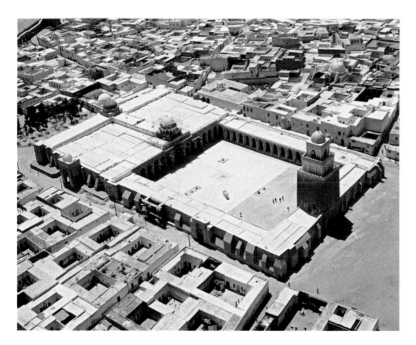

9.7. Aerial view of the Great Mosque of Kairouan, Tunisia. 8th century and later

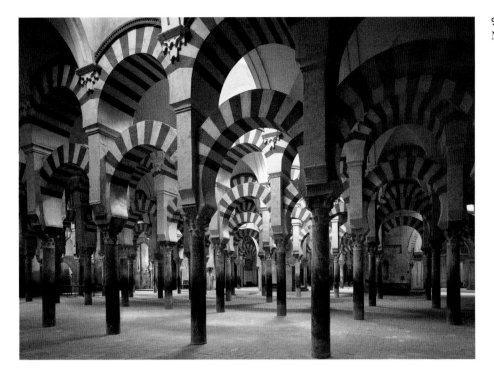

in the middle of the prayer hall facing the court. This aside, the multitude of entrances on three sides of the building, built in order to facilitate entry and exit for the five daily prayers, free the building from the domination of a central axis for processions of clergy; it is thus the very opposite of the early Christian basilican church, organized for priestly and theatrical ritual. The simplicity of the mosque reflects the simplicity of Islamic prayer. The mosque's lack of both axiality and uninterrupted interior space stems from the essential lack of hierarchy among worshipers and the absence of an ordained clergy in Islam. Each worshiper prays directly to God using a simple ritual formula usually completed in a few minutes. Artistic attention was lavished on the mihrab, of carved marble and ceramic tiles, and the minbar, elaborately carved of Indian teak. In the Kairouan mosque, a carved wooden screen, primarily a product of security rather than ritual needs, encloses a small area near the mihrab called the **maqsura**, where the ruler could pray alone.

GREAT MOSQUE OF CÓRDOBA Even farther to the west, in Spain, where the sole surviving prince of the exterminated Umayyad house founded an independent state after 750, a brilliant center of Islamic culture developed in the city of Córdoba, in the southern part of Spain, al-Andalus (now Andalusia). By the tenth century, the Great Mosque of Córdoba, after a series of embellishments and enlargements, had become one of the most beautiful Islamic houses of worship. A typical Arab hypostyle hall, the Córdoba mosque in its interior became after several expansions a virtual forest of columns (fig. **9.8**). Its characteristic "horseshoe" arcades are composed of arches using alternating red and white **voussoirs**, and include the additional element of one set of arches superimposed above another on elongated imposts. This creates an impression of almost limitless space—this space is,

however, composed of relatively small architectural elements repeated again and again. Compared with a Christian structure like Hagia Sophia (see figs. 8.28 and 8.29) or Old St. Peter's (see figs. 8.4 and 8.5), Córdoba has an equally large interior area, but there is no centralized space for the sacred theater of the Christian rite. The mosque interior, including the maqsura area around the mihrab, was lavishly decorated with mosaic and carved stone. Tenth-century marble grilles (fig. **9.9**) on the qibla wall present early examples of what we sometimes call **geometric arabesque**: The artist carves out of marble what is essentially a single straplike line that intertwines, creating a characteristic openwork screen of stars and polygons. In the beauty of such artistic geometry many Muslims see a reflection of God's creative hand in the universe.

In addition to providing a community prayer hall, the institutional operations of the great Islamic mosques such as the Great Mosque of Córdoba also often incorporated schools and universities, public baths, hospitals and medical schools, soup kitchens for the poor, hostels for travelers and merchants, public clocks (knowing the correct time was essential for the variable timing of the five daily prayers), public toilets, and fountains serving as the public water supply for the immediate area. Endowments known as *waqf*, based on the income from rental properties, supported the many functions of mosques. Waqfs were also established for social-service institutions and for shrines that were founded independently of mosques. Artistic votive gifts made to such institutions, such as Qur'an manuscripts, lamps, beautiful wooden furniture, carpets, and other objects, were in theory protected in perpetuity, becoming part of the waqf itself. As a consequence, such institutions often became great magnets for works of art, accumulating over time important libraries and collections of beautiful furnishings.

9.9. Carved stone grille on qibla wall of Great Mosque of Córdoba. Mid-10th century

ART IN TIME

700s CE—Construction begins on Great Mosque at Córdoba, Spain

750—Abbasid dynasty supplants Umayyad dynasty

1000s—Berber armies raze Medina al-Zahra

1215—*Magna Carta* signed by King John of England

1258—Mongols sack Baghdad

By 1300s—Almohad capital of Seville falls to kings of Castile

Luxury Arts

On the outskirts of Córdoba the Umayyads built another huge Islamic palace city, known as Medina al-Zahra. A ruin today, the palace complex once included royal workshops for luxury objects such as silk textiles and carved ivory, used as symbols of royal wealth and power and given as royal ceremonial gifts. A small, domed *pyxis* (ivory box) made there for a tenth-century Umayyad prince (fig. **9.10**) incorporates in its decoration a microcosm of Islamic royal imagery and symbolism, including depictions of falconry and hunting, sports, and court musicians, set amid lush carved vegetal ornament and a kufic inscription frieze. Such lavish objects had a symbolic importance far beyond their practical use as containers for jewelry or cosmetics. Their complex, many-layered iconography and their importance and symbolism as royal gifts continue to be studied by scholars today.

In the eleventh century, Berber armies serving the Almoravid dynasty from North Africa razed Medina al-Zahra to its foundations; although they and their successors, the Almohads, built significant monuments in the Maghreb (present-day Morocco and northwestern Africa) and in al-Andalus. But the growing and continual pressure of the Christian reconquest from the north saw a dramatic decline in Muslim power in Spain. By the fourteenth century, the Almohad capital of Seville had fallen to the

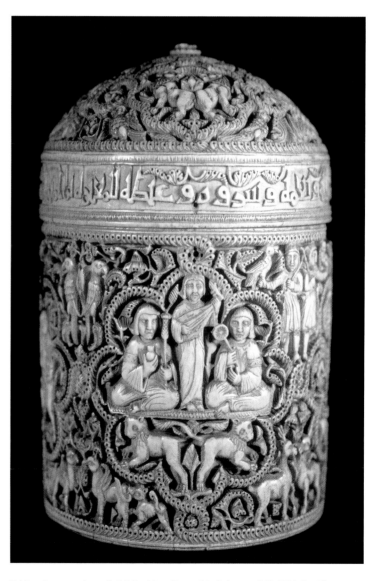

9.10. Ivory casket of al-Mughira, from Córdoba, ca. 960. Height 6″ (15 cm), diameter 3″ (8 cm). Musée du Louvre, Paris, Inv. 4068

ART IN TIME

242–272 CE—Sasanian ruler Shapur I builds audience hall at
Ctesiphon, Iraq

Early 900s CE—Islamic tombs built in Bukhara for Persian
Samanid dynasty

Mid-1000s—Seljuk Turkish invaders begin rule

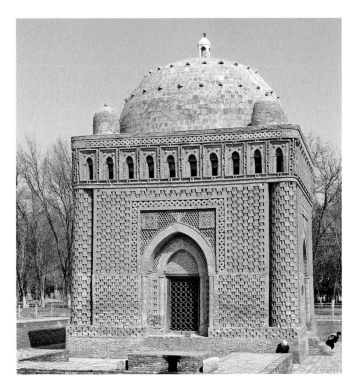

9.12. Tomb of the Samanids, Bukhara, Uzbekistan. ca. 901

kings of Castile, and Muslims working under Christian rule, known as *Mudejares,* continued Islamic artistic traditions under Christian patronage. (See *The Art Historian's Lens,* page 287.)

ISLAMIC ART AND THE PERSIAN INHERITANCE

In the central and western Islamic lands, from Spain to the western Mediterranean littoral, Islamic arts developed within the geography and culture of the Graeco-Roman tradition; in the east, however, the situation was in many respects quite different. In Mesopotamia and Iran, the Arab Muslim conquerors encountered the cultural sphere of the Sasanians, the heirs to over a thousand years of Persian civilization with an impressive tradition of art and architecture. This tradition included royal imagery of ceremonial pomp, warfare, and the royal sport of hunting (see fig. 2.21), as well as large and impressive palace buildings.

Architecture

In the eastern Islamic world, following pre-Islamic architectural practice, brick rather than stone was the most common masonry construction material. In place of cylindrical columns, massive brick piers often provided vertical structural support in buildings, and heavy vaults rather than tiled wooden-beam roofs were often chosen to cover interior spaces. Islamic architecture in Mesopotamia, Iran, and Central Asia reflects the available materials, earlier cultural traditions, and even the climate of those regions in distinctive ways. It also provides a curious blending of secular and religious buildings; just as the open arcaded courtyard helps to define both mosque and palace in the Islamic west, another form, known as the *iwan,* came to define both royal and religious structures in the east.

THE FOUR-IWAN MOSQUE One of the first large vaulted brick structures with one open side, known as an **iwan,** was constructed by the Sasanian ruler Shapur I as an audience hall for his royal palace at Ctesiphon in Mesopotamia (see fig. 2.32). The form seems originally to have symbolized royal authority in Iran, and under Islam it eventually was incorporated into a new type of prayer structure, the **four-iwan mosque,** by placing one massive brick recess in the middle of each of the sides of the rectangular courtyard (fig. **9.11**). From the twelfth century onward the four-iwan courtyard was a standard feature of both mosques and religious schools of a type known as *madrasa* throughout Iran and Islamic Central Asia. In most of Iran, as in Mesopotamia, brick was the preferred building material, and the vaults of Iranian mosques were supported by heavy brick piers.

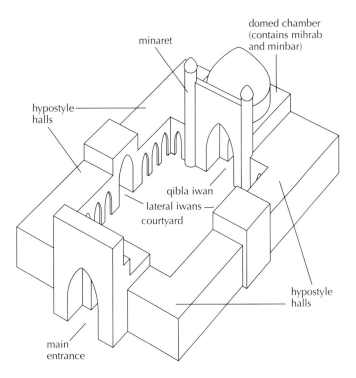

9.11. Schematic of a generic Persian four-iwan mosque

minaret

domed chamber (contains mihrab and minbar)

hypostyle halls

qibla iwan
lateral iwans
courtyard

hypostyle halls

main entrance

Spanish Islamic Art and Europe in the Middle Ages

In 711 the combined Arab and Berber forces of the Muslim commander Tariq ibn Ziyad crossed over the straits of Gibraltar and by 716 most of Spain was in Muslim hands. Under the rule of the Umayyad dynasty (751–1017), Córdoba became the capital of a prosperous, tolerant, and powerful Muslim kingdom in Spain, in which Christians and Jews played important roles in cultural life. During the eleventh and twelfth centuries, in the aftermath of the fall of the Umayyads, successive Berber invasions from North Africa, first by the Almoravids and then the Almohads, brought new Muslim dynastic patrons into Spain, who oversaw splendid new artistic production. But they also suffered a series of military defeats at the hands of the strengthening Christian powers in the north. Of the several small Islamic kingdoms that formed in the twilight of Muslim rule in Spain, one in particular, that of the Nasrids, ruling in Granada from 1230 to 1492, saw a last glorious flowering of the arts before its defeat by the Castilians and Aragonese united under Ferdinand and Isabella.

The dominant Muslim style in the arts of southern Spain affected artistic production of non-Muslims in many complex ways. From the tenth through the twelfth centuries, in the hardscrabble mountainside principalities of the Christian north, Christian builders built small churches and monasteries in the **mozarab** style, using the horseshoe arches, alternating colored voussoirs, and mosaics of colored stone they had seen in the Muslim south. At the same time, in the northern monasteries, artist monks illustrated manuscripts of the *Commentaries on the Apocalypse* of Beatus of Liebana with paintings that also reflected the dominant Muslim style. Beyond the Pyrenees, along the medieval pilgrimage roads into France, aspects of the Muslim style even influenced French Romanesque art; the twelfth-century wooden doors of Le Puy Cathedral in France bore an elaborate kufic inscription in Arabic: *mashallah*—"may God protect this place."

After the Christian Reconquest of central southern Spain gained momentum in the last part of the thirteenth century, artisans among the conquered Muslim peoples living under Christian rule, known as *Mudejares*, working under Catholic patrons, continued to produce works of art—buildings, carpets, ceramic wares, and ivories among them—in the Muslim style. The greatest monument of Mudejar art is the fourteenth-century Alcazar or royal palace of King Pedro of Castile in Seville,

the style of which is remarkably similar to that of the Alhambra (see fig 9.27), then being built in nearby Granada. Also noteworthy are the surviving Mudejar synagogues of Córdoba, Granada, and Toledo; with its Hebrew inscriptions intermingling with those in Arabic, the decoration of the Toledan synagogue of Samuel Halevy Abulafia, popularly known as El Tránsito (ca. 1360) follows the Muslim style closely. It appears to demonstrate that important elements of the Arabic-speaking Jewish population of Spain at the time felt themselves fully invested in the dominant artistic culture.

Nationalist European scholars once preferred to ignore or to deprecate this intermingling of cultures in medieval Spain, but recent scholarship together with recent exhibitions have brought about renewed interest in the Spanish Muslim impact on Europe and in the nature of the flowering of Christian and Jewish culture during the period of *convivencia* (living together) in medieval Muslim Spain. The final expulsion of Muslims and Jews from Spain by the ethnic cleansing of Ferdinand and Isabella in the early sixteenth century brought most of this productive symbiosis to an unhappy end.

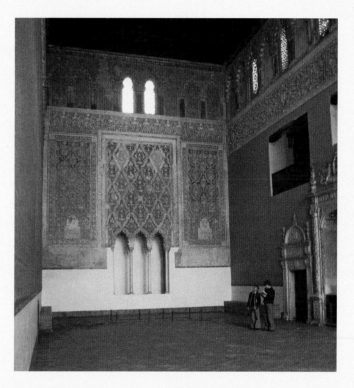

Interior, Tránsito Synagogue, ca. 1360. Toledo, Spain

TOMB OF THE SAMANIDS In the aftermath of the Arab conquest of Iran, the Persian cultural tradition gradually reasserted itself in many ways. One of the earliest surviving Islamic dynastic tombs was built in the early tenth century for the Persian Samanid dynasty in Bukhara, an eastern city beyond the Oxus River, today in Uzbekistan (fig. **9.12**). This small cubical structure is in basic concept a hemispherical dome on four massive piers, evidently derived in part from the form of a Sasanian fire temple used for Zoroastrian worship. The dome is supported on the square chamber by means of four squinches in

the corners, while the readily available and relatively humble material of brick is used to brilliant effect, with various surface textures recalling woven reeds, kufic inscriptions, and what look like engaged columns in the corners. While the Messenger had opposed all shrines and the prominent tomb structures of kings and saints, which he viewed as suggestive of polytheism or idolatry, the symbolism associated with dynastic kingship and the veneration of major religious figures in Islam meant that tombs and shrines were to figure prominently in the history of architecture throughout the Islamic world.

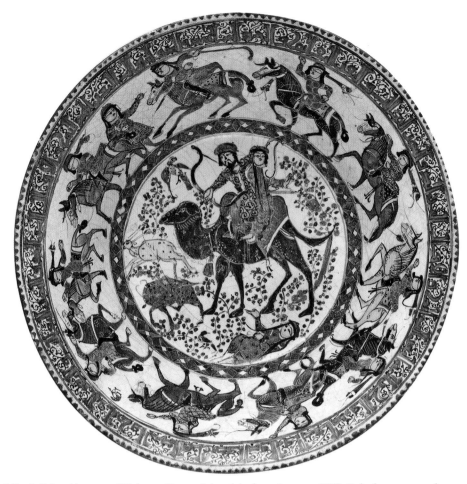

9.13. *Mina'i* dish with story of Bahram Gur and Azadeh, from Iran. ca. 1200. Polychrome overglaze enamels on white composite body. Diameter: 8½″ (22.2 cm); width: 3¹³⁄₁₆″ (9.7 cm). The Metropolitan Museum of Art, New York. Purchase, Rogers Fund and gift of the Schiff Foundation, 1957 (57.36.13)

Figural Art Forms in Iran

The Iranian part of the Islamic world had inherited a rich tradition of material culture, and the successive rulers of Iran, whether themselves Arab, Persian, Turkish, or Mongol in ancestry, fell under the seductive spell of the Persian heritage, which they combined with their Islamic beliefs and traditions. From the prosperous cities of tenth- and eleventh-century Iran there have survived beautiful ceramic wares decorated with maxims, good wishes, or prayers in beautiful calligraphy with figural and vegetal decoration, as well as some exceptional silk textiles and metal objects. The Seljuk Turkish invaders, who ruled Iran from the mid-eleventh century onward, not only built great mosques and tomb structures, but also ruled over a prosperous urban culture that among other things produced one of the richest known traditions of decorated ceramics. Using figural images of all kinds in a multitude of sophisticated techniques, including the use of a metallic pigment known as *luster* fired over the glaze and polychrome enamel decoration known as *mina'i*, these ceramic wares incorporated for middle-class patrons a very diverse repertoire of scenes from Persian romances and mythology, themes from sufism (the Islamic mystical religious tradition), and the now-familiar Islamic royal images of hunting and other courtly pleasures.

A favorite story finding its way into ceramics, metalwork, and book illustration was that of the royal hunter Bahram Gur and his skeptical girlfriend, the harpist Azadeh. A mina'i plate shows two episodes of continuous narrative, with Azadeh on the camel with her royal lover, and then pushed off the beast after making a remark belittling the hero's marksmanship (fig. **9.13**).

Also noteworthy was the practice of inlaying precious metals into brass or bronze, often incorporating human and animal images. This art form apparently began in Khurasan (the northeastern part of old Iran) in the twelfth century and gradually found its way west into upper Mesopotamia by the early thirteenth century. The full repertoire of royal themes is represented in these opulent objects, in which on occasion even the letters of the inscriptions themselves take on human forms (fig. **9.14**). Also created under the Iranian Seljuks were stucco relief sculptures incorporating the human figure. To what do we owe this burst of figural art in seeming contradiction to strict Islamic dogma? Practical rather than dogmatic, Iranians under the Seljuks apparently believed that figural images did not necessarily have to be identified with polytheism or idolatry, but could capably serve both secular and religious purposes without morally corrupting the viewer.

THE CLASSICAL AGE

In the center of the Islamic world, in what some scholars term its classical age (roughly 800–1250), the power and influence of Mesopotamia gradually waned with the decline of the Abbasid caliphate. In 969, the Fatimids, a North African Arab dynasty proclaiming descent from the Messenger's daughter Fatima, conquered Fostat, the Abbasids' major city in Egypt, and founded as their new capital the nearby city of Cairo. The Fatimids were Shi`ites—Muslims who believed that only descendants of Muhammad could legitimately lead the Islamic community. They took their name from the term *shi`at `Ali* ("the party of `Ali"), Muhammad's son-in-law, husband of Fatima and father of the Prophet's grandsons Hasan and Husein. Shi`ite Muslims themselves were divided into several major and many minor sects, all of which opposed the basic political tenets of Sunni or Orthodox Islam, where having the blood of the Messenger was not a prerequisite for holding political power.

The rise of the Fatimids in the tenth century coincided with a gradual weakening of the Abbasid power and a decline in the caliphate authority, based in Baghdad. By the eleventh century, the Seljuk Turks had moved westward out of Central Asia to gain control first in Iran and then in northern Mesopotamia and Asia Minor; around the same time, in 1099, the Norman warriors of the First Crusade captured Jerusalem. The Seljuks were Sunni Muslims; they fostered arts of all kinds and supported Sunni doctrine with the founding of many madrasa colleges for the teaching of Sunni law. In the late twelfth century, another Sunni dynasty, the Ayyubids, drove the infidel Christians out of Jerusalem, and for a brief time also oversaw important developments in the arts.

The Fatimid Artistic Impact

Under the Fatimids Egypt experienced a major artistic revival. The eleventh-century city walls of Cairo, incorporating the latest cutting-edge military technology, were constructed with stone stripped from the outer parts of the Pyramids in nearby Giza. Two great urban palaces, decorated with figural images of music, dance, the hunt, and royal ritual, were constructed within the city, and elaborate parades and ceremonial processions proclaimed the dynasty's power. Not one but two congregational mosques were constructed in Cairo under Fatimid rule, and smaller mosques served individual neighborhoods of the city, which by the twelfth century had expanded beyond its original walls.

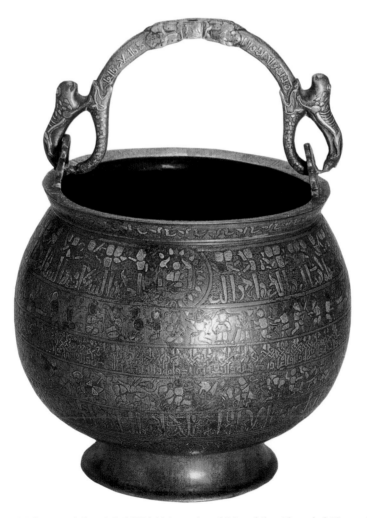

9.14. Muhammad ibn abd al-Wahid (caster) and Masud ibn Ahmad al-Naqqash (inlayer). 1163 CE. Cast bronze alloy bucket, inlaid with silver and copper, Herat. The State Hermitage Museum, St. Petersburg, Inv. no. IR 2268

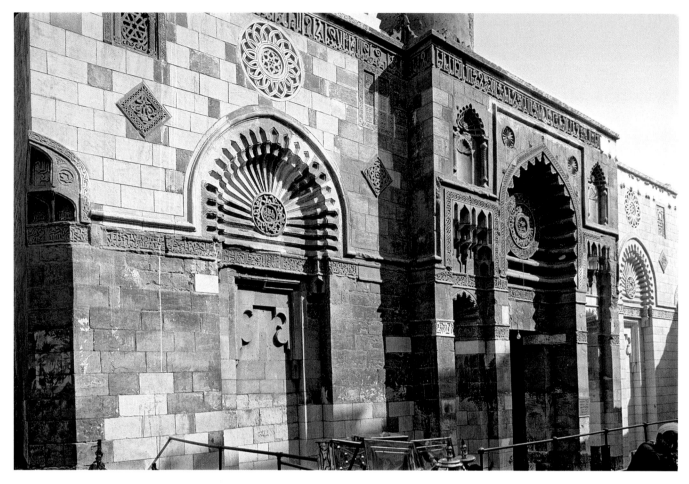

9.15. The al-Aqmar Mosque, Cairo. ca. 1026

AL-AQMAR MOSQUE Among the most beautiful of the Fatimid mosques in Cairo is the small mosque known as al-Aqmar (fig. **9.15**), built by a Fatimid noble. It was skillfully constructed on an irregular plot of land, with its off-axis facade corresponding to the original street. In addition to the carved stone, Arabic inscriptions, and ornamental niches, we see to either side of the main portal a developed form of **muqarnas**, the distinctive geometric, almost crystalline faceted decoration, composed of small nichelike forms, that eventually became an iconic form of Islamic decoration from the Atlantic to beyond the Oxus.

TEXTILES AND IVORIES Under the Fatimids, a thriving maritime commerce between Egypt and Italy left its mark in the Islamic artistic influence on twelfth-century Italian architecture in such port cities as Palermo, Salerno, Amalfi, and Pisa. In addition, preexisting traditions of weaving, much of it carried on by indigenous Coptic Christians, continued to flourish along with new textiles incorporating silk imported from Iran or China. In the twelfth century, Muslim artisans working in Palermo in Sicily, newly conquered by the Normans, created the elaborate embroidered cape of King Roger II (r. 1095–1154), with inscriptions in Arabic praising the Catholic ruler (fig. **9.16**). It was used

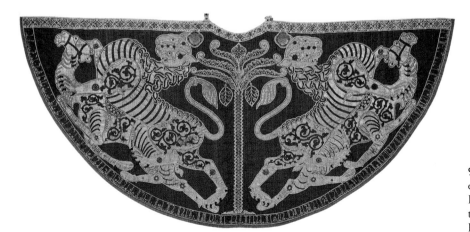

9.16. Cloak of Roger II of Sicily. Red silk cape embroidered with silk and pearls. 12th century. Diameter 11′3″ (342 cm). Made in Palermo for the coronation of Roger II in 1133–1134. Kunsthistoriches Museum, Vienna

9.17. Detail of carved ivory frame with court scenes. Egypt. 12th century. $17^3/_4 \times 14^1/_3''$ (44.9 × 36.5 cm). Staatliche Museen Preussischer Kulturbesitz, Museum für Islamische Kunst, Berlin, I.6375

for many centuries in Habsburg coronations. Along with remarkable luster-painted ceramics, textiles, rock crystal, and glassware, Fatimid artists produced carved ivory objects significant both for their beauty and for the insights they provide into Fatimid court life. One of these, an ivory frame now in Berlin (fig. **9.17**), shows a multitude of energetic figures engaged in dancing, music making, hunting, wrestling, and drinking what can only be supposed to be wine, whose prohibition in the Qur'an did not preclude its use or depiction in the private customs and art of Islamic palaces.

The Ayyubids and the Seljuk Turks of Asia Minor

It was during the Seljuk Turkish rule over central and northern Palestine, in 1099, that European warriors of the First Crusade captured Jerusalem, which remained briefly in Christian hands until its recapture in 1187 by the Ayyubid sultan Salah ad-Din, known in the West as Saladin. The period of the Crusades was to last until the fourteenth century, when all but the last vestiges of Crusader kingdoms disappeared from the eastern Mediterranean. Artistic cross-fertilization between Catholic Europe and the Muslim Middle East developed extensively during the entire period, and persisted long after the Crusaders departed. The Ayyubids, a Kurdish dynasty originating in northern Syria, reconquered greater Syria and Egypt for Sunni Islam in the twelfth century, and their brief reign, ending in the mid-thirteenth century, produced a remarkable record of accomplishment in architecture and the arts. Ayyubid military architecture, such as the citadels of Aleppo and Cairo, embodied the latest military technology, and was to inspire many a European castle constructed in the Romanesque and Gothic eras. Under the Ayyubids the arts of inlaid metalwork, ceramics, and enameled glassware also flourished.

To the east, in the twilight of its glory, the ancient Abbasid capital of Baghdad experienced by the early thirteenth century a revival in the arts of the book. Such artists as Yahya ibn al-Wasiti produced miniature paintings remarkable for their humor, their observations of everyday life, and their insights into human foibles (fig. **9.18**).

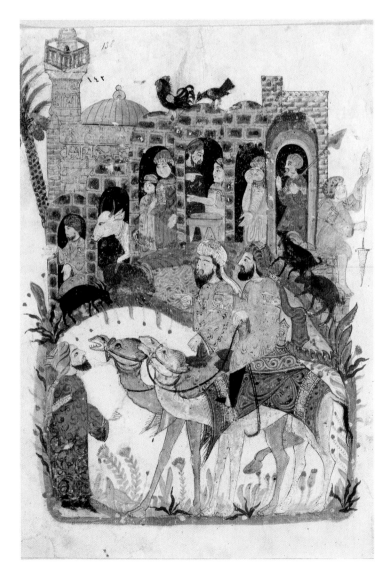

9.18. Yahya ibn Mahmud al-Wasiti. *Scene in an Arab Village,* illustration from a *Maqamat* manuscript. ca. 1237. Opaque watercolors on paper, $13^3/_4 \times 10^1/_4''$ (34.8 × 26 cm). Bibliothèque Nationale, Paris. MS. arabe 5847, folio 138 r

To the north, the Seljuk Turks had finally entered the Asia Minor heartland of the Byzantine Empire after 1071. In the following 200 years under their rule, with the full participation of the artistic talents of both Muslim and Christian communities in the prosperous urban centers of Asia Minor, art and architecture flourished under what were known as the Seljuks of Rum (Rome). Craftspeople and artists from Iran, as well as from Syria and Egypt, served the lavish patronage of the Seljuk sultans.

THE CARAVANSARAY The largest buildings constructed by the Seljuks in Asia Minor are a type of fortified wayside inn, warehouse, and stables known in Turkish as *han* and in the West as *caravansaray*. Built at regular intervals along the main caravan routes linking the cities of Asia Minor, these buildings usually consisted of an outer court and a vaulted

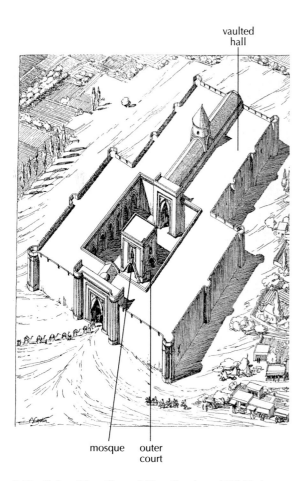

vaulted
hall

mosque outer
court

9.19. Sultan Han, Kayseri-Sivas Road, ca. 1229 Turkey. Drawing by Albert Gabriel, *Monuments Turcs d'Anatolie* (Paris, E. Boccard, 1931, p. 99)

inner hall. The outer court had stables for pack animals, a bath for travelers, a small mosque, and a kitchen. The inner hall, where goods could be stored and travelers slept, often had a tall dome on squinches, the pyramidal exterior of which could be seen along the highway from a great distance. The largest and most handsome of the Asia Minor hans, the Sultan Han built between the cities of Konya and Aksaray around 1229 by Sultan Alaeddin Keykubad, has beautifully carved doorways to the courtyard and vaulted hall, and evidently employed in its construction the services of both local and Syrian stonecarvers. A similiar Sultan Han built by the same ruler on the Kayseri-Sivas road (fig. **9.19**) and dozens of others are still today found in Turkey. They facilitated commerce throughout Asia Minor, where beautifully constructed and elaborately decorated mosques, madrasas, and palaces were built throughout the twelfth and thirteenth centuries.

LATER CLASSICAL ART AND ARCHITECTURE

By the second decade of the thirteenth century, in the Islamic lands of Central Asia, Iran, Egypt, Syria, and Asia Minor, reports began to arrive of an ominous power rising in the east. The eventual triumph of the Mongol successors of Genghis Khan brought devastation to much of the Islamic world east of the Mediterranean. Some areas, such as Asia Minor, emerged relatively unscathed. Others, such as the central Asian city of Bukhara (sacked and burned in 1220) and the Abbasid capital of Baghdad (sacked and destroyed in 1258), suffered untold losses in architectural monuments and artistic goods, as well as the even more serious destruction of infrastructure, such as irrigation canals, roads, and social services. By the end of the thirteenth century the western Mongol rulers, known as Il-Khans, had converted to Islam, and their patronage and that of their successors brought about in Iran and its surrounding areas yet another period of artistic flowering, in which artists of western Asia were exposed to new artistic inspiration from China, flowing west through the Mongol domains on what historians now call the Silk Road, a 5,000 mile network of caravan routes from Honan (present-day Luoyang) through the Islamic world to Europe.

The Mongol rule in Central Asia and Iran was short-lived, but the artistic legacy of the Mongols continued under the Timurids, who by the late fourteenth century had established their empire in the former Mongol lands and produced a brilliant court tradition, the legacy of which was eventually felt from the eastern Mediterranean to central India. Far to the west and south, after 1260, Sunni Mamluks in Syria and Egypt, inheritors of the Fatimid Shi`ite capital of Cairo, set about their own symbolic appropriation of the land, with a new architecture of tall domes and complex minarets, and an artistic economy that mixed the Turkic tastes of the ruling class with indigenous Egyptian traditions. Trade between Cairo and Italy was brisk, and Mamluk artistic production sometimes even reflected the commercial attractiveness of Mamluk artistic goods in Europe.

Mongol Patronage

In the realms of art and architecture, the Mongols built on what had come before them. Later Arab book illustration, centered in Baghdad, found its legacy by the beginning of the fourteenth century in a new focus of Mongol patronage in Tabriz, the western Mongol capital in northwest Iran. Artists in Tabriz produced painting in a new style incorporating aspects of Chinese brush-painting and the vision of Chinese landscape. In other Mongol centers, Chinese motifs and raw materials contributed to a revival of silk weaving, and preexisting traditions of inlaid metalwork and luster-painted ceramics developed in new directions. As with almost all foreigners who have conquered Iran from the time of Alexander the Great, the Mongol rulers quickly became Persianized, commissioning illustrated manuscripts of the Persian national epic, the *Shah-nameh* or "Book of Kings," and building four-iwan brick mosques and high-domed tomb structures in the Persian style. The nature of Mongol patronage in Iran can be seen in the tomb structure built by the Il-Khan Oljeytu (r. 1304–1317). The son of a Sunni father and a Christian mother, Oljeytu founded a new capital in Sultaniya, bringing artists and builders from all over his realms to embellish it. At the center of his capital stands a huge structure with a massive pointed dome covered with turquoise blue tiles, the royal mausoleum of Oljeytu (fig. **9.20**). With its painted interior

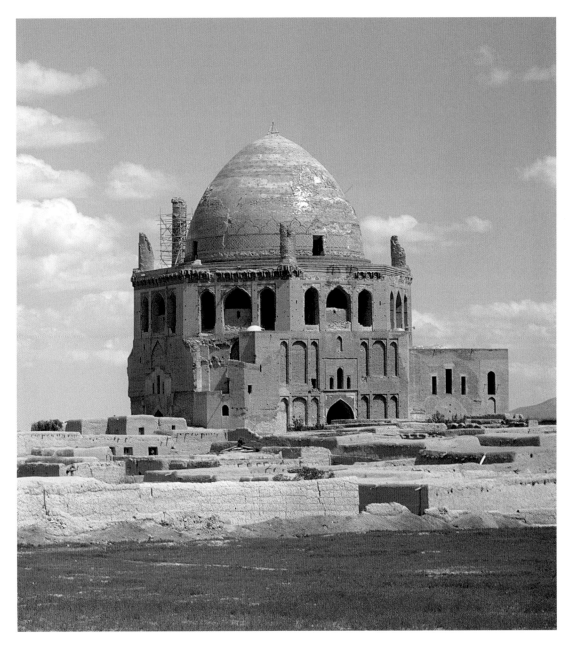

9.20. Tomb of Oljeytu, Sultaniya, Iran. ca. 1314

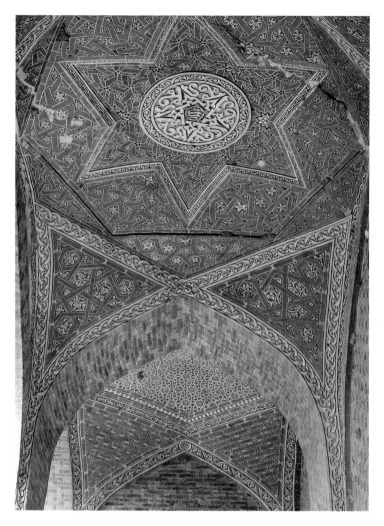

9.21. Interior, Tomb of Oljeytu, Iran.

decoration of carved and painted stucco (fig. **9.21**) and elaborate tile decoration, it has unprecedented size and scale for an Islamic shrine or tomb. This great domed building in Sultaniya represents the grandiose artistic aspirations of the Il-Khans, as well as their enlightened patronage of artistic innovation within the preexisting Persian traditions.

Timurid Patronage

After the death of the last ruler of the short-lived Il-Khan dynasty in 1337, Iran and Islamic Central Asia broke up into smaller principalities, one of which, the Jalayrid dynasty, kept the tradition of Mongol painting alive in Tabriz and Baghdad. By the late fourteenth century another Turko-Mongol power had risen beyond the Oxus, this time under the rule of the strategic genius Timur (r. ca. 1370–1405), known in the West as Tamerlane.

ARCHITECTURE AND ITS DECORATION In his capital city of Samarkand, Timur built in the 1390s a gigantic congregational mosque, the largest four-iwan mosque in the Iranian tradition, and his palace of Aq Saray in his nearby birthplace was built on an equally gargantuan scale. The artistic aspirations of the Timurid dynasty reached their climax in the fifteenth century. At Herat, which became the main capital under the rule of Timur's son Shah Rukh (r. 1405–1447), his grandson Baysunghur founded a royal library—in fact, a royal design studio—that in addition to producing beautiful books decorated with illuminations, miniature paintings, and calligraphy, served as a central source of designs for many other artistic media, drawing on the artistic legacy of the Jalayrids as well as the arts of China and Central Asia.

9.22. Madrasa of Ulugh Beg ca. 1435. Samarkand, Uzbekistan

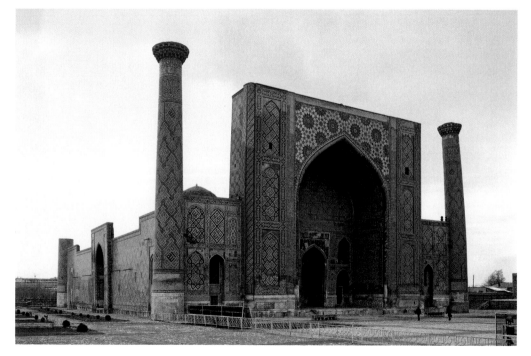

To the north in Samarkand, in present-day Uzbekistan, another of Timur's grandsons, Ulugh Beg, founded (ca. 1420) a major astronomical observatory as well as one of the most important of Timurid madrasa colleges (fig. 9.22). Ulugh Beg's college has a massive iwan before the main portal and two cylindrical minarets. Elaborate, carefully constructed mosaics of colored tiles in geometric and vegetal patterns lavishly decorate the entire facade. Ceramic building decoration in Central Asia under the Timurids and their immediate predecessors developed a rich variety and a complexity equaled but never surpassed in the subsequent history of art in greater Iran.

BOOK ILLUSTRATION It was in Herat, in the twilight of the Timurid dynasty at the end of the fifteenth century, that the long and complex history of Persian book painting saw one of its most glorious chapters. In the 1480s and 1490s, the great master Behzad and his colleagues brought about a series of refinements in Islamic painting that have become legendary. Behzad himself had not only a sensitivity to the lyrical and heroic themes of Persian poetical texts, but a keen eye for the world around him. In many of his paintings made to illustrate poetical texts, such as this illustration from a manuscript of the *Bostan* (*Poetic Garden*) of Sa'di, it is the everyday heart of Herat that we see so masterfully depicted (fig. **9.23**). In a scene outside a mosque, the high point of view allows us to look into the courtyard, while at the doorway a rich man encounters a beggar, and another man washes at a fountain. Behzad's spatial and narrative clarity, using a high point of view, overlapping in ingenious ways to give a sense of three dimensions while portraying all of his protagonists in the same scale, bring a new power to these small paintings, the small size of which does not restrict their generous pictorial space, complex settings, and large cast of characters.

Mamluk Patronage

In the central Islamic lands, only one power had successfully repulsed the Mongol invasions of the thirteenth century. When the last Ayyubid ruler of Egypt died in 1250, his wife married her husband's leading general, a Mamluk or slave soldier of Kipchak Turkish origin named Baybars, who became sultan, or ruler, in 1260. That year, at the battle of Ain Jalut (in what is now northern Israel), a Mamluk army defeated the Il-Khan's Mongol troops. As a result, Egypt and much of Syria remained free of Mongol rule under the various Mamluk dynasties, which ruled from Cairo and Damascus, from 1250 until the conquest of Cairo by the Ottoman Turks in 1517.

ARCHITECTURE It is easy to see an evolutionary progression from the art of Egypt in Fatimid and then Ayyubid times into the Mamluk reign. Mamluk patronage was at times quite lavish, and most of the artistic character of today's Cairo comes from the Mamluk period. Working within the confines of often irregularly shaped plots of urban land in the crowded Egyptian metropolis, builders under Mamluk patronage created mosques, madrasas, tombs, and a distinctive combination of public library and public water fountain. These works are characterized by a new style of elaborately decorated high domes, complex multibalconied minarets, and lavish decoration incorporating both carving and multicolored marble mosaic paneling. As Sunni Muslims living in the shadow of the Shi`ite Fatimid past, the Turkish-speaking Mamluks, often unable to speak or write Arabic, not only built mosques, but also a very large number of madrasas or institutions of Sunni higher education to serve the local populace.

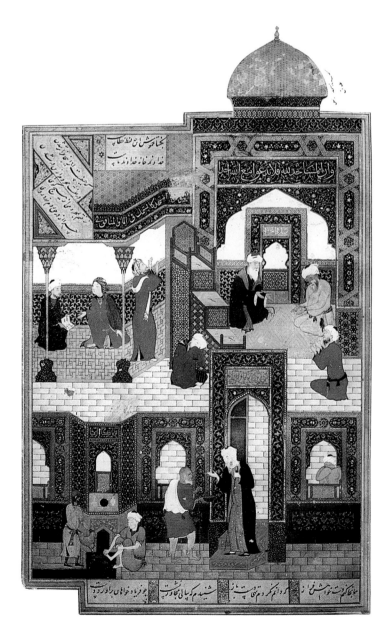

9.23. Behzad. *A Poor Man Refused Admittance to a Mosque*, from a manuscript of the *Bostan* (collection of narrative poems) of Sa`di, from Herat. 1486 CE. Opaque watercolors, ink, and gold on paper. Page dimension 12 × 8¹/₂″ (30.5 × 21.5 cm). General Egyptian Book Organization, Cairo, Adab Farsi 908. National Library of Egypt, Cairo

The largest and most impressive of these is the madrasa and tomb of Sultan Hasan (fig. **9.24**). It was constructed between 1354 and 1361 by the otherwise undistinguished Mamluk sultan Nasir ad-Din al-Hasan, into whose state coffers had flowed a torrent of riches as a result of the high mortality of the mid-century Black Death, which left many large estates without heirs. Designed as four separate colleges within one building (fig. **9.25**), each devoted to one of the four major schools of Islamic jurisprudence, the mammoth structure houses a mosque in the qibla iwan of its huge four-iwan courtyard, as well as classrooms, dormitory rooms, and, on the south side behind the qibla wall, the gigantic domed tomb of Sultan Hasan himself. Decorated with varicolored marble mosaic paneling, with spectacular carved portals, bronze doors inlaid with silver and gold, and furnishings such as a marble minbar and

muezzin platform and a walnut Qur'an lectern inlaid with ebony and ivory, the madrasa and tomb of Sultan Hasan show the artistic aspirations of the Mamluks to be equal to those of their Mongol rivals to the northeast in size, expense, and beauty. Right down to the Ottoman conquest in 1517, Mamluk patrons in Egypt and Syria continued to produce a large number of beautiful buildings, including the famous tombs that today crowd Cairo's Northern Cemetery.

ENAMELED GLASS, METALWORK, AND CARPETS

Mamluk patronage in Syria and Egypt also inherited a tradition of making enameled glass that had begun under the Ayyubids. By the early fourteenth century, Mamluk glass vessels enameled with bright colors had become world-famous. Various Mamluk nobles commissioned glass oil lamps destined to be hung in

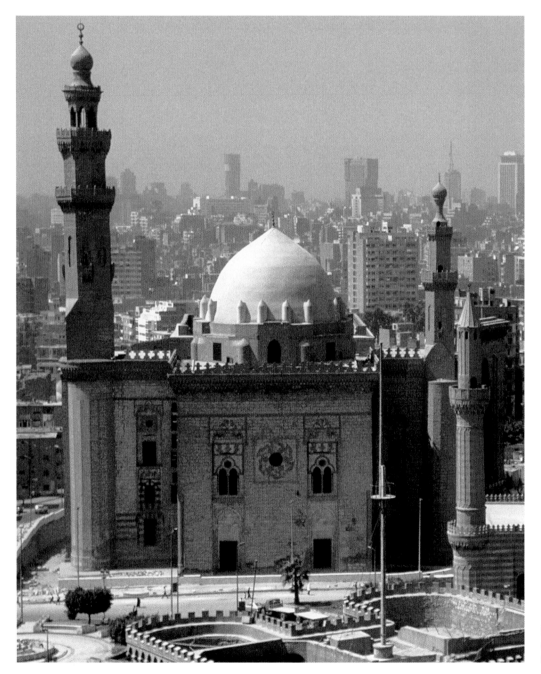

9.24. Madrasa-mosque-mausoleum complex of Sultan Hasan, Cairo. ca. 1354–1361

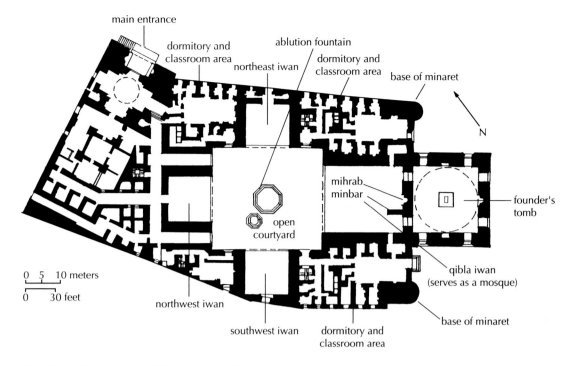

main entrance

dormitory and classroom area

northeast iwan

ablution fountain

dormitory and classroom area

base of minaret

N

mihrab
minbar

founder's
tomb

open
courtyard

0 5 10 meters
0 30 feet

qibla iwan
(serves as a mosque)

northwest iwan

southwest iwan

dormitory and
classroom area

base of minaret

9.25. Plan of the complex of Sultan Hasan, Cairo

their tombs and mosques, and artists incorporated the patrons' blazons, or coats of arms, in the decoration (fig. **9.26**). Under the Mamluks, by around 1300, the art of inlaying silver and gold into bronze and brass also reached its apogee in Islamic art. In later Mamluk times, from the fifteenth century onward, the Mamluk realms saw the production of spectacular carpets that were exported to Europe, where like the enameled glass, they were highly prized. (See *Materials and Techniques*, page 300.)

Nasrid Patronage: The Alhambra

By the mid-fourteenth century most of Muslim al-Andalus had fallen to the Christian Reconquest; Seville and Córdoba were part of the Castilian domains, and only the mountain kingdom of Granada in the south in the shadow of the Sierra Nevada remained under Muslim control, ruled by the Nasrid dynasty. On a flat hill towering over the city of Granada, the Nasrid monarchs built a palace known to them as al-Qasr al-Hamra (The Red Palace) and to history as the Alhambra. Originally conceived, as most Islamic palaces were, as a series of pavilions and smaller buildings constructed around one or more garden courtyards, the Alhambra was designed as a royal palace that incorporated metaphors for Paradise on earth. The inscriptions on its walls, some of which were written by one of the great Arab poets of the time, form a hymn of praise to the palace itself. Although what remains of the Alhambra today is only a small fragment of the original palace, the rest having been consumed by a mammoth Renaissance palace and an equally huge Franciscan monastery, the most beautiful of the Alhambra's surviving courtyards, known as the Court of the Lions, gives us a vivid picture of the elegance, beauty,

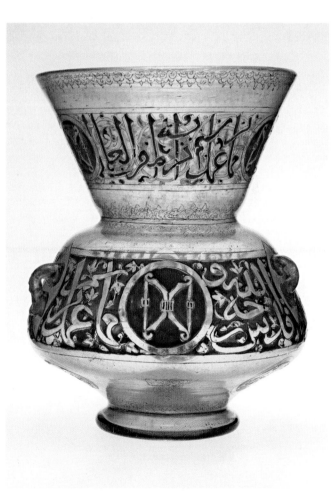

9.26. Mosque lamp with blazon, from Cairo. ca. 1285. Enameled, stained, and gilded glass. Height: 10⅓″ (26.2 cm), Width: 8¼″ (21 cm). Metropolitan Museum of Art, New York. Gift of J. Pierpont Morgan. 1919 17.190.985

The Oriental Carpet

No artistic product of the Islamic world has become better known outside its original home than the pile carpet, popularly called the oriental carpet. Carpets are heavy textiles meant to be used essentially in the form in which they leave the weaver's loom. That is, they are not cut or tailored, and they are usually woven as complete artistic works, not as goods sold by the yard. Their uses vary extensively from floor covering to architectural decoration, from cushions and bolsters to bags and sacks of all sizes and shapes, and from animal trappings to religious objects (prayer rugs that provide a clean place for Muslim prayer). They can be used as secular or religious wall decoration. Carpet weaving is a deeply embedded art in the culture of many Islamic societies. It is a part of the socialization of young women, who form the bulk of Islamic artist-weavers. It is found not only in nomadic encampments and villages, but also in urban commercial weaving establishments and, in former times, in special workshops that functioned directly under court patronage in Islamic lands.

There are several different techniques for weaving Islamic carpets, but the best-known is the *pile carpet*, in which row after horizontal row of individual knots of colored wool are tied on vertical pairs of *warp yarns*, and each row of knots is then beaten in place by a *beater*, a tool that resembles a combination of a comb and a hammer, and subsequently locked in place by the passing of one or more horizontal *weft yarns*. The ends of each knot protrude vertically on the upper or "right" side of the carpet, giving it a thick pile surface, at once highly reactive to light, conducive to rich color effects, and providing excellent insulation from cold floors or the earthen ground of a nomad's tent.

The carpet form probably arose originally among pre-Islamic nomadic peoples in Central Asia. The bulk of surviving early Islamic carpets, thought to have been woven from the thirteenth through the fifteenth centuries, show connections in both design and technique to a nomadic past. In the fifteenth century, the *carpet design revolution* led to the pro-

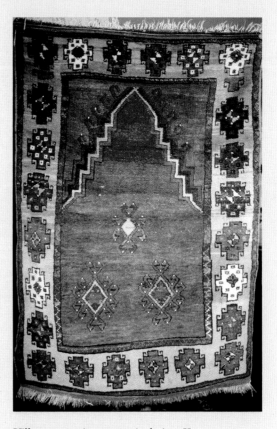

Village carpet in geometric design, Konya area, Turkey. 18th or 19th century. Private Collection. Courtesy of Gerard Paquin.

duction of Islamic carpets in designs that were created by court artists, and then translated into instructions for carpet weavers. These carpets were often used by royalty or given as gifts to royalty.

The design of a carpet, like that of picture made on an ink-jet printer, is created out of a grid of colored dots consisting of small individual knots of colored wool that when viewed together form a design. Some carpets are fairly coarse in weave, and use a long pile; such carpets tend to use bold geometric designs and brilliant colors. Other carpets, such as those produced after designs by court or commercial artists, may use a much finer weave (in extreme cases, more than 2,000 knots in a square inch) and a short pile to reproduce curvilinear ornamental designs, calligraphy, or even depictions of humans and animals (see fig. 9.32) in large carpets. The symbolism of carpets on all levels may be extremely complex, varying from totemic designs of tribal significance to complex figural designs with arcane religious or secular meanings.

Exported to Europe since the fourteenth century, Islamic pile carpets have historically formed an East–West cultural bridge. In Europe they not only decorated the palaces of the nobility and the houses of wealthy urban merchants, but were also used in churches, religious shrines, and as a part of both secular and religious ceremonies. Islamic carpets, as prized works of art and signs of status and wealth, were frequently depicted in European paintings (see figs. 14.16, 14.23, and 20.36). Carpet weaving continues to flourish in the Middle East today. The taste and demand for Islamic carpets in both East and West has actually increased in the late twentieth and early twenty-first century.

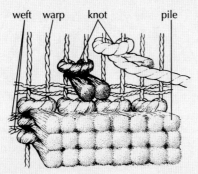

weft warp knot pile

Rows of individual knots, tied over two vertical warps, are tied, cut, and tightly hammered in place and locked in by a pair of horizontal wefts

The symmetrical knotting structure used in many Turkish and Transcaucasian carpets

and luxury of the Nasrid court (fig. **9.27**). In the center of the court, a large stone basin carried on the backs of twelve lions holds a playing fountain, the pressurized water coming from the distant mountains. From the basin, four water channels reflecting the four rivers of Paradise carry the water into four pavilions on the sides of the courtyard. In its elaborately carved stucco, once vividly polychromed, and in its delicate and elaborate muqarnas and intricate inscriptions carried on slender multiple or single columns, the richly textured and almost gravity-defying architecture of the Alhambra creates an awesome impression. The Alhambra was to influence artistic consciousness for centuries to come, finding artistic heirs in both sixteenth-century Morocco and in nineteenth-century Europe and the United States.

THE THREE LATE EMPIRES

In later Islamic times three large empires formed major centers of Islamic artistic accomplishment: the Ottoman, the Safavid, and the Mughal. At the end of the thirteenth century, in a corner of Asia Minor just a few dozens of kilometers from the Byzantine capital of Constantinople, a vassal of the declining Seljuk sultanate named Osman (r. ca. 1281–1324) established a tiny frontier principality hosting warriors eager to expand the

ART IN TIME

1258 CE—Mongols sack and destroy Baghdad

By end of 1200s—Western Mongol rulers converted to Islam

Mid-1300s—Most of Muslim al-Andalus fallen to Christian Reconquest

1354–1391—**The Alhambra, the Court of Lions**

1486—**Behzad's illustrations for the *Bostan***

realms of Islam at the expense of the Christians. From this seed grew a mighty empire, which by the mid-sixteenth century had almost turned the Mediterranean into a Turkish lake, ruling from Cairo to the outskirts of Vienna, and from Algiers to northwestern Iran. It lasted until 1922. At the beginning of the sixteenth century, five decades after the Ottomans had conquered Constantinople and made it their capital, a charismatic Shi`ite warrior from northwestern Iran, the Safavid prince Ismail (r. 1501–1524) founded another great empire. In its successive capitals of Tabriz, Qazvin, and Isfahan, the Safavid state was to bring many genres of art to new levels of accomplishment and reputation within the Islamic world. Until the

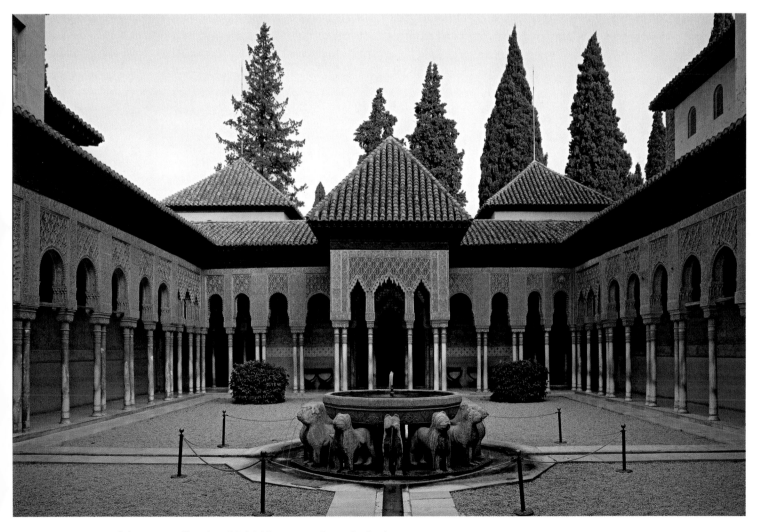

9.27. Court of the Lions, Alhambra, Mid-14th century. Granada, Spain

middle of the eighteenth century, the Safavids remained major rivals of the Ottomans, and their distinctive styles in architecture, book painting, and the applied arts of carpets and textiles, influenced their neighbors to both west and east. In 1526 a Turkish prince from Central Asia named Babur (r. 1526–1530) invaded northern India. After a series of reverses and recoveries, Babur's grandson Akbar the Great (r. 1556–1605) firmly established the Mughal dynasty in the subcontinent. Through the next century and a half, the fabled palaces and monuments of the Mughal capital cities of Delhi, Agra, and Fatehpur Sikri, visited by Muslim and European travelers alike, became a byword throughout the world for the beauty, luxury, and opulence of the Islamic arts.

The Ottomans in Europe and Asia

At first there was little to distinguish what became known as the Ottoman Empire (in Italy, Osman was known as "Ottomano") from more than a dozen other small Islamic states that filled the vacuum of the collapsing Seljuk power in Asia Minor. But by 1357 the Ottomans had crossed the Dardanelles, a narrow strait between Europe and Asia, into the Balkans, and eventually by 1453 they had claimed the elusive prize of Constantinople itself, the second Rome and the capital of eastern Christianity. In this, their capital city, popularly renamed Istanbul, and in their summer and military capital of Edirne, 120 miles farther west into Europe, the Ottomans used their enormous economic power to patronize art and architecture on an unprecedented scale.

ARCHITECTURE To their Topkapı Palace in Istanbul flocked artists from Iran, Egypt, the Balkans, and even from Western Europe, while in the sixteenth century the architect known to posterity as Sinan the Great presided over an architectural establishment that saw the erection of hundreds of bridges, hans, madrasas, palaces, baths, markets, and mosques. The great imperial mosques of the Ottomans paid homage to the traditional Arab mosque by incorporating an atriumlike arcaded courtyard into their design. However, for the Ottomans the vast interior space and daring engineering of Justinian's Hagia Sophia (see figs. 8.31 and 8.32), in combination with their own well-developed traditions, provoked an architectural response that made the Ottoman mosques, often built in climates with extensive rainfall and winter snows, vastly different from mosques of the Arab or Iranian traditions. In 1572, Sinan built for Sultan Selim II (r. 1566–1574) in Edirne a huge imperial mosque that the architect considered his masterpiece (fig. **9.28**). The courtyard with surrounding arcades and central fountain recalls the typical Arab mosque plan, but the huge lead-covered dome and the four pencil-thin triple-balconied minarets proclaim the Ottoman architecture style, while the vast interior, with its eight huge piers supporting a dome almost 197 feet high and over 108 feet in diameter, shows a unified and clearly delineated space (fig. **9.29**) at once completely different from the Arab hypostyle mosque with its fragmented space, and from the Hagia Sophia with its mysterious structural and spatial ambiguity. In Sinan's buildings, the structural components—the muscles and sinews, as it were—rather

9.28. Sinan the Architect. Cutaway of the mosque of Selim II (Selimiye), 1569–1574. Edirne, Turkey

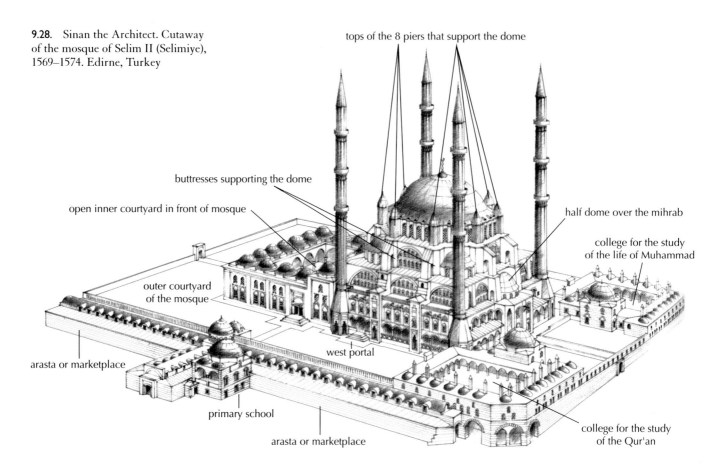

tops of the 8 piers that support the dome

buttresses supporting the dome

open inner courtyard in front of mosque

half dome over the mihrab

college for the study of the life of Muhammad

outer courtyard of the mosque

arasta or marketplace

west portal

primary school

arasta or marketplace

college for the study of the Qur'an

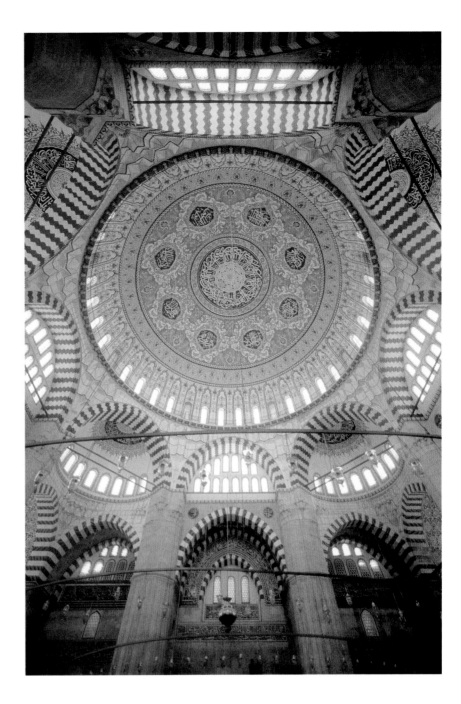

than being hidden, are a primary source of the buildings' visual appeal. The Ottomans preferred an austere exterior of bare whitish stone contrasting with the dark-gray lead sheets used for waterproofing the domes and semidomes of their structures, while the interiors frequently incorporated beautiful polychrome tiles with designs of strikingly naturalistic flowers (see *Primary Source*, page 302).

THE OTTOMAN COURT STYLE The Ottomans, like the Timurids before them, developed by 1500 a royal design studio, which they called the "house of design," that served as the central focus of royal artistic patronage. It reached its zenith under the patronage of Süleyman I, "The Magnificent" (r. 1520–1566), his son Selim II (r. 1566–1574), and grandson

Murad III (r. 1576–1595). Among the many artistic innovations to emerge from this complex of artists working in almost every conceivable medium and genre is a style of ornament called by some *saz*, taking its name from a legendary enchanted forest, and by others *hatayi*—that is, "from Cathay," or "China." Created in part by an emigré artist from Tabriz named Shah Kulu, who became head of the Ottoman royal studio by the mid-sixteenth century, the style is typified by energetic and graceful compositions of curved leaves and complex floral palmettes linked by vines that appear to overlap and penetrate each other, sometimes embellished with birds or strange antelopelike creatures. The saz or hatayi style is found in ceramic wares, manuscript illumination, carpets, silk textiles, a series of freehand drawings executed for the albums of royal collectors, and some remarkable

The Ottoman Sultan Selim II (1524–1574)

An Order from the Imperial Court

By spring of 1572 the building of the sultan's mosque in Edirne was well underway. From the royal palace, the sultan took a very close interest in the progress of affairs, an approach that seems to have bordered on micromanagement. He even dictated what inscriptions were to be placed in what locations in the building.

To the Architect in Chief:

For the inscriptions that are currently needed for my noble mosque in Edirne that I have ordered to be built, you have requested the services of the calligrapher Molla Hasan. Now this individual has been retained and dispatched for the above-mentioned business. I have ordered that, upon receipt and by fulfillment of this order, you show him the places in the noble mosque where he will prepare suitable and appropriate inscriptions, whether they be executed on tiles, or be simple painted inscriptions.

Conveyed though the Chief Tile-Maker
The 8th of Muharrem, 980 (May 21, 1572)

SOURCE: AHMED REFIK. *MIMAR SINAN.* TR. WALTER DENNY. (ISTANBUL: KANAAT KUTUPHANESI, 1931)

blue and turquoise paintings on tile, probably from the hand of Shah Kulu himself (fig. **9.30**). Ottoman ceramics and silks were exported in large quantities to Russia and Europe, where along with the much-prized carpets from Asia Minor they were quickly absorbed into European material culture.

The Safavid Period in Iran

Shortly after 1500, Ismail, a young and charismatic prince descended from a family of venerated Shi`ite clerics in northwestern Persia, declared himself the Safavid *shah* (king) of Iran. Quickly overrunning much of the formerly Timurid domains, the young ruler established his capital in the city of Tabriz in northwestern Iran, formerly the capital of two provincial Turkmen dynasties, precariously close to the eastern reaches of the Sunni Ottoman Empire. There, under Ismail (r. 1501–1523) and his successor Tahmasp (r. 1523–1576), who in 1548 moved his capital to the strategically more secure Qazvin to the east, the arts flourished.

BOOK ILLUSTRATION AND CARPETS: TABRIZ

Early in the sixteenth century, the aged painter Behzad was brought from the east to Tabriz, where his style, combined with the indigenous Turkmen painting style of pre-Safavid times, brought about a remarkable artistic synthesis. In the hands of one of the great geniuses of Islamic art, the Turkmen-born artist Sultan-Muhammad—it was not uncommon for artists in royal ateliers to incorporate honorifics like *shah* (king), *sultan* (ruler), or *aqa* (noble) into their names—the new Safavid style of miniature painting reached new heights in expressiveness as well as technique. One of the painter's most appealing creations is an illustration painted with opaque watercolors on paper in Tabriz around 1529 for a royal manuscript of a *divan,* or collection of poems, by the fourteenth-century poet Hafiz, utilizing the theme of heavenly and earthly intoxication, a favorite motif of mystical Persian poetry (fig. **9.31**). A group of elderly professors from

9.30. Tile painted in hatayi style with saz design, by Shah Kulu. ca. 1525–1550. Cobalt and turquoise underglaze painting on composite fritware body covered with white slip, 50 × 19″ (127 × 48.5 cm). Topkapı Palace Museum, Istanbul

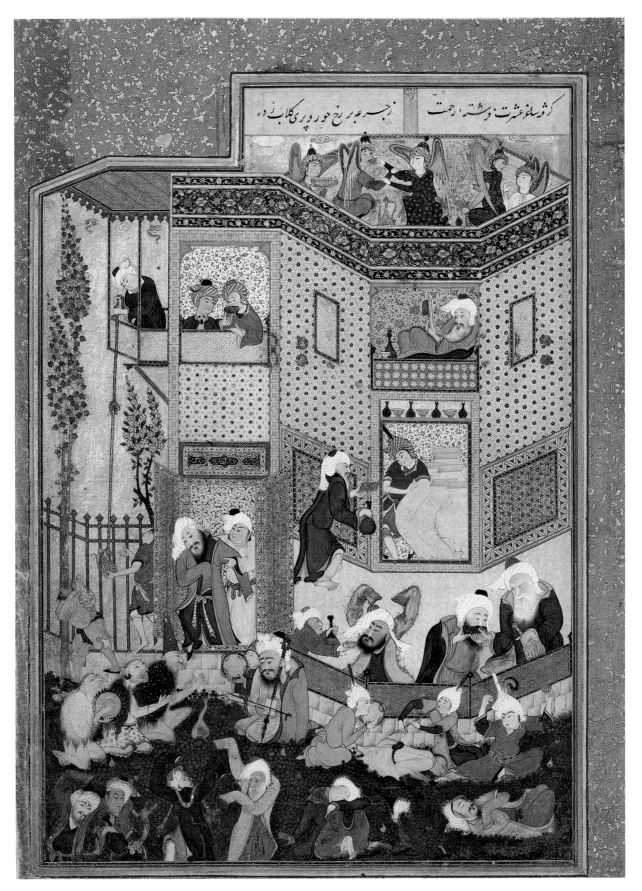

9.31. Sultan-Muhammad. *Allegory of Heavenly and Earthly Drunkenness*, from a *Divan* (collection of lyric poems) by Hafiz, from Tabriz. ca. 1529. Opaque watercolors, ink, and gold on paper, $11^3/_8 \times 8^1/_2$ ″ (28.9 × 21.6 cm). Promised Gift of Mr. and Mrs. Stuart Cary Welch Jr. Partially owned by Metropolitan Museum of Art, New York, and the Arthur Sackler Museum, Harvard University, 1988 (1988 430)

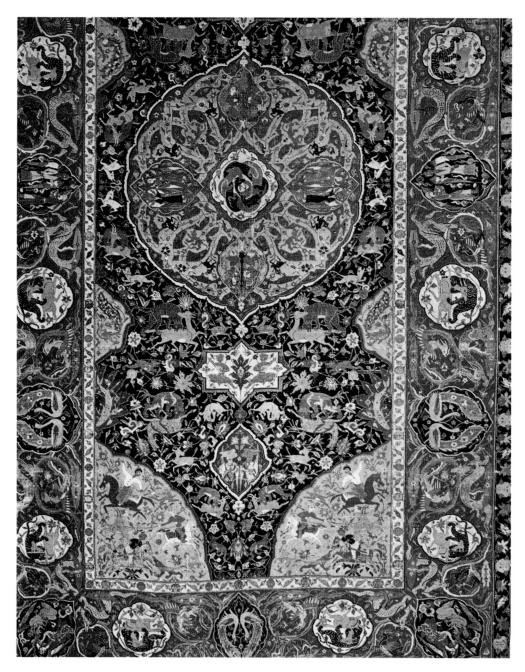

9.32. Detail of the Sanguszko figural-design carpet, from Iran. ca. 1575–1600. Wool pile knotted on cotton warp and weft; entire carpet 19′ 8″ × 10′ 8″ (6.4 × 3.3 m). Private collection

a religious college are shown in various stages of disorderly intoxication, accompanied by servants, some fawning and others apparently terrified, while a group of strangely attired and caricatured musicians provides background music. On the roof of the building angels join in the revelry, while on the balcony the pie-eyed poet himself struggles to write his poem. Using an incredibly fine brush stroke, and a thick white application of paint to create the textures of the white silk Safavid turbans, with their characteristic colored batonlike ornaments sticking out the top, Sultan Muhammad has created a work that reminds us that Islam-

ic civilization is no stranger to humor or to the enjoyment of a good time, both metaphorically and literally.

The new style in book painting, with its brilliant colors, expressive faces, and great variety of body types, often set in a landscape filled with flowers or a lavish architectural setting, was immediately transferable to other mediums. A carpet woven somewhere in the Safavid domains in the second half of the sixteenth century shows the application of the figural style of miniature painting to a symbolically complex composition of royal and heavenly motifs (fig. **9.32**). It incorporates the royal hunt, the enjoyment of

wine in a paradiselike setting, and a host of birds and animals. These forms are subject to a complex layering of symbolism, often intermingling the sacred and the profane, that reflects the strong role of Sufi mysticism in Safavid culture, as well as an age-old Persian love of wine, poetry, and beautiful possessions.

ARCHITECTURE: THE PLANNED CITY OF ISFAHAN

By the beginning of the seventeenth century, the Safavid capital had been moved once again to the old city of Isfahan in the Persian heartland. There the energetic and powerful Abbas I (r. 1588–1629) laid out to the south of the original city center of Isfahan a new city with large public spaces and broad avenues, with palaces for the nobility and a quarter for Armenian Christian merchants. The splendor and prosperity of Isfahan drew commerce and curious travelers from all over the world, and the luxury goods sold in its bazaars, from silks and ceramics to metalware and carpets, together with the beauty of its gardens and the richness of its inhabitants, led to a famous Persian adage: "Isfahan is half the World." At one end of a huge open square known as the **maidan**, itself oriented with the North Star, Shah Abbas built his Royal Mosque (fig. **9.33**). Because the qibla lies to the southwest, facing Mecca, the mosque has to be at an entirely different orientation than the maidan. An ingenious 45-degree turn beyond the main portal deftly accomplishes a directional accommodation, leading into the huge open courtyard of the mosque, with its enormous domed chamber behind the qibla iwan, all visible surfaces completely covered in brilliantly colored tiles.

The shops that line the sides of the maidan all contributed rents to the waqf or endowment of the mosque, and in the middle of the west side of the maidan, Shah Abbas built a palace from the balcony of which he could watch processions and

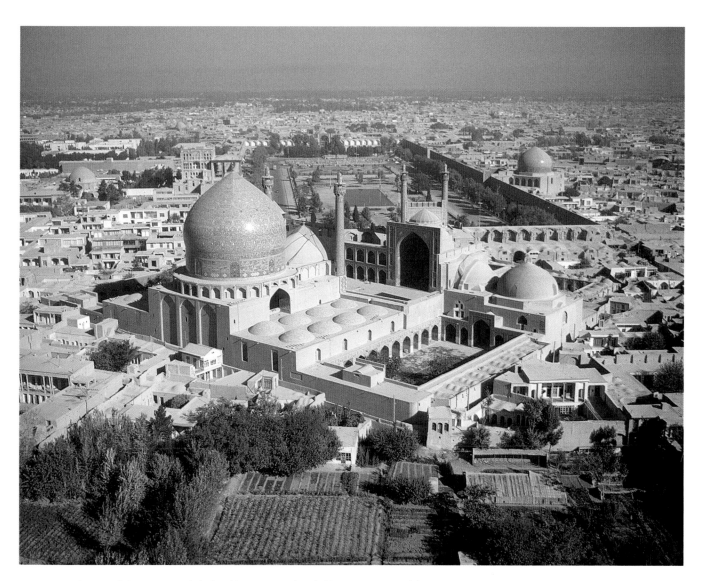

9.33. Aerial view of the mosque of Shah Abbas I (Masjid-i Shah), 1611–1616. Isfahan

sporting events in the square itself. The rest of the planned city of Isfahan consisted in large part of spacious gardens surrounding the pavilionlike palaces of the Safavid nobility.

The Mughal Period in India

In 1526 Babur, who claimed descent from the Mongol Timur (hence the name "Mughal"), defeated a combined army of Hindu princedoms in northern India to establish the Mughal dynasty in the subcontinent. Although India had an Islamic presence in Delhi since around 1200, the Mughal empire was to bring a new flowering of Islamic art and architecture to the subcontinent. Centered in the capital cities of Agra, Delhi, and Fatehpur-Sikri, the Mughal style built on an artistic combination of Central Asian, Safavid Persian, and indigenous Hindu art and culture. Under Babur's grandson Akbar the Great (r. 1556–1605), himself an unusually capable and charismatic ruler, the Mughal style in the arts took on its distinctive form. Akbar himself was a remarkably tolerant ruler, fascinated by Hinduism, interested in Persian poetry and art, and a patron of one of the major Indian Sufi orders. Under his patronage a royal studio of Persian and native painters blended their traditions to form a new style of miniature painting. In addition, Central Asian, Persian, and local builders and craftspeople blended their architectural styles and techniques together to create a new Mughal style in architecture, and the three Mughal capital cities were the scene of building and the production of works of art on a mammoth scale.

In a sense, the Mughal art of India revels in extremes—the largest and the smallest of Islamic miniature paintings, the largest but also the most finely woven small Islamic carpets, the most spectacular of all Islamic tomb structures, and the most extravagant Islamic jewelry and fanciful hardstone carving, are all to be found in India under the Mughals.

BOOK ILLUSTRATION A miniature painting in opaque watercolors on paper of a *darbar*, or ceremonial audience, of the Mughal emperor Jahangir (r. 1605–1627), probably completed around 1620 by the court artists Manohar and Abul Hasan, shows the characteristics of the Mughal style (fig. **9.34**). The Mughals liked realistic pictures of current events; each of the faces in the crowd is a true portrait, and almost every individual can be identified by comparison with individual portraits made around the same time. Along with this specificity, extended to the visiting black-clad European monk and even to the smiling elephant, is a love of opulent detail, while space is created in the time-honored Islamic fashion by the use of a high point of view and an overlapping technique.

DECORATIVE ARTS A different side of Mughal art is seen in a wine cup fashioned from translucent white jade (fig. **9.35**) for the emperor Shah Jahan (r. 1628–1657). The delicately petaled blossom that forms the bowl of the cup gently tapers to the handle in the form of a bearded mountain goat from Kashmir. Despite the hardness of the stone, which had to be shaped by grinding for hundreds of hours, millimeter by millimeter, the finished product has the freshness of a flower itself. The same attention to botanical realism can be seen in floral decoration in many Mughal mediums, from textiles and carpets to carved and inlaid marble.

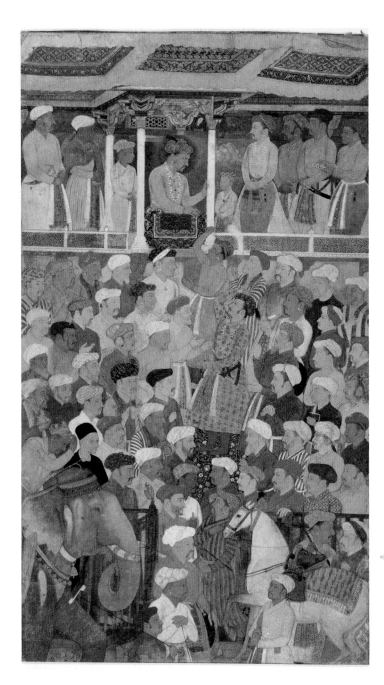

9.34. Manohar and Abul Hasan. *Ceremonial Audience of Jahangir,* from a *Jahangir-nama* manuscript, northern India. ca. 1620. Opaque watercolors and ink on paper, 13³/₄ × 7⁷/₈″ (35 × 20 cm). Museum of Fine Arts, Boston. Frances Bartlett Donation of 1912 and Picture Fund. Photograph © 2006 Museum of Fine Arts, Boston, 14654

9.35. Wine cup of Shah Jahan, from northern India. Mid-17th century. White jade, $2\frac{1}{4} \times 6\frac{3}{4}''$ (5.7 × 17.14 cm). Victoria and Albert Museum, London

ART IN TIME

1453 CE—Ottomans claim Constantinople as their capital

1501—Prince Ismail founds Safavid empire in Iran

1556–1605—Akbar the Great rules Mughal India

1616—Death of English playwright William Shakespeare

1650—Completion of Taj Mahal in Agra, India

ARCHITECTURE: TAJ MAHAL The most famous of all Mughal works is doubtless the Taj Mahal, a royal tomb in Agra completed around 1650 by Shah Jahan in memory of his deceased wife Mumtaz Mahal (fig. **9.36**). The building has the ground plan of a Timurid garden kiosk or palace from Central Asia, while the central dome recalls that of the Royal Mosque of Isfahan (see *Primary Source*, page 308). The snowy white marble is lavishly inlaid with colored semi-precious stones in the form of flowers, vines, and beautiful cursive inscriptions. Set at one end of an elaborate quadripartite formal garden with four axial pools in the Persian style, the Taj Mahal is far more than a royal tomb or a dynastic monument. The inscriptions evoke the metaphor of the gardens of Paradise that are promised to devout believers in the Qur'an, and the domed building is a self-conscious evocation of the throne of God, re-created in an earthly version of divine Paradise.

9.36. The Taj Mahal, Agra, India. ca. 1650

CONTINUITY AND CHANGE IN ISLAMIC ART

In the eighteenth and nineteenth centuries, the great traditions of Islamic art continued through tumultuous periods of change. Economic decline led to a diminution in the royal patronage that produced some of the most spectacular works of earlier periods, but stylistic traditions in every major area of the Islamic world continued to live on, despite political and economic dislocation, European colonialism, and the increase of factory-made goods in everyday life. Art of all kinds in a huge variety of mediums flourishes throughout the Islamic

world in many countries today, largely ignored even by historians who are specialists in Islamic art because they are trained to look at the works of earlier periods. Slowly, through encounters with new mediums and genres, with the pervasive American-European tradition of the later twentieth century, and through reencounters with their own historical past, Muslim artists are creating new traditions that seek to express what almost every artistic tradition has always embodied in almost every time—new creativity in the context of a rich and meaningful past.

Abd Al-Hamid Lahori (d. 1654)

From *Padshah Nama (Book of the Emperor)*

Abd al-Hamid Lahori was the official court historian to Shah Jahan, who built the Taj Mahal as a monument to the memory of his beloved wife Mumtaz Mahal. The Padshah Nama *was written in three volumes, each corresponding to a decade in Shah Jahan's reign. Before he could finish the third volume Lahori was taken ill, and the work was completed by his younger colleague Muhammad Waris in 1657. This excerpt is from a much longer discussion of the building of the monument, together with an elaborate description of the tomb itself, the outbuildings, and the surrounding gardens.*

At the beginning of the fifth year of the exalted accession (January, 1632), the excavation was started for the laying of the foundation of this sublime edifice, which is situated overlooking the Jumna river flowing adjacent to the north. And when the spade-wielders with robust arms and hands strong as steel, had with unceasing effort excavated down to the water-table, the ingenious masons and architects of astonishing achievements most firmly built its foundation with stone and mortar up to the level of the ground.

And on top of this foundation there was raised a kind of platform of brick and mortar in one solid block, measuring 374 cubits long by 140 wide and 16 high, to serve as the plinth of this exalted mausoleum—which evokes a vision of the heavenly gardens of Rizwan and epitomizes, as it were, the holy abodes of Paradise.

And from all parts of the empire, there were assembled great numbers of skilled stonecutters, lapidaries, and inlayers, each an expert in his art, who commenced work along with other craftsmen. . . . In the middle of this platform plinth—which ranks [in magnificence] with the heavenly Throne of God—there was constructed another solid and level platform. In the center of the second platform, the building of this heaven-lofty and Paradise-like mausoleum was constructed on the plan of a Baghdadi octagon, 70 cubits in diameter, on a base plinth one cubit in height.

Situated in the exact center of the building, the domed hall over the sepulcher of that recipient of divine grace has been finished with white marble within and without. From the floor to the curvature, the hall under the dome is octagonal in shape, with a diameter of 22 cubits. The curvature is ornamented with *muqarnas* motifs, while from the cornice to the inner summit of the dome, which is at a height of 32 yards from the floor of the building, there are arranged marble slabs cut in a geometric molded pattern. . . .

SOURCE: W. E. BEGLEY AND Z. A. DESAI, *TAJ MAHAL: THE ILLUMINED TOMB.* TR. BY W. E. BEGLEY AND Z. A. DESAI (CAMBRIDGE MA: AGA KAHN PROGRAM FOR ISLAMIC ARCHITECTURE, 1989)

SUMMARY

ISLAMIC ART

As Islam spread, the clashing and combining of this new religion with old cultures led to a vibrant tradition of Islamic art. Due to its vast geographical and chronological scope, Islamic art cannot be defined simply, but it does have certain unifying themes. These include the development of artistic expression independent of the human figure, which leads Islamic artists to use sophisticated vocabularies of vegetable, floral, and geometric designs. Another theme is the equality of genres; there is no hierarchy that separates "fine arts" from "decorative arts." Thus, ceramic making, metalware making, weaving, and carving are all equivalent in rank, and they are equal in rank with work in other mediums as well.

THE FORMATION OF ISLAMIC ART

Islamic art began as a series of appropriations of Graeco-Roman, Byzantine Christian, and Sasanian forms. The new religion of Islam required distinctive buildings, such as places for community prayers, that led to a rich variety of architecture emblematic of the faith itself. The Dome of the Rock in Jerusalem is one important early example. Other examples of Islamic architecture include hypostyle mosques and secular buildings, such as palaces and bathhouses.

THE DEVELOPMENT OF ISLAMIC STYLE

The Abbasid dynasty was centered in Mesopotamia. Its rulers, who supplanted the Umayyad dynasty, built new structures at Baghdad, Samarra, and elsewhere. Among these new structures were large mosques, including the Great Mosque of Kairouan. Farther to the west—in an independent state founded by an Umayyad survivor—Córdoba, Spain, became a brilliant center of Islamic culture and home to another great mosque.

ISLAMIC ART AND THE PERSIAN INHERITANCE

In eastern Islamic lands, Arab Muslim conquerors encountered the Sasanians, heirs to the cultural traditions of Persian civilization. Combining these traditions with their own Islamic beliefs and traditions led to the construction of large and impressive palace buildings, whose vaulted brick structures were different from the stone structures in central and western Islamic lands. A prosperous urban culture also arose that produced one of the richest known traditions of decorated ceramics.

THE CLASSICAL AGE

As Mesopotamia's power waned as the center of the Islamic world, the Fatimids rose in importance, founding a new capital at Cairo. Under their rule, Egypt saw a major artistic revival. New city walls, mosques, and palaces were built; earlier traditions of weaving flourished; and artists produced

carved ivory objects. The period of the Crusades—a time of artistic cross-fertilization between Catholic Europe and the Muslim Middle East—saw the achievements of both Ayyubid and Seljuk architecture and art.

LATER CLASSICAL ART AND ARCHITECTURE

By the end of the 1200s, the western Mongol rulers—who had devastated much of the Islamic world east of the Mediterranean—had converted to Islam. They and their successors brought about in Iran another period of artistic flowering. This legacy continued under the Timurids, whose patronage led to masterworks of architecture and book illustration. Elsewhere, in the Islamic lands of Syria and Egypt, Mamluk patronage led to elaborate architectural structures and highly prized glassmaking, metalwork, and carpet making. By the mid-1300s, the mountain kingdom of Granada on the Iberian peninsula was the only part of the former Muslim al-Andalus to remain under Muslim control. Here, the Nasrid monarchs constructed a famed "Red Palace," known to history as the Alhambra.

THE THREE LATE EMPIRES AND CONTINUITY AND CHANGE IN ISLAMIC ART

In later times, three large Islamic empires formed major artistic centers. The mighty empire of the Ottomans, which eventually conquered Constantinople, built elaborate mosques and the Topkapı Palace. The Safavids, major rivals of the Ottomans, developed distinctive artistic styles in book illustration, carpet making, and architecture. And in the Indian subcontinent, the Mughals built their own opulent palaces and monuments, including the Taj Mahal. Large-scale royal patronage declined in the eighteenth and nineteenth centuries, but stylistic traditions continued in every area, and today Muslims continue to produce new artistic traditions.

Early Medieval Art

THE TERM EARLY MEDIEVAL IS SOMETHING OF A CATCHALL PHRASE USED to describe the art of a number of cultures and a variety of regions in Western Europe after the Fall of Rome (476 CE) until the eleventh century (see map 10.1). Significant in Rome's demise was the power asserted by migrating Germanic peoples (including Franks, Visigoths, Ostrogoths, and

Saxons), who moved into and through Europe and eventually established permanent settlements both north of the Alps and in Italy, Spain, and southern France. These were clearly tumultuous times, as invaders clashed and eventually mixed with local inhabitants, including the Celts, the descendents of the Iron Age peoples of Europe. (*Celt* is a confusing term, since it is also used to define tribal groups who occupied Britain and Ireland between the fifth and twelfth centuries.) As the invaders established permanent settlements, they adopted many customs traditional to the areas they inhabited. Overlaid on this mix of customs were Roman traditions, including those of Christianity, which in many cases had been adopted by indigenous local tribes when they were conquered by Rome.

The allure of Christianity—for both its spiritual message and for the structure it imposed on a fragmented society in times of turmoil—once again proved momentous. Conversion from pagan worship, however, was now less an individual decision (as it had been in the Early Christian period) than a social one. Often, when a tribal leader decided to convert to Christianity, his subjects converted with him, virtually en masse, as occurred in Reims on Christmas Day in 496, when 3,000 Franks were baptized along with Clovis, their king.

The Church emerged as a force vitally important for European unification; even so, loyalty to family and clan continued to govern social and political alliances. Strong chiefs assumed leadership and established tribal allegiances and methods of exchange, both economic and political, that would eventually result in the development throughout Europe of a system of political organization known as *feudalism*. These social and political alignments eventually led to a succession of ruling dynasties governed by strong leaders who were able to increase the areas under their dominion. These dynasties (principally the Carolingian and Ottonian) were ambitious to reestablish a centralized authority, absent in Europe after the fall of Rome. The attempt to provide a stable political structure was based, if not in the reality of the Roman Empire, then at least in the ideals embodied in its legacy.

The art that resulted from this cultural interchange is a vibrant and vital mix. Artistic methods, materials, and traditions, brought with migration, were combined with those customs that predominated in the regions where tribes settled. Much of this art is marked by elaborate patterns of interlocking and interwoven designs that decorate sumptuous objects of personal adornment, reflecting their owners' social position. Eventually the Church assumed increasing importance in commissioning works of art, and there was a shift of emphasis in the types of objects produced. The Church built and decorated many houses of worship and established a large number of

Detail of figure 10.16, *Lindau Gospels*

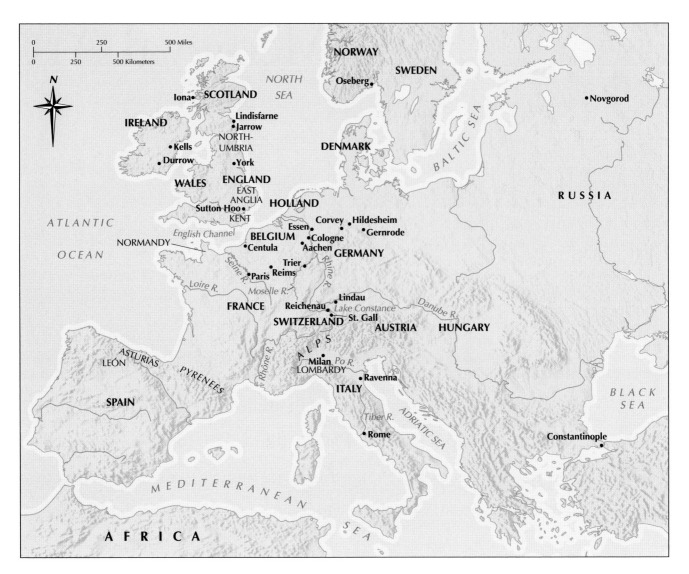

Map 10.1. Europe in the Early Middle Ages

monastic communities. Within the monasteries, scriptoria made elaborately decorated books, which were sent off with missionaries as aids in their efforts to convert and educate.

Carolingian and Ottonian artists expressed the imperial ambitions of their leaders by building churches and designing architectural complexes that consciously emulated Rome. Roman-derived Early Christian basilicas served as models for a large number of buildings north of the Alps. Court-related artists also produced copies of ancient books. And three-dimensional sculpture, an art form virtually abandoned after the fall of Rome, once again attracted the attention of artists and their patrons. Thus, out of an amalgam of diverse and conflicting forces, and as new social and cultural entities developed, an art emerged that is as varied as it is exciting.

ANGLO-SAXON AND VIKING ART

The widespread migrations of peoples transformed Europe. In 376, the Huns, who had advanced beyond the Black Sea from Central Asia, became a serious threat to Europe. They pushed the Germanic Visigoths westward into the Roman Empire

from the Danube. Then in 451, under Attila (d. 453), they invaded Gaul, present-day France and Germany, and its resident Celts. Also in the fifth century, the Angles and Saxons from today's Denmark and northern Germany invaded the British Isles, which had been colonized for centuries by Celts. Many of these Germanic tribes developed into virtual kingdoms: the Visigoths in Spain, the Burgundians and Franks in Gaul, the Ostrogoths and Lombards in Italy. The Vikings controlled Scandinavia and ventured afar, a result of their might as sailors.

The Germanic peoples brought with them art forms that were portable: weaving, metalwork, jewelry, and woodcarvings. Artistic production in these mediums required training and skill of execution, and metalwork in particular had intrinsic value, since it was often made of gold or silver and inlaid with precious stones. Metalworkers had high social status, a measure of respect for their labor and for the value of the objects they produced. (See *Materials and Techniques*, facing page.) In some Germanic folk legends metalworkers have abilities so remarkable that they are described as magical. Numerous small-scale objects reflect the vitality of artistic forms

Metalwork

Metal was a precious commodity in the Middle Ages. Even in the ancient world patterns of interchange and colonization can be related to exploration for desirable metals for example, the Greek settlements in Italy and Roman settlements in Spain were a result of a desire for metals. Popular metals employed in the early Middle Ages included gold, silver, copper, iron, and bronze. The many ways that metals could be worked was undoubtedly one of their most compelling features. They could be flattened, drawn thin, or made into an openwork **filigree** design. And they could be cast, engraved, punched, stamped, and decorated with colored stones, glass, or enamels.

The large gold buckle from the Sutton Hoo ship burial (see fig. 10.1) contains nearly a pound of gold, although it is only one among many gold pieces found in the burial site. That so much early medieval metalwork from gravesites is gold reflects the value attached to the metal. In addition, gold is not harmed by contact with either earth or water (whereas silver and other metals are subject to progressive destruction when exposed to the elements). Although gold had been obtained in Europe through mining since Roman times, the most common method of acquiring it was by collecting nuggets or small grains from rivers and streams (called *placer* or *alluvial* gold). The Rhine, Tiber, Po, Rhone, and Garonne rivers, along which the Germanic tribes settled, were major sources of this type of gold, which medieval writers refer to as "sand" gold.

Sutton Hoo's gold buckle is decorated with **granulation**, beads of gold bonded to the surface, as well as **inlaid niello**, the dark material that sets off the intricate interlace designs composed of lines and dots. Niello is a sulfur alloy of silver, copper, or lead that, when heated, fuses with the metal that surrounds it, in this case the gold, and produces a nearly black substance. The shiny dark niello serves to emphasize the brilliance of the gold and to accentuate the details of the intricate patterns.

A medieval treatise written by the monk Theophilus in Germany in the early twelfth century explains the way inlaid niello was polished. First the artist smooths the niello with a soft stone dampened with saliva; then, using a piece of limewood, the artist rubs it with a powder of ground soft stone and saliva. After that, as Theophilus explains:

> For a very long time, lightly rub the niello with this piece of wood and the powder, continually adding spittle so that it remains moist, until it becomes bright all over. Then take some wax from the hollow of your ear, and, when you have wiped the niello dry with a fine linen cloth, you smear this all over it and rub lightly with a goatskin or deerskin until it becomes completely bright.

—THEOPHILUS, *DE DIVERSIS ARTIBUS*. TR. C. R. DODWELL
AS *THEOPHILUS: THE VARIOUS ARTS*. LONDON: NELSON, 1961, P. 92.

The Sutton Hoo purse lid (fig. 10.3) and hinged clasps (fig. 10.2) are also notable for their **cloisonné** decoration. Cloisonné is an ancient technique, used as early as the second millennium BCE in the eastern Mediterranean. Individual metal strips or *cloisons* (French for "partitions") are attached on edge to a baseplate as little walls to form cells that enclose glass or gems. For the Sutton Hoo jewelry red garnets are used extensively. In fact, the Sutton Hoo jewelry includes more than 4,000 individual garnets. Colored glass, often arranged in checkered patterns, is also used in these pieces; on the main field of the hinged clasps, *cloisons* enclose colored glass to form a step pattern, which enhances the overall decorative effect.

Many of the decorative devices and materials employed in Anglo-Saxon metalwork were later used by Irish metalworkers. A spectacular example is the *Tara Brooch*, an accidental find made by a child playing by the seashore in County Meath, Ireland, in 1850. The brooch is a kind of stickpin used to join two pieces of a garment together. An incredible amount of decoration—including spirals, bird, animal and human heads, and interlace patterns—is compressed on a piece of jewelry of just over three and a half inches in diameter. Panels of gold filigree, consisting of fine soldered wire, are combined on the back of the brooch with silver plaques with inlaid spiral designs in copper. A braided wire attachment was possibly a safety chain.

Tara Brooch, from Bettystown, County Meath, Ireland. 8th century. Gilt, bronze, glass, and enamel. Diameter 3⅝″ (8.7 cm). National Museum of Ireland, Dublin

10.1. Golden buckle, from the Sutton Hoo ship burial. First half of 7th century. Gold. Length: 5¼ (13.4 cm). The British Museum, London. Courtesy of the Trustees

produced by these migrating peoples, demonstrating an aesthetic that is quite different from the tradition that derives from Greece and Rome, yet equally rich in myth and imagery.

The Animal Style

The artistic tradition of the Germanic peoples, referred to by some scholars as the **animal style** because of its heavy use of stylized animal-like forms, merged with the intricate ornamental metalwork of the Celts, producing a unique combination of abstract and organic shapes, of formal discipline and imaginative freedom.

SHIP BURIAL, SUTTON HOO, ENGLAND An Anglo-Saxon ship burial in England follows the age-old tradition of burying important people with their personal effects. This custom may reflect a concern for the afterlife, or it may simply be a way to honor the dead. The double ship burial at Sutton Hoo (*hoo* is Anglo-Saxon for "headland" or "promontory") is of a seventh-century Anglian king (generally thought to be King Raedwald, who died around 625). Military gear, silver and enamelware, official royal regalia, gold coins, and objects of personal adornment are all part of the entombment. Scholars have long noted that the Anglo-Saxon poem *Beowulf,* so concerned with displays of royal responsibility and obligation, includes a description of a ship fitted out for a funeral that is reminiscent of the Sutton Hoo burial. The funeral is that of Beowulf's father, King Scyld:

> They stretched their beloved lord in his boat,
> laid out by the mast, amidships,
> the great ring-giver. Far-fetched treasures
> were piled upon him, and precious gear.
> I never heard before of a ship so well furbished
> with battle tackle, bladed weapons
> and coats of mail. The massed treasure
> was loaded on top of him: it would travel far
> on out into the ocean's sway.
> —Translated by Seamus Heaney, *Beowulf. A New Verse Translation*.
> New York: Farrar, Straus & Giroux, 2000

Although *Beowulf* describes events that predate the Sutton Hoo find by at least a century, the poem was probably not composed until a century or more after that burial. So, while *Beowulf* should not be taken as a documentary account, it does suggest a royal context within which to appreciate the Sutton Hoo site.

Intricate animal-style design covers a large gold buckle from Sutton Hoo (fig. **10.1**). Two interlaced biting snakes decorate the stud to which the tongue is attached. That stud is in turn affixed to a plaque with intertwined serpents and eagle heads covering virtually every available space. It has been traditional for scholars to refer to the need to decorate all surfaces as an expression of *horror vacui*, a fear of empty space. But this

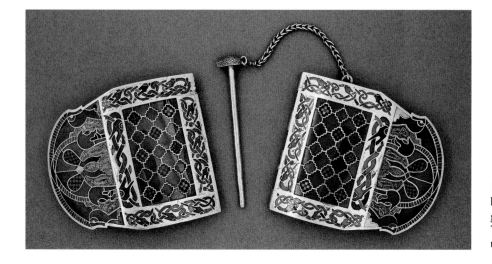

10.2. Hinged clasps, from Sutton Hoo ship burial. First half of 7th century. Gold with garnets and enamels. Length: 5" (12.7 cm). The British Museum, London. Courtesy of the Trustees

designation imposes our contemporary values on a culture alien to them. Unlike the Greeks and Romans, who used spatial illusionism to animate their art, Germanic and Celtic artists used intricate patterns to enliven the surface of their precious objects. Although the designs seem confusing and claustrophobic to us, there is a consistent and intentional tightness in the way the patterns hold together.

A pair of hinged clasps (fig. 10.2) from the burial also contains intertwined serpents, here functioning as framing devices for a diagonally oriented checkerboard field of garnets and glass set in gold. At the end of each clasp is a curved plaque on which crouch boars back to back, admittedly difficult to decipher. So tightly integrated into the design are these animals that it is difficult to decide if the plaque curves to allow for the representation of the boars or if the animals' backs hunch in response to the shape of the clasp.

A gold, enamel, and garnet purse cover (fig. 10.3) was also found at Sutton Hoo. Its original ivory or bone background does not survive and has been replaced. Each of four pairs of symmetrical motifs has its own distinctive character, an indication that they were assembled from different sources. One, the standing man between facing animals in the lower row, has a very long history indeed. We first saw him in Mesopotamian art more than 3,200 years earlier (see fig. 2.10). The upper design, at the center, is of more recent origin. It consists of fighting animals whose tails, legs, and jaws are elongated into bands that form a complex interweaving pattern. The fourth

design, on the top left and right, uses interlacing bands as an ornamental device. The combination of these bands with the animal style, as shown here, seems to have been invented not long before our purse cover was made.

The Sutton Hoo objects are significant for the way they illustrate the transmission of motifs and techniques through the migration of various peoples. They show evidence of cultural interchange with Germanic peoples, combined with evidence of Scandinavian roots, but there are other noteworthy connections as well. King Raedwald was reputed to have made offerings to Christ, as well as to his ancestral pagan gods. A number of the objects discovered at Sutton Hoo make specific reference to Christianity, including silver bowls decorated with a cross, undoubtedly the result of trade with the Mediterranean. There is also a set of spoons inscribed with the names of Saul and Paul, perhaps a reference to Christian conversion (Saul changed his name to Paul on his conversion). Is it too much to wonder, as some scholars have done, if the crosses inscribed in the glass checkerboards on the Sutton Hoo clasps (see fig. 10.2) are a conscious reference to the new religion? These clasps, although executed in the patterns of Anglo-Saxon style, take the form of fasteners very like those seen in Roman gear. In fact, Roman and Byzantine articles accompany other objects of local manufacture that copy imperial forms in the Sutton Hoo graves. This has been cited as evidence that the chieftain buried at Sutton Hoo consciously presented himself as a Roman ruler.

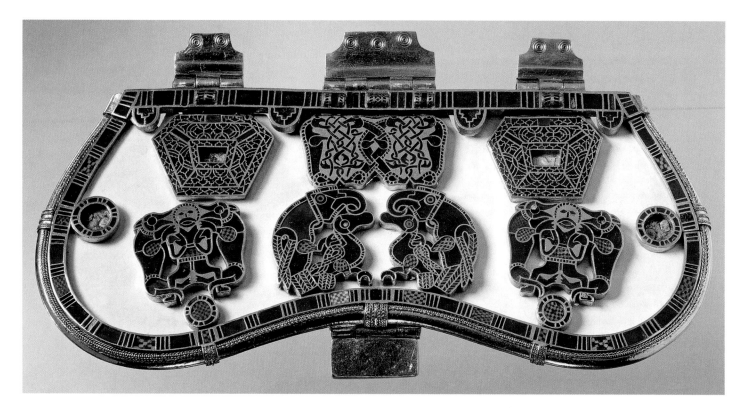

10.3. Purse cover, from the Sutton Hoo ship burial. First half of 7th century. Gold with garnets and enamels. Length: 8″ (20.3 cm). The British Museum, London. Courtesy of the Trustees

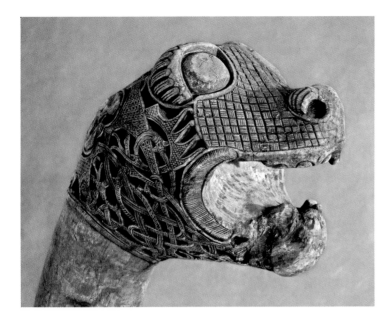

10.4. *Animal Head,* from the Oseberg ship burial. ca. 834 CE. Wood, height approx. 5″ (12.7 cm). © Museum of Cultural History, University of Oslo, Norway

The chief medium of the animal style was clearly metalwork, in a variety of materials and techniques. Such articles, small, durable, and often of exquisitely refined craftsmanship, were eagerly sought after, which accounts for the rapid diffusion of the animal-style repertoire of forms. These forms spread not only geographically but also from one material to another, migrating from metal into wood, stone, and even paint. They were used to convey a variety of messages, some clearly pagan and others Christian.

SHIP BURIAL, OSEBERG, NORWAY A splendid animal head of the early ninth century (fig. **10.4**) displays all the characteristics of the animal style. It is the decorated end of a wood post recovered from a buried Viking ship at Oseberg, in southern Norway. The practice of burying important people in ships seems to have begun in Scandinavia, where the animal style flourished longer than it did anywhere else, long beyond the Germanic-Nordic migrations in the region. The term Viking is a misleading one, since it derives from the Old Norse *Vinkingr,* which means sea pirate or raider; thus, these people were really only "Vikings" when they went "*a viking*" out of their own coastal waters to England or Russia, for instance.

The Oseberg ship was not a raiding vessel, but rather a pleasure craft, used for sailing in calm waters. Two women, placed on beds within a burial chamber, were interred within the ship, which also included oars, a ramp, an elaborately carved cart, sleds, and the skeletons of at least ten horses. Grave robbers stole whatever jewelry and metalwork, which is presumed to have been significant, that accompanied the deceased in the buried vessel.

Recent scientific studies using dendrochronology (the analysis of the growth rings of trees or wooden objects) date the Oseberg ship burial to 834. One of the women buried at Oseberg is often identified as Queen Asa, wife of Gudröd the Magnificent (ca. 780–820), because it is assumed that only a royal personage would have the resources to commission objects of such richness, but recent scholarship questions the royal nature of the burial.

Five wood posts decorated with snarling monsters looking like mythical sea dragons were found in the buried ship. Their actual function is not known, although suggestions include the possibility that they were carried in processions or used for cult functions or some ritual purposes. The basic shape of the head in figure 10.4 is surprisingly realistic, as are such details as the teeth, gums, and nostrils. Interlacing and geometric patterns cover the head, with deep undercutting and rounded forms accentuating these surface designs. Although the origins of the patterns employed here are found within Germanic and Anglo-Saxon motifs, they have been forcefully adapted to fit the animal head's dynamic curving forms.

HIBERNO-SAXON ART

During the early Middle Ages, the Irish (called Hibernians after the Roman name for Ireland, *Hibernia*) were the spiritual and cultural leaders of Western Europe. They had never been part of the Roman Empire, thus the missionaries who carried Christianity to them from England in the fifth century found a Celtic society that was barbarian by Roman standards. But the Irish readily accepted Christianity, which brought them into contact with Mediterranean civilization. However, they adapted what they had received in ways that reflected their unique circumstances.

Because the institutional framework of the Roman Church was essentially urban, it did not suit the rural Irish way of life. Irish Christians preferred to follow the example of the desert saints of Egypt and the Near East, who had sought spiritual perfection in the solitude of the wilderness, where groups of them founded the earliest monasteries. Thus, Irish monasteries were established in isolated, secluded areas, even on islands off the mainland, and such places required complete self-sufficiency. By the fifth century, monasticism had spread north into Italy, across the Continent and throughout western Britain and Ireland.

Manuscripts

Irish monasteries soon became centers of learning and the arts, with much energy spent copying literary and religious texts. They also sent monks abroad to preach to nonbelievers and to found monasteries in northern Britain and Europe, from present-day France to Austria. Each monastery's scriptorium became an artistic center for developing its style. Pictures illustrating biblical events held little interest for the Irish monks, but they devoted great effort to decorative embellishment. The finest of these manuscripts belong to the *Hiberno-Saxon style*— a style that combines Christian with Celtic and Germanic elements and that flourished in the monasteries of Ireland as well

as those founded by Irish monks in Saxon England. These Irish monks helped speed the conversion to Christianity in Europe north of the Alps. Throughout Europe they made the monastery a cultural center and thus influenced medieval civilization for several hundred years.

In order to spread the message concerning Christ, the kingdom of God, and salvation—called the *Gospel*—the Irish monasteries had to produce by hand copies of the Bible and other Christian books in large numbers. Every manuscript copy was looked upon as a sacred object containing the Word of God, and its beauty needed to reflect the importance of its contents. Irish monks must have been familiar with Early Christian illuminated manuscripts, but here, too, they developed an independent tradition instead of simply copying the older manuscripts. The earliest Hiberno-Saxon illuminators retained only the symbols of the four evangelists from the imagery in Early Christian manuscripts, perhaps because these symbols could be readily translated into their ornamental style. The four symbols—the man or angel (St. Matthew), the lion (St. Mark), the ox (St. Luke), and the eagle (St. John)—derive from the Old Testament Book of Ezekiel (1:5–14) and the Apocalypse of St. John the Evangelist (4:6–8) and were assigned to the four evangelists by St. Jerome and other early commentators.

The illustration of the symbol of St. Matthew in the *Book of Durrow* (fig. **10.5**) shows how ornamental pattern can animate a figure even while accentuating its surface decoration. The body of the figure, composed of framed sections of checkerboard pattern, recalls the ornamental quality of the Sutton Hoo clasps (see fig. 10.2). The addition of a head, which confronts us directly, and feet, turned to the side, transform the decorative motifs into a human figure. Active, elaborate patterns, previously seen in metalwork, are here employed to demonstrate that St. Matthew's message is precious. Irish scribes and artists were revered for their abilities and achievements. A medieval account relates how, after his death, an Irish scribe's talented hands were preserved as relics capable of performing miracles.

THE LINDISFARNE GOSPELS Thanks to a later **colophon** (a note at the end of a manuscript), we know a great deal about the origin of the *Lindisfarne Gospels,* produced in Northumbria, England, including the names of the translator (Aldred) and the scribe (Bishop Eadfrith), who presumably painted the illuminations as well. (See *Primary Source*, page 318.) Given the high regard in which Irish scribes and artists were held, it is not surprising that a bishop is credited with writing and decorating this manuscript. In Irish monasteries monks were divided into three categories: juniors (pupils and novice monks), working brothers (engaged in manual labor), and seniors (the most experienced monks), who were responsible for copying sacred books.

The Lindisfarne Cross page (fig. **10.6**) is a creation of breathtaking complexity. Working with the precision of a jeweler, the miniaturist poured into the geometric frame animal interlace so dense and yet so full of movement that the fighting beasts on the Sutton Hoo purse cover (see fig. 10.3) seem simple

ART IN TIME

400s CE—Angles and Saxons invade British Isles

451—Attila the Hun invades Europe

476—The Fall of Rome

ca. 570—Birth of the Prophet Muhammad in Mecca

First half of 600s—Double ship burial at Sutton Hoo, England

in comparison. In order to achieve this effect, the artist had to work within a severe discipline as though he were following specific rules. The smallest motifs and the largest patterns were worked out in advance of painting. Ruler and compass were used to mark the page with a network of grid lines and with points, both drawn and pricked. In applying paint, the artist followed his drawing exactly. No mark is allowed to interfere

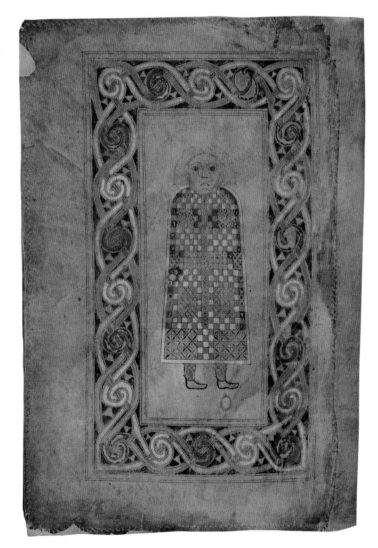

10.5. *Symbol of Saint Matthew,* from the *Book of Durrow.* ca. 680 CE. Tempera on vellum, $9\frac{5}{8} \times 6\frac{1}{8}''$ (24.7 × 15.7 cm). Trinity College, Dublin

The Lindisfarne Gospels

Colophon

Colophons are notes written at the end of some manuscripts recording who wrote them, when, for whom, etc. The colophon at the end of the Lindisfarne Gospels (ca. 700 CE) was written some 250 years after the text, but most scholars believe that its information is accurate. It names the scribe, the binder, the maker of the metal ornaments on the binding, and the author of the English translation of the Latin text, but no painter. The painting seems to have been done by Eadfrith, the scribe.

Eadfrith, Bishop of the Lindisfarne Church, originally wrote this book, for God and for Saint Cuthbert and . . . for all the saints whose relics are in the Island. And Ethelwald, Bishop of the Lindisfarne islanders, impressed it on the outside and covered it—as he well knew how to do. And Billfrith, the anchorite, forged the ornaments which are on it on the outside and adorned it with gold and with gems and also with gilded-over silver—pure metal. And Aldred, unworthy and most miserable priest, glossed it in English between the lines with the help of God and Saint Cuthbert. . . .

SOURCE: COTTON MS NERO, D. IV. THE BRITISH LIBRARY

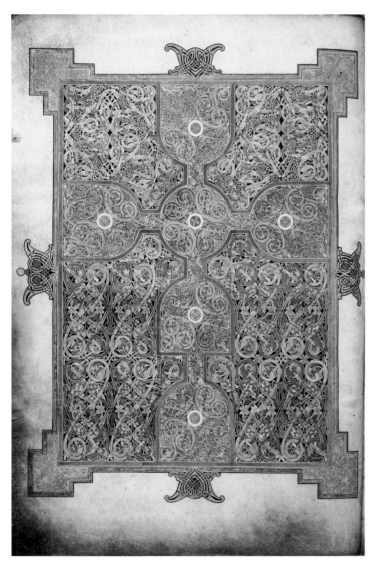

10.6. Cross page, from the *Lindisfarne Gospels*. ca. 700 CE. Tempera on vellum, 13$\frac{1}{2}$ × 9$\frac{1}{4}$″ (34.3 × 23.5 cm). The British Library, London

with either the rigid balance of individual features or the overall design. The scholar Françoise Henry has suggested that artists conceived of their work as "a sort of sacred riddle" composed of abstract forms to be sorted out and deciphered. Organic and geometric shapes had to be kept separate. Within the animal compartments, every line had to turn out to be part of an animal's body. Other rules concerned symmetry (notice how the illustration can be bisected horizontally, vertically, and on the diagonal), mirror-image effects, and repetitions of shapes and colors. Only by intense observation can we enter into the spirit of this mazelike world. It is as if these biting and clawing monsters are subdued by the power of the Cross, converted to Christian purpose just as were the Celtic tribes themselves.

Several factors came together to foster the development of the Hiberno-Saxon style: the isolation of the Irish, the sophistication of their scriptoria in the secluded monastic environments, and the zealous desire to spread the word of Christianity. In time and with more contact with the Continent—Rome, in particular—Hiberno-Saxon art reflected new influences. The illustration of Matthew in the *Lindisfarne Gospels* (fig. **10.7**) is striking by comparison with the Matthew from the *Book of Durrow* (see fig. 10.5), made only a generation or two earlier. In the *Lindisfarne Gospels*, Matthew studies his text intently, and the artist suggests a sense of space by turning the figure and the bench on an angle to indicate depth, whereas in the *Book of Durrow*, the saint stares out frontally at the reader with his hands at his sides. There are no other figures in the *Book of Durrow* image, whereas the tied-back curtain in the Lindisfarne manuscript reveals an unidentified figure, whom some scholars identify as Moses holding the Old Testament and some as Christ holding the New. Also, whereas Matthew in the *Book of Durrow* wears a costume of flat patterns, the Lindisfarne Matthew wears clothes marked by folds; a dark undergarment is distinguished from a lighter toga, suggesting a pliant material that responds to the body beneath it.

How do we explain this change? We know that in the seventh and eighth centuries the Irish had increased contact with Rome and came to adopt Roman liturgical practices. For example, the abbot of the monastery of Jarrow, near Lindisfarne, is reported to have returned from Rome at the end of the seventh

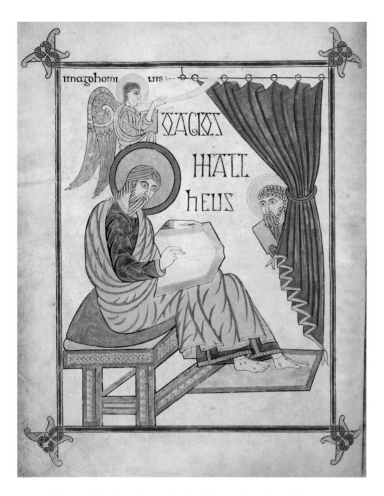

10.7. *St. Matthew,* from the *Lindisfarne Gospels.* ca. 700 CE. Tempera on vellum, 13½ × 9¼″ (34.3 × 23.5 cm). British Library, London (MS Cotton Nero D. 4)

unlike the Ezra artist, he decorated the bench with multiple patterns and suggested depth in the drapery by juxtaposing near complementary colors, playing off the reddish folds against the greenish cloth. Eadfrith employed the same rigid outline, geometric decoration, and flat planes of color that he used for the manuscript's nonfigural pages, such as the Cross page (see fig. 10.6).

THE BOOK OF KELLS The Hiberno-Saxon manuscript style reached its climax a hundred years after the *Lindisfarne Gospels* in the *Book of Kells,* the most elaborate codex of Celtic art. It was probably made, or at least begun, at the end of the eighth or the beginning of the ninth century at the monastery on the island of Iona, off the western coast of Scotland, which had been founded by Irish monks in the sixth century. The book's name derives from the Irish monastery of Kells, where the manuscript was housed from the late ninth century until the seventeenth century. Its many pages reflect a wide array of influences from the Mediterranean to the English Channel.

century with a host of manuscripts. Artists at Jarrow probably used the illuminations in these manuscripts as models. The illustration of the prophet Ezra restoring the Bible from the *Codex Amiatinus* (fig. **10.8**) is undoubtedly an adaptation of Roman illuminations available at the monastery. The artist depicts the book cupboard, table, bench, and footstool by using oblique angles, which convey a sense of perspective, as if the objects recede into depth. So, too, do the shading in the drapery and the shadow of the inkwell on the floor promote a sense of depth. The artist also used color blending (evident on Ezra's garments and on his hands, face, and feet) to model form. Notice, in particular, how Ezra's cushion seems to have been depressed by the weight of his body, lending further substance to the prophet's figure.

Some scholars have suggested that Eadfrith, the illustrator of the Lindisfarne Matthew (see fig. 10.7), referred to the same Roman manuscript that inspired the Ezra artist, who produced a more faithful interpretation of it. Indeed, identical poses and parallel features such as the bench are too conspicuous to be ignored. However, Eadfrith was eager, or perhaps felt required, to maintain some Hiberno-Saxon traditional devices;

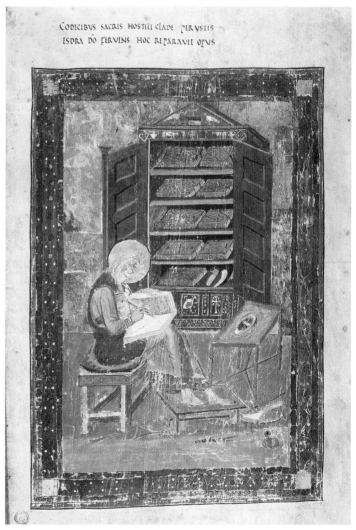

10.8. *Ezra Restoring the Bible,* from the *Codex Amiatinus.* Early 8th century. Tempera on vellum, 20 × 13½″ (50.5 × 34.3 cm). Biblioteca Medicea Laurenziana, Florence

The Chi Rho Iota monogram page illustrates Christ's initials, *XPI,* in Greek (fig. **10.9**). Alongside them appear the words *Christi autem generatio,* or "now this is how the birth of Christ came about," heralding the beginning of the Book of Matthew (1:18), in which the birth of Jesus is celebrated. The Chi Rho Iota page has much the same swirling design as the Cross page from the *Lindisfarne Gospels,* and a viewer can also see parallels to contemporary jewelry, such as the *Tara Brooch* (see *Materials and Techniques,* page 313).

On the Chi Rho Iota page, the rigid geometry of the Lindisfarne Cross page and the *Tara Brooch* has been relaxed somewhat, and for the first time images of humans are incorporated into the design. The very top of the X-shaped Chi sprouts a recognizable face, while along its shaft are three angels with wings. And in a touch of enchanting fantasy, the tendril-like P-shaped Rho ends in a human head that has been hypothesized to be a representation of Christ. More surprising still is the introduction of the natural world. Nearly hidden in the ornamentation, as if playing a game of hide-and-seek, are cats and mice, butterflies, even otters catching fish. No doubt they performed a symbolic function for medieval readers, even if the meaning is not apparent to us. The richness and intricacy of the illustration compels concentration, establishing a direct connection between the viewer and the image in much the same way as does the fixed, direct gaze of the holy figure in an Early Byzantine icon. In each work, icon and manuscript illumination, the power of the image is so strong that the viewer virtually enters into its realm, forgetting the world outside its frame.

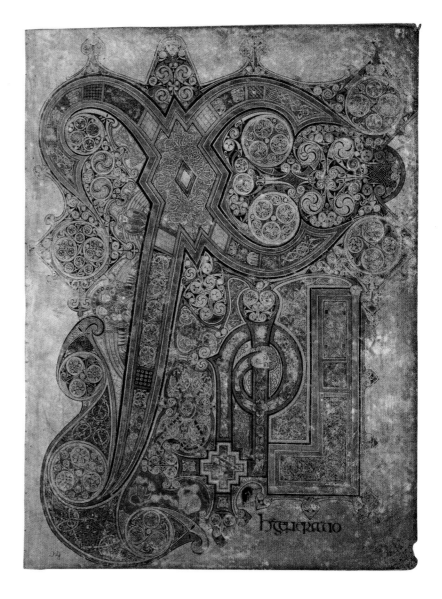

10.9. Chi Rho Iota page, from *Book of Matthew* (1:18), from the *Book of Kells.* ca. 800 CE. Ink and pigments on vellum, 13 × 9½″ (33 × 24.1 cm). Trinity College Library, Dublin

CAROLINGIAN ART

During the late eighth century a new empire developed out of the collection of tribes and kingdoms that dominated northern continental Europe. This empire, which united most of Europe from the North Sea to Spain and as far south as Lombardy in northern Italy, was founded by Charlemagne, who ruled as king of the Franks from 768. Pope Leo III bestowed on him the title of emperor of Rome in St. Peter's basilica on Christmas Day in the year 800, pronouncing him successor to Constantine, the first Christian emperor. Although Charlemagne was able to resist the pope's attempts to assert his authority over the newly created Catholic empire, there was now an interdependence of spiritual and political authority, of church and state, that would define the history of Western Europe for many centuries.

The emperors were crowned in Rome, but they did not live there. Charlemagne built his capital at the center of his power, in Aachen (Aix-la-Chapelle), located in what is now Germany and close to France, Belgium, and the Netherlands. The period dominated by Charlemagne and his successors, roughly from 768 to 877, is labeled Carolingian (derived from Charlemagne's Latin name, *Carolus Magnus*, meaning "Charles the Great"). Among Charlemagne's goals were to better the administration of his realm and the teaching of Christian truths. He summoned the best minds to his court, including Alcuin of York, the most learned scholar of the day, to restore ancient Roman learning and to establish a system of schools at every cathedral and monastery. The emperor took an active hand in this renewal, which went well beyond a mere interest in the old books to include political objectives. He modeled his rule after the Roman Empire under Constantine and Justinian—rather than their pagan predecessors—and proclaimed a *renovatio imperii romani*, a "renewal of imperial Rome," his efforts aided by the pope who had crowned him Holy Roman Emperor. The artists working for Charlemagne and other Carolingian rulers consciously sought to emulate Rome; by combining their admiration for antiquity with native northern European features, they produced original works of art of the highest quality.

Sculpture

A bronze *Equestrian Statue of a Carolingian Ruler* (fig. **10.10**), once thought to be Charlemagne himself but now generally assigned to his grandson Charles the Bald, conveys the political objectives of the Carolingian dynasty. The ruler, wearing imperial robes, sits as triumphantly on his steed as if he were on a throne. In his hand is an orb signifying his domination of the world. The statue is probably modeled on a now lost antique Roman equestrian statue of Theodoric, which Charlemagne had brought from Ravenna for the courtyard of his imperial palace. There are other possible sources, including a bronze equestrian statue of Marcus Aurelius (see fig. 7.21), mistakenly thought to represent Constantine, the first Christian Emperor, and thus also an appropriate model for the ambitious Charlemagne.

The Carolingian statue is not a slavish copy of its antique model. Compared to the statue of Marcus Aurelius, it is simpler, less cluttered with detail, in order to communicate the significant message that the Carolingian rulers were heirs to the Roman imperial throne. What is most striking is the difference in size: Marcus Aurelius stands more than 11 feet high, while the Carolingian figure does not reach 10 inches. Yet the diminutive statue expresses as much majesty and dignity as the more monumental example. Given the metalwork tradition of the Franks, the miniaturization is not only appropriate, but might in itself suggest value. Unfortunately, we do not know the audience for the work or how it was used, though its smallness could relate to portability.

10.10. *Equestrian Statue of a Carolingian Ruler* (Charles the Bald?). 9th century. Bronze. Height 9½″ (24.4 cm). Musée du Louvre, Paris

10.11. *Christ Enthroned,* from the *Godescalc Gospels (Lectionary).* 781–783 CE. Tempera on vellum, $12^5/_8 \times 8^1/_4''$ (32.4 × 21.2 cm). Bibliothèque Nationale, Paris

10.12. *St. Matthew,* from the *Gospel Book of Charlemagne (Coronation Gospels).* ca. 800–810 CE. Ink and colors on vellum, 13 × 10″ (33 × 25.4 cm). Kunsthistorisches Museum, Vienna

Illuminated Books

Charlemagne's interest in promoting learning and culture required the production of large numbers of books by his scriptoria. He established an "academy" at his court and encouraged the collecting and copying of many works of ancient Roman literature. In fact, the oldest surviving texts of many Classical Latin authors are found in Carolingian manuscripts that were long considered of Roman origin. This very page is printed in letters the shapes of which derive from the script in Carolingian manuscripts. The fact that these letters are known today as Roman rather than Carolingian is the result of this confusion.

THE GODESCALC GOSPELS One of the earliest manuscripts created in Charlemagne's imperial scriptoria is the *Godescalc Gospels,* named after the monk who signed his

name to the book; it is generally thought to reflect manuscripts and objects that Charlemagne brought back with him from Rome. The manuscript's most compelling image is of a monumental enthroned Christ (fig. **10.11**), whose large staring eyes communicate directly with the viewer. His purple garments denote imperial stature. (Purple was the color of royalty in the Roman world.) The concentration on imperial imagery reflects Charlemagne's personal ambitions, which were to be realized about 20 years later, when he received the title of Holy Roman Emperor in 800. Hard lines and swirling patterns around the knees suggest where drapery falls over the body, and white lines on the hands, neck, and face indicate highlights. It is as if the artist is attempting to emulate Roman modeling, but does so in a northern manner, by using linear patterns.

Christ sits within an enclosed garden, a motif reminiscent of Roman painting (see fig. 7.55), but transformed here into flat decorative elements, almost like the designs on a carpet. The outlined letters of Christ's name and the frame, composed of interlace patterns, are reminiscent of metalwork (see figs. 10.1–10.3) and Hiberno-Saxon illuminations (see figs. 10.5–10.7). A great painter has fused the heritage of Rome with the decorative devices traditionally employed by northern European artists.

This manuscript includes a dedicatory poem commemorating the baptism of Charlemagne's sons by Pope Hadrian in Rome in 781. By bringing his sons to Rome to be baptized Charlemagne acknowledged the authority of the pope in ecclesiastical matters; in turn, the pope placed himself and all of Western Christianity under the protection of the emperor.

THE GOSPEL BOOK OF CHARLEMAGNE The *Gospel Book of Charlemagne* (also known as the *Coronation Gospels*, because later German emperors swore on this book during their coronations) is said to have been found in Charlemagne's tomb and is thought to have been produced at his court. Looking at the page with St. Matthew (fig. **10.12**), we can hardly believe that such a work could have been executed in northern Europe and less than a generation after the *Godescalc Gospels*. Were it not for the large golden halo, the evangelist might almost be mistaken for the portrait of a Classical author, such as the one of Menander (fig. **10.13**) painted at Pompeii almost eight centuries earlier. Since the artist shows himself so fully conversant with the Roman tradition of painting and since his manner of painting is so clearly Mediterranean, some scholars claim that he must have come from Byzantium or Italy. This is evident throughout the work, from the painterly modeling of the forms to the acanthus ornament on the wide frame, which makes the picture seem like a window.

THE GOSPEL BOOK OF ARCHBISHOP EBBO OF REIMS Less reflective of Classical models, but equally reliant on them, is a miniature painted some three decades later for the *Gospel Book of Archbishop Ebbo of Reims* (fig. **10.14**). The subject is once again St. Matthew, and the pose is similar to that in the *Gospel Book of Charlemagne*, but this picture is filled with a vibrant energy that sets everything into motion. The thickly painted drapery swirls about the figure, the hills heave upward, and the architecture and vegetation seem tossed about by a whirlwind. Even the acanthus pattern on the frame assumes a strange, flamelike character. The evangelist has been transformed from a Roman author setting down his thoughts into a man seized with the frenzy of divine inspiration, a vehicle for recording the Word of God. The way the artist communicates this energy, particularly through the expressive use of flickering line, employing his brush as if it were a pen, recalls the endless interlaced movement in the ornamentation of Hiberno-Saxon manuscripts (see figs. 10.6, 10.9).

10.13. *Portrait of Menander.* ca. 70 CE. Wall painting. House of Menander, Pompeii

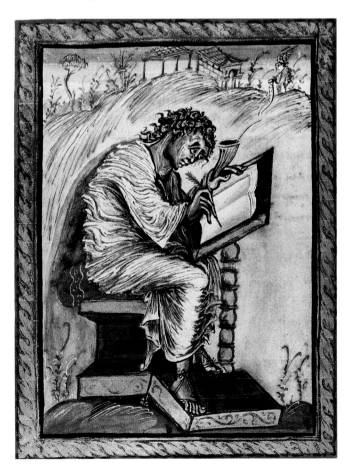

10.14. *St. Matthew,* from the *Gospel Book of Archbishop Ebbo of Reims.* 816–835 CE. Ink and colors on vellum, 10¼ × 8¾″ (26 × 22.2 cm). Bibliothèque Municipale, Épernay, France

THE UTRECHT PSALTER The imperial scriptorium at Reims responsible for the *Ebbo Gospels* also produced perhaps the most extraordinary of all Carolingian manuscripts, the *Utrecht Psalter* (fig. **10.15**). A *psalter* is an Old Testament book containing psalms, hymns to God that were traditionally believed to have been written by King David. Here, in the *Utrecht Psalter*, energetic form is expressed with pen drawings. That the artist has followed a much older model is indicated by the architectural and landscape settings of the scenes, which recall the Column of Trajan (see fig. 7.29). Another indication is the use of Roman capital lettering, which had gone out of general use several centuries before. The rhythmic quality of the draftsmanship, however, gives these sketches an expressive unity that could not have been present in earlier pictures. Without this rhythmic quality, the drawings of the *Utrecht Psalter* would carry little conviction, for the poetic language of the psalms does not lend itself to illustration in the same way as the narrative portions of the Bible. Perhaps we can attribute the drawn rather than painted style to the influence of an antique scroll that no longer survives.

The artist represented the psalms by taking each phrase literally and then visualizing it in some way. Thus the top of our page illustrates, "Let them bring me unto thy holy hill, and to thy tabernacles" (Psalms 43:3). Toward the bottom of the page, we see the Lord reclining on a bed, flanked by pleading angels. The image is based on the words, "Awake, why sleepest thou, Oh Lord?" (Psalms 44:23). On the left, the faithful crouch before the Temple ("for . . . our belly cleaveth unto the earth" [Psalms 44:25]), and at the city gate in the foreground they are killed ("as sheep for the slaughter"[Psalms 44:22]). In the hands of a less imaginative artist, this procedure could well have turned into a tiresome game; here it has the force of great drama. The wonderfully rhythmic and energetic quality of the draftsmanship renders these sketches both coherent and affecting.

THE LINDAU GOSPELS COVER The style of the Reims School is also apparent in the reliefs on the front cover of the *Lindau Gospels* (fig. **10.16**). Given the Carolingian investment in preserving and embellishing the written word, the cover was a fittingly sumptuous protection for a book. This master-

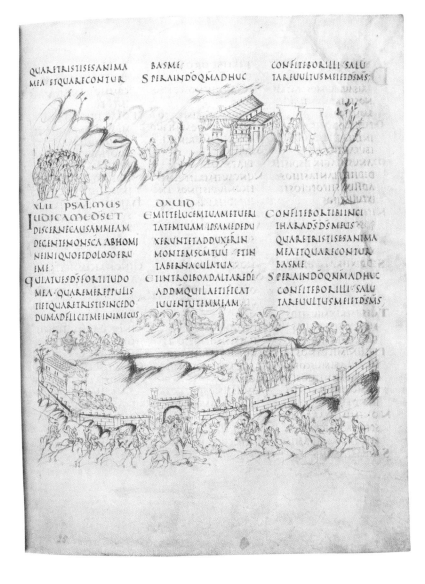

10.15. Illustrations to Psalms 43 and 44, from the *Utrecht Psalter*. ca. 820–832 CE. Ink on vellum, 13 × 9⅞″ (33 × 25 cm). University Library, Utrecht, the Netherlands

10.16. Front cover of binding, *Lindau Gospels*. ca. 870 CE. Gold and jewels, 13¾ × 10½″ (35 × 26.7 cm). The Pierpont Morgan Library, New York

piece of the goldsmith's art, dating from the third quarter of the ninth century, shows how splendidly the Germanic metalwork tradition was adapted to the Carolingian revival of the Roman Empire. The clusters of semiprecious stones are not mounted directly on the gold ground but raised on claw feet or arcaded **turrets** (towerlike projections), so that light can penetrate from beneath to bring out their full brilliance. The crucified Christ betrays no hint of pain or death. He

seems to stand rather than to hang, his arms spread out in a solemn gesture.

Architecture

Although relatively few Carolingian buildings survive, excavations demonstrate a significant increase in building activity during the Carolingian period, a reflection of the security and prosperity enjoyed during Charlemagne's reign. As was the

case with his painters, Charlemagne's architects sought to revive the splendor of the Roman Empire, which they did by erecting buildings whose models were largely from Rome and Ravenna, both of which Charlemagne visited. While Rome had been the capital of the Empire, Ravenna had been a Christian imperial outpost, thus a worthy prototype for what Charlemagne hoped to create in his own land.

PALACE CHAPEL OF CHARLEMAGNE, AACHEN
Toward the end of the eighth century, Charlemagne erected the imperial palace at Aachen. Prior to this time, Charlemagne's court was itinerant, moving from place to place as the political situation required. To signify Charlemagne's position as a Christian ruler, architects modeled his palace complex on Constantine's Lateran Palace in Rome. Charlemagne's palace included a basilica, called the Royal Hall, which was linked to the Palace Chapel (fig. **10.17**). The plan for the Palace Chapel was probably inspired by the Church of San Vitale in Ravenna, which the emperor saw firsthand (see figs. 8.21–8.24). It was designed by Odo of Metz, probably the earliest architect north of the Alps known to us by name. Einhard, Charlemagne's trusted adviser and biographer, supervised the project.

The debt to San Vitale is especially clear in cross section (fig. **10.18**; compare with fig. 8.22). The chapel design is by

10.17. Odo of Metz. Interior of the Palace Chapel of Charlemagne, 792–805 CE. Aachen, Germany

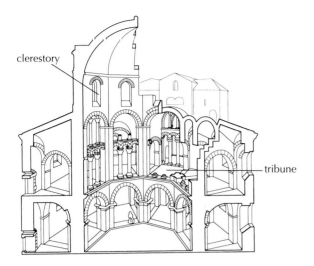

10.18. Section of the Palace Chapel of Charlemagne (after Kubach)

clerestory

tribune

ABBEY CHURCH OF SAINT-RIQUIER An even more elaborate westwork formed part of one of the greatest basilican churches of Carolingian times: the Abbey Church of Saint-Riquier at the Monastery of Centula in northeastern France. The monastery was rebuilt in 790 by Abbot Angilbert, a poet and scholar of Charlemagne's court. The monastery was destroyed long ago, but we know its design from descriptions, drawings, and prints, such as the engraving reproduced here (fig. **10.19**). The monastery included not only the abbey church, dedicated to Saint-Riquier, but also two chapels, one dedicated to St. Mary, the other to St. Benedict, founder of the Benedictine order, whose rule the monks followed. (See *Primary Source*, page 328.)

Benedict of Nursia established his order in 529 when he founded a monastery in Monte Cassino, south of Rome. Benedict's rules required monks to labor, study, and pray, providing for both the sound administration of the

no means a mere echo of San Vitale but a vigorous reinterpretation of it. Piers and vaults are impressively massive compared with San Vitale, while the geometric clarity of the spatial units is very different from the fluid space of the earlier structure. To construct such a building on northern soil was a difficult undertaking. Columns and bronze gratings were imported from Italy, and expert stonemasons must have been hard to find. The columns are placed within the arches of the upper story, where they are structurally unnecessary, but where they accentuate a sense of support and create opportunities to offer Roman details. San Vitale had been designed to be ambiguous, to produce an otherworldly interior space. Aachen, by comparison, is sturdy and sober. The soft, bulging curvilinear forms of San Vitale's arcades are replaced with clear-cut piers at Aachen. They make manifest their ability to support the heavy weight of Aachen's dome, while the dome at San Vitale seems light and to hover above the interior space of the building.

Equally important is Odo's scheme for the western entrance, now largely obscured by later additions and rebuilding. At San Vitale, the entrance consists of a broad, semidetached narthex with twin stair turrets, placed at an odd angle to the main axis of the church. At Aachen, these elements are molded into a tall, compact unit, in line with the main axis and attached to the chapel itself. This monumental structure, known as a **westwork** (from the German *westwerk*), makes one of its first appearances here.

Charlemagne placed his throne in the **tribune** (the gallery of the westwork), behind the great opening above the entrance. From here the emperor could emerge into the view of people assembled in the atrium below. The throne faced an altar dedicated to Christ, who seemed to bless the emperor from above in the dome mosaic. Thus, although contemporary documents say very little about its function, the westwork seems to have served initially as a royal compartment or chapel.

10.19. Abbey Church of Saint-Riquier, Monastery of Centula, France. Dedicated ca. 790. A 1673 engraving after a 1612 view by Petau, from an 11th-century manuscript illumination. Bibliothèque Nationale, Paris

Hariulf (ca. 1060–1143)

From *History of the Monastery of Saint-Riquier*

Hariulf was a monk at Saint-Riquier until 1105, when he became abbot of St. Peter's at Oudenbourg in Belgium.

The church dedicated to the Saviour and St. Richarius ... was among all other churches of its time the most famous. ... The eastern tower is close to the sepulcher of St. Richarius. ... The western tower is especially dedicated to the Savior. ...

If one surveys the place, one sees that the largest church, that of St. Richarius, lies to the north. The second, somewhat smaller one, which has been built in honor of our Lady on this side of the river, lies to the south. The third one, the smallest, lies to the east. The cloisters of the monks are laid out in a triangular fashion, one roof extending from St. Richarius' to St. Mary's, one from St. Mary's to St. Benedict's and one from St. Benedict's to St. Richarius'. ... The monastery is so arranged that, according to the rule laid down by St. Benedict, all arts and all necessary labors can be executed within its walls. The river flows through it, and turns the mill of the brothers.

SOURCE: CAECILIA DAVIS-WEYER, *EARLY MEDIEVAL ART 300–1150* (UPPER SADDLE RIVER, NJ: PRENTICE HALL, 1ST ED., 1971)

monastery and the spiritual needs of individual monks. (See end of Part II, *Additional Primary Sources*.) By the ninth century, largely due to support from Charlemagne, Benedict's rules for monastic life had been accepted by monasteries across Europe. Charlemagne recognized that the orderliness of the rules was consistent with his broader goal to provide

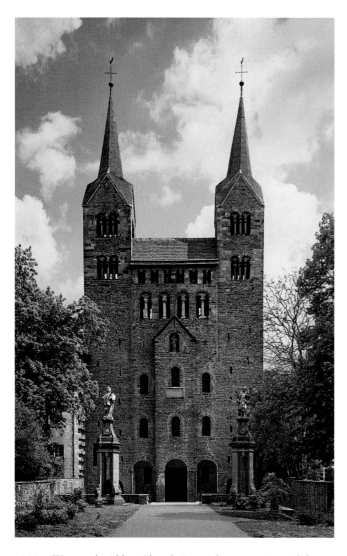

10.20. Westwork, Abbey Church. Late 9th century CE, with later additions. Corvey, Germany

stability through a sound, working system of governance, both civil and religious.

The three buildings of the monastery at Centula are connected by a covered walkway, forming a triangular **cloister** (an open court surrounded by a covered arcaded walk, used for meditation, study, and exercise). This shape has symbolic significance, reflecting this particular monastery's dedication to the Holy Trinity. The plan of Saint-Riquier reads as a traditional basilica with a central nave flanked by side aisles and terminating in a transept and apse. In fact, Charlemagne sent to Rome for drawings and measurements of traditional basilicas to guide his local builders. In elevation, however, Saint-Riquier's multiple towers provide vertical accents that are very different from the longitudinal silhouette of the Early Christian basilica, such as Old St. Peter's (see fig. 8.5).

The westwork of Saint-Riquier balanced the visual weight of the transept and east end of the church; it also provided additional room for the liturgical needs of a large community, which numbered some 300 monks, 100 novices, and numerous staff. Twenty-five relics related to Christ were displayed in the westwork entrance, and above that was an upper chapel dedicated to the Savior. On feast days, and in particular, on Easter, the community positioned itself here for the beginning of an elaborate processional liturgy. Thus, to some extent the westwork functioned as a separate commemorative building, the conceptual equivalent of the Early Christian mausoleum and martyrium, but now attached to a basilican church.

ABBEY CHURCH, CORVEY Saint-Riquier was widely imitated in other Carolingian monastery churches. The best-preserved surviving example is the abbey church at Corvey (fig. **10.20**), built in 873–885. Except for the upper stories, which date from around 1146, the westwork retains much of its original appearance. It is impressive not only because of its height but also because of its expansive surfaces, which emphasize the clear geometry and powerful masses of the exterior. The westwork provided a suitably regal entrance, which may well be its greatest significance. But the westwork had functional benefits too. At Corvey musical notation

scratched on the walls of the gallery reminds us that the boys choir would have been positioned here, its voices spreading upward as well as throughout the church.

PLAN OF A MONASTERY, ST. GALL The importance of monasteries in the culture of the early medieval period and their close link with the imperial court are evident in the plan for a monastery at St. Gall in Switzerland (fig. **10.21**). The plan exists in a large, unique drawing on five sheets of parchment sewn together and is preserved in the chapter library at St. Gall. This drawing was sent by Abbot Haito of Reichenau to Gozbert, the abbot of St. Gall, for "you to study only," as an aid to him in rebuilding his monastery. We may therefore regard it as a model or ideal plan, to be modified to meet local needs.

The monastery plan shows a complex, self-contained unit filling a rectangle about 500 by 700 feet and providing a logical arrangement of buildings based on their function. From the west end of the monastery, the main entrance path passes between stables and a hostelry toward a gate. This admits the visitor to a colonnaded semicircular **portico** (porch) flanked by two round towers forming a westwork that would have

loomed above the low outer buildings. The plan emphasizes the church as the center of the monastic community. This church is a traditional basilica (see figs. 8.4–8.6), with an apse at each end. The nave and aisles, which contain many other altars, do not form a single continuous space but are subdivided into compartments by screens. There are numerous entrances: two beside the western apse, others on the north and south flanks.

This arrangement reflects the functions of a monastery church, which was designed for the liturgical needs of the monks rather than for a lay congregation. Adjoining the church to the south is an arcaded cloister, around which are grouped the monks' dormitory (on the east side), a refectory (dining hall) and kitchen (on the south side), and a cellar. The three large buildings north of the church are a guesthouse, a school, and the abbot's house. To the east are the infirmary, a chapel, and quarters for novices (new members of the community), the cemetery (marked by a large cross), a garden, and coops for chickens and geese. On the south side are workshops, barns, and other service buildings.

The St. Gall plan was laid out using a **module** (standard unit). This module, expressed as parts or multiples of $2\frac{1}{2}$ feet,

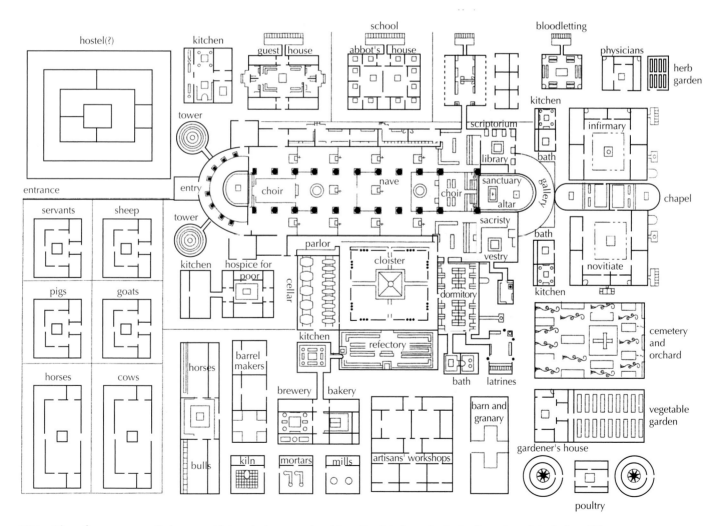

10.21. Plan of a monastery. Redrawn, with inscriptions translated into English from the Latin, from the original of ca. 820 CE. Red ink on parchment, 28 × 44$\frac{1}{8}$" (71.1 × 112.1 cm). Stiftsbibliothek, St. Gall, Switzerland

St. Angilbert (ca. 750–814)

From *Customary for the Different Devotions*

Angilbert, a member of Charlemagne's court, became lay abbot of Saint-Riquier in 781 and sponsored the monastery's rebuilding. His description reveals how the resident monks moved from one part of the basilica to another while chanting the devotions prescribed in The Rule of St. Benedict.

When the brethren have sung Vespers and Matins at the altar of the Savior, then one choir should descend on the side of the holy Resurrection, the other one on the side of the holy Ascension, and having prayed there the processions should in the same fashion as before move singing toward the altars of St. John and St. Martin. After having prayed they should enter from both sides through the arches in the middle of the church and pray at the holy Passion. From there they should go to the altar of St. Richarius. After praying they should divide themselves again as before and go to the altars of St. Stephen and St. Lawrence and from there go singing and praying to the altar of the Holy Cross. Thence they should go again to the altar of St. Maurice and through the long gallery to the church of St. Benedict.

SOURCE: CAECILIA DAVIS-WEYER, *EARLY MEDIEVAL ART 300–1150* (ENGLEWOOD CLIFFS, NJ: PRENTICE HALL, 1ST ED., 1971)

can be found throughout the plan, from the division of the church to the length of the cemetery plots. The imposition of a module on the plan of St. Gall is a tangible manifestation both of the administrative orderliness and stability so sought after by Charlemagne and the aims of monasticism, as defined by Benedict of Nursia's *Rule*.

Unfortunately, stability proved elusive. Upon the death of Charlemagne's son, Louis I, in 840, a bitter battle arose among Louis's sons for the empire built by their grandfather. The brothers eventually signed a treaty in 843 dividing the empire into western, central, and eastern parts: Charles the Bald became the West Frankish King, founding the French Carolingian dynasty in what became modern France; Louis the German became the East Frankish King, ruling an area roughly that of today's Germany; and Lothair I became the Holy Roman Emperor, ruling the middle area running from the Netherlands down to Italy. The distribution of the Carolingian domain among Louis's heirs weakened the empire, brought a halt to Carolingian cultural efforts, and eventually exposed continental Europe to attack by the Moslems from the south, the Slavs and Magyars from the east, and the Vikings from north. The Vikings invaded northwestern France and through a land grant from Charles the Bald occupied the area now known as Normandy.

Although political stability ultimately eluded Charlemagne's heirs, the artists of the Carolingian period had been able to create an enduring art that combined the northern reliance on decoration—on surface, pattern, and line—with the Mediterranean concern for solidity and monumentality. Carolingian art was to serve as a worthy model for emulation by artists and patrons when the revival of Charlemagne's vision of a united and stable Europe would reappear during the next centuries.

OTTONIAN ART

When the last East Frankish monarch died in 911, the center of political power consolidated in the eastern portion of the former Carolingian empire, in an area roughly equivalent to modern Germany, under German kings of Saxon descent. Beginning with Henry I, these kings pushed back invaders, reestablished an effective central government, improved trade and the economy, and began a new dynasty, called Ottonian after its three principal rulers: Otto 1, Otto II, and Otto III. During the Ottonian period, which lasted from 919 to 1024, Germany was the leading nation of Europe politically and artistically. German achievements in both areas began as revivals of Carolingian traditions but soon developed an original character.

The greatest of the Ottonian kings, Otto I, revived the imperial ambitions of Charlemagne. After marrying the widow of a Lombard king in 951, he extended his rule over most of what is now northern Italy. Then, in 962, he was crowned emperor by Pope John XII, at whose request he conquered Rome. The emperor later deposed this pope for conspiring against him.

Architecture

Among the most pressing concerns of the Ottonian emperors was the reform of the Church, which had become corrupt and mismanaged. They did this by establishing closer alliances with the papacy and by fostering monastic reforms, which they supported by sponsoring many new religious buildings. The renewal of impressive building programs effectively revived the architectural ambitions of their Carolingian predecessors, at the same time conveying and furthering the Ottonians' aspirations to restore the imperial glory of Christian Rome.

NUNNERY CHURCH OF ST. CYRIAKUS, GERNRODE

One of the best-preserved Ottonian churches was built in 961 for the nunnery at Gernrode (fig. **10.22**), founded by Gero, margrave (military governor) under Otto I. The church was dedicated to St. Cyriakus and relied on the basic form of the Early Christian basilica (see figs. 8.4–8.6), which had also dominated architectural planning during the Carolingian period (see page 328). However, at St. Cyriakus, a gallery, not present in the Early Christian basilica, has been inserted between the nave arcade and the clerestory. A series of columns and piers divide the gallery in such a way that the piers of the gallery are positioned over the piers of the nave arcade. This provides a series of repeated vertical accents, effectively dividing the building into vertical sections.

This emphasis on verticality is different from the overwhelming effect of horizontality that characterizes Early Christian buildings and indicates a trend that will be significant in the later development of medieval architecture. Neither the origin nor the intended function of the gallery is clear. Some scholars have noted similarities to galleried Byzantine churches, such as two fifth-century examples in Salonika in Greece. It is possible that the gallery at St. Cyriakus contained altars, as was the case in the galleried westworks of Carolingian churches, such as at Corvey (see fig. 10.20). They also might have provided space for the choir, another parallel to the use of Corvey's gallery (see page 329).

ST. MICHAEL'S AT HILDESHEIM The most ambitious patron of architecture and art in the Ottonian age was Bernward, who became bishop of Hildesheim after having been court chaplain. Bernward was also tutor of Otto III during the regency of his

ART IN TIME

785 CE—Construction starts on Great Mosque at
Córdoba Spain

ca. 820–832—Utrecht Psalter produced in France

843—Charlemagne's three grandsons divide his empire

mother the Empress Theophano, wife of Otto II and a Byzantine princess in her own right. Bernward's chief monument is the Benedictine abbey church of St. Michael's at Hildesheim. The plan of this monastic church (fig. **10.23**) derives from that of Saint-Riquier at Centula (see fig. 10.19). With its two choirs and side entrances, it also recalls the monastery church of the St. Gall plan (see fig. 10.21). However, in St. Michael's the symmetry is carried much further. There are two identical transepts, each with a tower,

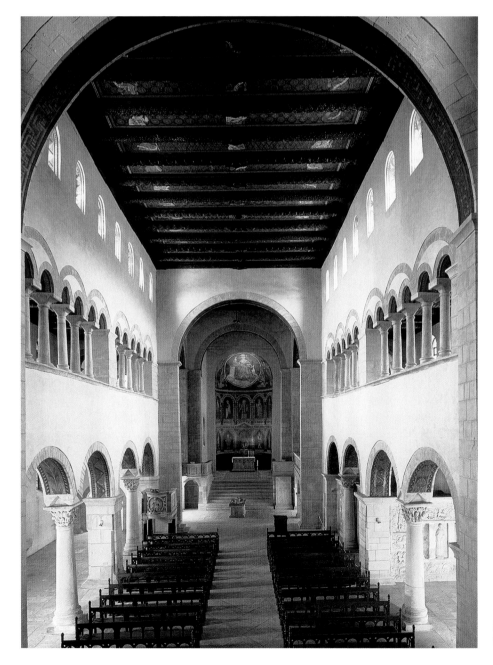

10.22. Interior, looking east, Church of St. Cyriakus. Founded 961 CE. Gernrode, Germany

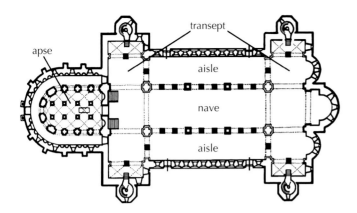

10.23. Reconstructed plan. Abbey Church of St. Michael's. 1001–1033 CE. Hildesheim, Germany. (after Beseler)

where the transept and the nave cross, and a pair of stair turrets at the end of each transept (fig. **10.24**; see also 10.23). But the supports of the nave arcade, instead of being uniform, consist of pairs of columns separated by square piers (fig. **10.25**). This alternating system divides the arcade into three equal units, each with three openings. These units are equal in length to the width of the transepts, which are similarly divided into three compartments.

Thus, as in the St. Gall plan, a modular system governs the division of spaces. The module can also be seen on the exterior of the building, which reads as a series of cubes arranged by stacking. The first and third units correspond with the entrances, thus echoing the axis of the transepts. Moreover, since the aisles and nave are unusually wide in relation to their length, the architect's intention must have been to achieve a harmonious balance between the longitudinal and horizontal axes throughout the structure.

St. Michael's was severely damaged during the Second World War, but the restored interior (see fig. 10.25), with its great expanse of wall space between the arcade and clerestory, retains the majestic feeling of the original design. (The capitals of the columns date from the twelfth century; the painted wooden ceiling from the thirteenth.) The western choir is especially interesting. The architect raised its floor above the level of the rest of the church to make room for a half-buried basement chapel, or **crypt**. Monks could enter the crypt (apparently a special sanctuary for relics of the saint) from both the transept and the west. Arched openings pierced the walls and linked the crypt with the U-shaped ambulatory wrapped around it. The ambulatory originally must have been visible above ground, where it enriched the exterior of the choir, since there were windows in

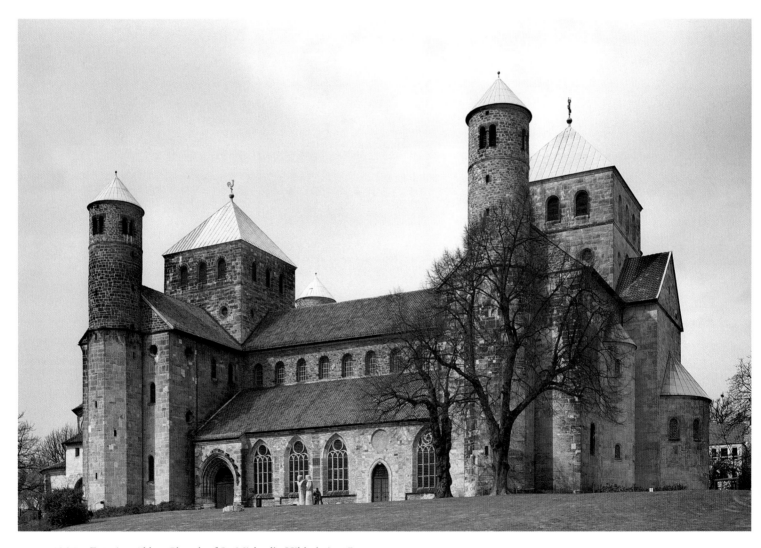

10.24. Exterior, Abbey Church of St. Michael's. Hildesheim, Germany

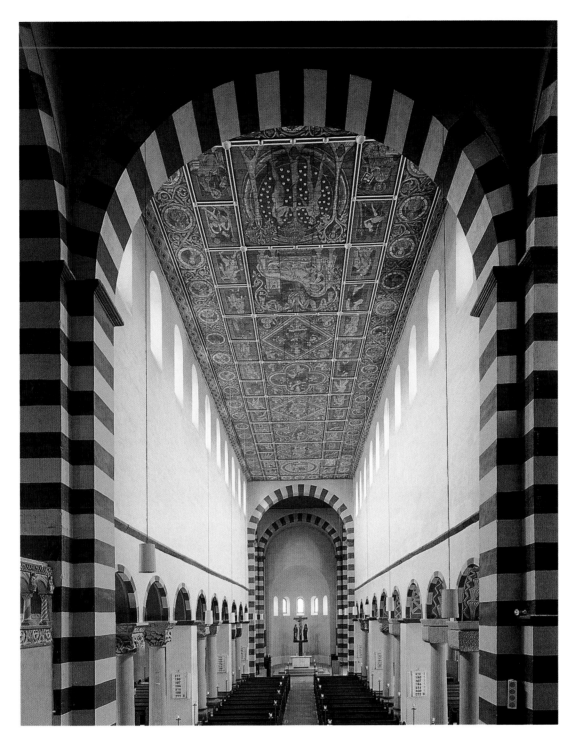

10.25. Interior, with view toward the apse (after restoration of 1950–1960), Abbey Church of St. Michael's. Hildesheim, Germany

its outer wall. Such crypts with ambulatories, usually housing the venerated tomb of a saint, had been introduced into Western church architecture during Carolingian times, and there is a crypt under the apse at St. Cyriakus at Gernrode. However, the design of St. Michael's is distinguished by the crypt's large scale and its careful integration with the rest of the building.

Metalwork

The Ottonian emperors' reliance on church authority to strengthen their own governmental rule encouraged them not only to build new churches but also to provide sumptuous works of art to decorate them. The works they and their cohorts sponsored were richly appointed and executed in expensive, often precious materials.

BRONZE DOORS OF BISHOP BERNWARD, HILDESHEIM For St. Michael's at Hildesheim, Bernward commissioned a pair of extensively sculptured bronze doors (figs. **10.26** and **10.27**) that were finished in 1015, the year the crypt was consecrated. According to his biographer, Thangmar of Heidelberg,

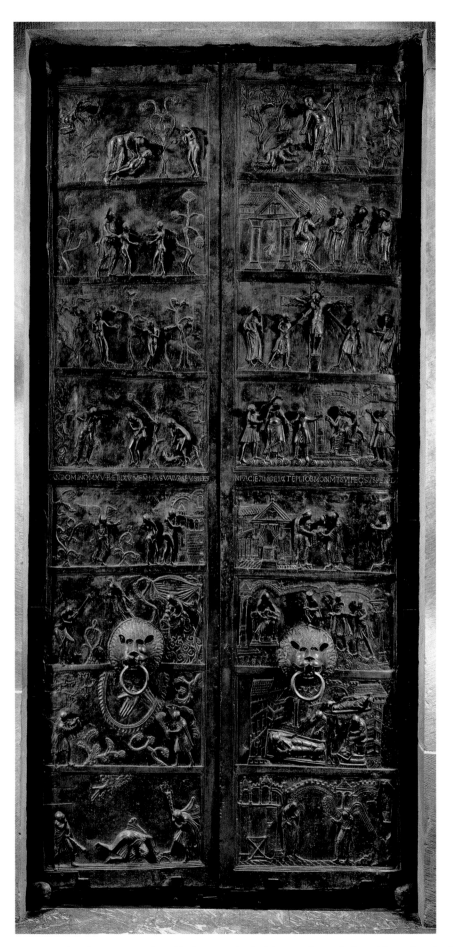

10.26. Doors of Bishop Bernward, Hildesheim Cathedral (originally made for Abbey Church of St. Michael's, Hildesheim). 1015 CE. Bronze, height approx. 16′ (4.8 m). Hildesheim, Germany

Old Testament	Comparison of themes	New Testament
Formation of Eve	Paradise Lost and then Paradise Gained	Noli Me Tangere
Eve Presented to Adam	Salutations	The Three Marys at the Tomb
Temptation and Fall	Tree of Knowledge (sin) vs. Tree of Life (The Cross, Salvation)	The Crucifixion
Accusation and Judgment of Adam and Eve	Judgment	Judgment of Jesus by Pilate
Expulsion from Paradise	Separation from God vs. Reunion with God	Presentation of Jesus in Temple
Adam and Eve Working	Firstborn Sons of Eve (Cain) and Mary (Jesus); Poverty vs. Wealth	Adoration of the Magi
Offerings by Cain (grain) and Abel (lamb)	Abel's Sacrificial Lamb vs. Jesus, Lamb of God	The Nativity
Cain Slaying Abel	Despair, Sin, Murder vs. Hope and Everlasting Life	The Annunciation

10.27. Schematic diagram of the scenes on the Doors of Bishop Bernward.

Bernward excelled in the arts and "distinguished himself remarkably in the science of metalwork and the whole art of building." So, he must have been closely involved in the project. The idea for the doors may have come to him as a result of his visit to Rome, where he could have seen ancient Roman (and perhaps Byzantine) doors of bronze or wood. He would also certainly have been aware of the bronze doors that Charlemagne had commissioned for his palace chapel at Aachen.

The doors at Hildsheim are considered by many scholars to be the first monumental sculptures created by the lost-wax process since antiquity (see *Materials and Techniques*, page 124). Each door was cast as one piece and measures over 16 feet high. They are also the first doors since the Early Christian period to have been decorated with stories. Our detail (fig. **10.28**) shows God accusing and judging Adam and Eve after they have committed the Original Sin of eating the forbidden fruit in the Garden of Eden. (This story is known as the Temptation and Fall.) Below it, in inlaid letters notable for their classical Roman character, is part of the inscription, with the date and Bernward's name. The inscription was added around 1035, when the doors were moved from the monastery of St. Michael and attached to the west-werk of Hildesheim Cathedral, where they would have been

seen by a larger public than in the monastic setting of St. Michael's. The new prominent setting indicates how valued they were in their own time.

The composition most likely derives from a manuscript illumination, since there are very similar scenes in medieval Bibles. Yet this is no mere imitation. The story is conveyed with splendid directness and expressive force. The accusing finger of the Lord, seen against a great void, is the focal point of the drama. It points to a cringing Adam, who passes the blame to Eve, who in turn passes it to the serpent at her feet.

The subjects on the left door are taken from the Old Testament and those on the right from the New Testament (see fig. 10.26). The Old Testament stories are presented chronologically from top to bottom, while the New Testament scenes move in reverse order, from bottom to top, suggesting the message of the Christian Bible is uplifting. When read as horizontal pairs, the panels deliver a message of the origin and redemption of sin through a system of **typology**, whereby Old Testament stories prefigure New Testament ones. For example, the *Temptation and Fall* (fig. **10.29**) is opposite the *Crucifixion*. In the center of the left panel is the tree whose fruit led to the Original Sin; in the center of the right panel is the cross on which Jesus was crucified, which medieval Christians believed was made from the wood of the tree from Eden and was therefore the instrument for redemption from the sin of that original act. Compositional similarities between the two scenes stress their typological relationship: In the left panel Adam and Eve's hands that flank the cross-shaped tree establish a visual parallel to the spears the soldiers use to pierce Christ's body on the right panel.

Eve plays a particularly significant role on the doors; in fact, the narrative begins with her formation, not with the creation of Adam, as might be expected. In the *Temptation and Fall*, Eve's attitude and gesture parallel those of the serpent at the right, who, like Eve, offers an apple. This parallel makes explicit Eve's role as seductive agent, accentuated by the way she holds the apple so closely to her chest that it almost appears as if she were grasping her breast rather than the fruit. With this gesture Eve's guilt in humankind's exile from Paradise is emphasized and her sexuality underscored.

While Early Christian writers had considered Eve responsible for the Original Sin, during the Ottonian period references to her guilt multiply and become more vigorous. This might be a result of efforts by Bishop Bernward and others to reform the morality of the clergy in an effort to restore the vow of celibacy to priests and monks, some of whom were known to allow their wives and children to cohabit monasteries. Thus, the burden of clerical immorality is, in effect, assigned to Eve, the first woman and the first seductress.

COLUMN OF BISHOP BERNWARD, HILDESHEIM

Those who visited St. Michael's at Hildesheim and those who lived in the monastery would have recognized Bernward's doors as a precious object suitable for a building with imperial associations, if only because it reminded them of doors made

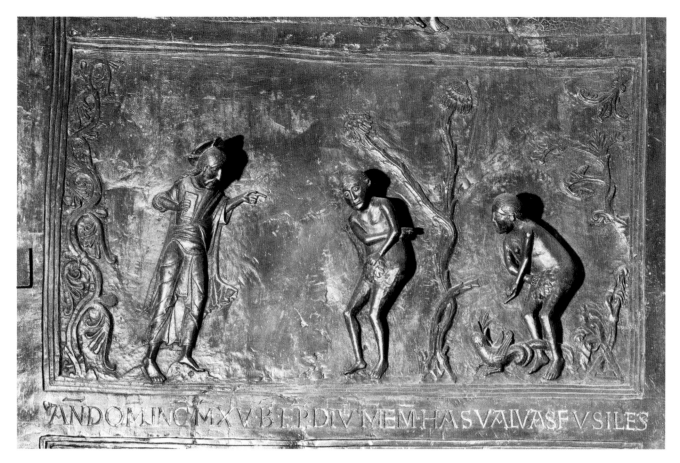

10.28. *Accusation and Judgment of Adam and Eve,* from the Doors of Bishop Bernward. Bronze, approx. 23 × 43″ (58.3 × 109.3 cm). Hildesheim, Germany

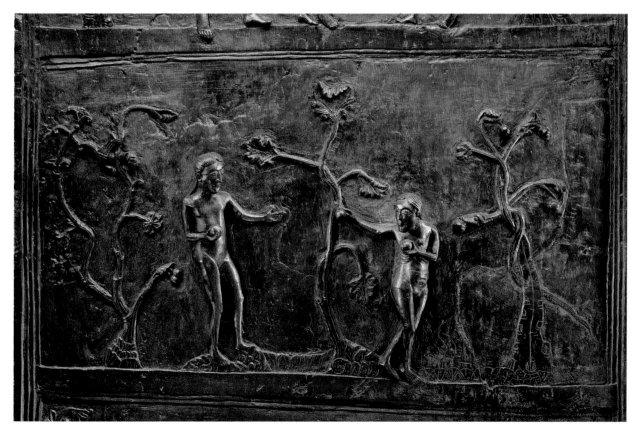

10.29. *Temptation and Fall,* from the Doors of Bishop Bernward. Bronze, approx. 23 × 43″ (58.3 × 109.3 cm). Hildesheim, Germany

for Charlemagne in Aachen and other bronze doors in Rome. Bernward made the allusions to Rome explicit when he commissioned for St. Michael's a bronze column with spiraling reliefs depicting Jesus' life (fig. **10.30**). Bernhard's column, which stands today in the transept of the cathedral, is a strong reminder of the Column of Trajan (see fig. 7.28) though it is only a tenth the size of the Roman example. The bishop was clearly pushing the Ottonian message of continuity with the ancient Roman emperors.

Ivories and Manuscripts: Conveyors of Imperial Grandeur

The right of the Ottonian monarchs to call themselves Roman emperors was challenged by Byzantine rulers, who continued to claim that title as their own even though the division of the Roman Empire into Eastern and Western empires was complete by the end of the fourth century. When Otto II married the Byzantine princess Theophano, Otto was able to use the full title Holy Roman Emperor with impunity. While early Ottonian illuminators faithfully replicated features of Carolingian manuscripts for the court school, later Ottonian manuscripts, as well as ivories, blend Carolingian and Byzantine elements into a new style of extraordinary scope and power. Byzantine artists working for the court provided an impetus for new ways of presenting both religious and imperial images. Ottonian manuscripts indicate an increasing interest on the part of artists and patrons in narrative cycles of Jesus' life, which is the period's most important contribution to the field of iconography.

CHRIST BLESSING OTTO II AND THEOPHANO An ivory of *Christ Blessing Emperor Otto II and Empress Theophano* (fig. **10.31**) commemorated their coronation and presents it as divinely sanctioned. In composition and style the ivory is quite similar to the Byzantine ivory of *Christ Crowning Romanos and Eudokia* (see fig. 8.42), carved a generation or so earlier. The composition of both works is identical: A long-haired, bearded Christ (identified by a halo inscribed with a cross) is elevated in the center of each panel and anoints the empress and emperor, who flank him. In both ivories the imperial costumes are composed of similar elaborate geometric surface decorations. This similarity argues for the Otto II ivory being an eastern import, as does the inscription, which seems to be the work of a Greek using both Greek and Latin letters. However, because Otto's costume is not accurate for a Byzantine ruler's coronation, and because the inscription tell us that the donor—who huddles in front of Otto's stool and grasps the leg of the larger stool that supports Christ—was an Ottonian bishop known to be a resident in Italy, it is more likely that the ivory was produced within Ottonian lands in Italy. No matter where this work was produced, it demonstrates the interest of the Ottonian court in importing Byzantine style as well as objects, thus establishing on another level a connection to the art of the Mediterranean. Here again, the king is presented as the Holy Roman emperor, a divinely ordained ruler.

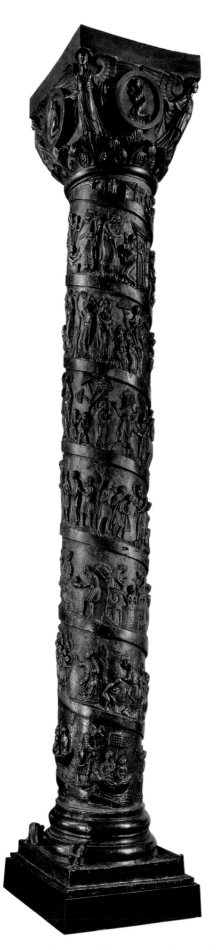

10.30. Column of Bishop Bernward, Hildesheim Cathedral (originally made for Abbey Church of St. Michael's). 1015–1022 CE. Bronze. Height 12′5″ (3.8 m). Hildesheim, Germany

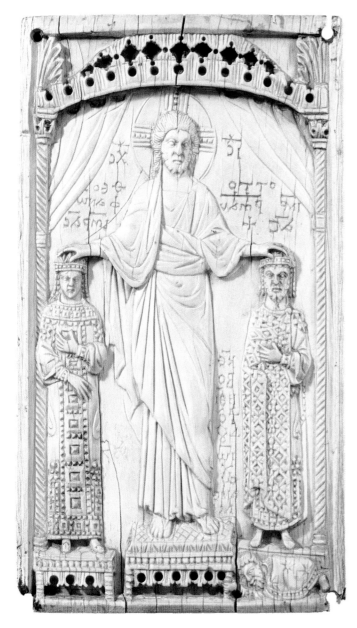

10.31. *Christ Blessing Emperor Otto II and Empress Theophano.* 982–983 CE. Ivory, 7$\frac{1}{8}$ × 4″ (18.3 × 10.3 cm). Musée du Moyen Age (Cluny), Paris

THE GOSPEL BOOK OF OTTO III Produced for the son of Otto II and Theophano, the *Gospel Book of Otto III* (fig. **10.32**) communicates an imperial grandeur equal to that of the coronation ivory of his parents. The emperor displays the imperial regalia—a crown, an eagle scepter, and a cross-inscribed orb—while his throne is decorated with imperial lions. Representatives of the two domains that he controls—the military and the ecclesiastical—flank him, reminiscent of Justinian's placement in the center of the same domains in the San Vitale mosaic (see fig. 8.25). On the facing folio, the four geographical parts of the realm—Slavinia, Germania, Gallia, and Roma—offer homage. Their stances recall traditional representations of the Magi offering gifts to Christ, such as the scene decorating Theodora's robe in the mosaic at San Vitale in Ravenna (see fig. 8.26)

The manuscript is dated around 1000, not long after Otto III was crowned king of Germany at Aachen in 986 and Holy Roman Emperor at Rome in 993. The way Otto is represented visually in the manuscript thus parallels historical facts; he is presented here as rightful and worthy heir to Roman and Byzantine emperors as well as to Charlemagne, and his imperial dignity is enhanced by association with Christ, a reverse of the case of Early Christian depictions, in which Christ is ennobled in the fashion of a Roman emperor. The soft pastel hues of the background recall the illusionism of Graeco-Roman landscapes and the *Quedlinburg Itala* fragment (see fig. 8.18). Such a style shows that the artist was probably aware of Roman, as well as Byzantine, manners of representation.

The *Gospel Book of Otto III* contains one of the most extensive sets of illustrations of the life of Christ. The scene of *Jesus Washing the Feet of St. Peter* (fig. **10.33**) once again contains strong echoes of ancient painting, transmitted through Byzantine art. The architectural frame around Jesus is a late descendant of the kind of architectural perspectives we saw in Roman wall painting (see figs. 7.52 and 7.56), and the intense gold background reminds us of Byzantine painting and mosaics, which the Ottonian artist has put to new use. What was an architectural vista in the mural from Boscoreale (see fig. 7.54) now becomes the Heavenly City, the House of the Lord, filled with golden celestial space in contrast with the atmospheric earthly space outside.

The figures have also been transformed. In ancient art this composition, in which a standing figure extends an arm to a seated supplicating figure and is watched by bystanders and assisted by others was used to depict a doctor treating a patient. Here the emphasis has shifted from physical to spiritual action. Not only do glances and gestures convey this new kind of action, but so too does scale. Jesus and his apostle Peter, the most animated figures, are larger than the rest, and Jesus' "active" arm is longer than his "passive" one. And the eight apostles, who are compressed into a tiny space and merely watch, have less physical substance than the fanlike Early Christian crowd from which this grouping derives (see fig. 8.17). The blending of Classical and Byzantine elements results in a new style of expressive abstraction.

A miniature of *St. Luke* from the *Gospel Book of Otto III* (fig. **10.34**) is a symbolic image of overwhelming grandeur despite its small size. Unlike depictions of evangelists in Carolingian manuscripts (see figs. 10.12 and 10.14), St. Luke is not shown writing. Instead, his Gospel lies completed on his lap. The evangelist seems to be as much a part of the mystical scene as he is its presenter. Enthroned on two rainbows, Luke holds aloft an awesome cluster of clouds from which tongues of light radiate in every direction. Within it we see his symbol, the ox, surrounded by five Old Testament prophets and an outer circle of angels. At the bottom, two lambs drink the life-giving waters that spring from beneath his feet. The key to the design is in the inscription: *Fonte patrum ductas bos agnis elicit undas* (From the source of the fathers, the ox brings forth a flow of water for the lambs). The Ottonian artist has truly "illuminated" the meaning of this terse phrase.

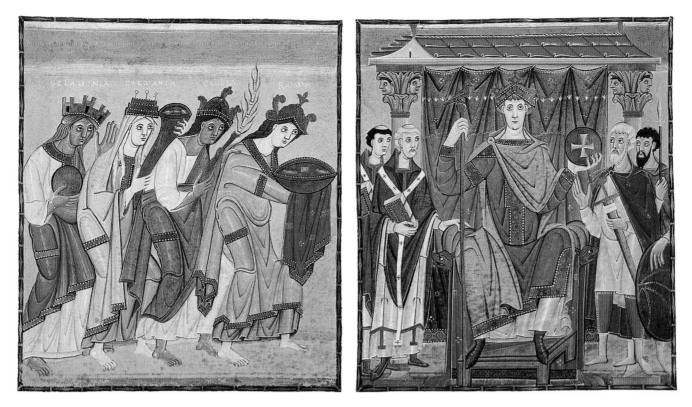

10.32. *Otto III Receiving the Homage of the Four Parts of the Empire* and *Otto III Between Church and State,* from the *Gospel Book of Otto III.* ca. 1000 CE. Tempera on vellum. Each folio 13 × 9 ⅜″ (33 × 23.8 cm). Staatsbibliothek, Munich

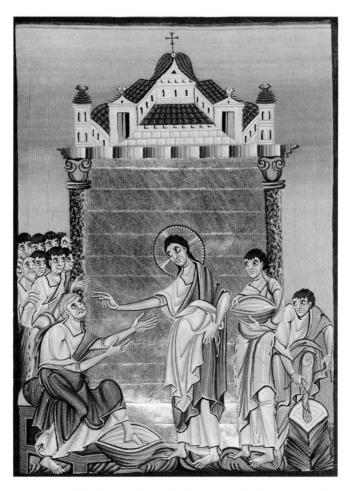

10.33. *Jesus Washing the Feet of St. Peter,* from the *Gospel Book of Otto III.* ca. 1000 CE. Tempera on vellum, 13 × 9⅜″ (33 × 23.8 cm). Staatsbibliothek, Munich

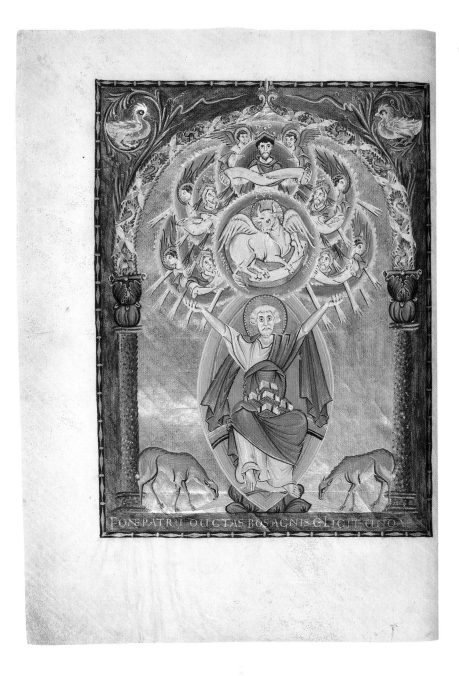

10.34. *St. Luke,* from the *Gospel Book of Otto III.* ca. 1000 CE. Tempera on vellum, 13 × 9⅜″ (33 × 23.8 cm). Staatsbibliothek, Munich

Sculpture

Large-scale and free-standing sculpture was rare in the early Middle Ages, in part because of the lingering fear of idol worship and because the general interest in producing portable objects virtually precluded its production. However, during the Ottonian period the scale of sculpture increased (witness Bernward's doors for St. Michael's at Hildesheim), and even many small-scale works demonstrate an imposing monumentality.

THE GERO CRUCIFIX The *Gero Crucifix* (fig. **10.35**), named for Archbishop Gero of Cologne, who commissioned it around 970, is an example of a large-scale work—it is in fact life-size—with a monumental presence, indicative of the major

transformation that Ottonian sculptors were able to achieve even when dealing with traditional subjects. How this happens is evident if we compare the *Gero Crucifix* with the Christ on the cover of the Lindau Gospels (see fig. 10.16). The two works are separated by little more than a hundred years but show marked contrast. The *Gero Crucifix* presents a sculptural image of the crucified Christ that is new to Western art, an image filled with deep feeling for Christ's suffering. Made of painted and gilded oak, it is carved in powerfully rounded forms. Particularly striking is the forward bulge of the heavy body, which emphasizes the physical strain on the arms and shoulders, making the pain seem almost unbearable. The face, with its deeply incised, angular features, is a mask of agony from which all life has fled.

How did the Ottonian sculptor arrive at this bold conception? The *Gero Crucifix* was clearly influenced by Middle Byzantine art, which had created the compassionate view of Christ on the Cross in other mediums (see fig. 8.46). Yet, that source alone is not enough to explain the results. It remained for the Ottonian artist to translate the Byzantine image into large-scale sculptural terms and to replace its gentle pathos with expressive realism. Even though there were some clerics who rekindled the deep-rooted fear of idolatry, they could not restrain the newly found emphasis on the humanity of Christ or the increasing interest in relics. In fact, there is a space in the back of the head of the Gero Christ to hold the Host (the bread or wafer taken during that part of the Mass referred to as Communion), transforming the sculpture into a **reliquary** (a container to enshrine holy remnants or relics).

ART IN TIME

911 CE—Last East Frankish monarch dies

962—Otto I crowned as Holy Roman Emperor

1015—Bernward bronze doors completed for St. Michael's at Hildesheim, Germany

10.35. The *Gero Crucifix*. ca. 970 CE. Painted and gilded wood. Height 6′2″ (1.88 m). Cathedral. Cologne, Germany

10.36. *Virgin of Essen.* ca. 980 CE. Gold over wood, enamel, filigree, and gems. Height 29½″ (75.6 cm). Cathedral Treasury, Essen, Germany

THE VIRGIN OF ESSEN The *Virgin of Essen* (fig. **10.36**), given to the Cathedral of Essen around 980 by Abbess Matilda, granddaughter of Otto I, almost surely was designed as a reliquary, although that is hard to establish definitively since its original wooden core does not survive. All that is left is the exterior covering of gold sheets. Matilda also donated two—and possibly three—gold, enamel, and jeweled crosses to the cathedral. This rich treasure, glittering on candlelit altars, would have made an impressive display and signaled the church's patronage by a member of the imperial family. The *Virgin of Essen* is one of the earliest free-standing sculptures of the Virgin Mary. The golden apple Mary holds symbolizes her typological status as the new Eve; thus the sculpture is related conceptually to the message on Bernward's bronze doors (see fig. 10.26).

Despite the tender, almost doll-like figures of Mary and Christ, the *Virgin of Essen* has a commanding presence. This is due to Mary's frontal pose, her large staring eyes, and the brilliance of the gold, which is enhanced by the gems, enamels, and filigree that decorate the apple and Christ's book and halo. Linear details, such as drapery folds, and facial features are suppressed to place emphasis on the figure's corporeality. Thus, the Essen Madonna has moved away from the earlier Germanic concentration on line and surface effect. Despite her small size—less than $2\frac{1}{2}$ feet high—the simplification of form and the concentration on abstract shapes result in a marked movement toward monumentality, which also characterized the *Gero Crucifix*. These works herald new aesthetic aims that will dominate eleventh-century sculpture throughout Europe.

SUMMARY

EARLY MEDIEVAL ART

Western Europe was home to a number of cultures after the Fall of Rome. Migrations and invasions were common, and groups frequently clashed and mixed with one another. Overlaid on this mix were Roman traditions, including Christianity. Over time, the Church became an important force of European unification, and strong political leaders led a succession of ruling dynasties, including the Carolingian and the Ottonian. The art resulting from the cultural interchanges of the early Middle Ages is vibrant and varied. Artists created intricate and sumptuous metalwork, built and adorned churches and monastic structures, and produced elaborately decorated books.

ANGLO-SAXON AND VIKING ART

Among the widespread migrations across Europe in the 300s and 400s were those of the Germanic peoples, whose art, including metalwork and jewelry, was portable. Their skillfully executed objects were often made of gold or silver and included precious stones. The artistic tradition of these peoples— sometimes referred to as the "animal style" because of its use of stylized animal-like forms— mixed with other traditions to produce unique objects such as those found in an Anglo-Saxon ship burial at Sutton Hoo, England.

HIBERNO-SAXON ART

During the early Middle Ages, Irish monasteries became centers of learning and the arts, with special attention devoted to copying and decorating literary and religious texts. The finest of these manuscripts belong to the Hiberno-Saxon style, which combines Christian, Celtic, and Germanic elements. Outstanding examples include the *Lindisfarne Gospels* and the *Book of Kells*.

CAROLINGIAN ART

A new empire developed in Europe in the late 700s. Founded by Charlemagne, this Carolingian empire would eventually unite lands from the North Sea to Spain to northern Italy. Artists who worked for Charlemagne and his successors during this Carolingian period combined admiration for antiquity with native northern European features. High-quality works of the time include bronze sculptures and illuminated books. An increase in architectural projects reposition—including the imperial palace at Aachen and the abbey church of Saint-Riquier—also reflect the security and prosperity of the time.

OTTONIAN ART

After the last Carolingian monarch died, German kings of Saxon descent consolidated political power in the eastern portion of the empire. These rulers pushed back invaders, reestablished an effective central government, and began a new dynasty: the Ottonian. A pressing concern of these leaders was Church reform. Impressive building programs of the time include the Benedictine abbey church of St. Michael's at Hildesheim. Ottonian artists produced ivories and manuscripts that blended Carolingian and Byzantine elements, and they showed an increased interest in large-scale sculpture.

Romanesque Art

ROMANESQUE MEANS, LITERALLY, "IN THE ROMAN MANNER." WE USE THIS stylistic term today to identify the art of much of the eleventh and twelfth centuries. The borrowing of details or specific features from the antique past does not distinguish Romanesque art from the art of other post-Classical periods, for Early Christian, Byzantine, Carolingian,

and Islamic art also relied heavily on Rome for their formal and expressive languages. However, in Romanesque art, the aesthetic integrity and grandeur of the Roman model survive in a more vital and compelling form than in any previous period of art history. Even after the turmoil and displacement experienced in the Roman Empire during Late Antiquity and the early Middle Ages, the power and glory that Rome represented in its enduring monuments continued to provide an appealing model. Yet Rome was not the period's only inspiration: Romanesque artists tapped sources in Carolingian and Ottonian art, and were influenced by Early Christian, Byzantine, Celtic-Germanic, and Islamic traditions as well.

As opposed to Carolingian and Ottonian art, which developed principally in response to the culture and programs of the royal courts, Romanesque art sprang up all over Western Europe at about the same time and in a variety of regional styles that are nevertheless closely related. What welded this variety into a coherent style was not any single force but several factors.

For one thing, Christianity was close to triumph everywhere in Europe. The Vikings, still largely pagan in the ninth and tenth centuries when their raids terrorized the British Isles and the Continent, had finally entered the Catholic fold, not only in Normandy but in Scandinavia as well. Meanwhile,

in 1031 the caliphate of Córdoba had broken up into many small Muslim states, opening the way for Christian conquest of the Iberian peninsula.

Another factor was the growing spirit of religious enthusiasm. The year 1000—the millennium—had come and gone without the apocalyptic end of the world that many had predicted from their reading of the book of Revelation in the Bible. Chapter 20 of this New Testament book, written about 50 years after Jesus' death, prophesizes that the Second Coming, when Christ will return to earth and end the world as we know it, was to occur after 1,000 years. Scholars have suggested that many people, fearing the dreaded end of days, reacted to the approach of the year 1000 with terror and to its smooth passing with great relief and, in some quarters, a heightened spirituality. This was demonstrated by the large number of people making pilgrimages to sacred sites, by repeated Christian Crusades against the Muslims in the Holy Land, and by an increase in the number and size of monasteries, which also reflected the general growth in population and an increase in prosperity.

Equally important was the reopening of the Mediterranean trade routes by the navies of Venice, Genoa, Amalfi, Pisa, and Rimini (see map 11.1). The revival of trade and travel linked Europe commercially and culturally, stimulating the flowering of urban life. The new pace of religious and secular life is vividly described in pilgrim guides of the time.

Detail of figure 11.20, Sarcophagus of Doña Sancha

Map 11.1. Europe in the Romanesque Period

At the end of the early medieval period, Europe was still largely an agricultural society. A decentralized political and social system, known today as *feudalism,* had developed, mainly in France and Germany, where it had deep historical roots. In this system, landowning lords granted some of their property to knights (originally, these were cavalry officers). In return for these fiefs, or *feuds,* as the land parcels were called, the knights gave military and other service to their lords, to whom they were linked through a complex system of personal bonds—termed *vassalage*—that extended all the way to the king. A large class of generally downtrodden, virtually powerless peasants (*serfs*) worked the land itself. Towns that had shrunk in size during the migrations and invasions of the early

Middle Ages—Rome, for instance, with about 1 million people in 300 CE had fallen to less than 50,000 at one point, and some smaller cities were deserted altogether—started to regain their former importance. New towns sprang up everywhere, achieving independence via charters that enumerated a town's privileges and immunities in return for a feudal lord's guarantee of protection

These social changes were also made possible by technological advances in agriculture, such as improved milling machinery and better iron plows that dug deeper furrows. For the first time since the fall of Rome, farmers could grow more food than they needed for themselves. In many ways, then, Western Europe between 1050 and 1200 became a great

deal more "Roman-esque" than it had been since the sixth century. It recaptured some of the trade patterns, the urban quality, and the military strength of ancient imperial times. To be sure, there was no central political authority, for Europe was still divided into small units ruled by powerful families. Even the king of France controlled not much more than the area around Paris. However, some monasteries came to rival the wealth and power of kings, and the central spiritual authority of the pope acted as a unifying force throughout Europe. In 1095 Pope Urban II called for the First Crusade to liberate the Holy Land from Muslim rule and to aid the Byzantine emperor against the advancing Turks. The army of Crusaders was far larger than a secular ruler could have raised for the purpose.

This First Crusade managed to win Jerusalem after three years, but later crusades were generally disastrous. The Second Crusade (1147–1149), which was called for by St. Bernard of Clairvaux after the fall of Edessa to the Turks, succeeded only in capturing Lisbon from the Arabs, while the Third Crusade, begun in 1189, failed to reconquer Jerusalem from the sultan Saladin, who had taken it two years earlier. The Fourth and final major Crusade did little to hinder the advance of Islam; its sole result was the fall of Constantinople in 1204.

This brief historical account underscores the number of institutions, organizations and systems that helped to create European stability. Monasticism, feudalism, urbanism, commerce, pilgrimage, crusade, papacy, and the royal court all played their roles by setting into motion internationalizing forces that affected the transmission of artistic forms. Population growth and the increase in the number of new settlements stimulated building activity, much of it for Christian use. The development of better tools, such as saws to cut stone, resulted in improved masonry techniques. Many new constructions were made of well-cut, straight-edged blocks of stone and were monumental, built on a scale that rivaled the achievements of Rome. The heavy walls created solid and durable structures that convey a sense of enclosure and security, and the stone vaults covering these buildings enhanced their stability. These vaults, as well as the proliferation of architectural sculpture, consciously emulated the Roman manner of construction and design. Embellishing churches and monasteries with reliquaries and other adornments, including illuminated manuscripts, provided for the needs of both the local population and pilgrims.

FIRST EXPRESSIONS
OF ROMANESQUE STYLE

Although Romanesque art quickly spread throughout Europe, its first appearances occur in a zone running from Lombardy in Italy through southern France and into northern Spain, into the region of Catalonia. Even today, stone-vaulted buildings decorated with wall arcades and architectural sculpture, which are characteristic features of this early phase, survive in great numbers in these regions.

Architecture

The most striking feature of Romanesque art is the amazing increase in building activity. An eleventh-century monk, Raoul Glaber, conveys the enthusiasm for building that characterizes the period:

> . . . there occurred throughout the world, particularly in Italy and in Gaul, a rebuilding of church basilicas . . . each Christian people strove against the others to erect nobler ones. It was as if the whole earth, having cast off the old by shaking itself, were clothing itself everywhere in the white mantel of the church.
>
> E.G. Holt, *A Documentary History of Art*. Vol. I, 1957, p. 18.

These churches were not only more numerous than those of the early Middle Ages, they were also larger, more richly ornamented, and more "Roman-looking." Their naves had stone vaults instead of wooden roofs, and their exteriors were decorated with both architectural ornament and sculpture. Romanesque monuments of the first importance are distributed over an area that might well have represented the Catholic world: from northern Spain to the Rhineland, from the Scottish-English border to central Italy.

CHURCH OF SANT VINCENÇ, CARDONA An excellent example of an early phase of Romanesque architecture is the collegiate church of Sant Vincenç (fig. **11.1**), built within the walled confines of the castle at Cardona on the southern flank of the Catalan Pyrenees. The church, begun in 1029 and consecrated in 1040, is straightforward both in plan and in elevation. A barrel-vaulted nave creates a continuous space marked off by transverse arches into units of space called **bays**. The domed bay in front of the **chancel**, the part of the church containing the altar and seats for the clergy and choir, focuses attention on the ceremonial heart of the church. Blind niches in the chancel walls establish a rhythmic variety that is accentuated in the nave by the staggered cadence of massive **compound piers**, solid masonry supports with rectangular projections attached to their four faces. The projections reflect the different structural elements that combine to support the building. One projection rises the full height of the nave to support the transverse arch, another forms the arch that extends across the side aisle, and two others connect to the arches of the nave arcade.

Sant Vincenç's vertical integration of piers and vault is undoubtedly derived from the desire to unify the elevation in early medieval buildings, for example the Carolingian chapel at Aachen (see fig. 10.17) and the Ottonian church at Gernrode (see fig. 10.22). However, the wall planes of the Ottonian church appear flat by comparison to the angular surfaces of Sant Vincenç, where the clarity of articulation endows the building with a heightened sense of unity and harmony. The compound pier is, in fact, a major architectural innovation of the Romanesque period. Limited light and robust stone construction create an interior at once sheltering and inspiring; the sober arrangement of simple yet powerful forms is masterfully realized.

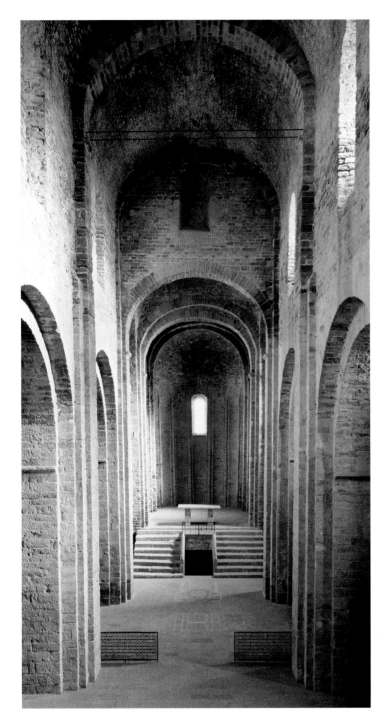

11.1. Nave and choir (looking east), Sant Vincenç. ca. 1029–1040. Cardona, Spain

Monumental Stone Sculpture

The revival of monumental stone sculpture in the Romanesque era is as significant as the architectural achievements of the period. Free-standing statues had all but disappeared from Western art after the fifth century, and stone relief survived only as architectural ornament or surface decoration, while three-dimensional sculpture was rare. Thus, the only sculptural tradition that continued through the early medieval period was that of sculpture-in-miniature: small reliefs and occasional statuettes in metal or ivory. In works such as the bronze doors of Bishop Bernward (see fig. 10.26), Ottonian art had enlarged the small

scale of this tradition but had not changed its spirit. Moreover, its truly large-scale sculptural efforts, such as the *Gero Crucifix* (see fig. 10.35), were limited almost entirely to wood.

LINTEL AT SAINT-GENIS-DES-FONTAINES The marble lintel at Saint-Genis-des-Fontaines, on the French side of the Pyrenees, is dated by inscription to between 1020 and 1021 (fig. **11.2**). It spans the doorway of the church and is one of the earliest examples of Romanesque figurative sculpture. The inscription cites the leaders of two stabilizing institutions of the period, *Rotberto Rege* (King Robert) and *Willelmus Aba* (Abbot William), the former a feudal lord and the latter the leader of a monastery. The central motif, Christ in Majesty supported by angels, is flanked by six apostles; each apostle holds a book and stands under an arcade. Christ's mandorla is formed by two intersecting circles. One symbolizes the Earth and the other the heavens, the two realms over which he presides.

The Saint-Genis lintel is modest in size, only about 2 feet high by 7 feet long. The reliance on line to indicate facial features, drapery folds, and ornamental decoration is reminiscent of early medieval manuscript illuminations and reaches as far back as the Hiberno-Saxon period (see fig. 10.7). The carving, with flat surfaces marked by incision, resembles the minor arts, particularly ivory and metalwork. This can be verified by comparing some of the patterns (for example, the beading around the arches) with metalwork techniques (see fig. 10.1). The correlation explains where carvers might have found their sources of inspiration after centuries during which stone sculpture had been virtually abandoned.

Although the figures are rendered with individualized hairstyles and facial features and with a variety of gestures, they are clearly stylized. Each conforms to the frame around him so that it is difficult to decide if the figures are governed by their frames or if the arches swell in response to the figures. The equilibrium between frame and figure parallels the harmonious balance between structure and decoration that characterizes early Romanesque buildings such as Sant Vincenç at Cardona.

MATURE ROMANESQUE

Early Romanesque experiments in sturdy construction, which relied on the skills of masons and sculptors, led to buildings that employed both more sculpture and increasingly sophisticated vaulting techniques. Sculptural decoration was arranged into complicated and didactic iconographic programs. Romanesque architecture and sculpture continue to convey messages of security and spirituality, employing a consistent aesthetic approach that is also visible in the manuscripts and metalwork produced during the period. As Romanesque art developed, it spread throughout Europe becoming a pan-European art.

Pilgrimage Churches and Their Art

Among the most significant social phenomena of eleventh- and twelfth-century Europe was the increased ability of people of all classes to travel. While some journeys were a result

of expanded trade, others, such as a crusade or pilgrimage, were ostensibly for religious purposes. Individual pilgrims made journeys to holy places for different reasons, but most shared the hope that they would find special powers or dispensations as a result of their journey. Pilgrimage was not a Romanesque invention. As early as the late fourth century, Egeria, a Spanish pilgrim to Jerusalem, chronicled her visit to the locations central to Christ's life, among them the Church of the Holy Sepulcher (see fig. 8.9). Special, often miraculous, powers associated with these holy sites were transferred to *relics*, those body parts of holy persons or objects that had come in contact with Christ, his close followers (see end of Part II, *Additional Primary Sources*), or other holy figures, particularly his mother, the Virgin Mary.

Partly due to the Muslim conquest of the Holy Land, travel there was difficult during the Middle Ages. This led, on the one hand, to the zeal for crusade and, on the other, to the veneration of places within Europe that had important relics or that had been the site of special events. Rome, in particular, became a popular pilgrimage site, beneficiary of the aura of sanctity surrounding SS. Peter and Paul, both of whom lived and were buried there (see page 242). So did Santiago de Compostela on the Iberian peninsula. Cultural anthropologists have attempted to explain the incredible popularity and significance of pilgrimage to the medieval world as well as to our own. They claim that when pilgrims embark on their journey they enter a special transitional

ART IN TIME

1020/21 CE—Marble lintel at Saint-Genis-des-Fontaines, France

ca. 1026—Construction of the al-Aqmar mosque, Cairo

1031—The Caliphate of Córdoba breaks up

1040—Consecration of church of Sant Vicenç in Cardona, Spain

zone where social norms and hierarchies are replaced with a sense of shared experience. This creates a temporary condition of community, in which people of disparate backgrounds and social levels can communicate as equals. The appeal of an escape from daily concerns is particularly understandable after a period of social turmoil. The buildings and objects pilgrims saw and experienced fostered this sense of community.

SANTIAGO DE COMPOSTELA The tomb of St. James at Santiago de Compostela in northwest Spain marked the most westerly point of Christian Europe. According to tradition, the apostle James (*Santiago* in Spanish) had preached Christianity on the Iberian peninsula and returned there under dramatic circumstances after his death. Reports of the tomb's miraculous power attracted large numbers of pilgrims from all over Europe. Many had to brave a difficult

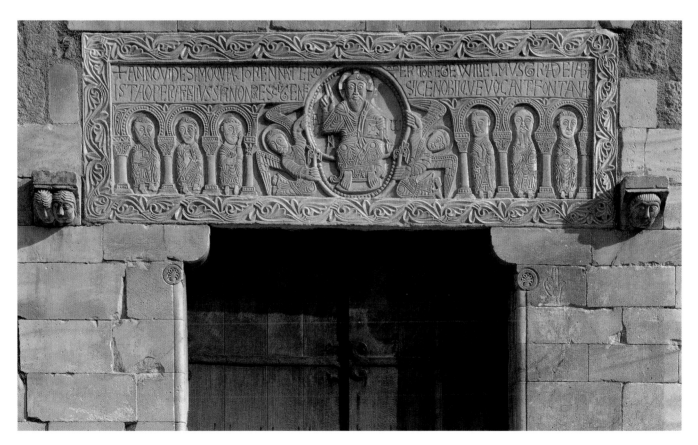

11.2. Lintel of west portal, Saint-Genis-des-Fontaines, France. 1020–1021. Approx. 2 × 7′ (61 × 213.4 cm)

From *Pilgrim's Guide*
to Santiago de Compostela

The Pilgrim's Guide*, written in the mid-twelfth century, gives a vivid account of the routes and what was to be met along them by pilgrims traveling to the shrine of the apostle James in Compostela (see map 11.2). It also provides interesting information on the personnel in charge of the construction of the shrine at the cathedral in Santiago de Compostela.*

There are four roads which, leading to Santiago, converge to form a single road at Puente la Reina, in Spanish territory. One crosses Saint-Gilles [see fig. 11.32], Montpellier, Toulouse [see figs. 11.6–11.9] and the pass of Somport; another goes through Notre-Dame of Le Puy, Sainte-Foy of Conques and Saint-Pierre of Moissac [see figs. 11.13, 11.14]; another traverses Sainte-Marie-Madeleine of Vézelay, Saint-Léonard in the Limousin as well as the city of Périgueux; still another cuts through Saint-Martin of Tours, Saint-Hilaire of Poitiers, Saint-Jean-d'Angély, Saint-Eutrope of Saintes and the city of Bordeaux. . . .

One needs three more days of march, for people already tired, to traverse the Landes of the Bordelais.

This is a desolate region deprived of all good: there is here no bread, wine, meat, fish, water or springs; villages are rare here. The sandy and flat land abounds none the less in honey, millet, panic-grass, and wild boars. If perchance you cross it in summertime, guard your face diligently from the enormous flies that greatly abound there and which are called in the vulgar wasps or horseflies; and if you do not watch your feet carefully, you will rapidly sink up to the knees in the sea-sand copiously found all over.

Having traversed this region, one comes to the land of Gascon rich in white bread and excellent red wine. . . . The Gascons are fast in words, loquacious, given to mockery, libidinous, drunkards, prodigal in food. . . . However, they are well-trained in combat and generous in the hospitality they provide for the poor. . . .

They have the habit of eating without a table and of drinking all of them out of one single cup. In fact, they eat and drink a lot, wear rather poor clothes, and lie down shamelessly on a thin and rotten straw litter, the servants together with the master and the mistress.

On leaving that country, . . . on the road of St. James, there are two rivers. . . . There is no way of crossing them without a raft. May their ferrymen be damned! . . . They have the habit of demanding one coin from each man, whether poor or rich, whom they ferry over, and for a horse they ignominiously extort by force four. . . . When boarding . . . one must be most careful not to fall by chance into the water. . . .

Many times the ferryman, having received his money, has such a large troop of pilgrims enter the boat that it capsizes and the pilgrims drown in the waves. Upon which the boatmen, having laid their hands upon the spoils of the dead, wickedly rejoice.

The Stonecutters of the Church [of St. James] and the Beginning and Completion of Their Work

The master stonecutters that first undertook the construction of the basilica of the Blessed James were called Master Bernard the elder—a marvelously gifted craftsman—and Robert, as well as other stonecutters, about fifty in number, who worked assiduously under the most faithful administration of Don Wicart, the head of the chapter Don Segeredo, and the abbot Don Gundesindo, during the reign of Alphonso king of Spain and during the bishopric of Don Diego I, a valiant soldier and a generous man.

The church was begun in the year 1116 of the era. . . . And from the year that the first stone of the foundations was laid down until such a time that the last one was put in place, forty-four years have elapsed.

SOURCE: *THE PILGRIM'S GUIDE TO SANTIAGO DE CAMPOSTELA*, ED. AND TR. WILLIAM MELCZER (NY: ITHACA PRESS, 1993)

sea journey or an exhausting crossing of the Pyrenees Mountains in order to reach the apostle's tomb at Compostela. (See *Primary Source*, above.) Some years during the twelfth century tens of thousands made the journey. The difficulty of the journey added to its allure. Since much of Spain was under Muslim control, pilgrims considered the trip to Santiago equivalent to a journey to the Muslim-held Holy Land.

The Cathedral at Santiago de Compostela had much to offer those brave hearts sufficiently fortunate to reach their goal. The plan of the church (fig. **11.3**) includes side aisles that run uninterruptedly around the church and form an ambulatory around the apse. Visitors used these aisles to circumambulate the church, even when the religious offices were being celebrated in the nave and crossing. **Apsidioles**, or small apse-like chapels, arranged along the eastern walls of the transepts and around the apse, provide multiple opportunities to display the relics that pilgrims had come to venerate. As pilgrims approached the nave from the west entrance and walked through the building, they were conscious of marching step by step toward their goals in the apses, altars, and reliquaries at the east end of the church.

Passage through the cathedral was thus a microcosm of the longer journey the pilgrims has taken on the open road, and the cathedral might readily be called a **pilgrimage plan** church. Although not all pilgrimage churches have this same plan, a group of great churches of varying sizes and details, using the same pilgrimage plan as Santiago de Compostela, were built along the roads leading to Compostela. A major church built using this pilgrimage plan is situated on each of the four main roads leading through France: Saint-Martin at Tours (on the road from Paris), Saint-Martial at Limoges (on the road from Vézelay), Sainte-Foy at Conques (on the road from Le Puy), and Saint-Sernin at Toulouse (on the road from Saint-Gilles-du-Gard). (See map 11.2.)

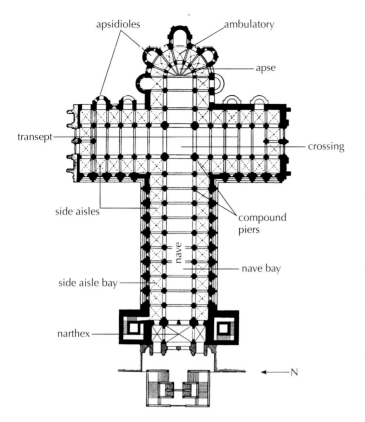

11.3. Plan of Cathedral of Santiago de Compostela, Spain (after Dehio)

In truth, in this church no fissure or fault is found; it is admirably constructed, grand, spacious, bright, of proper magnitude, harmonious in width, length and height, of admirable and ineffable workmanship, built in two storys, just like a royal palace. For indeed, whoever visits the naves of the gallery, if he goes up sad, after having seen the perfect beauty of this temple, he will be made happy and joyful.

Paula Gerson, Annie Shaver Crandell, Alison Stoves and Jeanne Krochalis, *Pilgrim's Guide to Santiago de Compostela: A Critical Edition*, II. London, 1998, pp. 69–71.

The synthesis of emotional and spiritual response described in the *Pilgrim's Guide* results from the Romanesque builders' ability to fuse structure and aesthetics. In another section of his book, the *Guide*'s author notes with admiration the quality of the stonework, as "hard as marble." By using a simile that compares the stone used to build the cathedral with the quintessential building material of the Classical past, he clearly expresses a fact that viewers today can also appreciate, that in both detail and execution Santiago de Compostela emulates the nobility and dignity of Roman architecture.

The plan of Santiago de Compostela (see fig. 11.3) is composed of multiple modular units. It recalls the system of architectural composition based on additive components that was employed during the early Middle Ages (see pages 329–332). The bays of the nave and the transept are half the size of the square crossing, and the square bays of the side aisles are in turn a quarter the size of the crossing and thus half the size of the nave bays. The building's elevation (fig. **11.4**) mirrors the clarity of its plan. As at Sant Vincenç at Cardona (see fig. 11.1), the four colonnettes of the compound piers reflect the building's structural elements. However, there is less wall surface in the Santiago de Compostela nave, and **colonnettes**, small attached columns, more richly articulate the compound piers.

So as not to weaken the barrel vaults at their springing, precisely where they would need the most support, Santiago de Compostela was built without a clerestory. Diffused light, subtle and atmospheric, filters into the nave through the side aisles and the galleries above. What function the galleries might have served is much debated. Conceivably they provided overflow space for the large numbers of pilgrims who visited the church, particularly on feast days, and indeed the famous *Pilgrim's Guide*, written around 1130, mentions the presence of altars in the galleries. But the galleries also provide for an elegantly elaborated interior, as the *Pilgrim's Guide* also makes clear:

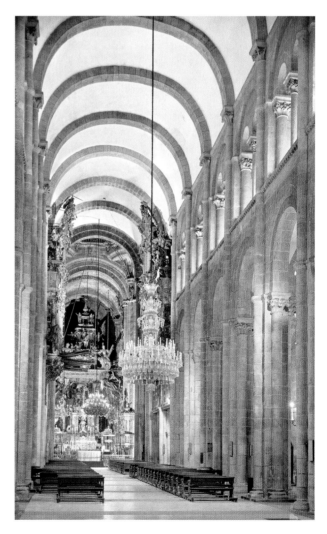

11.4. Nave, Santiago de Compostela, Spain. ca. 1075–1120

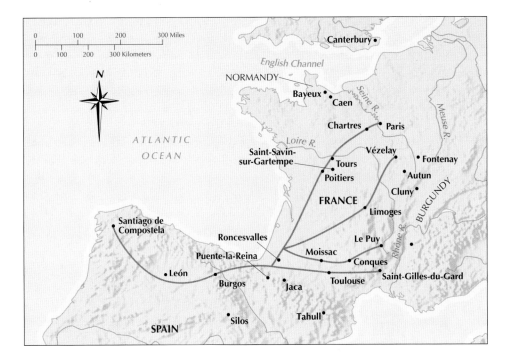

Map 11.2. The Pilgrimage Routes to Santiago de Compostela

RELIQUARIES A twelfth-century casket, today in the Metropolitan Museum of Art in New York (fig. **11.5**), is typical of the kinds of decorated reliquaries that pilgrims saw on their journeys to Compostela and Rome. This one was probably made in Limoges, a major stop on the road to Compostela and a center of enamel production, where there was a large church built in the pilgrimage plan. The material and the bold areas of flat color, evident in both the foliage and the symbols of the four evangelists, relate this work to the tradition of migration and early medieval metalwork (see fig. 10.3). The method of manufacture is **champlevé**, which was derived from the cloisonné technique (see page 313). Instead of cells formed from thin strips of metal attached to a support, as with cloisonné, the metal surface of champlevé is gouged out to create compartments that contain the colored enamel. The preciousness of the enamel on the gilt copper of our reliquary and its lavish decoration suit its exceptional and holy contents, thought to be relics of St. Martial, identified by inscription on the other side of the box, since the reliquary comes from a church dedicated to him in Champagnat, about 60 miles from Limoges.

CHURCH OF SAINT-SERNIN, TOULOUSE The plan of Saint-Sernin, at Toulouse (fig. **11.6**) in southwestern France and on the pilgrimage road, is nearly identical to that of Santiago de Compostela (see fig. 11.3) aside from

11.5. Reliquary casket with symbols of the four Evangelists. ca. 1150. Champlevé enamel on gilt copper, $4^7/_8 \times 7^7/_{16} \times 3^3/_8''$ (12.4 × 18.9 × 8.5 cm). The Metropolitan Museum of Art, New York. Gift of J. Pierpont Morgan, 1917 (17.190.685-687, 695, 710-711)

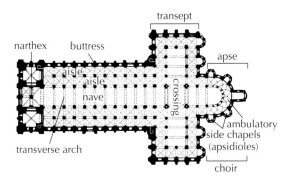

11.6. Plan of Saint-Sernin, Toulouse. ca. 1070–1120. France (after Conant)

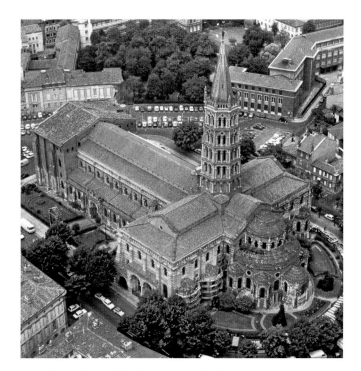

11.7. Saint-Sernin, Toulouse (aerial view)

having two aisles, not one, on either side of the nave. This arrangement is reminiscent of Old St. Peter's Basilica (see fig. 8.4), and it is certainly possible that Saint-Sernin's architects had that Roman basilica in mind when designing this building.

On the exterior of Saint-Sernin (fig. **11.7**), the relationship of elements is enhanced by the different roof levels, which set off the nave and transept against the inner and outer aisles, the apse, the ambulatory, and its radiating chapels. The effect is increased by the buttresses, which reinforce the walls between the windows in order to contain the outward thrust of the vaults, while decorative framing emphasizes the structure of the windows. (The crossing tower was completed several centuries later, in a different style, and is taller than originally intended. The two facade towers, unfortunately, were never finished and remain as mere stumps, not visible in fig. 11.7.)

Inside the nave (fig. **11.8**), vaults, arches, engaged columns, and pilasters are all firmly knit together into a coherent order that recaptures the vocabulary and syntax of ancient Roman architecture to a remarkable degree. Yet the nave of Saint-Sernin no longer expresses the physical, muscular forces of Graeco-Roman architecture. The columns seem driven upward by some tremendous, unseen pressure, as if hastening to meet the transverse arches that subdivide the barrel vault of the nave. Beauty and engineering are once again inseparable in achieving this effect.

Clearly the architectural effort at Saint-Sernin required detailed, systematic planning. Vaulting the nave to eliminate the fire hazard of a wooden roof was not only a practical necessity, it also challenged architects to make the House of the Lord grander. Since a vault becomes more difficult to sustain the farther it is from the ground, every resource had to be strained to enable the nave to be as tall as possible. Here, as at Compostela, galleries were built over the inner aisles, and they counterbalance the lateral pressure of the nave vault. Saint-Sernin reminds us that architecture, like politics, is the art of the possible. Its success, here as elsewhere, is measured by how far the architect has explored the limits of what

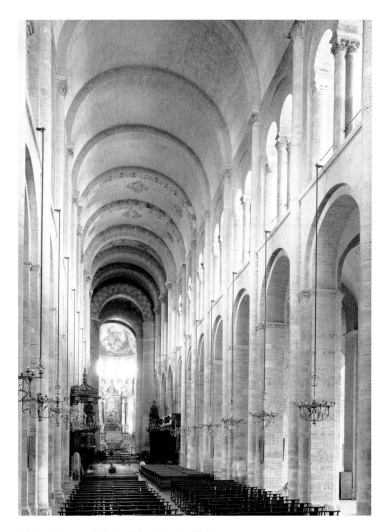

11.8. Nave and choir, Saint-Sernin, Toulouse

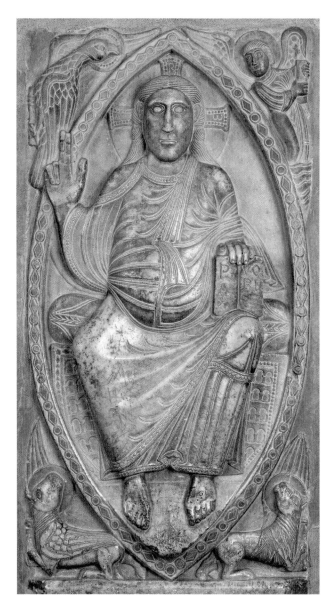

11.9. *Christ in Majesty (Maiestas Domini)*. ca. 1096.
Marble. Height 50″ (127 cm). Saint-Sernin, Toulouse

seemed possible, both structurally and aesthetically, under those particular conditions.

SCULPTURE AT SAINT-SERNIN Both Saint-Sernin and Santiago de Compostela have stone sculptures decorating their interiors and their portals. A series of large marble plaques, currently placed in the ambulatory of Saint-Sernin, date to the years immediately preceding 1100. Six of these plaques depict angels and apostles, while one represents a seated Christ, the *Christ in Majesty* (fig. **11.9**). Although their original location is not certain, the plaques most likely decorated the zone around the altar and shrine of St. Sernin, thus embellishing an area deemed particularly holy by pilgrims.

The shallow relief and many decorative effects of the Christ plaque recall earlier metalwork and ivory objects (see figs. 10.16, 10.31). The extensive use of double lines, some creating raised sections, some impressed ones, enhances the figure's vol-

umetric presence. The treatment also brings to mind manuscript illumination, particularly Carolingian and Ottonian examples, but also Byzantine ones. In the arrangement of the figure, the play of linear drapery folds, and the variety of ornamental devices, we are not far from the Christ of the *Godescalc Gospels* (see fig. 10.11), which was in Saint-Sernin during the Middle Ages.

The figure of Christ, somewhat more than half life-size, was not meant to be viewed exclusively at close range. Its impressive bulk and weight make it prominent even from a considerable distance. This emphasis on volume hints at what may have been the main inspiration behind the revival of large-scale sculpture. A stone-carved image, being solid and three-dimensional, is far more "real" than a painted one. To a cleric steeped in abstract theology, this might seem irrelevant or even dangerous, but for unsophisticated lay worshipers, by contrast, imposing sculpture must have had great appeal.

Cluniac Architecture and Sculpture

During the time when the sculptural decoration of Saint-Sernin was executed, that church was under the auspices of monks from the great Benedictine monastery of Cluny. Cluny was responsible for a network of dependencies; its "daughter" houses, spread across Europe, numbered more than 1,400. This is evidence of the order's influence and growth. The Cluniac order could determine papal elections and call for crusades against the Muslims. The rise and spread of various monastic orders was significant for the development of Romanesque art, but none was more important than Cluny.

ABBEY CHURCH OF CLUNY The rapid growth of the Cluniac order can also be seen in the fact that its original basilica church of about 910 was replaced with an ample one that itself was replaced only about 75 years later, in 1088, by the largest Romanesque church ever built, the third abbey church of Cluny (fig. **11.10**). Unfortunately Cluny III, as it is known, was destroyed after the French Revolution, and only the south transept (the one to the right in the plan), and the octagonal tower remain from what was once the most impressive massing of towers in all of Europe. The auspicious use of towers in Carolingian buildings such as Saint-Riquier (see fig. 10.19) here reached its culmination. The apsidioles,

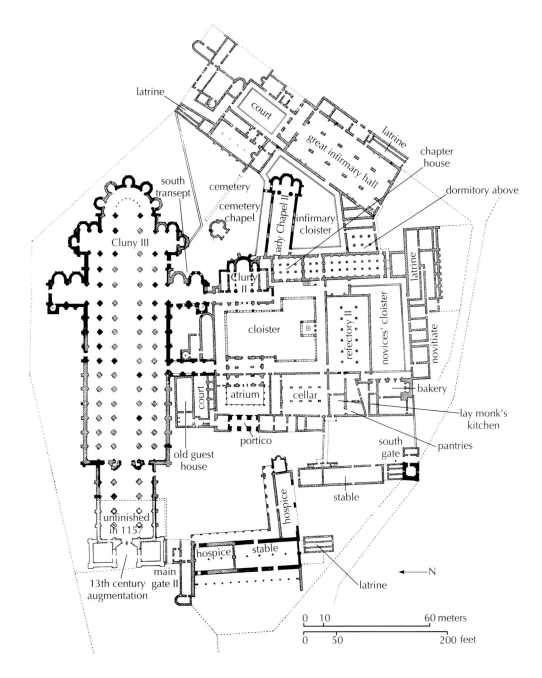

11.10. Gunzo and others. Plan of Monastery of Cluny (Cluny III), France (after Conant). ca. 1088–1130. Darkened areas represent the actual scant remains

apses, and towers at the east end of Cluny created a monumental gathering of ever-higher forms. Individual elements functioned together in built harmony (fig. **11.11**); the south transept with octagonal tower at its crossing is on the left in this reconstruction).

The proportions of Cluny III were based on ratios of "perfect" numbers and on musical harmonies, reminding us of the importance of music to the medieval church. Monks chanted their prayers in the church eight times a day and Gunzo, one of the architects of Cluny III, was noted for his musicianship. A benefit of stone-vaulted buildings was their acoustic resonance; this feature might well have encouraged the widespread use of stone vaulting or at least made the heavy financial investment acceptable to the community. Even today it is a moving experience to hear Gregorian chants sung beneath the vaults of a Romanesque church.

The interior of Cluny III (fig. **11.12**) was as elegant as it was huge, its vaults reaching 100 feet. Below the clerestory,

and in place of a gallery, is a **triforium**, the series of three-arched openings (one series per bay); it creates a space within the wall that lightens the wall both physically and visually. The clerestory and triforium are connected by pilaster strips with Corinthian capitals, reminiscent of Roman architectural decoration. What is not Roman is the use of slightly pointed arches in the nave arcade, a device thought to derive from contact with Islamic culture (see fig. 9.12). By eliminating the center part of the rounded arch, which responds the most to the pull of gravity, the two halves of a pointed arch brace each other. Because the pointed arch exerts less outward pressure than the semicircular arch, not only can it be made steeper, but the walls can be pierced and made lighter.

MONASTERY OF MOISSAC The priory of Saint-Pierre at Moissac, located on the pilgrimage road close to Toulouse and also under the direction of Cluny, was another important center of Romanesque art. The cloister, adjacent to the church and reserved for use by its monks, was formed by four covered passageways arranged around an open garden (fig. **11.13**). Protected from the elements, the monks could practice their spiritual exercises here. The cloister was central to monastic life and physically occupied a central position within the monastic complex, as is seen in the St. Gall and Cluny plans. Seventy-six sculptured capitals decorate this private zone. While they include both Old Testament and New Testament stories, many are decorated with foliage, birds, animals, and monstrous creatures.

Although the Romanesque period is far removed chronologically from the Early Christian aversion to image making, even during this period there were those who objected to the corruptive powers of visual representation. One of them was St. Bernard of Clairvaux, a member of the Cistercian order, a reform movement of Benedictines, created around 1100 as a reaction to the increasing economic and political successes of Cluny. In truth, it is hard to correlate the worldly achievements of a monastery such as those at Moissac or Cluny—the wealth they acquired and the political clout they exercised—with the values to which monks traditionally aspired, which were based on the renunciation of earthly pleasures in favor of the pursuit of spiritual ideals. The pictorial representation of Christian themes was often justified by a famous saying: *Quod legentibus scriptura, hoc idiotis ... pictura.* Translated freely, it means that painting conveys the Word of God to the unlettered. Although St. Bernard did not object specifically to the teaching role of art, he had little use for church decoration and he would surely have disapproved of Moissac cloister's excesses which were clearly meant to appeal to the eye as well as the spirit. In a letter of 1127 to Abbot William of Saint-Thierry concerning the decoration of Cluniac churches, St. Bernard condemned art made for contemplation by monks. (See *Primary Source*, p. 358).

If the Moissac monks had a profusion of sculpture to engage them, so too did pilgrims and layfolk visiting the

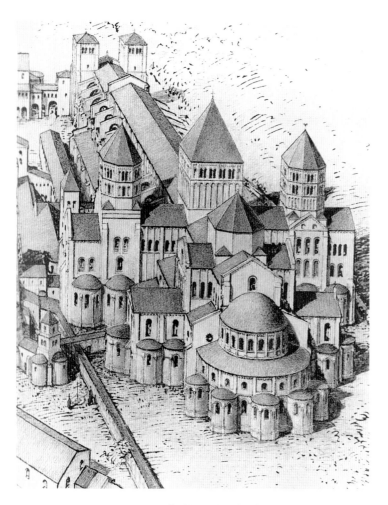

11.11. Reconstruction of Abbey Church of Cluny (Cluny III), from east. (after Conant)

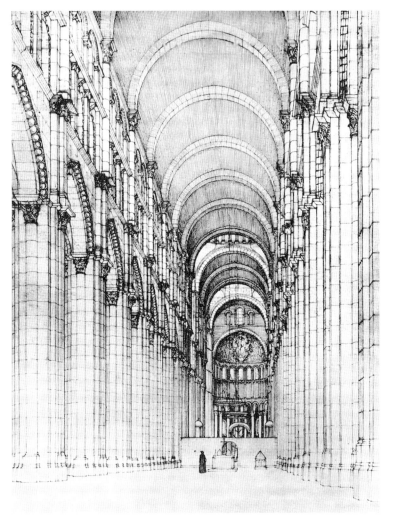

11.12. Reconstruction of Abbey Church of Cluny (Cluny III), nave and interior. (after Conant)

11.13. Cloister, Priory of Saint-Pierre. ca. 1100. Moissac, France

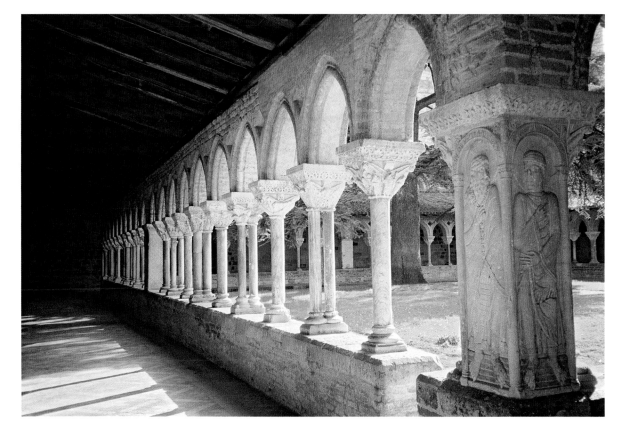

St. Bernard of Clairvaux (1090–1153)

From *Apologia to Abbot William of Saint-Thierry*

Bernard of Clairvaux was a member of the Cistercians, an ascetic order founded in the eleventh century in opposition to the increasing opulence of the Benedictines. His letter to the Benedictine Abbot William of Saint-Thierry of about 1127 denounces all monastic luxury, especially the presence of art in cloisters. Like many others, Bernard believed that monks were spiritually superior to the "carnal" layfolk and so should not need material inducements to devotion.

As a monk, I put to monks the same question that a pagan used to criticize other pagans: "Tell me, priests," he said, "what is gold doing in the holy place?" I, however, say, . . . "Tell me, poor men, if indeed you are poor men, what is gold doing in the holy place?" For certainly bishops have one kind of business, and monks another. We [monks] know that since they [bishops] are responsible for both the wise and the foolish, they stimulate the devotion of a carnal people with material ornaments because they cannot do so with spiritual ones. But we who have withdrawn from the people, we who have left behind all that is precious and beautiful in this world for the sake of Christ, we who regard as dung all things shining in beauty, soothing in sound, agreeable in fragrance, sweet in taste, pleasant in touch—in short, all material pleasures—. . . whose devotion, I ask, do we strive to excite in all this? . . .

Does not avarice cause all this? Money is sown with such skill that it may be multiplied. The very sight of these costly but wonderful illusions inflames men more to give than to pray. In this way wealth is derived from wealth. Eyes are fixed on relics covered with gold and purses are opened. The thoroughly beautiful image of some male or female saint is exhibited and that saint is believed to be the more holy the more highly colored the image is. People rush to kiss it, they are invited to donate, and they admire the beautiful more than they venerate the sacred. What do you think is being sought in all this? The compunction of penitents, or the astonishment of those who gaze at it? O vanity of vanities! The Church is radiant in its walls and destitute in its poor. It serves the eyes of the rich at the expense of the poor. The curious find that which may delight them, but those in need do not find that which should sustain them.

But apart from this, in the cloisters, before the eyes of the brothers while they read—what is that ridiculous monstrosity doing, an amazing kind of deformed beauty and yet a beautiful deformity? What are the filthy apes doing there? The fierce lions? The monstrous centaurs? The creatures, part man and part beast? The striped tigers? The fighting soldiers? The hunters blowing horns? You may see many bodies under one head, and conversely many heads on one body. On one side the tail of a serpent is seen on a quadruped, on the other side the head of a quadruped is on the body of a fish. Over there an animal has a horse for the front half and a goat for the back; here a creature which is horned in front is equine behind. In short, everywhere so plentiful and astonishing a variety of contradictory forms is seen that one would rather read in the marble than in books, and spend the whole day wondering at every single one of them than in meditating on the law of God. Good God! If one is not ashamed of the absurdity, why is one not at least troubled at the expense?

SOURCE: CONRAD RUDOLPH, *THE "THINGS OF GREATER IMPORTANCE": BERNARD OF CLAIRVAUX'S APOLOGIA AND THE MEDIEVAL ATTITUDE TOWARD ART.* (PHILADELPHIA: UNIVERSITY OF PENNSYLVANIA PRESS, 1990)

monastery's church of Saint-Pierre. Its elaborately sculptured portal (fig. **11.14**) was executed almost a generation after the cloister was finished. It displays the parts of a typical Romanesque portal (fig. **11.15**). Christ in Majesty takes center stage in the **tympanum**, the lunette above the lintel of the portal. He is shown during his Second Coming, when he returns to Earth after the apocalyptic end of days, as described in the book of Revelation (4:1–8), in order to judge mortals as saved or damned. In accord with the biblical account, Christ is attended by four beasts, which accompany two angels and 24 elders, while wavy lines beneath their feet represent "the sea of glass like crystal." The elders, relatively small compared with the other figures, and many of them gesticulating, can barely contain their excitement in the face of the remarkable vision. Abstraction and activity characterize the style of carving, in which quivering lines, borders of meandering ribbon patterns, and fluttering drapery offset a hierarchy of scale and pose. The use of abstraction in the service of religious zeal has parallels in earlier medieval art, for example the manuscript illuminations of the *Ebbo Gospels* (see fig. 10.14) and the *Utrecht Psalter* (see fig. 10.15). At Moissac, however, the presentation is on a monumental and public scale.

Other parts of the Moissac portal are also treated sculpturally. Both the **trumeau** (the center post supporting the lintel) and the **jambs** (the sides of the doorway) have scalloped outlines (see fig. 11.14), modeled on a popular Islamic device. By borrowing forms from the art of Islam at Moissac and other churches, Christians were expressing their admiration and regard for Arab artistic achievements. At the same time, such acts of appropriation could also express the Christian ambition to dominate the Muslim enemy. The pilgrimage to Santiago was a similar manifestation of anti-Islamic feeling.

The scalloped outlines framing the doorway activate and dramatize the experience of entering the church. Human and animal forms are treated with flexibility; for instance, the spidery prophet on the side of the trumeau seems perfectly

11.14. South portal with *Second Coming of Christ* on tympanum, Church of Saint-Pierre, Moissac. ca. 1115–1130

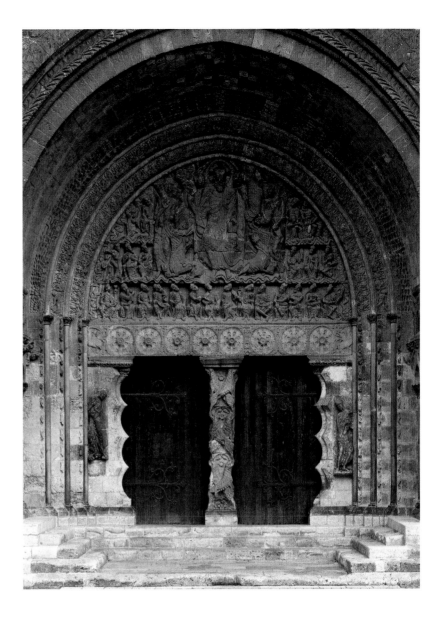

11.15. Romanesque portal ensemble

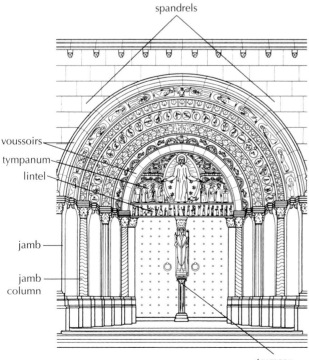

spandrels

voussoirs

tympanum

lintel

jamb

jamb column

trumeau

adapted to his precarious perch, even as he struggles to free himself from the stone (fig. **11.16**). With legs crossed in a graceful movement, he turns his head toward the interior of the church as he unfurls his scroll. The crossed lions that form a symmetrical zigzag on the face of the trumeau "animate" the shaft the same way the interlacing beasts of Irish miniatures (from which they are descended) enliven the spaces they inhabit.

We can trace the crossed lions through textiles to Persian metalwork, although not in this towerlike formation. Ultimately they descend from the heraldic animals of ancient Near Eastern art (see fig. 2.10). Yet we cannot account for their presence at Moissac in terms of their effectiveness as ornament alone. They belong to an extensive family of savage or monstrous creatures in Romanesque art that retain their demoniacal vitality even as they are forced to perform a supporting function. Their purpose is thus not only decorative but expressive; they embody dark forces that have been domesticated into guardian figures or banished to a position that holds them fixed

for all eternity, however much they may snarl in protest. One medieval bishop argued that seeing animals sculpted in churches would so terrify parishioners that they would be encouraged to refrain from sinful deeds.

A deep porch with lavishly sculptured lateral ends frames the Moissac portal. Within an arcade on the east flank (fig. **11.17**), we see the Annunciation to the Virgin, on the lower left, and to the right, the Visitation (when Mary visits her cousin Elizabeth, mother of John the Baptist, to announce that she is pregnant) and the Adoration of the Magi in the top two panels under the arches. Other events from the early life of Jesus are on the frieze above. All of the figures have the same thin limbs and eloquent gestures as the prophet on the trumeau. Note, in particular, the wonderful play of hands in the Visitation and Annunciation. (The angel of the Annunciation is a modern replacement.). On the west flank, not illustrated here, is a representation of the vice of *luxuria* (lust) presented as antithetical to the virtue of the Virgin Mary. The juxtaposition recalls the pairing during the early Middle Ages of Eve's sinfulness with Mary's purity (see fig. 10.26). The messages at Moissac are patently didactic, meant both to command and to enlighten. When visitors on the pilgrim road faced the deep portal of the church they were virtually surrounded by the sculptural program, and this intensified the liminal experience of crossing into the church. The journey into the church became a veritable rite of passage, transformative both physically and spiritually.

CATHEDRAL OF SAINT-LAZARE, AUTUN Close to Cluny and dependent on it was the Cathedral of Saint-Lazare at Autun. The tympanum of its west portal (fig. **11.18**) represents the Last Judgment, the most awe-inspiring scene in Christian art. This scene depicts Christ after his Second Coming as he separates those who will be eternally saved from those who are damned. His figure, much larger than any other, dominates the tympanum. The sculptor, Gislebertus, whose signature appears immediately under the feet of Christ in the center of the tympanum, treats the subject with extraordinary force. Gislebertus is only one of a number of Romanesque sculptors with distinct artistic personalities who are known to us by name. His style is sufficiently individual to enable scholars to posit convincingly that he trained at Cluny before his elevation to master's rank at Autun.

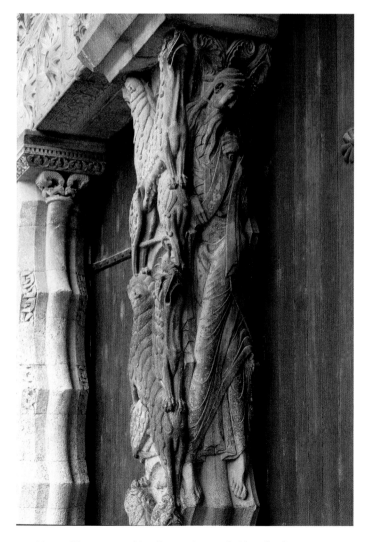

11.16. Trumeau and jambs, south portal, Church of Saint-Pierre, Moissac

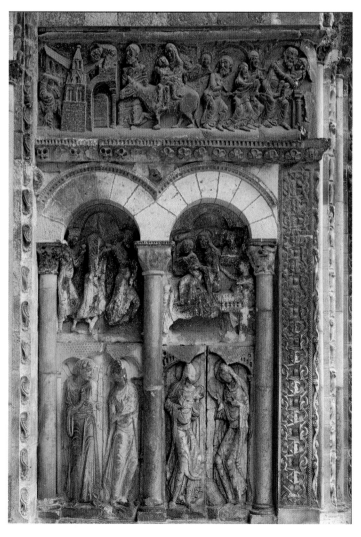

11.17. East flank, south portal, Church of Saint-Pierre, Moissac

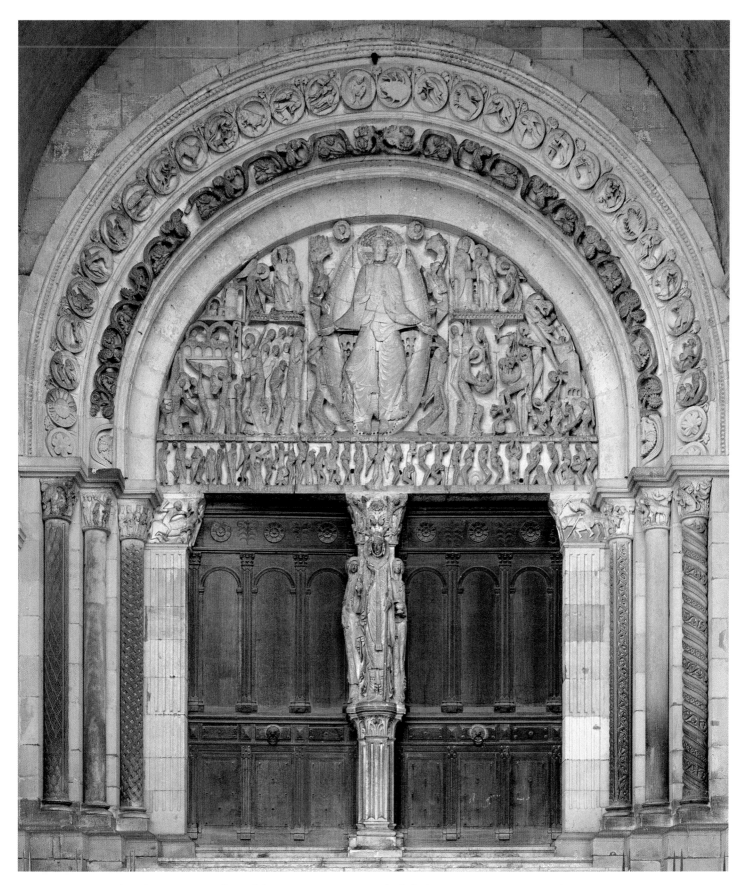

11.18. West portal, with *Last Judgment* by Gislebertus on tympanum, Cathedral of Saint-Lazare. ca. 1120–1135. Autun, France

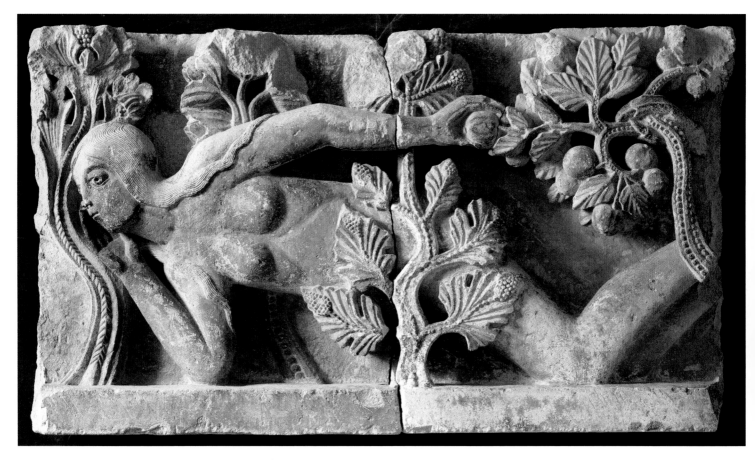

11.19. Gislebertus. *Eve*, right half of lintel, north portal from Cathedral of Saint-Lazare, Autun. 1120–1132. $28\frac{1}{2} \times 51''$ (72.4 × 129.5 cm). Musée Rolin, Autun

On the left side of the tympanum, apostles observe the weighing of souls, which takes place on the right side. Four angels in the corners sound the trumpets of the Apocalypse. At the bottom, the dead rise from their graves, trembling with fear; some are already beset by snakes or gripped by huge, clawlike hands. Above, their fate quite literally hangs in the balance, with devils yanking at one end of the scales and angels at the other. The saved souls cling like children to the angels for protection before their ascent to the Heavenly Jerusalem (far left), while the condemned, seized by grinning devils, are cast into the mouth of Hell (far right). These nightmarish devils are human in general outline, but they have birdlike legs, furry thighs, tails, pointed ears, and savage mouths. The hierarchical, abstract, and patterned representation of Christ conveys his formidable power more effectively than any naturalistic image could. No visitor who had "read in the marble" (to quote St. Bernard of Clairvaux) could fail to enter the church in a chastened spirit.

The Last Judgment, with its emphasis on retribution, was a standard subject for the tympana of Romanesque churches. It was probably chosen because medieval judgment was dispensed in front of the church portal, *ante ecclesium*. Thus, actual judicial proceedings paralleled the divine judgment represented here. Trial was by *ordeal*, whereby the accused established innocence only by withstanding grueling physical tests. The ordeals must, in reality, have been as terrifying as the scenes depicted on the tympanum.

The outer **archivolt** (a molded band forming an arch) surrounding the west tympanum on Autun's cathedral is composed of medallions containing calendar scenes, comprised, in typical medieval fashion, of the signs of the zodiac and the corresponding labors of the months. The calendar serves to place the fearsome events of the Last Judgment within cosmological time, that is, within the physical realm that all of us occupy on earth.

The north portal of the cathedral was dismantled in the eighteenth century but Gislebertus's *Eve* (fig. **11.19**), a fragment of the lintel, survives in the Musée Rolin. It demonstrates the master's incredibly expressive range. The relief was balanced on the other side of the lintel by a representation of Adam. Once again the choice of subjects undoubtedly relates to the portal's liturgical function, since public penitential rites took place in front of the north portal. Adam and Eve's sin—the original one, after all—was mentioned in the penitential liturgy, in which sinners, seeking forgiveness for their transgressions, participated. In the relief, Eve's delicate gestures of grasping the fruit and touching her cheek as if in contemplation result in a beguiling, sensual silhouette. Her posture is not merely the consequence of the narrow horizontal space she occupies; rather, her pose emulates a slithering earthbound serpent, so she is temptress as well as tempted. As we saw on the bronze doors of Bishop Bernward at Hildesheim (see fig. 10.26), in medieval eyes Eve symbolized the base enchantments embodied by all worldly women, though not all regions of Romanesque Europe saw women so negatively.

SARCOPHAGUS OF DOÑA SANCHA Worldly women are not always represented as debased subjects in the Middle Ages, as a viewer can see in the stone sarcophagus created around 1120 to house the remains of Doña Sancha, a princess of the kingdom of Aragon, in northern Spain. Aragon had strong ties to Cluny; about 50 years before Sancha's sarcophagus was carved, her brother, King Sancho Ramírez, undertook a Cluniac reform of the monasteries in his kingdom. This was part of his efforts to strengthen Christian foundations in Spain, a reaction to the Muslim presence on the Iberian peninsula. Sancha was active in supporting her brother's efforts.

At the center of one side of the *Sarcophagus of Doña Sancha* (fig. **11.20**), two angels support a nude figure in a mandorla, representing the soul of the deceased being lifted to heaven, an appropriate subject for a funerary monument. On the left, three clerics under an arch perform a Mass for the dead, and on the right, two women, probably Sancha's sisters, stand under an arch and flank the enthroned princess. The arrangement in this right panel, which proclaims the dignity and importance of the larger central figure of Sancha, relies on an antique tradition, seen, for example, on the fourth-century *Sarcophagus of Junius Bassus* (see fig. 8.20).

On the other side of the sarcophagus are three mounted figures, each under an arch. Two armed horsemen confront each other, while the third straddles a lion and grasps its open jaws with his hands. The most compelling interpretation of the confronted horsemen identifies them as combatants in the struggle between good and evil, a common subject in Christian art. The lion rider in the right arcade has variously been identified as the long-haired Samson or the youthful David, both Old Testament prototypes for the Christian struggle over evil. The stone sarcophagus connects Sancha's tomb with Early Christian precedents (see figs. 8.2, 8.20); so too, the iconographic program relates it to Early Christian methods of argument.

Sancha was a major personage in her kingdom at a time when the Aragonese kings struggled to conquer Spain from the Muslims, who held sway over much of the Iberian peninsula. That scenes of battle, even ones that can be symbolically or allegorically interpreted, were considered appropriate for the sarcophagus of a woman is a mark of the culture of Romanesque Spain, which one scholar has called "a society organized for war." Many legends sprang up about women's roles in the defense of newly conquered Christian territories. The pressing needs for settlement and permanent organization required

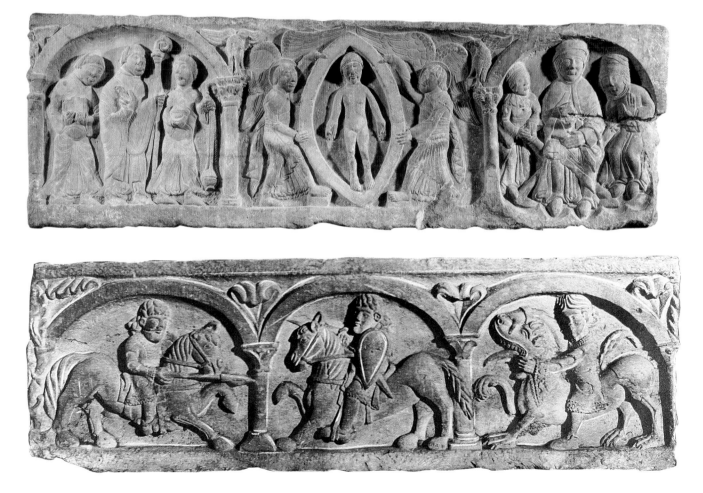

11.20. *Sarcophagus of Doña Sancha,* front and back sides. ca. 1120. Stone, 25.8 × 78.74″ (65 × 200 cm). Monastério de las Benedictinas, Jaca, Spain

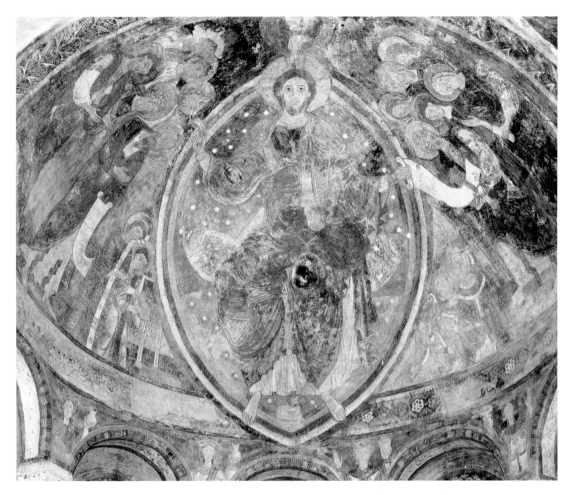

11.21. *Christ and Apostles*. Painting in the apse. Early 12th century. Priory of Berzé-la-Ville, France

women to engage actively in the acquisition and exchange of land and other properties at a time when their men were away on military campaigns.

Doña Sancha herself assumed enormous responsibilities within the court and kingdom. These included the management of large estates, which she held in her own right, and for some years she was administrator of the bishopric of Pamplona, a remarkable assignment for a woman. If Sancha were an isolated instance of a woman of power enjoying special prestige, it would not add much to our knowledge of the Romanesque period. But in fact, women in eleventh- and twelfth-century Spain played an inordinately important role in the formation of political structures, and as commissioners of works of art.

The triumphal aspirations represented on Sancha's sarcophagus are balanced by the sensitive representation of the soul, whose tender expression suggests hope as well as anxiety, common human responses when contemplating death. Notice how the center group is the only one not covered by an arch, a strategy that emphasizes a sense of upward thrust and hence suggests a heavenly journey.

Cluniac Wall Painting

Because the destruction of Cluny's buildings resulted in the loss of its wall paintings, we can best appreciate what these might have looked like by examining allied monuments. A good one for this purpose is the priory of Berzé-la-Ville

THE BERZÉ-LA-VILLE APSE The early twelfth-century priory of Berzé-la-Ville, just a few miles southeast of Cluny, was built as a retreat for Cluny's abbot, and the apse paintings in its chapel (fig. **11.21**) emulate those in the church of the motherhouse. Christ in Majesty occupies the center of the composition, surrounded by the apostles. The elongated faces and the graceful manner in which drapery is pulled across limbs impart delicacy and elegance to the images; patterns of rhythmic concentric lines and bright highlights indicate the multiple folds in the cloth. Although these devices ultimately derive from Byzantine sources, such as the *Paris Psalter* (see fig. 8.40), the path by which they were acquired was indirect, coming from Byzantine art in Italy, not Constantinople. The library at Cluny was rich in Italo-Byzantine manuscripts, and Cluniac manuscript illumination also favors this style.

Cistercian Architecture and Art

As we have seen, Cluny's very success made it the subject of criticism, particularly by the Cistercians, whose motherhouse was at Cîteaux in Burgundy. In addition to prayer, the Cistercians devoted themselves to hard work, which helped guarantee their own great success. Sound economic planning, skill in agriculture and husbandry, and wealthy benefactors furthered their cause. At a time of rising urban growth, the serenity of the isolated sites of their monasteries must also have been attractive. The Cistercian order and its style spread across

11.22. Plan of Fontenay Abbey, France

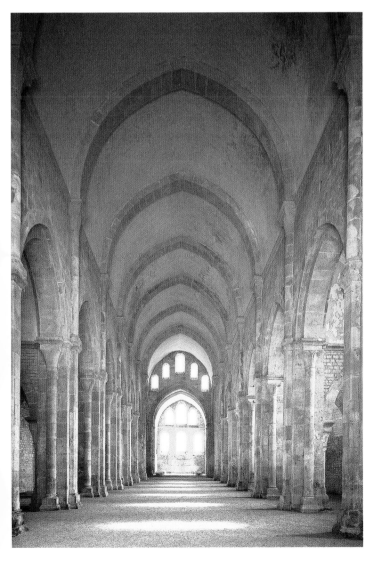

11.23. Nave, Abbey Church, Fontenay. 1139–1147

Europe, and by the end of the twelfth century the Cistercians controlled nearly 700 monasteries. Cistercian architecture in its simplicity contrasts markedly with the architecture of the Cluniac order.

ABBEY CHURCH AT FONTENAY The abbey church at Fontenay, not far from Cîteaux, was begun in 1139, a generation after St. Bernard founded a monastery there. It is the best-preserved Cistercian church built in the first half of the twelfth century. Fontenay exemplifies the Cistercian reliance on simple and unadorned forms in contrast to the opulence promulgated by Cluny. In its orderliness, the plan of simple geometric shapes (fig. **11.22**) builds on monastic schemes dating as far back as the St. Gall drawing (see fig. 10.21). By comparison to the expansive plan of Cluny (see fig. 11.10), where the huge abbey church dominated a sprawling complex, Fontenay is precise, a pure and tightly controlled equilibrium balancing all of its constituent parts.

The east end of the church at Fontenay is unembellished by apses, and no towers were planned. Since Cistercians permitted neither sculpture nor wall painting, the interior of the church (fig. **11.23**) lacks applied decoration. Clerestory and gallery are suppressed. However, in their own terms, the clean lines of the pointed transverse arches that define the nave and openings into the side aisles, and the pattern of unframed windows, create an elegant refinement. The simple forms are at once graceful and moving. Once again, the church serves as a safe, tranquil, and spiritual refuge from worldly burdens, although different in effect from the protective enclosures that other Romanesque churches offer (see figs. 11.1, 11.4, and 11.8).

Other Benedictine Architecture and Wall Painting

The Benedictine abbey church of Saint-Savin-sur-Gartempe is of a type known as a **hall church** (fig. **11.24**). The nave vault lacks transverse arches. Its weight rests directly on the nave arcade, which is supported by a majestic set of columns. The nave is fairly well lit, for the two aisles are carried almost to the same height as the nave, and their outer walls have generous windows.

Although Saint-Savin-sur-Gartempe has a luxurious sculptural program and a rich doorway, the hall church was designed particularly to offer a continuous surface for murals. *The Building of the Tower of Babel* (fig. **11.25**) is part of an extensive cycle of Old Testament scenes on the vault. It is an intensely dramatic design, crowded with strenuous action. God himself, on the far left, participates directly in the narrative, addressing the builders of the huge structure. He is counterbalanced, on the right, by the giant Nimrod, leader of the project, who frantically hands blocks of stone to the masons atop the tower. The entire scene becomes a great test of strength between God and mortals. The heavy, dark contours and the emphatic gestures make the composition easy to read from the floor below. Elsewhere in the church the viewer can see New Testament scenes and scenes from the lives

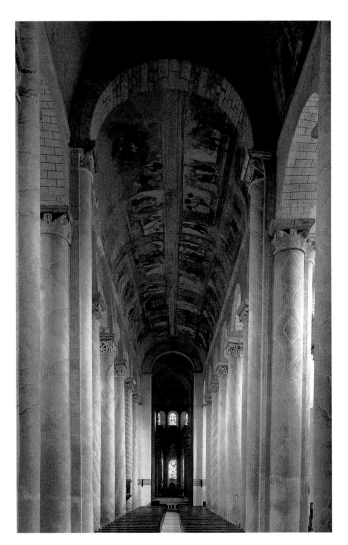

11.24. Choir ca. 1060–1075 and nave ca. 1095–1115. Saint-Savin-sur-Gartempe, France

of local saints. Although paintings in Romanesque churches were not necessarily the norm, they were common features. Many frescoes no longer exist as a result of restoration programs. (See *The Art Historian's Lens*, page 368.)

Book Illustration

As in the early Middle Ages, manuscript production in the Romanesque period continued to be largely the responsibility of monastic scriptoria under the supervision of monks. Manuscripts produced by Cluniac scriptoria are stylistically similar to wall painting in Cluniac churches and often express concerns remarkably akin to those of the period's architects and sculptors. Those produced in Cistercian scriptoria are particularly inventive, often based on the observation of daily life. Many manuscripts produced at Cîteaux show strong English influence, and some were perhaps executed by English illuminators. The interrelationship of monastic communities accounts for a consistency of manuscript production across various regions during the Romanesque period. Some manuscripts produced in northern France, Belgium, and southern England are so related in style that at times we cannot be sure on which side of the English Channel a given manuscript was produced.

THE CLUNY LECTIONARY The *Pentecost* (fig. **11.26**), an illumination from the *Cluny Lectionary*, represents the descent of the Holy Spirit on the apostles after the Resurrection of Christ. As in the apse fresco at Berzé-la-Ville (see fig. 11.21), once again a viewer sees highlighted drapery tautly drawn across limbs. Other stylistic features also recall Byzantine

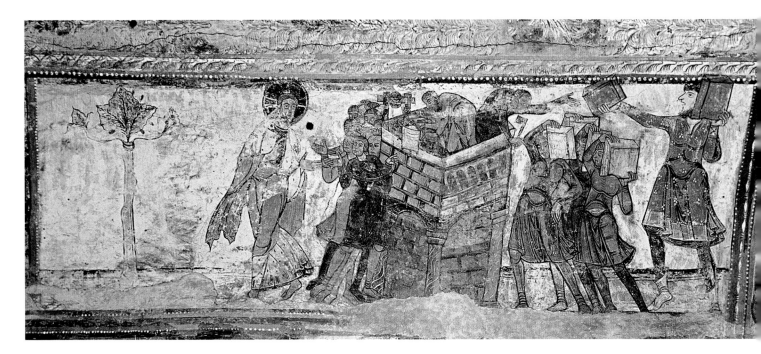

11.25. *The Building of the Tower of Babel.* Early 12th century. Detail of painting on the nave vault, Saint-Savin-sur-Gartempe, France

11.26. *Pentecost*, from the *Cluny Lectionary*. Early 12th century. Tempera on vellum, 9 × 5″ (22.9 × 12.7 cm). Bibliothèque Nationale, Paris, France

beginning of his Gospel, next to an embellished letter L, the first letter of *Liber,* meaning "book." Figures, animals, foliage, and decorative patterns conform to the shape of the letter, recalling the way Romanesque sculptured figures correspond to their frames (see fig. 11.2).

In contrast to the small, freely disposed figures and animals in the initial, the figure of Matthew confronts us directly. Although he fills the available space of the architectural setting, a number of features deny his solidity. The heavy outlines and bold colors are reminiscent of enamelwork (see fig. 11.5) and, in combination with a variety of juxtaposed patterns, serve to flatten the image. These devices demonstrate to what extent forms popular during the early Middle Ages remained vital.

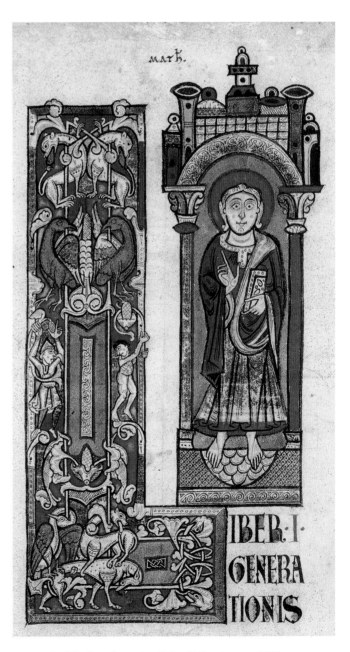

11.27. *St. Matthew*, from the *Codex Colbertinus*. ca. 1100. Tempera on vellum, 7½ × 4″ (19 cm × 10.16 cm). Bibliothèque Nationale, Paris, France

devices. The delicate, classicizing faces of some of the prophets evoke Middle Byzantine painting (see figs. 8.39 and 8.40), and the other faces with long moustaches falling over ample beards recall the Byzantine manner of representing saints and prophets (see fig. 8.41). Even Christ at the top of the folio is presented in his typical Byzantine role as Pantocrator. The apostle distinguished by his central placement is Peter, the same saint who receives the scroll from Christ in the Berzé-la-Ville apse painting. Since Cluny was dedicated to St. Peter, it was only logical to stress his importance, but there is a political message as well. Cluny's foundation charter states that the monastery was answerable only to Rome and the pope, heir to Peter's throne, and not to any king or emperor. This special privilege assured Cluny enormous power and ultimately its success as well.

THE CODEX COLBERTINUS The illustration of *St. Matthew* from the *Codex Colbertinus* (fig. **11.27**) is similar in concept and pose to a number of Romanesque carvings, particularly the pier reliefs from the Moissac cloister (see fig. 11.13). The manuscript was made at that monastery, or nearby, just when sculptors were at work in the cloister. Matthew appears at the

Preserving and Restoring Architecture

The conservation and the preservation of any work of art are delicate tasks. In the case of architecture, the issues to be considered are particularly acute since, in addition to aesthetic criteria, restorers must take into account a building's function. What does one do, for example, with a building originally built to satisfy functions that are no longer relevant? Such is the question with medieval castles and palaces, as well as with churches located in areas where population shifts have reduced the size of their parishes. Should these buildings be retrofitted for new uses, even if that transforms their original character?

The restoration of Romanesque buildings poses some special problems. In many regions of Europe virtually every village has its own Romanesque church, but diocesan and governmental institutions have difficulty in obtaining the funds to preserve them. Moreover, Romanesque architecture is characterized by its great variety. Thus, a one-size-fits-all approach to restoration, which might be efficient on a practical level, only erases the essential distinctions that give Romanesque its exceptional quality.

Art historian C. Edson Armi has written penetratingly about recent restorations of Romanesque churches in the Burgundy region of France.* Although the French Restoration Service has a long tradition of intervention to save historic buildings, it does not have the resources to maintain all needy monuments. Increasingly, it has had to focus on simply reacting to severe problems, often when it is too late to correct them. Additionally, the service has a pattern of applying a universal, rather than a specific, approach to the restoration of buildings. In the mid-twentieth century it was fashionable to clean the surfaces of Romanesque churches within an inch of their lives, and restorers indiscriminately removed any surface coverings—sometimes including original ones—to expose underlying stone or brick. It was thought that by exposing the original materials and structure, the building's true expressive nature would be revealed.

By late in the last century the pendulum had swung the other way, and the norm was to plaster both interior and exterior surfaces of Romanesque churches—in some cases the same ones that had been completely stripped only a generation or so earlier. While it is true that during the Middle Ages the surfaces of buildings, whether of brick or stone, were often covered with plaster, this was not always the case. Armi demonstrates how recent interventions have covered up valuable evidence of original materials and structure, information that would help an architectural historian "appreciate large issues like the concept, process and history of a building." Since Armi has shown that a mason's techniques are as distinctive as a painter's or a sculptor's, the lost information could well be key to placing a building in its art historical context. Armi proposes early preservation programs to prevent the need for severe reconstructions that are often based more on conjecture than on fact. Before undertaking any project, he would require modern restorers to acquire a sound understanding of the historical and architectural situation of individual buildings and regions. He proposes that review committees participate in decisions about the restoration of important buildings. Armi has been guided by standards established in the 1964 Venice International Congress of Architects and Technicians of Historic Monuments, which require that whatever is done to a building demonstrates "respect for original material and authentic documents . . . and must stop at the point where conjecture begins." Any restorations "must be distinguishable from the original so that restoration does not falsify the artistic or historic evidence."

We also need to ask to what extent one should accept or reject previous changes to buildings. Is it always important to get back to the hypothetical origin of a building, or is it appropriate to consider buildings as entities that change over time? Is there an ideal moment that restorers should aim to preserve? When is it proper to remove a later addition to a building and when should that addition be preserved? A case in point is the apse of the Early Christian basilica of Santa Maria Maggiore (see pages 248–249). The original fifth-century apse was destroyed when a new one was added in 1290; during the next 35 years leading artists of the day decorated the apse with magnificent mosaics. Certainly in this case, to restore the building to its fifth-century state would produce a loss much greater than any advantage obtained by recreating original forms.

*C. EDSON ARMI, "REPORT ON THE DESTRUCTION OF ROMANESQUE ARCHITECTURE IN BURGUNDY," JOURNAL OF THE SOCIETY OF ARCHITECTURAL HISTORIANS, VOL. 55, 1996, PP. 300–327.

THE CORBIE GOSPEL BOOK In its monumentality, the image of *St. Mark* from an early twelfth-century gospel book produced at Corbie (fig. **11.28**) can also be likened to Romanesque sculpture. The active pose and zigzag composition bear comparison with the prophet on the Moissac trumeau (see fig. 11.16). The twisting movement of the lines, not only in the figure of Mark but also in the winged lion, the scroll, and the curtain, also recalls Carolingian miniatures of the Reims School, such as the *Ebbo Gospels* (see fig. 10.14).

This resemblance helps us see the differences between them as well. In the Romanesque manuscript, every trace of Classical illusionism has disappeared. The fluid modeling of the Reims School, with its suggestion of light and space, has been replaced here by firm contours filled in with bright, solid colors. As a result, the three-dimensional aspects of the picture are reduced to overlapping planes. Yet by sacrificing the last remnants of modeling in terms of light and shade, the Romanesque artist has given his work a clarity and precision that had not been possible in Carolingian or Ottonian times. Here, the representational, the symbolic, and the decorative elements of the design are fully integrated.

GREGORY'S MORALIA IN JOB Although in principle Cistercian manuscripts were to be decorated only with nonfigurative initials of single colors, in actuality a number of beautiful and fascinating manuscripts were produced for the order. It is not easy to explain why an exception was made for this genre of art, although it might be because official statutes against the decoration of manuscripts were not established until 1134. (Some scholars claim these statutes date from 1152.) Pope Gregory's *Moralia*

ART IN TIME

Mid-1000s CE—Seljuk Turkish invaders begin their rule of Iran

ca. 1075–1120—Cathedral built at Santiago de Compostela, Spain

1099—The First Crusade warriors capture Jerusalem

By end of 1100s—Cistercians control nearly 700 monasteries

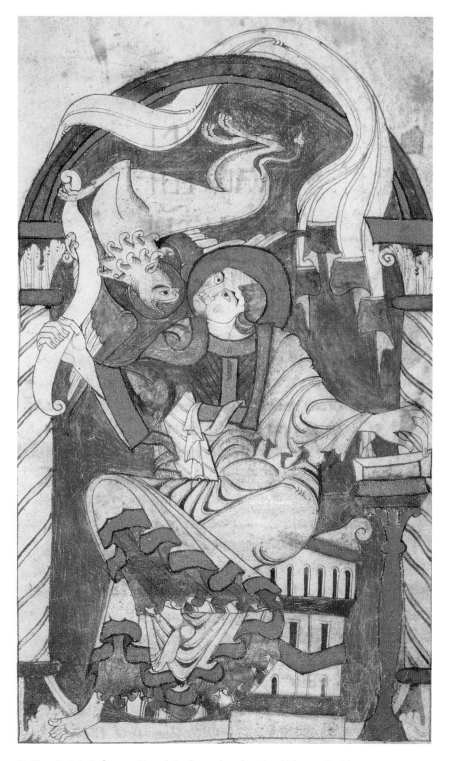

11.28. *St. Mark*, from a Gospel Book produced at the Abbey at Corbie. Early 12th century. Tempera on vellum, $10\frac{3}{4} \times 7\frac{7}{8}''$ (27.3 cm × 20 cm). Bibliothèque Municipale, Amiens, France

ad indaganda myfteria trahim?"uerrtatem
fortaffe opif uacuare uideamur;

EXPŁ LIB·XX·
INCIPIT·XXI·
NTELLECTVS

facri eloqui inter textu & myfte
rium tanta eft libratione penfand?
ut utriufq; partif lance moderata
hunc neq; nimie difcuffioni pondus
deprimat? neq; rurfus torpor incu
rie uacui relinquat; Multe quip
pe eius fententie tanta allegoria
conceptione funt graunde ut qfqf
eas ad folam tenere hyftoria nitit?
earu noticia p fua incuriam puet;
Nonnulle uero ita exterioribf pcep
tif inferuiunt? ut fi quif eas fubti
luf penetrare defiderat? int?quide
nil inueniat? fed hoc fibi etia quod
forif locuntur abfcondat; Unde be
ne quoq; narratione hiftorica per
fignificatione dicitur; Tollenf iacob
uirgaf populeaf uiridef·& amigda
linaf· & explanataf· ex parte deco
ticauit eaf· detractafq; corticibuf in
hif que expoliata fuerant candor
apparuit; Illa u que integra erat·
uiridia manferunt? atq; inhunc
modu· color effectuf·e· uariuf;Ubi
& fubditur; Pofuitq; eaf incanalib:

11.29. *Initial I*, from Gregory the Great's *Moralia in Job*. 1111.
Tempera on vellum, 21 × 6″ (53.34 × 15.24 cm). Bibliothèque
Municipale, Dijon, France

in Job, produced in 1111 at Cîteaux, is a charming example (fig.
11.29). The manuscript contains decorated initials, depicting
some of the monastery's daily activities, including the initial "I,"
formed by a tree, which a lay brother and a monk work together
to fell. The bright, flat colors and patterned foliage of the tree
contrast with seemingly naturalistic details. The monk's garment,
his bunched trousers, and the dagger suspended on his belt con-
vey the workaday quality of monastic life. In the second half of
the twelfth century, with few exceptions, Cistercian manuscripts
received only very simple decorations, apparently as a result of
the statutes prohibiting elaborate adornments.

GOSPEL BOOK OF ABBOT WEDRICUS The style of
the miniature of St. John from the *Gospel Book of Abbot Wedri-
cus* (fig. **11.30**) has been linked with both northern France and
England, and its linear draftsmanship was influenced by
Byzantine art. Note the ropelike loops of drapery, the origin of

which can be traced to such works as the *Crucifixion* at Daphni
(see fig. 8.46) and, even further back, to the *Archangel Michael*
ivory (see fig. 8.34). The energetic rhythm unifying the compo-
sition of the Corbie style (see fig. 11.28) has not been lost entire-
ly, however. The controlled dynamics of every contour, both in
the main figure and in the frame, unite the varied elements of
the composition. This quality of line betrays its ultimate source:
the Celtic-Germanic heritage.

If we compare the Abbot Wedricus miniature of St. John
with the Cross page from the *Lindisfarne Gospels* (see fig.
10.6), we see how much the interlacing patterns of the early
Middle Ages have contributed to the design of the St. John
page. The drapery folds and the clusters of floral ornament
have an impulsive yet disciplined liveliness that echoes the
intertwined snakelike monsters of the animal style (even
though the foliage is derived from the classical acanthus), and
the human figures are based on Carolingian and Byzantine

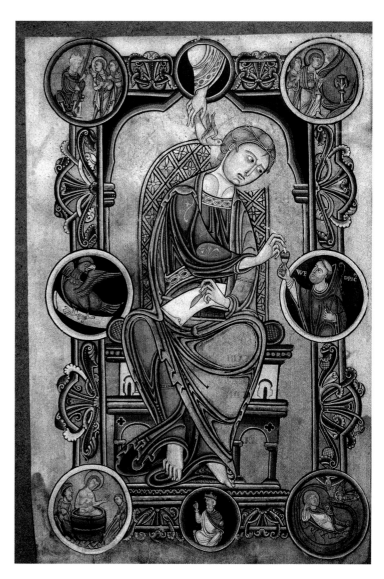

11.30. *St. John the Evangelist*, from the *Gospel Book of Abbot
Wedricus*. ca. 1147. Tempera on vellum, 14 × 9½″ (35.5 × 24.1 cm).
Société Archéologique et Historique, Avesnes-sur-Helpe, France

models. The unity of the page is conveyed not only by the forms but by the content as well. St. John inhabits the frame so thoroughly that we could not remove him from it without cutting off his ink supply (offered by the donor of the manuscript, Abbot Wedricus), his source of inspiration (the dove of the Holy Spirit in the hand of God), or his symbol (the eagle), all located in medallions on the page borders. The other medallions, less closely linked with the main figure, show scenes from the life of St. John.

REGIONAL VARIANTS OF ROMANESQUE STYLE

Although consistent aesthetic aims expressed across mediums link the art of diverse areas of Europe during the Romanesque period, a variety of distinct regional approaches can also be identified. These distinct approaches appear in regions of what is now France as well as in other parts of Europe, such as Tuscany in Italy, the Meuse Valley, Germany, and England. Regional variety in Romanesque art reflects the political conditions of eleventh- and twelfth-century Western Europe, which was governed by a feudal, though loose, alliance of princes and dukes. Language differences also help account for regional diversity. For example, even within France a number of languages were spoken, among them *langue d'oc*, the language of southwestern France, and *langue d'oil*, the language of the center and north. Different regions had different artistic sources available to artists and patrons. In Germany and other parts of northern Europe, Ottonian art provided compelling models, while in Italy and southern France, where antique survivals were numerous, artists borrowed and transformed Roman forms in order to realize Romanesque aesthetic aims. In England, which through conquest had become the domain of Norman dukes in 1066, the artwork of French Normandy provided models.

Western France: Poitou

A so-called school of sculptural decoration appears during the Romanesque period in the region known as Poitou, part of the Duchy of Aquitaine in southwestern France. A notable example is Notre-Dame-la-Grande in Poitiers, seat of the lords of Aquitaine.

NOTRE-DAME-LA-GRANDE, POITIERS The broad screen-like facade of Notre-Dame-la-Grande (fig. **11.31**) offers an expanded field for sculptural decoration. Elaborately bordered arcades house large seated or standing figures. Below them a wide band of relief carving stretches across the facade. The Fall of Adam and Eve appears with scenes from the life of Mary, including the Annunciation and Nativity, once again juxtaposing Eve and Mary (see pages 335, 342). Next to the representation of Adam and Eve, an inscription identifies an enthroned figure as Nebuchadnezzar, the king of Babylon mentioned in the Old Testament. The *Play of Adam*—a twelfth-century medieval drama of a type that was traditionally performed in churches—probably served as the source

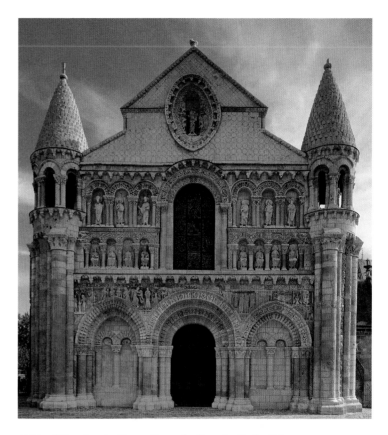

11.31. West facade, Notre-Dame-la-Grande, Early 12th century. Poitiers, France

for the choice and arrangement of figures at Notre-Dame-la-Grande. Beside Nebuchadnezzar, centered above the arch on the left of the portal, there are four figures carrying either scrolls or books on which are inscribed lines from the Adam play, in which Adam and Eve figure prominently and Nebuchadnezzar is also mentioned.

Essential to the rich sculptural effect is the deeply recessed doorway, without tympanum but framed by a series of arches with multiple archivolts. The conical helmets of the towers nearly match the height of the **gable** (the triangular wall section at the top of the facade), which rises above the actual level of the roof behind it. The gable contains a representation of Christ with angels, their height in the composition denoting their heavenly place. The sculptural program spread out over this entire area is a visual exposition of Christian doctrine intended as a feast for the eyes as well as the mind.

Southeastern France: Provence

In the French region of Provence, south of Burgundy, Romanesque art benefited from its proximity to Italy. The name *Provence* derives from its ancient designation as *Provincia Romana* in recognition of close political and cultural connections to Rome, and even today vestiges of Roman art and architecture abound in the region, such as the Maison Carrée in Nîmes (see fig. 7.46).

11.32. West facade, Saint-Gilles-du-Gard, France. Mid-12th century

11.33. Baptistery, Cathedral, and Campanile (view from the west). 1053–1272. Pisa, Italy

11.34. Interior, Pisa Cathedral

SAINT-GILLES-DU-GARD The facade of the abbey church of Saint-Gilles-du-Gard (fig. **11.32**), like Notre-Dame-la-Grande in Poitiers, screens the church. The inspiration for Saint-Gilles-du-Gard's facade, composed of three arches, can be found in the Roman triumphal arch (see fig. 7.65), connecting ancient triumphal imagery with the important liminal function of entering the church. Given contemporary concerns for Christian victory, in particular the struggle to conquer the Muslims, the formal association between the facade and a Roman triumphal monument must have seemed particularly fitting. The depiction of Jesus' triumphal entry into Jerusalem on the lintel supporting the left tympanum would have had special meaning to contemporary viewers, who were aware that the town of Saint-Gilles on the Rhone River estuary was a principal site of embarkation for French crusaders on their way to the Holy Land.

Tuscany

During the Romanesque period, Tuscany, a region in northwestern Italy divided into several independent city-states, chief of which were Pisa, Florence, Prato, and Livorno, continued what were basically Early Christian architectural forms. However, they added decorative features inspired by Roman architecture.

PISA CATHEDRAL The most famous monument of the Italian Romanesque owes its fame to an accident. Because of poor foundations, the Leaning Tower of Pisa in Tuscany, designed by the sculptor Bonanno Pisano (active 1174–1186), began to tilt even before it was completed (fig. **11.33**). This type of free-standing tower, or **campanile**, appears in Italy as early as the ninth or tenth century. The tradition of the detached cam-

panile remained so strong in Italy that towers hardly ever became an integral part of the church itself. The complex at Pisa includes a church and a circular, domed baptistery to the west. The ensemble of buildings, built on an open site north of the city, reflects the wealth and pride of the city-republic of Pisa after its naval victory over the Muslims at Palermo in 1062.

The Pisa Baptistery was begun in 1153 by Diotisalvi but everything above the arcaded first level was reworked a century later. Throughout the Middle Ages, Tuscany remained conscious of its antique heritage. The idea of a separate baptistery relies on Early Christian precedents, for example the Orthodox Baptistery at Ravenna (see fig. 8.13). The round form of the Pisa Baptistery and its original cone vault also reflect the structure of the Rotunda of the Anastasis in Jerusalem (see fig. 8.9). The comparison would undoubtedly have been comprehensible to Pisans, whose seamen profited by carrying pilgrims and crusaders to the Holy Land. Once again, the opportunity for increased trade and travel, the lure of pilgrimage, and the ongoing struggle against the Muslims in Iberia and the eastern Mediterranean were decisive forces in shaping Romanesque monuments.

The basic plan of Pisa Cathedral is that of an Early Christian basilica, but it has been transformed into a **Latin cross** (where three arms are of equal length and one is longer) by the addition of transept arms that resemble small basilicas with apses of their own. A dome marks the crossing. The rest of the church has a wooden roof except for the aisles (four in the nave, two in the transept arms), which have **groin vaults**, formed when two barrel vaults intersect. The interior (fig. **11.34**) has somewhat taller proportions than an Early Christian basilica, because there are galleries over the aisles as well

severely geometric lines. The triple arches of the second-story blind arcades, with their triumphal-arch design, are extraordinarily Classical in proportion and detail.

SAN MINIATO AL MONTE, FLORENCE The magnificent site of the Benedictine monastery of San Miniato al Monte overlooking the city of Florence reflects that monastery's grandeur during the Middle Ages. The gabled facade of the church (fig. **11.36**) coincides with the shape of the wooden-roofed and aisled basilica. Like the Baptistery of San Giovanni, and begun only a few years after it, geometric precision governs the arrangement of the facade's green-and-white marble covering. Although the treatment of surface and the materials employed are distinctive to Tuscany, the organization of elements compares with Romanesque arrangements elsewhere. The individual, additive units decorating Florentine Romanesque buildings parallel the compartmentalized bays in pilgrimage churches (see figs. 11.4 and 11.8) also and the way French Romanesque portals (see figs. 11.14, 11.31, 11.32) are composed of individual units that maintain their identities though functioning in unison. Roman elements in conscious revival—here the use of marble and the repeated arches that rest on columns topped with Corinthian capitals—unite many of these Romanesque works as well.

11.35. Baptistery of San Giovanni. ca. 1060–1150. Florence, Italy

as a clerestory. Yet the Classical columns supporting the nave and aisle arcades still recall types that would fit comfortably in an Early Christian basilica (see fig. 8.6).

A deliberate revival of the antique Roman style in Tuscan architecture was the use of a multicolored marble "skin" on the exteriors of churches. Little of this inlay is left today on the ancient monuments of Rome because much of it was literally "lifted" to decorate later buildings. However, the interior of the Pantheon still gives us some idea of what this must have looked like (see fig. 7.41). Pisa Cathedral and its companions are covered in white marble inlaid with horizontal stripes and ornamental patterns in dark-green marble. This decorative scheme is combined with blind arcades and galleries. The result is a richness very different from austere Early Christian exteriors.

BAPTISTERY OF SAN GIOVANNI, FLORENCE In Florence, which was to outstrip Pisa commercially and artistically, the greatest achievement of the Tuscan Romanesque is the baptistery of San Giovanni (fig. **11.35**) opposite the Cathedral (see fig. 13.11). It is a domed, octagonal building of impressive size, begun in the middle of the eleventh century. The symbolic significance of the eight-sided structure continues a long tradition in baptistery design (see page 248). The green-and-white marble paneling is typical of the Florentine Romanesque in its

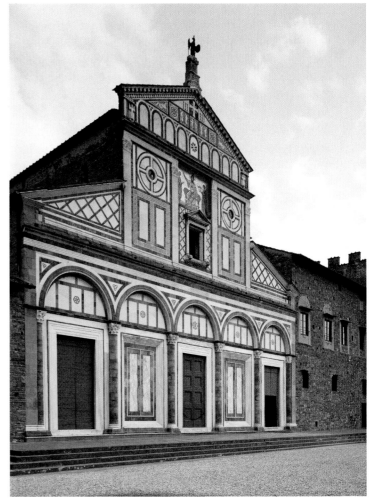

11.36. Facade, San Miniato al Monte, 1062–1150. Florence, Italy

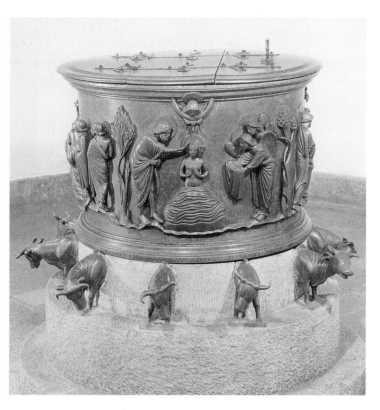

11.37. Renier of Huy. Baptismal Font. 1107–1118. Bronze. Height 25″ (63.5 cm). Saint-Barthélemy, Liège, Belgium

The Meuse Valley: Mosan Style

An important group of Romanesque sculptors, who excelled in metalwork, operated in the valley of the Meuse River, which runs from northeastern France into present-day Belgium and Holland. This region had been the home of the classicizing Reims style in Carolingian times (see figs. 10.14–10.16), and during the Romanesque period an awareness of Classical sources pervades its art, called Mosan. Abbott Hellinus of Liège commissioned a bronze baptismal font for the church of Notre-Dame-aux-Fonts in Liège (fig. 11.37). The generally accepted attribution to Renier of Huy, the earliest Mosan artist whose name we know, is largely circumstantial. The font, completed by 1118 and today in the church of Saint-Barthélemy, is a remarkable achievement: Cast in one piece, it is over 2 feet high and $3\frac{1}{2}$ feet in diameter. The vessel rested on 12 oxen, like Solomon's basin in the Temple at Jerusalem as described in the Old Testament book of I Kings: "And he made the molten sea . . . It stood upon twelve oxen . . . and all their hinder parts were inward." Christian writers described Solomon's basin as a prototype for the baptismal font and the twelve oxen as precursors of the apostles.

The reliefs are about the same height as those on bronze doors of Bishop Bernward at Hildesheim (see fig. 10.26). Instead of the rough expressive power of the Ottonian panel, however, the viewer sees a harmonious balance of design, a subtle control of the sculptured surfaces, and an understanding of

organic structure that are surprisingly Classical in a medieval work. The figure seen from the back (beyond the tree on the left), with its graceful movement and Greek-looking drapery, might almost be taken for an ancient work. Renier also expressed his interest in antique form through the use of bronze, rejecting the monumentality implicit in stone sculpture. The strong northern European metalwork tradition now serves to convey Classical values, so alien to early medieval metalworkers who had previously dominated the art of this area.

The Romanesque antique revival in the Mosan region has a special character, quite different from the abstract, decorative qualities that characterize the work of other regions, demonstrating that while Romanesque art shares a common interest in reviving Classical forms, there was great variety in the way that classicism was expressed. The Liège font and other Mosan sculptures are carved in high relief or are fully three dimensional, with convincing anatomical details and proportions. Yet, Mosan sculptures, like Romanesque works in other regions, are not naturalistic; it is the concern for idealism that here produces Classical forms.

Germany

In Germany, the traditions of the Holy Roman Empire functioned as filters for the revival of Roman forms. As a result, German Romanesque architecture, centered in the Rhineland, relied for its organization and formal vocabulary on buildings patronized by Carolingian and Ottonian rulers.

SPEYER CATHEDRAL The Cathedral of Speyer, which contained tombs of the Holy Roman Emperors, was consecrated in 1061. It included a timber-roof nave, not unlike those of Carolingian and Ottonian buildings (fig. 11.38). A major rebuilding of the cathedral in 1080 added groin vaults to the nave (fig. 11.39), providing a solution to a problem that had limited Romanesque builders: While the barrel vault used in the churches we have previously examined offered an aesthetically pleasing, acoustically resonant, and fire-resistant space, it limited the amount of light that could enter the nave. The problem was that the weakest part of the vault, the **springing**—the point where the arch rises from its support—was precisely the point where clerestory windows were needed. There had been exceptional buildings that included clerestories, such as Sant Vincenç at Cardona (see fig. 11.1) and the abbey church at Cluny (see fig. 11.12). But Sant Vincenç's windows are limited in number and scale, and at Cluny it was necessary to employ a series of devices, including pointed arches and enlarged buttresses, to provide adequate support for the high barrel vault.

The builders of Speyer Cathedral solved this problem with the groin vault. (See *Materials and Techniques*, page 378.) The groin vault, which had been used so effectively by the Romans (see page 378), efficiently channeled thrust onto four corner points. This allowed for open space under each arch, which could be used for window openings without diminishing the strength of the vault. The erection of groin vaults in the nave of

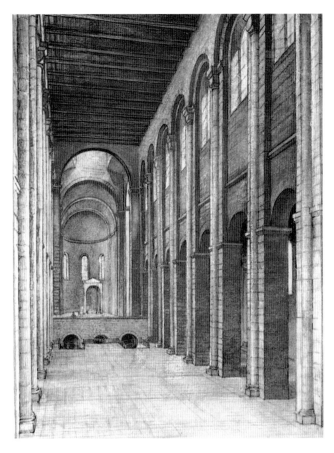

11.38. Reconstruction of interior of Speyer Cathedral, Germany. ca. 1030–1061. (after Conant)

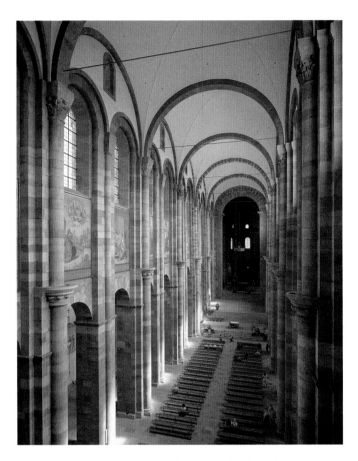

11.39. Interior, Speyer Cathedral. ca. 1030–1061; vaulted ca. 1080–1106

Speyer Cathedral was accompanied by an enlargement of its clerestory windows. Romanesque builders knew the technology of groin-vault construction and had previously employed groin vaults to cover lower spaces, in side aisles and in crypts, as at Pisa (see page 373), but apparently they found them daunting to build on a large scale. Speyer represents a genuine breakthrough in building technology. The scale of the church is so great that it dwarfs every other church of the period.

The individual groin-vaulted bays at Speyer form a chain of compartmentalized units of space. Each groin vault comprises two bays of the original nave. Colonnettes attached to alternate piers articulate the distribution of weight necessary to support the vaults. The use of these compound piers aligns Speyer with Romanesque buildings of other regions (see figs. 11.1, 11.4, and 11.8). The alternating support system establishes a rhythm that must have struck a familiar chord in Germany. It had appeared in the Ottonian buildings of Gernrode (see fig. 10.22) and Hildesheim (see fig. 10.25), although in these buildings such a system was purely aesthetic.

Normandy and England

Farther north, in Normandy, Christianity was strongly supported by the Norman dukes and barons, former Vikings who had turned Normandy into a powerful feudal domain that included the allegiance of abbots and bishops as vassals in return for grants of land. Duke William II of Normandy actively promoted monastic reform and founded numerous abbeys. Normandy soon became a cultural center of international importance. When William invaded Anglo-Saxon England in 1066 and became king of England, that country became politically allied to northern France. And for that reason Norman and English art of the Romanesque period share many stylistic traits.

THE BAYEUX TAPESTRY The complex relationship between the Normans and the English is hinted at in the *Bayeux Tapestry* (fig. **11.40** and fig. **11.41**). In actuality it is not a tapestry at all, since it is not woven, but rather, an embroidered linen frieze 230 feet long. The fifty surviving scenes record the events, culminating in 1066, when William the Conqueror crossed the English Channel to claim the throne of England upon the death of King Edward the Confessor. According to the narrative of the tapestry, Harold, an Anglo-Saxon earl, had retracted his oath of fealty to William in order to accept the throne offered him by the English nobles. William retaliated by invading England, and his Norman troops vanquished the English as Harold fell in battle. Since a Norman patron presumably commissioned the "tapestry," the story is told from the conquerors' perspective, yet its manufacture has generally been credited to English needlewomen, justly famous during the Middle Ages for the skill of their artisanry.

The *Bayeux Tapestry* exhibits the same monumentality and profound interest in narrative that we saw in the illuminations

11.40. *Crowds Gaze in Awe at a Comet as Harold Is Told of an Omen.* Detail of the *Bayeux Tapestry.* ca. 1066–1183. Wool embroidery on linen. Height 20″ (50.7 cm). Centre Guillaume le Conquérant, Bayeux, France

11.41. *The Battle of Hastings.* Detail of the *Bayeux Tapestry.* Wool embroidery on linen. Height 20″ (50.7 cm). Centre Guillaume le Conquérant, Bayeux, France

Vaulting

Vaulting is a technique for covering buildings that is based on the principles of **arcuation**, that is, construction that uses the arch form (a). Although vaulting was used in Mesopotamia, Egypt, and Greece, it was the Etruscans and Romans who first exploited the vault for expressive and aesthetic purposes (see pages 224–225). While most early medieval buildings were covered with timber roofs, during the Romanesque period vaulting became the dominant roofing type. Its reintroduction in the eleventh century was a major component of the revival of Roman artistic forms during the Romanesque period. Although Roman vaults were principally made of concrete, medieval vaults were usually made either of rubble or masonry, bound with mortar.

The erection of stone vaults in medieval buildings required enormous effort and great expense, but the benefits were numerous. They included fire resistance, particularly important for buildings illuminated by candles and for tall structures that attracted lightning. The history of medieval buildings is largely a history of fires. Widespread attacks by Vikings, Magyars, and Muslims also made stronger buildings desirable. In addition, stone vaulting provides excellent acoustics, a significant consideration for churches in which the liturgy was chanted. No less important than these practical benefits were the aesthetic ones: Vaulted buildings appear dignified and monumental, and they provide an unambiguous sense of enclosure. There are many types of vaults: barrel, quadrant, groin, ribbed, and the dome.

The **barrel vault**, essentially an arch projected in depth, is the most basic form (b). This was the first type exploited by medieval builders because it lent itself to covering rectangular basilicas. Unfortunately the barrel vault creates dark spaces, since opening up the nave walls with clerestory windows weakens the vault at its most vulnerable point, the **springing**. It is here at the base of the arch that the force of gravity, which is channeled through the arch, results in lateral forces pushing sideways. This outward thrust needs to be contained, usually by building thick walls to buttress the vault.

In Romanesque churches with wide side aisles, architects were faced with the problem of transferring the thrust of the barrel vault across the side aisles to the outer walls. They were able to do this by vaulting the galleries over the aisles with **quadrant vaults** (half-barrel vaults), which buttress the barrel vault of the nave. These buildings were also dark, with light entering only from windows at the ends of the barrel vaults and in the side walls, filtered through aisle and gallery before reaching the nave.

The introduction of the **groin vault** provided for more luminous structures that required less building material; thus buildings became lighter in both senses of the word. A groin vault is formed when two barrel vaults intersect (c); the thrust of each vault is countered by the vault running perpendicular to it. (The term *groin* refers to the junction where the vaults intersect.) Thrust is thus channeled to four corner points, allowing for windows or other openings in the wall under each of the intersecting arches.

The **ribbed vault**, introduced at Durham Cathedral, was probably invented as a decorative device (d); only later did architects and masons appreciate its structural advantages. Larger stones are placed on the groins of the vault to form diagonal arches. These function as a fixed scaffold to support the vault's curved panels, called **webs**, which essentially fill the spaces between the ribs. Ribbed vaults were easier to construct and required less centering than unribbed vaults; their webs could be built of lighter material, since the ribbed groins channeled the major lateral thrust more efficiently.

Romanesque masons also employed the **dome**, which is essentially an arch rotated on axis to form a vault (e). In Romanesque churches, domes cover centralized buildings or mark significant elements, for example the area where the transept crosses the nave. Vaults are not easy to construct and Romanesque vaults were heavy: Often more than a foot thick, each could weigh several tons. Arcuation is a dynamic system with all its elements interlocked; as a result, the vault is stable only when it is complete. During construction it needs to be supported by a wooden framework, called a **centering**. Once the vault is built and the buttresses are in place, the vault becomes self-supporting and the centering can be removed. The widespread use of the vault and its progressive refinement during the Romanesque period represent significant achievements, which proved to be crucial for the continued development of medieval building, particularly during the Gothic period.

Vault Forms: (a) arch; (b) barrel vault; (c) groin vault; (d) ribbed groin vault; (e) dome

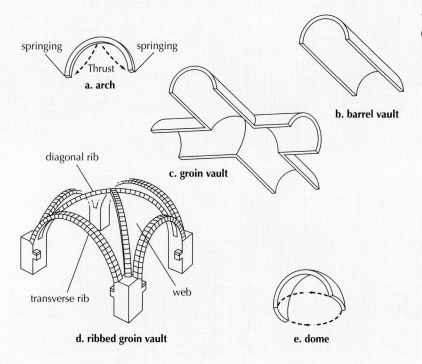

springing springing
Thrust
a. arch

b. barrel vault

c. groin vault

diagonal rib

transverse rib web

d. ribbed groin vault

e. dome

of the *Gospel Book of Abbot Wedricus* (see fig. 11.30), which, as noted, is a manuscript linked to both Normandy and England. The designer of the tapestry has integrated narrative and ornament with complete ease. Two border strips frame the main frieze; while some of the images of these margins are decorative, others offer commentary on the tapestry's continuous narrative. In one scene (see fig. 11.40) an aide announces to a recently crowned Harold the appearance of an amazing natural phenomenon, represented in the upper border as a spinning star leaving its fiery trail. The inscription ISTI MIRANT STELLA ("These men marvel at the star") records the brilliant apparition of Halley's Comet in 1066, during the days immediately following Harold's coronation. To the medieval viewer, the prophetic significance of the natural event would have been clear, especially when viewed after the fact. Beneath Harold, ghostly boats await the Normans, who are preparing to cross the English Channel. The scene foreshadows the violent events to come.

Although the *Bayeux Tapestry* does not use the pictorial devices of classical painting, such as foreshortening and overlapping (see fig. 5.79), it presents a vivid and detailed account of warfare in the eleventh century as well as a hint of the Normans as builders of fortresslike castles. The massed forms of the Graeco-Roman scene are replaced by a new kind of individualism that makes each figure a potential hero, whether by force or by cunning. Note how the soldier who has fallen from the horse with its hind legs in the air is, in turn, toppling his foe by yanking at the saddle girth of his mount. The kinship with the Corbie gospel book manuscript (see fig. 11.28) is noticeable in the lively somersaults of the horses, so like the pose of the lion in the miniature. In the Middle Ages, since the religious and secular spheres were not sharply distinguished from each other, the same pictorial devices were employed to represent both. The energy and linear clarity of the *Bayeux Tapestry* and the Corbie gospel book remind the viewer of the monumental figures of Romanesque sculpture.

DURHAM CATHEDRAL Norman architecture is responsible for a great breakthrough in structural engineering, which took place in England, where William made donations to build in a Norman style after his conquest of the country. Durham Cathedral, begun in 1093, is among the largest churches of medieval Europe (fig. **11.42**). Its nave is one-third wider than Saint-Sernin's, and its overall length (400 feet) is also greater. The nave may have been designed to be vaulted from the start. The vault over its eastern end had been completed by 1107, in a remarkably short time, and the rest of the nave was vaulted by 1130 (fig. **11.43**).

This vault is of great interest. As the earliest systematic use of a ribbed groin vault over a three-story nave, it marks a basic advance beyond Speyer. Looking at the plan (see fig. 11.42),

ART IN TIME

ca. 1066–1083 CE—Fabrication of the *Bayeux Tapestry*

1093—Construction begins on Durham Cathedral, England

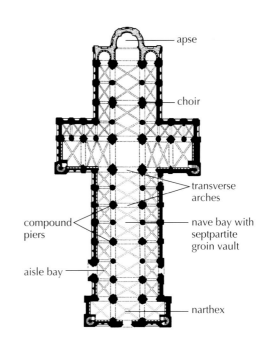

11.42. Plan of Durham Cathedral, England. 1093–1130. (after Conant)

we see that the aisles consist of the usual almost-square groin-vaulted compartments. The bays of the nave, separated by strong transverse arches, are oblong and also groin-vaulted so that the ribs of each bay form a double-X design. Each vault of the nave is thus divided into seven sections These vaults are referred to as *septpartite* (or seven-part) groin vaults. Since the nave bays are twice as long as the aisle bays, transverse arches occur only at the odd-numbered piers of the nave arcade (see fig. 11.43). The piers therefore alternate in size. Unlike Speyer Cathedral (see fig. 11.39), where a colonnette was added to every other nave pier to strengthen it, at Durham the odd-numbered piers are intrinsically different from the even-numbered ones. The larger odd-numbered ones are compound, with bundles of column and pilaster shafts attached to a square or oblong core, while the even-numbered ones are thinner and cylindrical.

The outward thrust and weight of the whole vault are concentrated at six securely anchored points on the gallery level from which the ribs spring. The ribs were needed to provide a stable skeleton for the groin vault, so that the curved surfaces

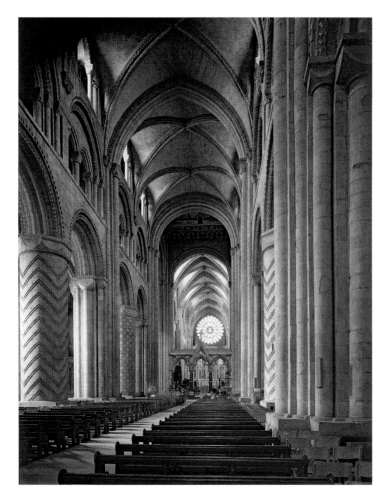

11.43. Nave (looking east), Durham Cathedral

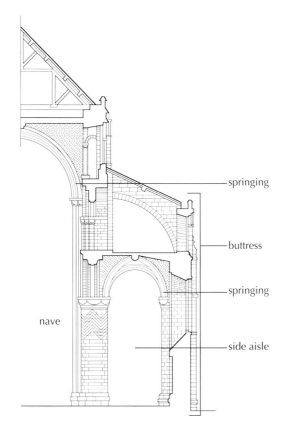

springing

buttress

springing

nave

side aisle

11.44. Transverse section of Durham Cathedral (after Acland)

between them could be filled in with masonry of a minimal thickness. Thus both weight and thrust were reduced. They were carried downward to the outer wall of the aisles by buttresses (fig. **11.44**). This flexible system resulted in more efficient vault erection and greater economy of construction. We do not know whether this ingenious scheme was actually invented at Durham, but it could not have been devised much earlier, for it is still in an experimental stage. While the transverse arches at the crossing are round, those to the west of it are slightly pointed, indicating an ongoing search for improvements (see fig. 11.43).

The ribbed groin-vault system had other advantages as well. From an aesthetic standpoint, the nave at Durham is among the finest in all Romanesque architecture. The sturdiness of the alternating piers makes a splendid contrast to the dramatically lit, sail-like surfaces of the vault. This relatively lightweight, flexible system permits broad expanses of great height to be covered with fireproof vaulting and yet retain the ample lighting of a clerestory. Durham exhibits great structural strength; even so, the decoration incised in its round piers, each different from the other, and the pattern established by the vault ribs hark back to the Anglo-Saxon love of decoration and interest in surface pattern (see figs. 10.1–10.3).

SAINT-ÉTIENNE, CAEN The abbey church of Saint-Étienne at Caen (fig. **11.45**) was founded by William the Conqueror a year or two after his invasion of England in 1066, but it took over a hundred years to complete. Over this period of time the fruits of Durham Cathedral's ribbed groin-vault system matured. The west facade (fig. **11.46**) offers a striking contrast with Notre-Dame-la-Grande in Poitiers (see fig. 11.31) and other Romanesque facades (figs. 11.15, 11.18, 11.32). The westwork proclaims this an imperial church. Its closest ancestors are Carolingian churches, such as the abbey church at Corvey (see fig. 10.20), built under royal patronage. Like them, it has a minimum of decoration. Four huge buttresses divide the front of the church into three vertical sections. The thrust upward continues in the two towers, the height of which would be impressive even without the tall helmets, which are later additions. Saint-Étienne is cool and composed, encouraging viewers to appreciate its refined proportions, a feature shared with many other Romanesque buildings.

On the interior of Saint-Étienne (fig. **11.47**), the nave was originally planned to have a wooden ceiling, as well as galleries and a clerestory, but after the experience of Durham, it became possible in the early twelfth century to build a groined nave vault, with only slight changes in the wall design. The bays of the nave here are approximately square (see fig. 11.45), whereas

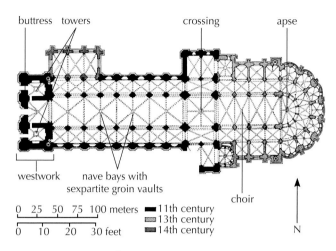

11.45. Plan of Saint-Étienne. Begun 1068. Caen, France

Labels on plan: buttress, towers, crossing, apse, westwork, nave bays with sexpartite groin vaults, choir

Scale legend:
0 25 50 75 100 meters
0 10 20 30 feet
■ 11th century
▨ 13th century
▩ 14th century
N

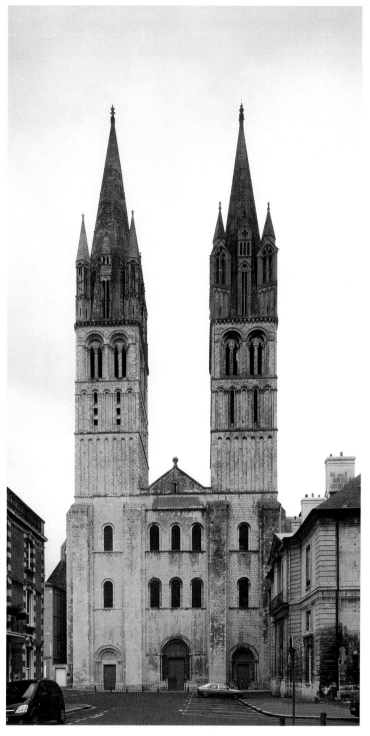

11.46. West facade, Saint-Étienne. Caen, France

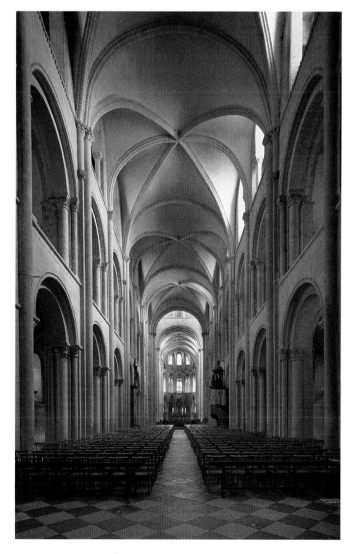

11.47. Nave, Saint-Étienne. Vaulted ca. 1115–1120. Caen, France

at Durham they were oblong. Therefore, the double-X rib pattern could be replaced by a single X with an additional transverse rib, which produced a *sexpartite* (or six-part) groin vault, with six sections instead of seven. These vaults are no longer separated by heavy transverse arches but instead by simple ribs. The resulting reduction in weight also gives a stronger sense of continuity to the nave vault as a whole and produces a less emphatic alternation of piers. Compared with Durham, the nave of Saint-Étienne has an airy lightness.

11.48. *Mouth of Hell*, from the *Winchester Psalter*. ca. 1150. From Winchester, England. Tempera on vellum, 12³/₄ × 9″ (32.5 × 23 cm). The British Library, London (MS Cotton Nero D.4)

THE PARADOXICAL MEANING OF ROMANESQUE

Durham and Caen mark the culmination of Romanesque architectural experiments. The improved economic conditions and political stability of Europe, outlined at the beginning of this chapter, had their rewards in the secure structures built in the twelfth century. However, the architecture's defensive qualities also suggest a paradox: As much as the stalwart, powerfully built buildings express a new-found confidence, they also reveal lingering apprehension. The terrifying Last Judgment scenes (see fig. 11.18) and other Romanesque visions of monsters and diabolical beings attest to this anxiety. A folio of the *Winchester Psalter* (fig. **11.48**), produced in England during the middle of the twelfth century, depicts a large hell mouth: The heavy arched jaws of the devil's head contain monstrous forms devouring sinners of all

classes. The inscription, written in Anglo-Norman French, translates as "Here is hell and the angels who lock the doors." The heavy walls and repeated enclosures that govern so much Romanesque sculpture and architecture have their counterpart in this representation. The serene cadence of the heavily outlined and decorated frame serves to enclose and control the frightening image.

The manuscript was commissioned by Henry of Blois, bishop of Winchester, who had been a monk at Cluny and collected antique sculpture and Byzantine paintings on his journeys to Rome. The *Winchester Psalter* exemplifies how international artistic forces functioned during the Romanesque period to help create a vision expressive of the hopes and fears of a society yearning for protection from dark elements. It is instructive that, in the end, assistance from a heavenly being—the angel who locks the hell-mouth door—is required to contain the potent forces of evil.

SUMMARY

ROMANESQUE ART

Much of Western European art of the eleventh and twelfth centuries is identified as Romanesque. This term means "in the Roman manner," but Romanesque architects and artists were also influenced by Carolingian, Byzantine, Islamic, and other traditions. Population growth, increased trade and travel, and new settlements all stimulated building activity, much of it for Christian use. In fact, the monumental structures of the period—stone-vaulted constructions decorated with architectural sculptures—were built on a scale that rivaled the achievements of Rome.

FIRST EXPRESSIONS OF ROMANESQUE STYLE

Romanesque art sprang up at a time when the Continent had no central political authority, and it exists in a variety of closely related regional styles. Its first appearances occur in parts of Italy, France, and Spain. An excellent example of early Romanesque architecture is the church of Sant Vincenç in Cardona, Spain, which demonstrates a mastery of stone vaulting techniques. Figurative sculpture—such as the marble lintel at Saint-Genis-des-Fontaines, France—is also a significant achievement of the period.

MATURE ROMANESQUE

Buildings of the mature Romanesque style—such as the Cathedral of Santiago de Compostela in Spain and the priory of Saint-Pierre at Moissac, France—employed both more sculpture and increasingly sophisticated vaulting techniques. As the Romanesque style matured and developed, it spread throughout Europe. The aesthetic concepts employed by its builders and sculptors are also visible in manuscripts, metalwork, and wall paintings of the period, including those at the church of Saint-Savin-sur-Gartempe.

REGIONAL VARIANTS OF ROMANESQUE STYLE

Regional variety in Romanesque art reflects the political conditions of a continent governed by a loose feudal alliance of princes and dukes. Different regions had different artistic sources available to them, and distinct approaches appeared in parts of France, Italy, Germany, and England. Examples include Pisa Cathedral in Italy and Speyer Cathedral in Germany. The famed *Bayeux Tapestry* exemplifies the complex relationship between English and Norman art of the period.

THE PARADOXICAL MEANING OF ROMANESQUE

The secure structures built across Western Europe during the Romanesque period reflect improving economic conditions and political stability. However, the defensive qualities of the architecture—as well as the terrifying visions seen in illuminated manuscripts of the period—also suggest society's lingering anxieties and yearning for protection.

Gothic Art

WE TEND TO THINK OF HISTORY AS THE UNFOLDING OF EVENTS in time without sufficient awareness of their unfolding in space. We visualize history as a stack of chronological layers, or periods, each one having a specific depth that corresponds to its duration. For the more remote past, where our sources of information are scanty, this simple image works reasonably well. It becomes less satisfactory as we draw closer to the present and our knowledge is more precise. Thus, we cannot define the Gothic era in terms of chronology alone; we must consider its changing surface area as it expands geographically as well.

At the start, about 1140, this geographical area was small indeed. It included only the province known as the Île-de-France (Paris and vicinity), the royal domain of the French kings. (See map 12.1.) A hundred years later, most of Europe, from Sicily to Iceland, had adopted the Gothic style, with only a few Romanesque pockets left here and there. By 1400, however, the Gothic area had begun to shrink. It no longer included Italy, and by 1550 it had disappeared almost entirely, except in England. The Gothic layer, then, has a rather complicated shape. Its depth ranges from close to 400 years in some places to only 150 in others. Moreover, this shape does not emerge with equal clarity in all the visual arts.

The term **Gothic** was used in the sixteenth century to describe a style of buildings thought to have descended from the Goths, those tribes that occupied northern Europe during the early Middle Ages. Although the ancestry of the style is not as direct as these early writers claimed, they were accurate about its geography, since the style is most recognizable north

Detail of figure 12.39, *Nahash the Ammonite Threatening the Jews at Jabesh*

of the Alps. As Gothic art spread from the Île-de-France to the rest of the country and then through all of Europe, it was referred to as *opus modernum* (modern work) or *opus francigenum* (French work). These designations are significant, because they tell us that in its own time the style was viewed as innovative and as having its origins in France. In the course of the thirteenth century, the new style gradually lost its imported flavor, and regional variety began to reassert itself.

For a century—from about 1150 to 1250, during the Age of the Great Cathedrals—architecture played the dominant role in the formation of a coherent Gothic style. In addition to religious buildings, secular architecture—including castles, palaces, and civic buildings, such as hospitals—also flourished during the Gothic period. Gothic sculpture was at first severely architectural in spirit but became more independent after 1200. Early Gothic sculpture and painting reflect the discipline of their monumental setting, while Late Gothic architecture and sculpture strive for more picturesque effects.

Artistic developments roughly parallel what was happening in the political arena, for the Gothic was a distinctive period not only artistically but politically as well. Aided by advances in cannons and the iron crossbow, princes and kings were able to conquer increasingly large territories, which were administered for them by vassals, who in turn collected taxes to support armies and navies. In France, the Capetian line at first ruled only the fertile territory of the Île-de-France, but by 1300

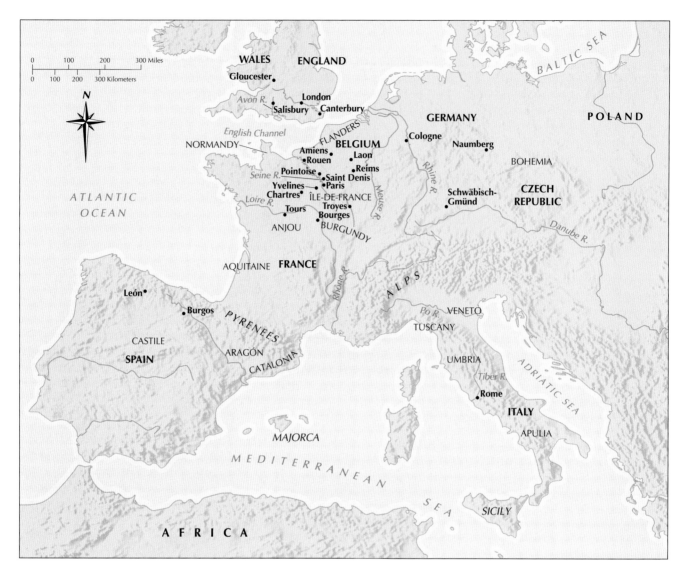

Map 12.1. Europe in the Gothic Period

it had added much of the land previously held by the Count of Flanders, as well as Bourges, Tours, and Amiens—all of which were to become the sites of important Gothic cathedrals—and the central provinces of the Auvergne and the southern provinces of Languedoc. King Philip Augustus, who reigned from 1180–1223, was able to quadruple the size of the royal domain and, at the same time, concentrate authority in the figure of the king. The French kings also acquired Normandy from England. This gave rise to the conflicting claims over the kingship of France known as the Hundred Years' War (1339–1453), which consolidated a growing sense of nationalism on both sides of the English Channel. While much Gothic art seems to develop in a logical and indeed progressive manner, the Hundred Years' War, with its shifting alliances and threats to economic and social stability, interrupted the progress of art in some areas of Europe.

Germany remained a collection of independent city-states ruled by electors, who were responsible for, among other things, choosing kings. The powers of German kings were therefore severely limited. Supported by shifting alliances with

the papacy, the kings of France and England emerged as the leading powers at the expense of the Germans in the early thirteenth century, which was generally a time of peace and prosperity. After 1290, however, the balance of power quickly broke down.

The growth of urban centers and the increasing importance of cathedrals, the seats of bishops, are formative features of the Gothic period. In the century before the death of King Louis IX in 1270, there were 80 cathedrals built in France, many of them new foundations. Universities developed out of cathedral schools as the principal centers of learning, thus taking on the role previously played by monasteries. The university provided instruction in theology, philosophy, law, and medicine, those areas of study deemed necessary for *universitas litterarum* (universal learning). At the same time literature written in the vernacular (as opposed to Latin) begins to emerge, making it accessible to a broader public. It was during the thirteenth century that French became an official state language. Romanesque art had been predominantly a rural and monastic art, while Gothic art, by contrast, becomes increasingly cosmopolitan.

Urban growth was both the result and cause of economic, social, and demographic changes. Agriculture became more efficient, with increased acreage under cultivation, and surplus production provided commodities for sale and purchase. This produced, in turn, a money economy based on investment, profit, and trade, in place of barter. Money rather than personal services now directed social interchange, and the increased amount of it in circulation produced a veritable middle class, living in cities, which were the centers of trade and commerce. Once out from under the feudal yoke, merchants and artists of this middle class were free to form guilds to control the production and distribution of goods and services. A general and significant increase in population also spurred urban growth. Roughly 42 million people occupied Europe around the year 1000; by 1300, the population had reached about 73 million.

During the thirteenth century Catholicism found in St. Thomas Aquinas its greatest intellect since St. Augustine and St. Jerome some 850 years earlier. Aquinas, an Italian theologian, studied in Cologne and taught in Paris. His method of argument, called **scholasticism**, used reason to understand and explain faith. Scholasticism had a profound effect on European thought; its harmonization of rationalism and spirituality effectively sanctioned the systematic study of all natural phenomena as expressions of divine truths. Gothic builders shared qualities with the Scholastics. They brought the logic and clarity of engineering principles to bear on revelation, using physical forces to create a concord of spiritual experiences in much the same way the Scholastics used elucidation and clarification to build their well-constructed arguments.

EARLY GOTHIC ART IN FRANCE

It is not clear why Gothic art first appeared in the Île-de-France, the area around Paris. Some scholars believe that because this region had not developed a strong local style during the Romanesque period, it was particularly open to innovation and influence from other areas. Others have suggested that it was a result of a concerted effort on the part of the kings of France to aggrandize themselves, since it was here that their domains were located. Certainly the Île-de-France is fortuitously positioned, near the center of France and thus accessible to the south and west, where major sculptural programs flourished during the Romanesque period, and adjacent to Normandy, where many structural innovations, including the ribbed groin vault, had been introduced to France (see pages 380–381).

Saint-Denis: Suger and the Beginnings of Gothic Architecture

The study of Gothic art begins with an examination of the rebuilding of the royal Abbey Church of Saint-Denis just outside the city of Paris. The rebuilding of this historic church was undertaken between 1137 and 1144 by its abbot, Suger. His ambitious building program was designed to emphasize the relationship between Saint-Denis and the French monarchy. The kings of France, who belonged to the Capetian line, derived their authority from a Carolingian tradition. However, they had less power than the nobles who, in theory, were their vassals. The only area the king ruled directly was the Île-de-France, and even there his authority was often challenged. Not until the early twelfth century did royal power begin to expand, and Suger, as chief adviser to King Louis VI, helped shape this process. It was Suger who forged the alliance between the monarchy and the Church. This union brought the bishops of France (and the cities under their authority) to the king's side; the king, in turn, supported the papacy in its struggle against the German emperors.

Suger also engaged in spiritual politics. By giving the monarchy religious significance and glorifying it as the strong right arm of justice, he sought to rally the nation behind the king. The Abbey Church of Saint-Denis was a key element in his plan. The church, founded in the late eighth century, enjoyed a dual prestige. It was the shrine of Saint Denis, the Apostle of France and its patron saint, as well as the chief memorial of the Carolingian dynasty. Both Charlemagne and his father, Pepin, were consecrated as kings at Saint-Denis. It was also the burial place of the kings Charles Martel, Pepin, and Charles the Bald. Suger aspired to make the abbey the spiritual center of France, a pilgrimage church to outshine all others and to provide a focal point for religious as well as patriotic emotion. To achieve this goal, the old structure had to be rebuilt and enlarged. The great abbot himself wrote two accounts of the church and its rebuilding. (See *Primary Sources*, pages 388 and 390.)

AMBULATORY AND CHOIR The ambulatory and radiating chapels surrounding the arcaded apse (figs. **12.1** and **12.2**) are familiar elements from the Romanesque pilgrimage choir (compare figs. 11.3 and 11.6), but at Saint-Denis they have been integrated in a new way. The choir is as rationally planned and constructed as any Romanesque church, yet the

12.1. Plan of the choir and ambulatory, Abbey Church of Saint-Denis, France. 1140–1144 (Peter Kidson)

Suger of Saint-Denis (1081–1151)

From *On the Consecration of the Church of Saint-Denis*

Abbot Suger left two accounts of his rebuilding of the Abbey Church of Saint-Denis: a booklet that describes the entire campaign from its conception to the consecration of the new east end on June 11, 1144; and a record of the precious outfittings, including the stained-glass windows, in a review of his accomplishments as abbot. In these excerpts from the first text (1144–1147), Suger justifies his enlargement of the Carolingian building with reference to its overcrowding on religious holidays, and he recounts the auspicious discovery of a local quarry and the appearance of the workers needed to execute his project. After rebuilding the west end of the Carolingian church, he destroyed its eastern apse and built a much larger, more elaborate choir over the old crypt. Suger notes as his principal innovation the radiating chapels filled with stained-glass windows.

Through a fortunate circumstance—the number of the faithful growing and frequently gathering to seek the intercession of the Saints—the [old] basilica had come to suffer grave inconveniences. Often on feast days, completely filled, it disgorged through all its doors the excess of the crowds as they moved in opposite directions, and the outward pressure of the foremost ones not only prevented those attempting to enter from entering but also expelled those who had already entered. At times you could see that no one among the countless thousands of people because of their very density could move a foot; that no one, because of their very congestion, could [do] anything but stand like a marble statue, stay benumbed or, as a last resort, scream. The distress of the women was so great and so intolerable that you could see how they cried out horribly, how several of them, lifted by the pious assistance of men above the heads of the crowd, marched forward as though upon a pavement; and how many others, gasping with their last breath, panted in the cloisters of the brethren to the despair of everyone.

Through a gift of God a new quarry, yielding very strong stone, was discovered such as in quality and quantity had never been found in these regions. There arrived a skillful crowd of masons, stonecutters, sculptors and other workmen, so that—thus and otherwise—Divinity relieved us of our fears and favored us with Its goodwill by comforting us and by providing us with unexpected [resources]. I used to compare the least to the greatest: Solomon's riches could not have sufficed for his Temple any more than did ours for this work had not the same Author [God] of the same work abundantly supplied His attendants. The identity of the author and the work provides a sufficiency for the worker.

Upon consideration, then, it was decided to remove that vault, unequal to the higher one, which, overhead, closed the apse containing the bodies of our Patron Saints, all the way [down] to the upper surface of the crypt to which it adhered; so that this crypt might offer its top as a pavement to those approaching by either of the two stairs, and might present the chasses [reliquaries] of the Saints, adorned with gold and precious gems, to the visitors' glances in a more elevated place. Moreover, it was cunningly provided that—through the upper columns and central arches which were to be placed upon the lower ones built in the crypt—the central nave of the old [church] should be equalized, by means of geometrical and arithmetical instruments, with the central nave of the new addition; and, likewise, that the dimensions of the old side-aisles should be equalized with the dimensions of the new side-aisles, except for that elegant and praiseworthy extension, in [the form of] a circular string of chapels, by virtue of which the whole [church] would shine with the wonderful and uninterrupted light of most luminous windows, pervading the interior beauty.

SOURCE: *ABBOTT SUGER ON THE ABBEY CHURCH OF SAINT-DENIS AND ITS ART TREASURES*, ED. AND TR. ERWIN PANOFSKY, (PRINCETON, NJ: PRINCETON UNIVERSITY PRESS, 1946)

entire plan is held together by a new kind of geometric order (see fig. 12.1). Seven nearly identical wedge-shaped units fan out from the center of the apse. Instead of being in separate apsidioles, the chapels merge to form, in effect, a second ambulatory. We experience this double ambulatory not as a series of individual compartments but as a continuous space, the shape of which is outlined by the network of slender arches, ribs, and columns that sustains the vaults. Ribbed groin vaulting based on the pointed arch is used throughout. By this date, the pointed arch (which can be "stretched" to reach any desired height regardless of the width of its base) has become an essential part of the ribbed groin vault, which is no longer restricted to square or near-square compartments. It has a new flexibility that allows it to cover areas of almost any shape, such as the trapezoids and pentagons of this ambulatory.

What most distinguishes the interior of Saint-Denis (see fig. 12.2) from earlier church interiors is its lightness, in both senses of the word. The architectural forms seem graceful, almost weightless, compared to the massive solidity of Romanesque architecture. The fluid spaciousness of Saint-Denis' choir results from its slim columns, whose use was made possible by the relative lightness of the vaults they needed to support. In addition, the windows are so large that they are no longer openings cut into a wall but, in effect, translucent walls, filled with stained glass. What makes this abundance of light possible are heavy buttresses that jut out between the chapels to contain the outward pressure of the vaults. In the plan (see fig. 12.1), they look like stubby arrows pointing toward the center of the apse. No wonder, then, that the interior appears so airy, since the heaviest parts of the structural skeleton are relegated to the exterior. The impression would be even more striking if we could see all of Suger's choir, for the upper part of the apse, rising above the double ambulatory, had very large, tall windows. Unfortunately, later transformations of the building destroyed the choir's original effect.

In describing Suger's ambulatory and choir, we have also described the essentials of Gothic architecture. Yet none of the

12.2. Ambulatory, Abbey Church of Saint-Denis

This symbolic interpretation of light and numerical harmony was well established in Christian thought long before Suger's time. It derived from the writings of a sixth-century Greek theologian who, in the Middle Ages, was mistakenly believed to have been Dionysius the Areopagite, an Athenian disciple of St. Paul, who is mentioned in the New Testament book of Acts. In France, the writer Dionysius was identified with St. Denis, since the saint's name in Latin is Dionysius. Not surprisingly, Suger attached great authority to the writings of Dionysius, which were available to him in the library at Saint-Denis; Dionysian light-and-number symbolism particularly appealed to him

At the heart of Suger's mystical intent for Saint-Denis was the belief that the material realm is the steppingstone for spiritual contemplation and thus that dark, jewel-like light filtering through the church's stained-glass windows would transport the viewer to "some strange region of the universe which neither exists entirely in the slime of earth nor entirely in the purity of Heaven." The success of the choir design at Saint-Denis, therefore, derives not only from its architectural qualities but also from its extraordinary psychological impact. Vistors, it seems, were overwhelmed by both, and within a few decades the new style had spread far beyond the Île-de-France.

SUGER AND THE MEDIEVAL ARCHITECT Although Suger was not an architect, there is no contradiction between his lack of professional training and his claim of responsibility for the technical advances and resultant style of "his" new church. In the twelfth century the term *architect* had a very different meaning from the modern one. To the medieval mind, the overall leader of the project could be considered its architect. Even God, as creator of the universe, was sometimes represented as an architect employing builders' tools. After all, the function of a church is not merely to enclose a maximum of space with a minimum of material, but also to embody and convey religious ideas. For the master who built the choir of Saint-Denis, the technical problems of vaulting must have been inseparable from issues of form and its meaning. The design includes elements that express function without actually performing it. An example is the slender shafts (**responds**) that seem to transfer the weight of the vaults to the church floor.

In order to know what concepts to convey, the medieval builder needed the guidance of religious authority. At a minimum, such guidance might be a simple directive to follow some established model. Suger, however, took a more active role, proposing objectives to which his master masons must have been singularly responsive. Close collaboration between patron and architect or master builder had of course occurred before—between Djoser and Imhotep (Chapter 3), Perikles and Pheidias (Chapter 5)—just as it does today.

CONSTRUCTING SAINT-DENIS Building Saint-Denis was an expensive and complex task that required the combined resources of church and state. Suger used stone from quarries near Pontoise for the ambulatory columns and lumber from the forest of Yvelines for the roof. Both had to be transported by land and river, which was a slow and costly

elements that make up its design is really new. The pilgrimage choir plan, the pointed arch, and the ribbed groin vault can be found in regional schools of the French and Anglo-Norman Romanesque. However, they were never combined in the same building until Suger—as he himself tells us—brought together artisans from many different regions for Saint-Denis. We must not conclude from this, however, that Gothic architecture was merely a synthesis of Romanesque traits. Otherwise we would be hard pressed to explain the new spirit, particularly the quest for luminosity, that strikes us so forcibly at Saint-Denis. Suger's account of the rebuilding of his church stresses luminosity as the highest value achieved in the new structure. Thus, Suger suggests, the "miraculous" light that floods the choir through the "most sacred" stained-glass windows becomes the Light Divine, a revelation of the spirit of God. Suger also claims that **harmony**, the perfect relationship among parts in terms of mathematical proportions or ratios, is the source of all beauty, since it exemplifies the laws by which divine reason made the universe.

Suger of Saint-Denis (1081–1151)

From *On What Was Done Under His Administration*

Saint-Denis was a Benedictine abbey, though its church was open to layfolk and attracted them in large numbers. The ostentatious embellishment of the church was the type of material display deplored by St. Bernard of Clairvaux. Suger's descriptions of it, recorded between 1144 and 1149, suggest a sensuous love of precious materials, but also a belief that contemplation of these materials could lead the worshiper to a state of heightened spiritual awareness. Like the Byzantine rationale for icons, the notion of "anagogical" transportation to another dimension is indebted to Neo-Platonism.

We insisted that the adorable, life-giving cross should be adorned. Therefore we searched around everywhere by ourselves and by our agents for an abundance of precious pearls and gems. One merry but notable miracle which the Lord granted us in this connection we do not wish to pass over. For when I was in difficulty for want of gems and could not sufficiently provide myself with more (for their scarcity makes them very expensive): then, lo and behold, [monks] from three abbeys of two Orders—that is, from Cîteaux and another abbey of the [Cistercian] Order, and from Fontevrault offered us for sale an abundance of gems such as we had not hoped to find in ten years, hyacinths, sapphires, rubies, emeralds, topazes. Their owners had obtained them from Count Thibaut for alms; and he in turn had received them, through the hands of his brother Stephen, King of England [r. 1135–1154], from the treasures of his uncle, the late King [Henry I, r. 1100–1135], who had amassed them throughout his life in wonderful vessels. We, however, freed from the worry of searching for gems, thanked God

and gave four hundred pounds for the lot though they were worth much more.

We hastened to adorn the Main Altar of the blessed Denis where there was only one beautiful and precious frontal panel from Charles the Bald [843–877], the third Emperor; for at this [altar] we had been offered to the monastic life.

The rear panel, of marvelous workmanship and lavish sumptuousness (for the barbarian artists were even more lavish than ours), we ennobled with chased relief work equally admirable for its form as for its material. Much of what had been acquired and more of such ornaments of the church as we were afraid of losing—for instance, a golden chalice that was curtailed of its foot and several other things—we ordered to be fastened there.

Often we contemplate these different ornaments both new and old. When the loveliness of the many-colored gems has called me away from external cares, and worthy meditation has induced me to reflect, transferring that which is material to that which is immaterial, on the diversity of the sacred virtues: then it seems to me that I see myself dwelling, as it were, in some strange region of the universe which neither exists entirely in the slime of the earth nor entirely in the purity of Heaven; and that, by the grace of God, I can be transported from this inferior to that higher world in an anagogical manner.

We [also] caused to be painted, by the exquisite hands of many masters from different regions, a splendid variety of new windows.

Because [these windows] are very valuable on account of their wonderful execution and the profuse expenditure of painted glass and sapphire glass, we appointed an official master craftsman for their protection and repair.

SOURCE: *ABBOTT SUGER ON THE ABBEY CHURCH OF SAINT-DENIS AND ITS ART TREASURES*, ED. AND TR. ERWIN PANOFSKY, (PRINCETON, NJ: PRINCETON UNIVERSITY PRESS, 1946)

process. The master builder probably employed several hundred stonemasons and two or three times that many laborers. Advances in technology spurred by warfare made possible improved construction techniques that were essential for building the new rib vaults. Especially important were better cranes powered by windlasses, treadwheels that used counterweights, and double pulleys for greater efficiency. These devices could be put up and taken down with ease, allowing for lighter scaffolding suspended from the wall instead of resting on the ground.

WEST FACADE Although Abbot Suger planned to rebuild all of Saint-Denis, the only part of the church that he saw completed, other than the ambulatory and choir, was the west facade. The overall design of the Saint-Denis west facade (fig. **12.3**) derived from Norman Romanesque facades. A comparison between Saint-Denis and Saint-Étienne at Caen (see fig. 11.46) reveals a number of shared basic features. These include the pier buttresses that reinforce the corners of the

towers and divide the facade vertically into three main parts, the placement of the portals, and the three-story arrangement. However, Saint-Denis's three portals are far larger and more richly carved than those at Saint-Étienne at Caen or any other Norman Romanesque church. From this we can conjecture that Abbot Suger attached considerable importance to the sculptural decoration of Saint-Denis, although his account of the church does not discuss it at length.

The rich sculptural decoration included carved tympana, archivolts, and jambs. The arrangement recalls the facades of southwestern France, such as at Moissac (see fig. 11.14) and the carved portals of Burgundy, such as at Autun (see fig. 11.18). These correlations corroborate Suger's claim that his workforce included artists from many regions. Unhappily, the trumeau figure of St. Denis and the statue-columns of the jambs were removed in 1770 and 1771, when the central portal was enlarged. A few years later, during the French Revolution, a mob attacked the heads of the remaining figures and melted down the metal doors. As a result of

12.3. West facade, Abbey Church of Saint-Denis. ca. 1137–1140.

these ravages and a series of clumsy restorations undertaken during the eighteenth and nineteenth centuries, we can gain only a general view of Suger's ideas about the role of sculpture at Saint-Denis. To envision what the Saint-Denis west portal originally looked like we turn to the Cathedral of Chartres, where some of the Saint-Denis sculptors subsequently worked.

Chartres Cathedral

Toward 1145 the bishop of the town of Chartres, who was a friend of Abbot Suger and shared many of his ideas, began to rebuild a cathedral in the new style, dedicated to Notre-Dame ("Our Lady," the Virgin Mary). Fifty years later a fire destroyed all but the eastern crypt and the west facade. (See end of Part II, *Additional Primary Sources*.)

WEST FACADE The surviving west facade (fig. **12.4**), in many ways reminiscent of Saint-Denis, is divided into units of two and three and is a model of clarity. Yet, because construction proceeded in stages and was never entirely finished, the harmony of the result is evolutionary rather than systematic. For example, the two west towers, though similar, are by no means identical. Moreover, their **spires**, the tall towers with tapering roofs, are very different: The spire on the left in figure 12.4 dates from the early sixteenth century, nearly 300 years later than its mate.

To judge from old drawings of Saint-Denis, the Chartres jambs (figs. **12.5** and **12.6**) are so similar to those of the original Saint-Denis portals that the same sculptors must have worked on both buildings. Tall figures attached to columns flanked the doorways of both cathedrals. Figures had appeared on the jambs or trumeaux of Romanesque portals (see figs. 11.14 and 11.16), but they were reliefs carved from the masonry of the doorway. The Chartres jamb figures, in contrast, are essentially

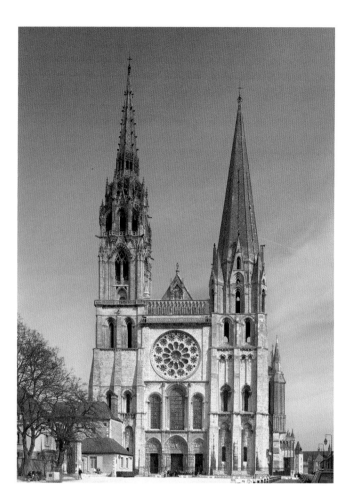

12.4. West facade, Cathedral of Notre-Dame. Chartres, France. (Left spire is from 16th century.) ca. 1145–1220

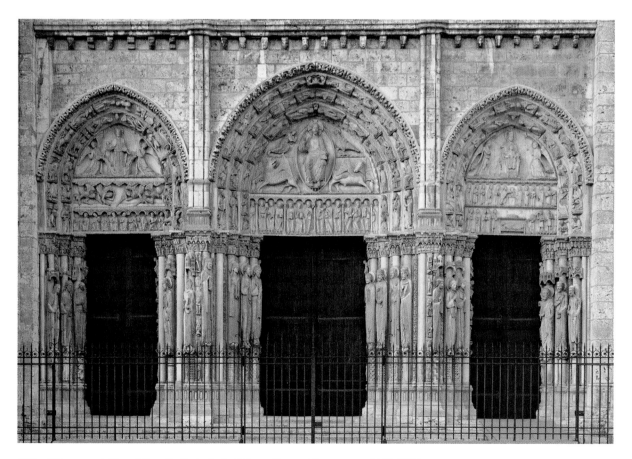

12.5. West portal (Royal Portal), Cathedral of Notre-Dame. Chartres. ca. 1145–1150

states, each with its own axis. They could, in theory at least, be detached from their supports. This is a development of truly revolutionary importance and could apparently be taken only by borrowing the cylindrical shape of the column for the human figure. That the figures are round gives them a more convincing presence than any we have seen in Romanesque architectural sculpture, and their heads show a gentle, human quality that indicates a naturalistic trend in Gothic sculpture.

On the west portal of Chartres naturalism appears to spring from a reaction against the fantastic and demoniacal aspects of Romanesque art, a response that may be seen in the solemn spirit of the figures and their increased physical bulk. This is apparent by comparing the Christ of Chartres's center tympanum (see fig. 12.5) with his counterpart in the tympanum at Moissac (see fig. 11.14.) It also appears in the discipline of the symbolic program underlying the entire sculptural scheme at Chartres. While an understanding of the subtler aspects of this program requires a knowledge of the theology that would have been taught by leading scholars of the day at the Chartres Cathedral School, its main elements can be readily understood.

The jamb statues form a continuous sequence linking all three portals (see fig. 12.5). Together they represent the prophets, kings, and queens of the Bible. Their purpose is to acclaim the rulers of France as the spiritual descendants of Old Testament royalty and to stress the harmony of spiritual and secular rule, of priests (or bishops) and kings—ideals previously put forward by Abbot Suger. Above the main doorway symbols of the four evangelists flank Christ in Majesty. The apostles are below, while the 24 elders occupy the two outer archivolts. Although the components are similar to those of the Moissac tympanum, the effect at Chartres is calm and comforting whereas at Moissac the effect was dramatic and unsettling. The right-hand tympanum at Chartres shows Christ's Incarnation: the Birth, the Presentation in the Temple, and the infant Christ Child on the lap of the Virgin, who symbolizes the Church. The design achieves compositional and thematic unity by elevating Christ in the center of each register: on the manger, on an altar, and on the lap of his mother. In the surrounding archivolts, representations of the liberal arts as human wisdom pay homage to the divine wisdom of Christ. Finally, in the left-hand tympanum, we see the timeless Heavenly Christ (or perhaps the Christ of the Ascension) framed by the ever-repeating cycle of the year: the signs of the zodiac and their earthly counterparts, the labors of the 12 months.

Laon Cathedral

Because the mid–twelfth-century church that stood behind the west facade of Chartres Cathedral was destroyed by fire in 1194, we must turn to the Cathedral of Notre-Dame at Laon to appreciate an Early Gothic interior. This cathedral was begun just before 1160.

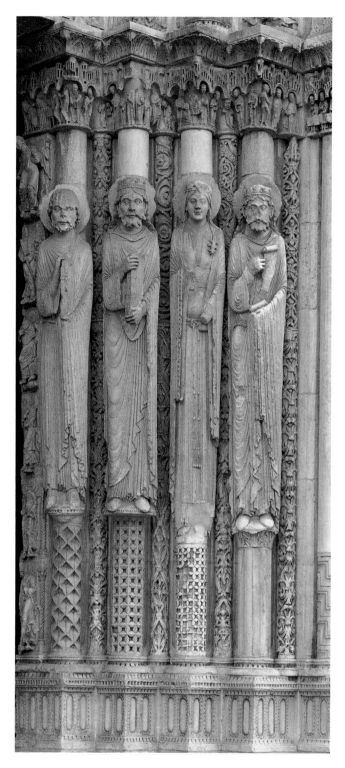

12.6. Jamb statues, west portal, Cathedral of Notre-Dame, Chartres

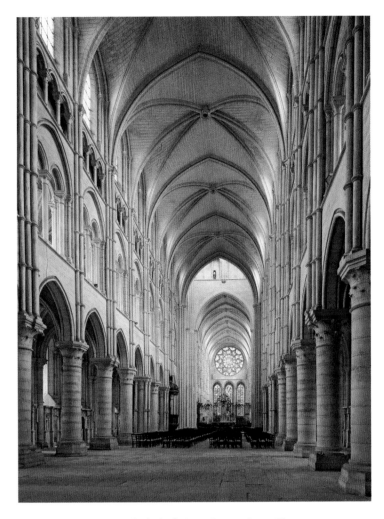

12.7. Nave, Cathedral of Notre-Dame, Laon, France. ca. 1160–1210

NAVE The interior elevation of Laon Cathedral (fig. **12.7**) includes a nave arcade, gallery, triforium, and clerestory, all features found in Romanesque architecture but never together in the same building. The stacking of four levels is a Gothic innovation and lightens the weight of the walls. The elevation develops logically and harmoniously: The single opening of the nave arcade is doubled in the gallery, then triple arches follow in the triforium, while a broad clerestory window balances the single nave arcade opening that began the vertical sequence. The rhythmical arrangement articulates a heightened sense of verticality, while the multiple openings allow increased light to enter the nave, directly from the clerestory and indirectly through galleries and side aisles.

Sexpartite nave vaults over squarish bays at Laon continue the kind of structural experimentation begun by the Norman Romanesque builders of Saint-Étienne at Caen (see fig. 11.45) and Durham Cathedral (see fig. 11.42). Laon uses the pointed ribbed vaults, pioneered in the western bays of the nave at Durham, throughout the building. Alternating bundles of shafts rising along the wall reflect the nature of the sexpartite vaults above: Clusters of five colonnettes indicate where transverse arches cross the nave, while three colonnettes adorn the

intermediate piers. Although the system develops from Romanesque building practice (see pages 347 and 349), the elements seem more delicate in the Gothic building. By contrast, Romanesque interiors such as Saint-Sernin (see fig. 11.8) and Durham Cathedral (see fig. 11.43) emphasize the great effort required to support the weight of the vaults.

A change in program at Laon reveals the evolving objectives of this cathedral's designers. At the east end of the nave, where the building work began, clustered shafts were added to piers as well as to the wall. In the later more westerly nave bays, the round piers are plain. Instead of the staggered rhythm created by the earlier alternating pier arrangement, the change produced a more flowing effect. However, the tradeoff for the increased uniformity of the new arrangement was a loss of structural explicitness.

Cathedral of Notre-Dame at Paris

The plan of the Cathedral of Notre-Dame at Paris is recorded as having been begun in 1163, only a few years after Notre-Dame at Laon, although there is evidence that it might have been started as early as the mid-1150s. Notre-Dame, Paris is extraordinarily compact and achieves a unity not present in either Romanesque buildings or earlier Gothic ones (fig. **12.8**).

NAVE In the nave, the transept barely exceeds the width of the facade. As at Saint-Denis (see fig. 12.1), the double ambulatory of the choir continues directly into the aisles, but there are no radiating chapels. This stress on uniformity in the plan finds a parallel in the treatment of the elevation; despite the use of sexpartite vaults, there is no alternating system of supports. As at Laon (see fig. 12.7), the Paris elevation was originally four-part, though oculi were inserted in place of the arcaded triforium. Stylish as this change might have been when the building was begun, a thirteenth-century reconstruction completely

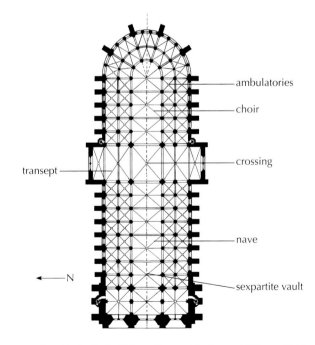

12.8. Plan, Cathedral of Notre-Dame, Paris. ca. 1155–ca. 1250

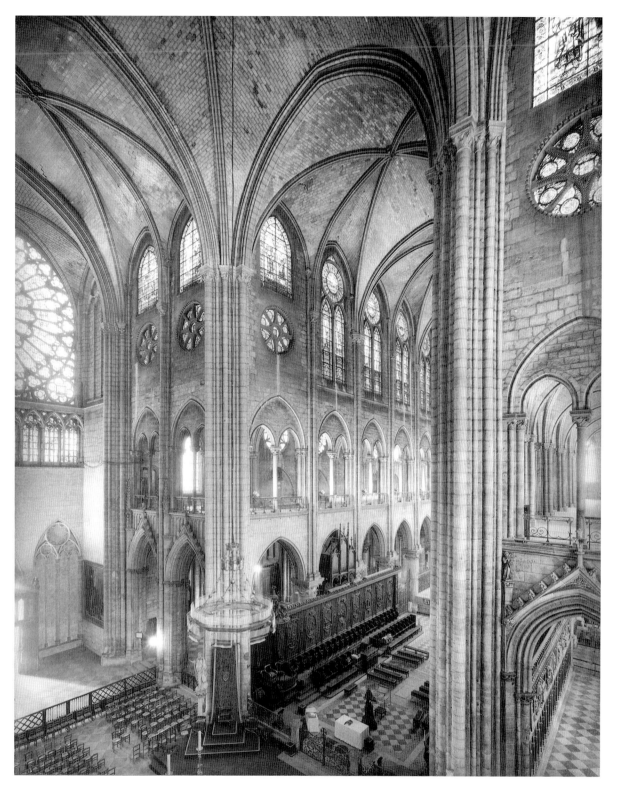

12.9. Nave, Cathedral of Notre-Dame, Paris

eliminated the triforium in order to enlarge the clerestory windows. Because a few bays were returned to their original four-part elevation in a nineteenth-century restoration, we can compare the original and the remodeled elevations (fig. **12.9**). The design change reveals a continuing desire to reduce wall surface and increase the amount of light entering the building. The large clerestory windows and the light and slender forms produce nave walls that seem amazingly thin. This creates the effect of weightlessness.

Like uniformity in the plan, the vertical emphasis of the interior is a clear Gothic trait. It depends not only on the actual proportions of the nave, but also on a constant and repeated accentuation of upward momentum and the apparent ease with which a sense of height is attained.

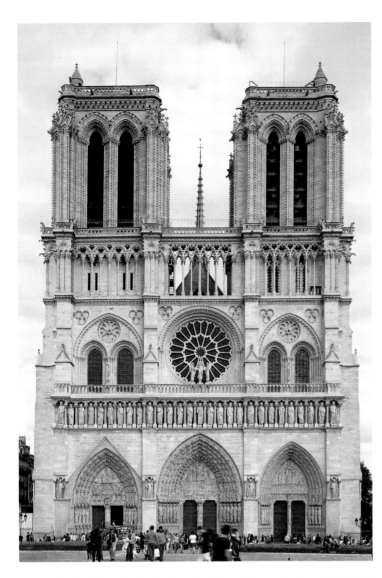

12.10. West facade, Cathedral of Notre-Dame, Paris. ca. 1200–1250

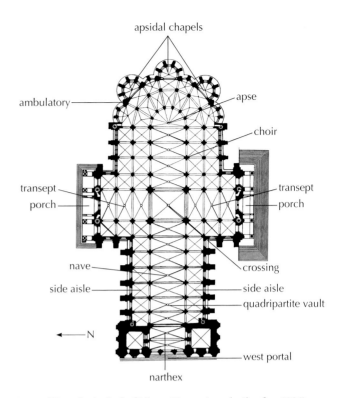

12.11. Plan, Cathedral of Notre-Dame (as rebuilt after 1194), Chartres

WEST FACADE The most monumental aspect of the exterior of Notre-Dame in Paris is its west facade (fig. **12.10**). It retains its original appearance, except for the sculpture, which was badly damaged during the French Revolution and is largely restored. All of its details are integrated into a coherent whole. Here the meaning of Suger's emphasis on harmony, geometric order, and proportion are even more evident than at Saint-Denis itself and go well beyond the achievement of the Chartres Cathedral west portal.

This formal discipline is also apparent in the placement of the sculpture, which no longer shows the spontaneous growth typical of the Romanesque. Instead, it has been assigned a precise role within the architectural framework. At the same time, the cubic solidity of the facade has been moderated by lacelike arcades and window perforations, which break down the continuity of the wall surfaces so that the total effect is of a weightless openwork screen.

HIGH GOTHIC ART IN FRANCE

The political and economic stability of France during the thirteenth century encouraged the continued growth of cities, an ideal climate for producing monumental architecture.

Some art historians have seen the integration of structure and design in Early Gothic art as a series of experiments that were resolved during the High Gothic period. This is undoubtedly true to some extent, but art during the thirteenth century also demonstrates an interest in pursuing refinements that synthesize engineering and aesthetics. Thus, High Gothic art is as much a continuation of Early Gothic experiments as it is their culmination. It is during this time that the names of architects, who previously had been largely anonymous, proliferate, a reflection of the value placed on their achievements and of an increasing interest in personal identity. This concern for the individual also reflects a changing class structure in which those engaged in trade and commerce become more independent.

The Rebuilding of Chartres Cathedral

The rebuilding of Chartres Cathedral after the fire of 1194 (see page 393) marks the next step in the development of Gothic architecture. The new building was largely completed within the astonishingly brief span of 26 years. Its crypt houses Chartres's most important possession: remnants of a tunic said to have been worn by the Virgin Mary, to whom the cathedral is dedicated, at the time of Jesus' nativity. The relic, which miraculously survived the great fire of 1194, had drawn pilgrims from all over Europe.

The fire also spared the west facade and portals, and the decision to conserve these architectural features, which, at the time of the fire, were nearly 50 years old and certainly out of fashion, is

worth noting. After initial despair at the damage wrought by the fire, civic and ecclesiastical authorities animated their followers by interpreting the fire as an expression of the will of the Virgin herself that a new and more glorious cathedral be built. Since the west end of the church, like the famous relic of the Virgin, had also been spared, it too was treated as a relic worthy of preservation. Recognizing the divine plan in what otherwise would have been disheartening circumstances helped fuel enthusiasm for rebuilding and accounts for the rapid pace of construction.

To provide room for large numbers of visitors without disturbing worshipers, there is a wide aisle running the length of the nave and around the transept (fig. **12.11**). It is joined at the choir by a second aisle, forming an ambulatory that connects the apsidal chapels. Worshipers entered the building through the old west portal and passed through a relatively low narthex. It would have taken some time for their eyes to adjust to the darkness of the interior. Even the noise of daily life would have been shut out, and sounds within the building would have been at first eerily muffled. Once worshipers had recovered from this disorienting effect, they would have become aware of a glimmering light, which guided them into the cavernous church. The transition, both subtle and profound, accentuated the significance of entering the church. As with entries into

ART IN TIME

1137–1144—Rebuilding of Abbey Church of Saint-Denis, outside Paris by Suger

1163—Construction begins on the Cathedral of Notre-Dame at Paris

Romanesque and Byzantine churches (see pages 254, 360, and 363), a liminal, or transitional, zone signaled that visitors had left the temporal world behind. Patrons, designers, and builders of a religious edifice had again found meaningful physical forms to encourage and sustain powerful spiritual experiences.

NAVE Designed a generation after Notre-Dame in Paris, the rebuilt nave of Chartres Cathedral (fig. **12.12**) is the first masterpiece of the mature, or High Gothic, style. Several features distinguish this style (fig. **12.13**). By eliminating the gallery, the designers of Chartres imposed a three-part elevation on

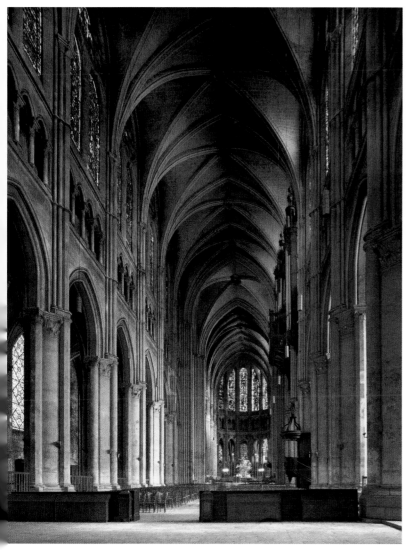

12.12. Nave and choir, Cathedral of Notre-Dame, Chartres. ca. 1194–1220

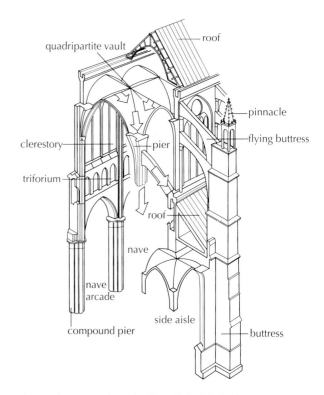

12.13. Axonometric projection of a High Gothic cathedral (after Acland)

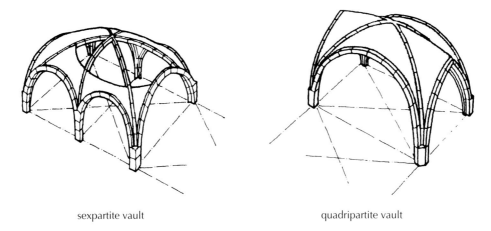

sexpartite vault quadripartite vault

12.14. (a) Sexpartite vaulting and (b) quadripartite vaulting

the wall. Romanesque builders had used tripartite wall divisions (see figs. 11.12, 11.43, and 11.47), but the Chartres solution diminishes horizontality and treats the wall surface as a coherent vertical unit. (It was in an attempt to rival High Gothic buildings such as Chartres that the Early Gothic nave wall of Notre-Dame was reconfigured into a three-part elevation from its original Early Gothic four-part form [see fig. 12.9].) Shafts attached to the piers at Chartres stress the continuity of the vertical lines and guide our eye upward to the vaults, which appear as diaphanous webs stretched across the slender ribs. Quadripartite, or four-part, vaults now replace the sexpartite vaults of Early Gothic buildings (fig. **12.14**). Quadripartite vaults cover rectangular bays and, as a result, the builders did not need to worry any longer about an alternating system of supports. The quickened rhythm of shorter, rectangular bays intensifies the perceived pace of propulsion down the nave.

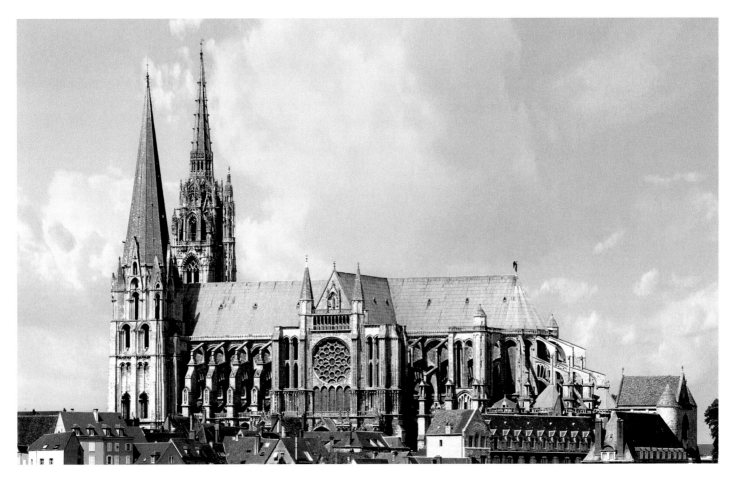

12.15. Cathedral of Notre-Dame, Chartres (from the south)

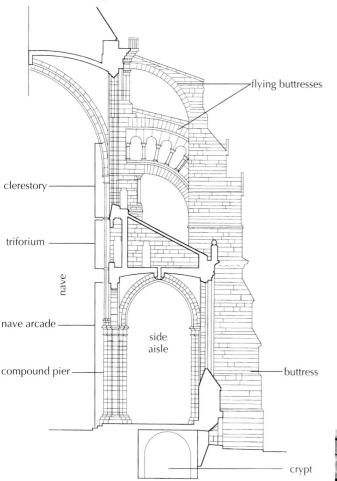

clerestory

triforium

nave

nave arcade

compound pier

flying buttresses

side aisle

buttress

crypt

12.16. Transverse section of Cathedral of Notre-Dame, Chartres (after Acland)

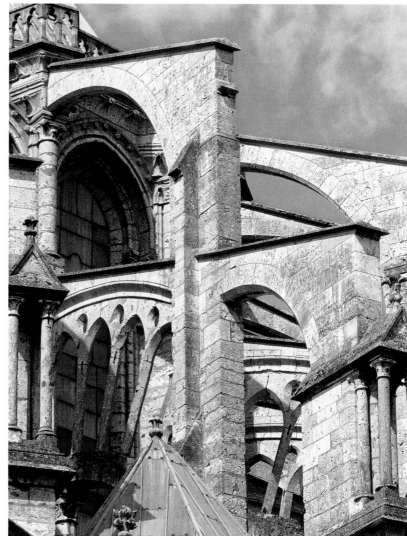

12.17. Flying buttresses, Cathedral of Notre-Dame, Chartres

The openings of the pointed nave arcade are taller and narrower than before, and the clerestory is larger so that it is the same height as the nave arcade. Because there are so few walls, the vast interior space appears at first to lack clear boundaries.

BUTTRESSES In Chartres, as in Suger's choir at Saint-Denis, the buttresses (the heavy bones of the structural skeleton) are visible only outside the building (figs. **12.15–12.17**). The plan (see fig. 12.11) shows them as massive blocks of masonry that stick out from the building like a row of teeth. Above the aisles, these piers turn into **flying buttresses**—arched bridges that reach upward to the critical spots between the clerestory windows where the outward thrust of the nave vault is concentrated (see fig. 12.16). The flying buttresses were also designed to resist the considerable wind pressure on the high-pitched roof. This method of anchoring vaults, so characteristic of Gothic architecture, certainly owed its origin to functional considerations. Yet even the flying buttress is an integral aesthetic and expressive feature of the building (see fig. 12.17). Its shape could express both verticality and support (in addition to actually providing it) in a variety of ways, according to the designer's sense of style.

Theophilus Presbyter (12th century)

De diversis artibus, from Book II: "The Art of the Worker in Glass"

"Theophilus" may have been the pseudonym of Roger of Helmarshausen, a Benedictine monk and metalworker. Metalwork is the subject of the third book of this treatise, following books on painting and stained glass. Theophilus' text, written in the twelfth century, is the first in the Western tradition to give a practitioner's account of the technology of art production.

Chapter 17: *Laying Out Windows*
When you want to lay out glass windows, first make yourself a smooth flat wooden board. Then take a piece of chalk, scrape it with a knife all over the board, sprinkle water on it everywhere, and rub it all over with a cloth. When it has dried, take the measurements of one section in a window, and draw it on the board with a rule and compasses. Draw as many figures as you wish, first with [a point made of] lead or tin, then with red or black pigment, making all the lines carefully, because, when you have painted the glass, you will have to fit together the shadows and highlights in accordance with [the design on] the board. Then arrange the different kinds of robes and designate the color of each with a mark in its proper place; and indicate the color of anything else you want to paint with a letter.

After this, take a lead pot and in it put chalk ground with water. Make yourself two or three brushes out of hair from the tail of a marten, badger, squirrel, or cat or from the mane of a donkey. Now take a piece of glass of whatever kind you have chosen, but larger on all sides than the place in which it is to be set, and lay it on the ground for that place. Then you will see the drawing on the board through the intervening glass, and, following it, draw the outlines only on the glass with chalk.

Chapter 18: *Glass Cutting*
Next heat on the fireplace an iron cutting tool, which should be thin everywhere except at the end, where it should be thicker. When the thicker part is red-hot, apply it to the glass that you want to cut, and soon there will appear the beginning of a crack. If the glass is hard [and does not crack at once], wet it with saliva on your finger in the place where you had applied the tool. It will immediately split and, as soon as it has, draw the tool along the line you want to cut and the split will follow.

SOURCE: THEOPHILUS, *ON DIVERS ART: THE FOREMOST MEDIEVAL TREATISE ON PAINTING, GLASSMAKING, AND METALWORK,* TR. BY JOHN G. HAWTHORNE AND SYRIL STANLEY SMITH (NY: DOVER PUBLICATIONS, 1979)

The masonry techniques involved in constructing cathedrals required both brute labor and skill. *Freemasons,* those who worked in *freestone,* which has a uniform texture and can be chiseled without breaking, carved the individual blocks and set them together to form walls, both outer and inner. The intermediate space was filled with mortar and rough stones, a task which the less skilled *roughmasons* performed. The inner and outer walls were connected by tie-courses of finished freestone, which gave added strength to the walls.

STAINED GLASS Alone among all major Gothic cathedrals, Chartres still retains most of its more than 180 original stained-glass windows (fig. **12.18**). The magic of the jewel-like light from the clerestory is unforgettable to anyone who has experienced it. The windows admit far less light than one might expect. They act mainly as diffusing filters that change the quality of daylight, giving it the poetic and symbolic values so highly praised by Abbot Suger. The sensation of ethereal light dissolves the physical solidity of the church and, hence, the distinction between the temporal and the divine realms. This "miraculous light" creates the intensely mystical experience that lies at the heart of Gothic spirituality.

The majestic *Notre Dame de la Belle Verrière* (literally, "Our Lady of the beautiful window") at Chartres (fig. **12.19**) appears as a weightless form hovering effortlessly in indeterminate space. This window, the only one apart from those of the west facade to survive the 1194 fire, consists of hundreds of small pieces of tinted glass held together by strips of lead. Methods of medieval glassmaking limited the maximum size of these pieces, so the design could not simply be "painted on glass." Rather, the window was painted *with* glass. It was assembled

12.18. North transept, Cathedral of Notre-Dame, Chartres

12.19. *Notre Dame de la Belle Verrière.* ca. 1170 (framing panels are 13th century). Stained-glass window, height approx. 14′ (4.27 m). Cathedral of Notre-Dame, Chartres

much like a mosaic or a jigsaw puzzle, out of odd-shaped fragments cut to fit the contours of the shapes. (See *Primary Source*, page 400.) This process encourages an abstract, ornamental style, which tends to resist any attempt at three-dimensional effects. Only in the hands of a great master could the maze of lead strips lead to such monumental forms. (See *Methods and Materials*, page 403.)

Given the way stained glass accentuates pattern and decorative effect, it is not surprising that it was so popular during the Middle Ages. Its brilliant surfaces are like the flat stones and enamelwork so highly prized in earlier periods (see fig. 10.2); enamel is in fact a kind of glass. The intensity with which the viewer engages with the image parallels the direct connection between viewer and object evident in much of the art of the earlier Middle Ages. Worthy comparisons with *Notre Dame de la Belle Verrière* are the Byzantine mosaics from the Church of the Dormition at Daphni (see figs. 8.45–8.46) for the way they command our attention and communicate directly with a viewer. Both use otherworldly light to convey spiritual messages: on the one hand, filtered through stained glass, and on the other, reflected off gold-glass mosaics.

The stained-glass workers who filled the windows of the great Gothic cathedrals also had to face difficulties arising from the enormous scale of their work. The task required a degree of orderly planning that had no precedent in medieval painting. Only architects and stonemasons knew how to deal with this problem, and it was their methods that the stained-glass workers borrowed in mapping out their own designs. Gothic architectural design relied on a system of geometric relationships to establish numerical harmony (see *The Art Historian's Lens*, page 402); the same rules could be used to control the design of stained-glass windows or even an individual figure.

The drawings in a notebook compiled about 1240 by Villard de Honnecourt, who traveled widely and documented the major buildings he examined, provide some insight into this procedure. (See end of Part II, *Additional Primary Sources*.) What we see in his *Wheel of Fortune* (fig. **12.20**) is not the final version of the design but the system of circles and triangles on which the artist based the image. Another drawing, from the same notebook, the *Front View of a Lion* (fig. **12.21**), illustrates the fundamental importance of such geometric schemes. According to the inscription, Villard portrayed the animal from life. However, a closer look shows that he was able to do so only after he had laid down a geometric pattern: a circle for the face (the dot between the eyes is its center) and a second, larger circle for the body. To Villard, then, drawing from life meant something far different from what it does to us. It meant filling in an abstract framework with details based on direct observation.

TRANSEPTS AND THEIR SCULPTURE Each of the transept arms of Chartres Cathedral has three deeply recessed and lavishly decorated portals, five **lancets** (tall, narrow windows crowned by a sharply pointed arch), and an immense **rose window**, the large medallion of glass in the center of the facade (see figs. 12.15 and 12.18). The wall of these north and south facades has little solidity; it is so heavily pierced as to be nearly skeletal.

Modules and Proportions

Just as musicologists have tried to reconstruct original performance practice during the Middle Ages, so too architectural historians have tried to find the underlying systems that govern the design and construction of medieval buildings, so that they can understand the methods and intentions of medieval builders. How medieval architects and masons decided on the measurements and patterns they employed is a fascinating topic that has been explored by architectural historians since the nineteenth century. Few medieval documents explain how individual architects went about establishing the specific relationships they used, so scholars have to measure buildings and analyze those measurements in order to decipher the systems that were used to design them. The task is not always easy. The medieval yardstick was not the same in all regions, as it was the responsibility of local authorities to control measurement; so, for example, a specific measure in Paris was often different from the measure used in another French town.

The most basic method of establishing a proportional order in building was to either multiply or divide a unit of measure, a system employed in the ninth century in the St. Gall monastery plan (see fig. 10.21), and in later buildings, such as the cathedrals of Santiago de Compostela (see fig. 11.3) and Saint-Sernin in Toulouse (see fig. 11.6), where the square at the crossing of the nave is halved to determine the size of the nave bays and quartered for aisle bays. Medieval architects also employed more complicated proportional schemes. For example, by taking the diagonal of a square and rotating it, a designer could produce a rectangle with a consistent proportional relationship based on the square root of 2 (1.414);

that is, the proportion of the shorter side of the rectangle to its longer side is 1:1.414. This proportional system had been used throughout antiquity, appearing, for example, in Vitruvius' writings (see end of Part II, *Additional Primary Sources*.). The design tools an architect would have needed to produce shapes using these proportions were simply a right angle, a measuring rod, and a compass or a string, which could be used to rotate diagonals and thus form arches.

Art historians have also attempted to understand the philosophical and symbolic significance of medieval systems of measurements. In his analysis of the Gothic cathedral, Otto von Simson described how St. Augustine—whose fifth-century writings were of singular importance throughout the Middle Ages—saw modulation as producing a whole and perfect system that, in effect, reflects the order of the universe. Augustine relies on the biblical description (Wisdom of Solomon 11:21) of an omnipotent God who "hast ordered all things in measure, and number, and weight." For Augustine the employment of ratios in art, as well as in music, not only produces beauty but also allows us to appreciate the divine order. Architectural historians have demonstrated that figures from Platonic geometry, including the pentagon, the equilateral triangle, and the square, were also understood and employed by medieval builders. For Plato, these shapes were associated with the elements that form the cosmos. Thus, once again medieval architects found a physical system that expressed the perfection and wholeness of the universe.

Since the plans and elevations of Gothic cathedrals were viewed as mirrors of divine truths, these buildings can be appreciated as a union of engineering and theology, structure and meaning. Undoubtedly, for the medieval mind, the mathematics needed to plan medieval buildings and the symbolism of the proportions and geometry employed were inseparable.

12.20. Villard de Honnecourt. *Wheel of Fortune*. ca. 1240. Ink on vellum. Bibliothèque Nationale, Paris

12.21. Villard de Honnecourt. *Front View of a Lion*. ca. 1240. Ink on vellum. Bibliothèque Nationale, Paris

Stained Glass

Colored glass was not new in the thirteenth century, when it was used to spectacular effect in the windows of Gothic churches. It can be traced back more than 3,000 years to Egypt, and abundant evidence indicates that the Romans employed thin translucent sheets of glass in their buildings. Literary accounts, supported by some surviving examples, also describe colored glass in Early Christian, Byzantine, Muslim, and early medieval buildings.

In the twelfth-century artist's handbook *De diversis artibus*, the monk Theophilus Presbyter described in great detail the technique for making stained glass (see *Primary Source*, page 400). It required a molten mixture of silica (basically sand), potash (to lower the temperature at which silica melts), and lime (a stabilizer), plus the addition of metal oxides to color or "stain" the glass: The addition of cobalt oxide resulted in blue glass, copper oxide in red, and manganese oxide in purple. The glassworker heated the mixture in a wood-fired furnace and either poured it into molds to cool or shaped it by blowing air through a tube to form the soft glass mixture into an oval ball or cylinder, which he then cut open and flattened.

On a wooden board that had previously been covered with chalk, a designer created a drawing the same size as the window to be filled. Individual pieces of colored glass were cut with hot iron rods to fit the drawing and then arranged on it. Finer details, such as facial features and drapery folds, were then painted on with lead oxides, and the glass was placed in a wood-fired kiln to fuse the painted on designs with the glass. Individual glass pieces were fitted together into malleable lead strips called **cames**. To permanently hold the composition in place, it was attached to an iron frame secured within the window opening. In the early twelfth century, the iron frame formed a grid of squares of about 2 feet on each side (see fig. 12.19). By the thirteenth century, glaziers employed complicated shapes, including circles, lozenges, and quatrefoils, to create increasingly complex designs (see fig. 12.34).

Stained-glass production was a costly, time-consuming, and labor-intensive activity with a marked division of labor. The artisans who made the glass supported the work of the glaziers who designed and produced the windows.

Although stained glass appears throughout Europe (see fig. 12.59), the most significant achievements in glass were made in northern Europe. To produce stained glass required abundant wood, both for firing the furnaces and kilns and for making potash, and it was in the north where there were sufficient forests to support a glassmaking industry. It was also in the north where the value of light entering a building could best be appreciated.

The effect of multicolored refracted light playing off surfaces and across spaces virtually transforms Gothic buildings. Glaziers needed to consider how individual windows could harmoniously relate to the buildings that enframed them and to a larger iconographic and aesthetic program. At Chartres, for example, blue glass predominates in the north transept rose window, while red, which admits less light, predominates in the southern rose window. Since southern light is much stronger than northern, the effect of the two roses is balanced in relation to the amount of natural light entering the building. Stained glass also provided the means to relate stories and images and to imbue them with metaphoric form. The thirteenth-century writer William Durandus of Mende, in his *Rationale divinorum officiorum,* wrote that "the windows of the church are the Holy Scriptures, which expel the wind and the rain, that is all things hurtful, but transmit the light of the true Sun, that is God, into the hearts of the faithful," while St. Bernard of Clairvaux (see page 356) explained that light could pass through glass without damaging it, just as the word of God had penetrated the womb of the Virgin Mary without violating it.

By the late thirteenth century the preference for colored glass had diminished and large areas of clear glass dominate church construction (see fig. 12.36). Where figures are employed, they remain quite vividly colored, but are isolated within large expanses of grayish **grisaille glass**, with yellow-stained glass used to represent architectural frames around the figures. This paler glass allows light to illuminate more fully the increasingly complex architectural details of later Gothic architecture.

Detail from *Notre Dame de la Belle Verrière,* Cathedral of Notre-Dame, Chartres. ca. 1170

12.22. Portals, north transept, Cathedral of Notre-Dame, Chartres. ca. 1204–1230

On the earlier west facade, which holds the main entrance to the cathedral, the rose window, which was added after the 1194 fire, is composed of a grouping of holes cut out of the solid wall (see fig. 12.4). By comparison, thin membranes hold the glass of the north rose in place. Art historians use the terms **plate tracery** and **bar tracery** to describe the different methods of composition employed here. The bar tracery of the transept roses creates intricate decorative patterns and permits an increased amount of glass in relation to frame or wall surface.

The north transept (fig. **12.22**) is devoted to the Virgin Mary. She had already appeared over the right portal of the west facade in her traditional role as the Mother of God seated on the Throne of Divine Wisdom (see fig. 12.5). Her new prominence reflects the growing importance of the cult of the Virgin, which the Church had actively promoted since the Romanesque period. The growth of *Mariology,* as it is known, was linked to a new emphasis on divine love, embraced by the faithful as part of the more human view that increased in popularity during the Gothic era. The cult of the Virgin at Chartres developed special meaning about 1204, when the cathedral received the head of her mother, St. Anne, as a relic. This relic, in combination with the robe of the Virgin that had miraculously survived the fire of a decade earlier, gave Chartres exceptional status among those devoted to Mary.

The north tympanum of about 1210 depicts events associated with the Feast of the Assumption, when Mary was transported to Heaven (fig. **12.23**). These events are the Death (Dormition), Assumption, and Coronation of the Virgin, which, along with the Annunciation, became the most frequently portrayed subjects relating to her life. They identify Mary with the Church as

12.23. *Coronation of the Virgin* (tympanum), *Dormition and Assumption of the Virgin* (lintel), north portal, Cathedral of Notre-Dame, Chartres. ca. 1210

12.24. Jamb statues, south transept portal, Cathedral of Notre-Dame, Chartres. ca. 1215–1220. Left-most figure (St. Theodore) ca. 1230

the Bride of Christ and the Gateway to Heaven, in addition to her traditional role as divine intercessor. She becomes not only Christ's companion, but also his Queen. Unlike earlier representations, many of which rely on Byzantine examples, these are of Western invention. The figures have a monumentality never found before in medieval sculpture. Moreover, the treatment is so pictorial that the scenes are independent of the architectural setting into which they are crammed.

Whereas the *Coronation of the Virgin* represents a relatively early phase of High Gothic sculpture, the jamb statues of the transept portals show a discernible evolution, even among themselves since they were carved at different times. The relationship of statue and column begins to dissolve. The columns are quite literally put in the shade by the greater width of the figures, by the strongly projecting canopies, and by the elaborately carved bases of the statues.

A good instance of this early dissolution of the relationship between statues and columns is seen on one of the south transept portal jambs (fig. **12.24**). The three saints on the right still echo the cylindrical shape of Early Gothic jamb statues

(see fig. 12.6), though the heads are no longer strictly in line with the central axis of the body. By comparison, the knight on the left, St. Theodore, who was carved about ten or fifteen years later than his companions, stands at ease, in a semblance of classical *contrapposto*. His feet rest on a horizontal platform, rather than on a sloping shelf as before, and the axis of his body, instead of being straight, describes a slight but perceptible S-curve. Even more surprising is the wealth of carefully observed detail in his weapons and in the texture of his tunic and chain mail. Above all, there is the organic structure of the body. Not since imperial Roman times have we seen a figure as thoroughly alive as this. Yet the most impressive quality of the St. Theodore statue is not its naturalism but the serene, balanced image that it conveys. This ideal portrait of the Christian soldier expresses the spirit of the Crusades in its most elevated form.

Amiens Cathedral

The High Gothic style defined at Chartres reaches its climax a generation later in the interior of Amiens Cathedral (figs. **12.25 and 12.26**). Amiens was begun in 1220, two years after a fire destroyed an earlier cathedral on the site and while Chartres was still under construction; the nave was vaulted by 1236 and work on the choir continued for another 25 years. It is significant that we know the names of the cathedral's architects, Robert de Luzarches, Thomas de Cormont, and his son Renaud de Cormont, since it indicates a heightened social status of Gothic builders.

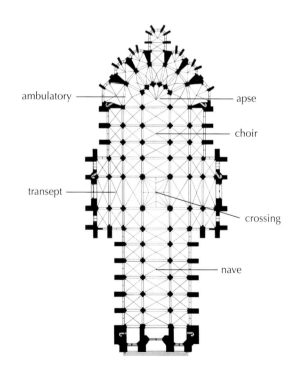

12.25. Robert de Luzarches, Thomas de Cormont, and Renaud de Cormont. Plan, Cathedral of Notre-Dame, Amiens. Begun 1220

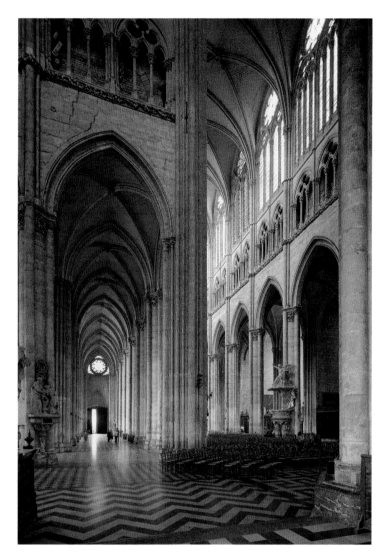

12.26. Nave and side aisle, Cathedral of Notre-Dame, Amiens

NAVE The breathtaking height of the nave (fig. 12.26) is the dominant achievement both technically and aesthetically at Amiens. We can see clearly the relatively swift and continuous progression toward verticality in French Gothic cathedral architecture by comparing the nave elevations of the Early Gothic Cathedral of Notre-Dame in Paris and the High Gothic cathedrals of Chartres and Amiens (fig. **12.27**). The height of the Amiens nave arcade, greatly increased in proportion to the rest of the wall, creates a soaring effect; it alone is almost as high (70 feet) as the entire four-story elevation of Laon (78 feet). The complete nave rises 140 feet above the ground, while that at Chartres measures "only" 118 feet from floor to vault. Moreover, the width of the Amiens nave is narrower in proportion to its height; at Paris the ratio of nave width to height is 1:2.2 and at Chartres 1:2.4, while at Amiens it is 1:3. Thus the effect of soaring verticality increased in direct proportion to the narrowing of the nave. There is also increased vertical integration through the use of shafts that rise directly through the capitals of the piers. Moreover, the triforium and clerestory are connected visually by means of a central colonnette, so that the entire wall above the nave arcade is pulled together vertically. At Amiens the vaults are as taut and thin as membranes; skeletal construction is carried to its virtual limits.

Reims Cathedral

We can trace the same emphasis on verticality and translucency in the development of the High Gothic facade. The one at Reims Cathedral makes an instructive contrast with Notre-Dame in Paris, even though it was designed only about 30 years

12.27. Comparison of nave elevations in same scale (after Grodecki)

Notre-Dame, Paris

Chartres Cathedral

Amiens Cathedral

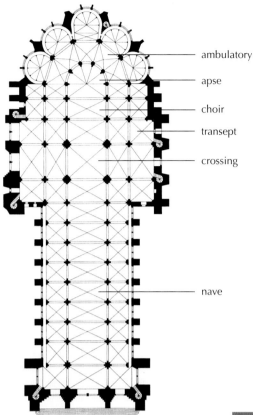

ambulatory

apse

choir

transept

crossing

nave

12.28. Plan, Cathedral of Notre-Dame, Reims. ca. 1225–1290

later. Reims, as the coronation cathedral of the kings of France, was closely linked to Paris, where the kings held court. The two share many elements, including broad transepts that extend out from the body of the church only slightly, but they have been reshaped into very different ensembles (fig. **12.28**).

WEST FACADE The portals on the west facade of Reims Cathedral (fig. **12.29**), instead of being recessed as in Paris (see fig. 12.10), project forward as gabled porches, with windows in place of tympana above the doorways. The gallery of royal statues, which in Paris forms a horizontal band between the first and second stories, has been raised in Reims until it merges with the third-story arcade. Every detail except the rose window has become taller and narrower than before. **Pinnacles** (small pointed elements capping piers, buttresses, and other architectural forms) everywhere accentuate restless upward movement. The sculptural decoration, by far the most lavish of its kind, no longer remains in clearly marked-off zones, but has now spread to so many new perches, not only on the facade but on the flanks of the edifice as well, that the exterior begins to look like a dovecote for statues.

12.29. Cathedral of Notre-Dame, Reims (from the west)

ART IN TIME

1180–1223 CE—Reign of French King Philip August

**1194—A fire destroys much of Chartres Cathedral
in France**

1252—Italian theologian Thomas Aquinas begins teaching
in Paris

WEST PORTAL SCULPTURE The jamb figures at Reims are not in their original positions because some sculptures were moved between the west facade and the transept portals. As a result, continuity of style and program is difficult to assess. However, we can study here individual sculptures of distinctive style and high quality. Gothic classicism (see page 405) reached its climax in some of these Reims statues. The most famous of them is the *Visitation* group (fig. **12.30**, the two figures on the right), which was carved between 1230 and 1233. It depicts the Virgin Mary announcing the news of her pregnancy to her cousin Elizabeth.

For a pair of jamb figures to enact a narrative scene such as this would have been inconceivable in Early Gothic sculpture, where individual figures remained isolated, even within unified programs. That the *Visitation* figures are now free to interact shows how far the column has receded into the background.

12.30. *Annunciation* and *Visitation*, west portal, Cathedral of Notre-Dame, Reims. ca. 1230–1265

The S-curve, resulting from the pronounced *contrapposto*, is much more obvious here than in the St. Theodore from Chartres (see fig. 12.24) and dominates both the side and the front views of the figures. The figures gesture at each other as they communicate across the space that separates them, an engagement with open space that recalls the more active role taken on by space in High Gothic architecture, too.

Horizontal folds of cloth pulled across the women's abdomens emphasize the physical bulk of their bodies. Mary and Elizabeth remind us so strongly of ancient Roman matrons that we might wonder if the artist was inspired by large-scale Roman sculpture (compare fig. 7.13). A surviving Roman gate attests to the Roman presence in Reims, and excavations during the last century established that the first cathedral on the site was built over Roman baths. That Roman models might have been available to the Reims sculptors is thus a real possibility.

Because of the vast scale and time frame of the sculptural program at Reims (and at other cathedrals as well), it was necessary to employ a variety of sculptors working in distinct styles. Two of these styles, both clearly different from the classicism of the *Visitation*, appear in the *Annunciation* group (fig. 12.30, the two figures on the left). The difference in style within a single group derives from the fact that the angel Gabriel and the Virgin were not originally intended as a pair, but were installed next to each other, as we see them today. The Virgin, from between 1240 and 1245, has a rigidly vertical axis, and her garments form straight, tubular folds meeting at sharp angles. This severe style was probably invented about 1220 by the sculptors of the west portals of Notre-Dame in Paris; from there it traveled to Reims as well as Amiens. The angel, in contrast, is remarkably graceful and was carved at least a decade later than the Virgin of the *Annunciation*, between 1255 and 1265. The tiny, round face framed by curly locks, the emphatic smile, the strong S-curve of the slender body, and the rich drapery of this "elegant style" spread far and wide during the following decades. In fact, it soon became the standard formula for Gothic sculpture. Its effect will be seen for many years to come, not only in France but also abroad.

RELIEF SCULPTURE A mature example of the elegant style is the Old Testament group of *Melchizedek and Abraham* (fig. **12.31**), carved shortly after the middle of the thirteenth century, for the interior west wall of Reims Cathedral. These sculptures were probably conceived in relation to the royal coronation ceremonies held in the Cathedral. Abraham and Melchizedek were chosen as subjects because they are Old Testament sacred leaders, and the scene emphasizes that earthly power is bestowed through and in the service of the Church. Abraham, in the costume of a medieval knight, recalls the vigorous realism of the St. Theodore at Chartres (see fig. 12.24) in the attention the sculptor invested in his garments and trappings. Melchizedek, however, shows clearly his proximity to the angel of the Reims *Annunciation* (see fig. 12.30) in his even more elaborately curled hair and beard and the ample draperies that nearly swallow the body among the play of folds. Deep recesses and sharply projecting ridges show a new awareness of the effects of

12.31. *Melchizedek and Abraham*, interior west wall, Cathedral of Notre-Dame, Reims. ca. 1260–1270

light and shadow that are as pictorial as they are sculptural. This pictorialism is also apparent in the way the figures interact, despite being placed in deep niches. The realism of these figures is heightened by the foliage that occupies the framing elements around them, representing specific and recognizable plants, which include oak and fig leaves as well as acorns.

References to the increasing realism of Gothic sculpture need qualification, since Gothic realism was never systematic.

Rather, it was a *realism of particulars*, focused on specific details rather than on overall structure. Its most characteristic products are not only the classically oriented jamb statues and tympanum compositions of the early and mid-thirteenth century, but also small-scale carvings, such as the *Labors of the Months* and the *Signs of the Zodiac* in **quatrefoil** (four-lobed) frames on the facade of Amiens Cathedral (fig. **12.32**). The same subjects appear on Romanesque and early Gothic portals, but at

12.32. *Signs of the Zodiac* (Leo, Virgo, and Libra) and *Labors of the Months* (July, August and September), west facade, Amiens Cathedral. ca. 1220–1230

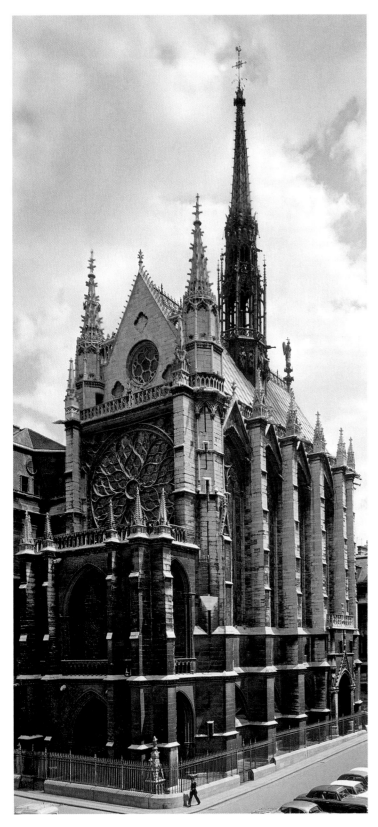

12.33. Sainte-Chapelle, Paris (from the southwest). 1241–1248. (Rose window, late 15th century)

Amiens they demonstrate a delightful observation of everyday life. The sculptor was clever in arranging individual scenes within the decorative quatrefoils, a shape difficult to master compositionally.

The High Gothic cathedrals of France represent a concentrated effort rarely seen before or since. The huge cost of these truly national monuments was borne by donations collected from all over the country and from all classes of society. These cathedrals express the merging of religious and patriotic fervor that had been Abbot Suger's goal. However, the great expense and forced taxation required to construct these buildings did produce vehement objections, and in 1233, for example, construction of Reims Cathedral was suspended as a result of civil unrest directed against the cathedral authorities and was not resumed for another three years. The cessation of building activity helps explain the variety of styles at Reims. By the middle of the thirteenth century the wave of enthusiasm for large-scale projects had passed its crest. Work on the vast structures now proceeded at a slower pace. New projects were fewer and generally far less ambitious. As a result, the highly organized teams of masons and sculptors that had formed at the sites of the great cathedrals during the preceding decades gradually broke up into smaller units.

RAYONNANT OR COURT STYLE

One of those who still had the will and means to build on an impressive scale during the mid-thirteenth century was King Louis IX (known as St. Louis following his canonization in 1297, fewer than 30 years after his death). Under the king's governance and as a result of a treaty with the English that resulted in French control of Normandy, the map of Louis's possessions begins to take on the shape of present-day France. The increasing importance of the monarchy and the rising importance of Paris, where the court was located, is reflected in the degree to which Louis was able to define a court style; our sense of Paris as an artistic center effectively begins under St. Louis.

Sainte-Chapelle

St. Louis's mark on the stylistic evolution of Gothic is most dramatically seen in his court chapel, called the Sainte-Chapelle, which was designed by 1241 and completed within seven years (fig. **12.33**). The two-story building comprises a ground floor, a relatively low chapel for court officials, and an upper floor to which the royal family had direct access from their quarters in the palace. In essence, the building is a type of palatine chapel for which Charlemagne's building at Aachen (see fig. 10.17) serves as an early prototype.

The impetus for the building's construction was Louis's acquisition from his cousin, the emperor of Constantinople, of the Crown of Thorns and other relics of Christ's Passion, including a part of the True Cross, the iron lance, the sponge, and a nail. Such sacred relics required a glorious space for their display. Rich colors, elaborate patterns, and extensive amounts of gold cover Sainte-Chapelle's walls, vaults, and other structural members (fig. **12.34**). This decoration complements the

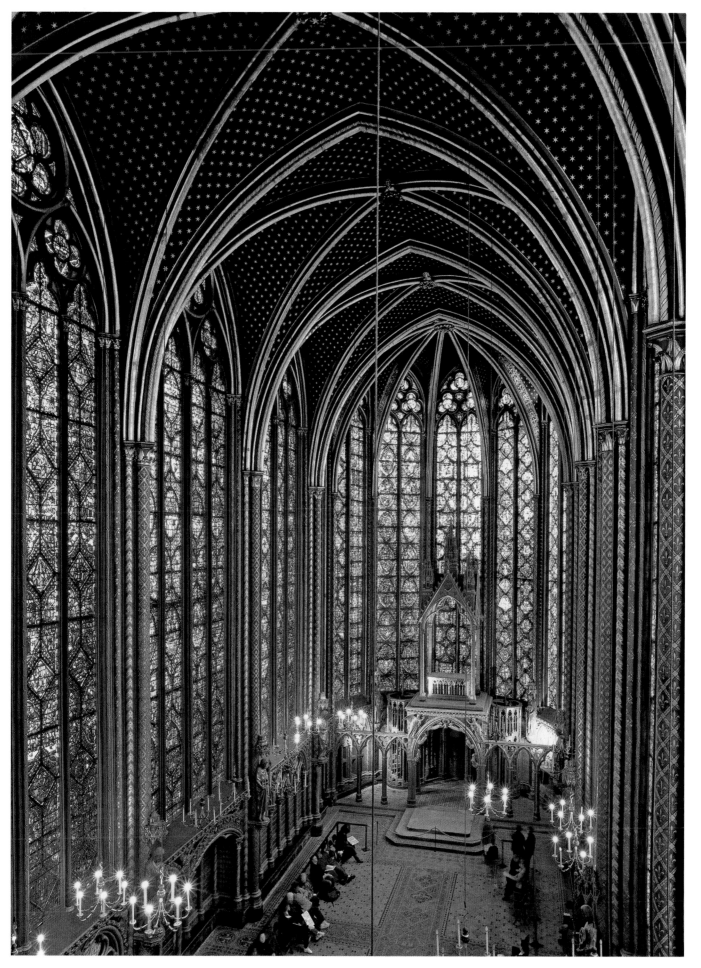

12.34. Interior of upper chapel, Sainte-Chapelle

stained glass that constitutes most of the surface of the chapel. Above the altar, an elevated shrine, destined to frame and display the sacred relics, was left open at the back so that filtered light would bathe the venerated objects on display. The delicate glass cage of a building, jewel-like in the intensity of the colored light that enters it, functions in effect as a monumental reliquary. The tall, thin lancets accentuate verticality to such a degree that the building conveys a sense of monumentality comparable to any cathedral despite its diminutive scale. On entering the building the viewer is virtually immersed within its aura of light, different from any normal experience of the physical world. Thus, as with the Hagia Sophia (see pages 256–259), spirituality is made manifest through the materiality of architecture and its decoration.

Sainte-Chapelle's exterior buttresses are relatively modest in scale, given the great amount of glass and the large size of the windows in proportion to the walls (see fig. 12.33). By keeping the buttresses close to the building, the builders kept to a minimum the shadows cast across the windows. In order to withstand the physical forces usually contained by more promi-nent buttresses, two horizontal iron chains passing across the chapel's windows reinforce the structure, a remarkably effective solution to the structural and aesthetic problems the builders faced.

This phase of Gothic is often referred to as *rayonnant*, from the French *rayonner*, "to radiate light." The term derives from the prevalence of raylike bar tracery in buildings of the period, which originally appeared in rose windows and later began to appear throughout entire churches. The style, closely associated with the court, spread through the royal domain and then through much of Europe.

Saint-Urbain in Troyes

Saint-Urbain in Troyes (figs. **12.35** and **12.36**), built during the later years of the thirteenth century, was commissioned by Pope Urban IV (r. 1261–1264) to mark his birthplace and was dedicated to his patron saint. By eliminating the triforium and simplifying the plan, the designer created a delicate glass cage of only two stories; the slightly larger upper one is virtually all glass, much of it clear. The delicate tracery of the choir

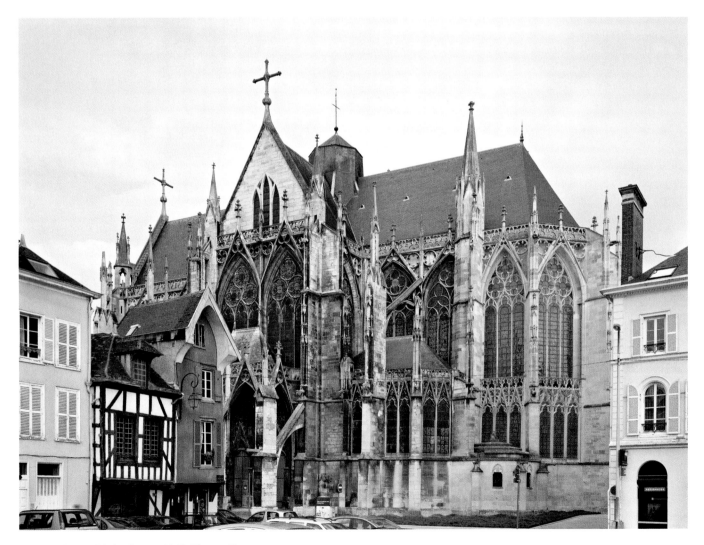

12.35. Saint-Urbain, Begun 1262. Troyes, France

PSALTER OF BLANCHE OF CASTILE A psalter execut-ed around 1230 for Blanche of Castile, mother of King Louis IX, shows these connections. The psalter (fig. **12.37**) was proba-bly made during the period when Blanche served as regent (1226–1234) for Louis, who had inherited the throne at age 12 and could not reign in his own right for another six years. The range and intensity of colors (particularly of red and blue), the heavy outlines, and the placement of scenes within geomet-ric shapes—here interlocked circles and semicircles—recall the treatment and arrangement of stained glass seen, for example, behind the shrine at Sainte-Chapelle (see fig. 12.34). The polished gold background of the illuminated page creates a dazzling display, not unlike the effect of light transmitted through glass.

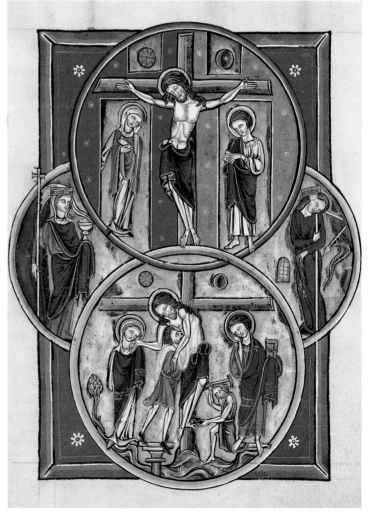

12.37. *Crucifixion and Deposition*, from the *Psalter of Blanche of Castile*. ca. 1230. Ink, tempera, and gold leaf on vellum. $7^3/_4 \times 6''$ (19.9 × 15.4 cm). Bibliothèque de l'Arsenal, Paris. Res ms 1186

windows, which begin only 10 feet above the floor, emphasizes the effect of a screen dematerialized by light. Flying buttresses so thin as to be hardly noticeable support the building. The same spiny elegance characterizes the architectural ornament: Gables are fully detached from the window walls they are designed to support. The delicacy of Saint-Urbain leaves no doubt that the heroic age of the Gothic style is past. Refinement of detail, rather than monumentality, is now the chief concern.

Manuscript Illumination

Some authors have been concerned that the term *rayonnant* is appropriate only for architecture. Recognizing that there were also major achievements in the pictorial arts within Louis IX's court and in the upper echelons of aristocratic society, they prefer the term *court style,* which they use synonymously with *rayonnant* to define the art of this time. In fact, there are many connections between the building arts and the elaborate devo-tional works with exquisite miniatures produced for the per-sonal enjoyment and education of the royal family and for others who were literate and could afford them. These products of French manuscript workshops disseminated the refined taste that made the court art of Paris the standard for all Europe.

The scenes on our page of this Bible are arranged in vertically stacked roundels, and once again the tall and narrow windows of Sainte-Chapelle (see fig. 12.34) offer a particularly clear parallel. The spaces around the roundels in the manuscript abound with flourishes and diaper patterns of repeated diamonds, analogous to the decoration surrounding the scenes in the Sainte-Chapelle windows.

PSALTER OF SAINT LOUIS Perhaps the closest parallel between painting and architectural form is the *Psalter of Saint Louis*, which was executed about 1260 (fig. **12.39**). The folio reproduced here illustrates 1 Samuel 11:2, in which Nahash the Ammonite threatens the Jews at Jabesh. The manuscript's painted architecture is modeled directly on Sainte-Chapelle (see fig. 12.33). The illustration also recalls the canopies above the heads of jamb statues at Chartres (see fig. 12.24) and the arched twin niches that enclose the relief of *Melchizadek and Abraham* at Reims (see fig. 12.31). Against the two-dimensional background of the page, the figures stand out in relief by their smooth and skillful mod-

12.38. *Scenes from the Apocalypse*, from a *Bible moralisée*. ca. 1225–1235. Ink, tempera, and gold leaf on vellum, $15 \times 10\frac{1}{2}''$ (38 × 26.6 cm). Pierpoint Morgan Library, New York

BIBLE MORALISÉE At about the same time as the *Psalter of Blanche of Castile*, a *Bible moralisée*, or **moralized Bible** (fig. **12.38**), in which a biblical image accompanies a relatively brief biblical text or a moralizing commentary in Latin or French, was also commissioned by the queen of France in a style comparable to the *Psalter of Blanche of Castile*. This manuscript is today divided between the Cathedral of Toledo, in Spain, and the Pierpoint Morgan Library, in New York, and originally comprised nearly 3,000 illustrated pages. There are a number of moralizing bibles of this type; the original one was probably invented for Blanche and produced a few years earlier than this example and, like this one, in Paris.

These bibles were made for the personal use of the kings and queens of France and were intended both as precious objects and guides for good conduct. The tone of these instructional guides is very much in keeping with the character and accomplishments of Louis, guided by his powerful and involved mother. Louis was an eager warrior for Christianity who organized and participated in two Crusades—he died in 1270 while on crusade in Tunisia—and he was both pious and compassionate.

12.39. *Nahash the Ammonite Threatening the Jews at Jabesh*, from the *Psalter of St. Louis*. 1253–1270. Ink, tempera, and gold leaf on vellum. $5 \times 3\frac{1}{2}''$ (13.6 × 8.9 cm). Bibliothèque Nationale, Paris

12.40. Master Honoré. *David and Goliath,* from *The Prayer Book of Philip IV the Fair.* 1296. Ink and tempera on vellum, $7^7/_8 \times 4^7/_8''$ (20.2 × 12.5 cm). Bibliothèque Nationale, Paris

ART IN TIME

1241—Sainte-Chapelle, court chapel of French King Louis IX, designed

1265—Birth of Italian poet Dante, author of *The Divine Comedy*

1273—Emergence of the Hapsburgs; Rudolf I elected king

complex visual displays. Late Gothic manuscripts and sculptures are also highly decorated and are rich in surface treatment, accentuating their precious qualities.

Manuscript Illumination

Until the thirteenth century, illuminated manuscripts had been produced in monastic scriptoria. Now, along with many other activities that were once the special preserve of the clergy, manuscript production shifted to urban workshops organized by laypeople, the ancestors of the publishing houses of today. Here again the workshops of sculptors and stained-glass painters may have set the pattern. Paris was renowned as a center of manuscript production, and it is possible even today to identify the streets on which the workshops were clustered.

PRAYER BOOK OF PHILIP IV THE FAIR Some of these new, secular illuminators are known to us by name. Among them is Master Honoré of Paris, who in 1296 painted the miniatures in the *Prayer Book of Philip IV the Fair,* commissioned by the grandson of Louis IX (fig. **12.40**). Our illustration shows him working in a style derived from the *Psalter of Saint Louis* (see fig. 12.39). Here, however, the framework no longer dominates the composition. The figures have become larger and their relieflike modeling more pronounced, an effect achieved through gentle shifts of color and modulated white highlights, quite different from the flat planes of color so characteristic of earlier manuscripts. The figures do not appear to stand comfortably, since their turned-down feet are flattened against the page. However, the figures are allowed to overlap the frame, which helps to detach them from the flat pattern of the background and thus introduces a certain, though very limited, depth into the picture. The implication of space helps further the storytelling quality of the representation. In the lower scene, David and Goliath each appear twice; in an expressive detail, Goliath, as if in distress, brings his hand to his forehead even before David has released his shot.

HOURS OF JEANNE D'ÉVREUX The interest in depicting sculptural figures represented in depth was further developed by the illuminator Jean Pucelle in a tiny, private prayer book—called a **book of hours**—illuminated in Paris between 1325 and 1328 for Jeanne d'Évreux, queen of France

eling. The outer contours are defined by heavy, dark lines, once again like the lead strips in stained-glass windows. The figures themselves display all the features of the elegant style invented by sculptors a few years earlier: graceful gestures, swaying poses, smiling faces, and neatly waved hair. (Compare the *Annunciation* angel in figure 12.30 and *Melchizedek and Abraham* in figure 12.31.) This miniature thus exemplifies the refined taste of the court art of Paris.

LATE GOTHIC ART IN FRANCE

Although Late Gothic art builds on earlier Gothic achievements, during this period artists felt free to deviate from previous patterns of development. Builders showed increased concern for unity of plan, but they also employed curvilinear and elaborate decorative forms that often undermined the clarity of structure so important in earlier Gothic works. Elaborate arrangements of overlapping and pierced planes produced

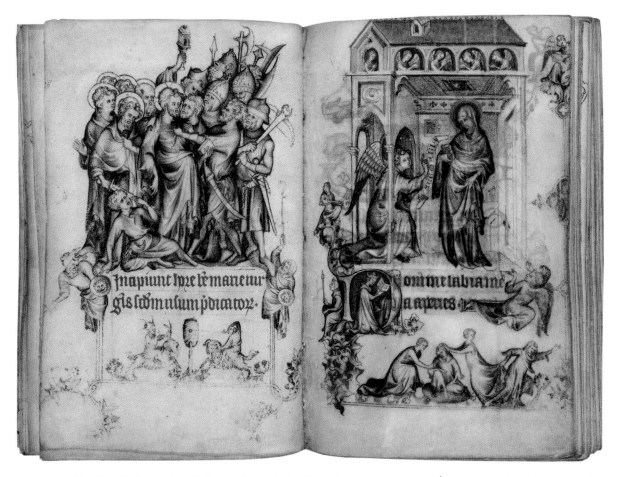

12.41. Jean Pucelle. *The Betrayal of Christ* and *Annunciation*, from the *Hours of Jeanne d'Évreux*. 1325–1328. Tempera and gold leaf on parchment. Each page, $3\frac{1}{2} \times 2\frac{7}{16}$ (8.9 × 6.2 cm). Shown larger than actual size. The Metropolitan Museum of Art, New York. The Cloisters Collection, Purchase, 1954 (54.1.2)

(fig. **12.41**). The *Annunciation* is represented on the right page and the *Betrayal of Jesus* on the left. The style of the figures recalls Master Honoré (see fig. 12.40), but the delicate **grisaille** (painting in gray) adds a soft roundness to the forms. This is not Pucelle's only contribution: The architectural interior reveals a spatial recession previously unknown in northern European painting. In the *Annunciation*, Gabriel kneels in an anteroom, while angels appear in the windows of an attic, from which the dove of the Holy Spirit descends.

In representing this new pictorial space, Jean Pucelle had to take into account the special needs of a manuscript page. The Virgin's chamber does not fill the entire picture surface. It is as though it were an airy cage floating on the blank background (note the supporting angel on the right), like the rest of the ornamental framework, so that the entire page forms a harmonious unit. Many of the details are peripheral to the religious purpose of the manuscript. The kneeling queen inside the initial D is surely meant to be Jeanne d'Évreux at her prayers; it is as if her intense devotions have produced a tangible vision of the Annunciation. The identity of the man with the staff next to her is unclear, although he appears to be a courtier listening to the lute player perched on the tendril above him. The combination of scenes is a commentary on experiences that become real even

if they lack physical substance: Music is at once actual and ephemeral, as is Jeanne's religious vision.

Other enchanting vignettes fill the page. A rabbit peers from its burrow beneath the girl on the left, and in the foliage leading up to the initial we find a monkey and a squirrel. These fanciful marginal designs—or **drôleries**—are a common feature of Northern Gothic manuscripts. They originated more than a century before Jean Pucelle in the regions along the English Channel. From there they quickly spread to Paris and the other centers of Gothic art. Their subjects include a wide range of motifs; fantasy, fable, and grotesque humor, as well as scenes of everyday life, which appear side by side with religious themes. The essence of *drôlerie* is its playfulness. In this special domain, the artist enjoys an almost unlimited freedom—comparable to a jester's—which accounts for the wide appeal of *drôleries* during the later Middle Ages.

The seeming innocence of Pucelle's *drôleries* nevertheless hides a serious purpose, which is particularly evident in the *drôlerie* at the bottom of the right-hand page, a type of illustration referred to as a **bas-de-page** (French for "bottom of the page"). The four figures are playing a game of tag called Froggy in the Middle, a reference to the *Betrayal of Jesus* on the opposite page. Below the *Betrayal of Jesus*, two knights on goats

joust at a barrel. This image not only mocks courtly chivalry but also refers to Jesus as a "scapegoat," and to the spear that pierced his side at the Crucifixion.

Sculpture

Portal sculpture, the principal interest of the Early and High Gothic periods, is of relatively little consequence during the Late Gothic period. Single figures, carved in the round, many of them cult figures, are now fully detached from any architectural setting. As the individual's importance in society increased, so individual sculpted figures became prominent. Sculptors' guilds were now well established. Two guild masters, appointed by the king, guaranteed that sculptors would fulfill the statutes that governed their corporation. In addition to stone carving, sculptors produced a significant number of precious objects in metal and ivory.

VIRGIN OF JEANNE D'ÉVREUX Pucelle's Virgin of the *Annunciation*, with its poised elegance, has a remarkable counterpart in the silver-gilt statue that the same patron offered to the Abbey of Saint-Denis in 1339 (fig. **12.42**). The elegance and refinement of the *Virgin of Jeanne d'Évreux* reminds us that metalwork—so significant during the earlier Middle Ages—continued

12.42. *Virgin of Jeanne d'Évreux*. 1339. Silver gilt and enamel, height 27½″ (68 cm). Musée du Louvre, Paris (Inv MR342; MR419)

VIRGIN OF PARIS In another early fourteenth-century sculpture of the Virgin, we see how traces of classicism increasingly disappear from Gothic sculpture, while elegance becomes a virtual end in itself. Thus the human figure of the *Virgin of Paris* (fig. **12.43**) in Notre-Dame Cathedral is now strangely abstract. It consists largely of hollows, and the projections are so reduced that a viewer sees them as lines rather than volumes. The statue is quite literally disembodied—its swaying stance bears little relation to Classical *contrapposto*, since it no longer supports the figure. Compared to such unearthly grace, the angel of the Reims *Annunciation* (see fig. 12.30) seems solid indeed; yet it contains the seed of the very qualities expressed so strikingly in the *Virgin of Paris*. Earlier instances of Gothic naturalism (see pages 409), which focused on particulars, survive here as a kind of intimate realism in which the infant Christ is no longer a savior-in-miniature facing the viewer but, rather, a human child playing with his mother's veil.

The elegant manner of this new style was encouraged by the royal court of France and thus had special authority. It is this graceful expressive quality, not realism or classicism, that is the essence of Gothic art. These Late Gothic sculptures might lack the epic quality of Early Gothic sculpture, but they are still impressive works that also relate to Late Gothic art in other mediums, such as ivory, as we shall now see.

SIEGE OF THE CASTLE OF LOVE The *Virgin of Jeanne d'Évreux* and the *Virgin of Paris* were made for a sophisticated audience that valued elegant and luxurious objects. These patrons

12.43. *Virgin of Paris*. Early 14th century. Stone. Notre-Dame, Paris

to be a valued medium. Even during the Early Gothic period, Abbot Suger made clear the expense that patrons were willing to invest in reliquaries, shrines, altar embellishments, and liturgical vessels. And, it has been calculated that the reliquary designed for the Crown of Thorns cost more than twice the construction expenses of the Sainte-Chapelle, which was built to house it.

In the *Virgin of Jeanne d'Évreux*, the graceful sway of the Virgin's body is counterbalanced by the harmonious way in which the drapery's vertical folds and soft curves play off each other. The Christ Child touches his mother's lips in a gesture both delicate and intimate. The inscription on the base of the statue recording the royal gift and the *fleur-de-lis*, symbol of French royalty, held by the Virgin, associate her royal stature with that of the donor.

12.44. *Siege of the Castle of Love*. Back of a mirror. ca. 1320–1350. Ivory, $4^{1}/_{2} \times 4^{1}/_{4} \times ^{1}/_{2}''$ (11.5 × 10.9 × 1.27 cm). Seattle Art Museum. Donald E. Frederick Memorial Collection (49.37)

also commissioned secular articles for their own use, many of which were made by the same artists who created religious images. Objects, in precious materials such as ivory, were often decorated with scenes from the romantic courtly literature that was popular at the time. These stories were recounted by troubadours, whose favorite subjects were the sweetness and the bitterness of love. The *Siege of the Castle of Love* (fig. **12.44**) is depicted on a fourteenth-century ivory mirror back, which originally held a polished metal disk on its other side. Knights, some on horseback, attack a castle inhabited by women. However, by conscious design the battle lacks intensity, since the equestrian at the left is more concerned with the women in the castle, who toss roses at their attackers, than he is with the combat taking place in front of him. In the upper right, a knight scales the castle walls, helped up by a lady within it. On the other side, a soldier climbs a tree in order to surrender his sword to a woman armed with roses.

The scene depicted is remarkably close to the thirteenth-century poem *Roman de la Rose* (*Romance of the Rose*) written in vernacular French by Guillaume de Lorris and Jean de Meung, in which a knight and his colleagues assault the Castle of Love. The fairytale quality of the ivory reflects the images in the poem, which describe a dream sequence. The story is an allegory, with the castle symbolizing women and the attack upon it a form of courtship. Thus, even if the battle represented here is a mock one, all parties have something to gain from it.

The courtly subject with women as its focus is clearly appropriate for this object, since the mirror is put to use in the cause of female personal adornment. Small mirrors like this were car-ried by their owners, and some were suspended from belts. In fact, it was only in the twelfth century that cosmetics were reintroduced to Western Europe. Although they had been in common use in antiquity, they had fallen out of use after the fall of Rome. The Crusaders helped reestablish the habit of applying cosmetics, a result of their contact with the Eastern Mediterranean, where the custom had continued from antiquity.

This ivory was made in Paris, where a guild of makers of ivory combs and mirrors is documented at this time. The production of luxury ivories trails off after the middle of the fourteenth century, a result of the economic turmoil precipitated by the Hundred Years' War.

Architecture: The Flamboyant Phase

Although the beginnings of the Late, or *Flamboyant*, phase of Gothic architecture go back to the late thirteenth century, its growth was delayed by the Hundred Years' War (1338–1453) between France and England. Hence we do not meet any full-fledged examples of it until the early fifteenth century. *Flamboyant*, literally meaning "flamelike," refers to the undulating curves and reverse curves that are a main feature of Late Gothic bar tracery. Structurally, Flamboyant Gothic shows few significant developments of its own.

SAINT-MACLOU AT ROUEN What distinguishes Saint-Maclou at Rouen (fig. **12.45**) from Saint-Urbain at Troyes (see fig. 12.35) is the profusion of its ornament, which clearly announces the Flamboyant style. The church was designed by

12.45. Pierre Robin and Ambroise Harel. West facade, Saint-Maclou, Rouen, France. 1434–1490

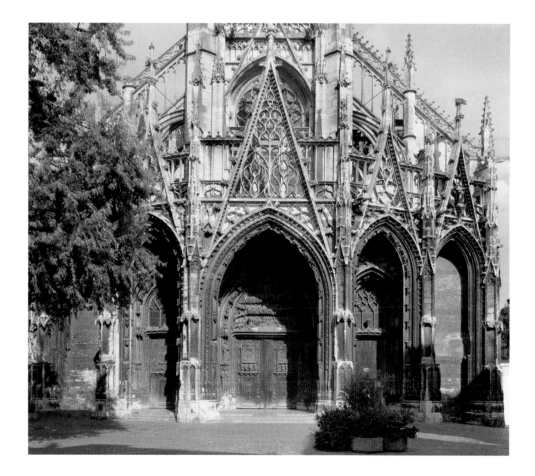

Pierre Robin in 1434; Ambroise Harel directed the workshop from 1467 to 1480, during which time a substantial portion of the west facade was built, although it was not completed until around 1490. The facade curves back on either side, allowing the central portal to project outward, establishing a hierarchy of forms, which variations in height accentuate.

Harel covered Saint-Maclou's structural skeleton with a web of decoration so dense and fanciful as to hide it almost completely. To locate the bones of the building within this picturesque tangle of lines becomes a fascinating game of hide-and-seek. Even a careful examination of the exterior of the building does not help to decipher the interior arrangement of the church. Repeated motifs, such as the pointed gable, appear both to emerge from the building and to soar above it. It is through the central gable, rather than above it, that the rose window appears. The gable, previously an element of enclosure (see figs. 12.22 and 12.29), is now so eaten into by shimmering tracery that it has become a purely decorative form used to create a lively if unsettling effect. The activation of architectural forms through spatial means is comparable to the interest in volume and depth exhibited by Late Gothic sculptors and painters.

THE SPREAD OF GOTHIC ART

The royal French style of the Paris region, with its refined taste, was enthusiastically received abroad, where it was adapted to a variety of local conditions. In fact, the Gothic monuments of England and Germany have become objects of such intense national pride since the early nineteenth century that Gothic was claimed as a native style in both countries. A number of factors contributed to the rapid spread of Gothic art. Among them were the skill of French architects and stone carvers and the prestige of French centers of learning, such as the Cathedral School of Chartres and the University of Paris. Still, one wonders whether any of these explanations really go to the heart of the matter. The basic reason for the spread of Gothic art was undoubtedly the persuasive power of the style itself. It kindled the imagination and aroused religious feeling even among people far removed from the cultural climate of the Île-de-France.

England

England was especially receptive to the new style, which developed there as the influence of Gothic forms from the Île-de-France melded with Anglo-Norman Romanesque features. A French architect who rebuilt the choir of Canterbury Cathedral introduced the French Gothic manner to England in 1175. Within less than 50 years, English Gothic developed a well-defined character of its own, known as the *Early English style*, which dominated the second quarter of the thirteenth century. Although there was a great deal of building during those decades, it consisted mostly of additions to existing Anglo-Norman structures. Many English cathedrals begun during the Romanesque period had remained unfinished; they were now completed or enlarged. As a result, we find few churches that are designed in the Early English style throughout.

SALISBURY CATHEDRAL The exception to the trend of multiple periods and styles in a single English Gothic church is Salisbury Cathedral (figs. **12.46–12.48**), begun in 1220, the same year as Amiens Cathedral. One sees immediately how different the exterior of Salisbury (see fig. 12.47) is from French Gothic churches (see figs. 12.10, 12.22, and 12.29) and how futile it would be to judge it by the same standards. Compactness and verticality have given way to a long, low, sprawling look. (The crossing tower, which provides a dramatic unifying accent, was built a century later than the rest and is much taller than originally planned.) Since height is not the main goal, flying buttresses are used only as an afterthought, not as integral design elements. The west facade is treated like a screen wall, wider than the church itself and divided into horizontal bands of ornament and statuary. The towers have shrunk to stubby **turrets** (small towers). The plan (see fig. 12.46), with its double transept, retains the segmented quality of the Romanesque, while the square east end derives from Cistercian architecture (see fig. 11.22).

As we enter the nave (see fig. 12.48), we recognize many elements familiar to us from French interiors of the time, such as Chartres Cathedral (see fig. 12.12). However, the English interpretation produces a very different effect. As on the facade, horizontal divisions dominate at the expense of the vertical. Hence we experience the nave wall not as a succession of vertical bays but as a series of arches and supports. These supports, carved of dark stone, stand out against the rest of the interior. This method of stressing their special function is one of the hallmarks of the Early English style. The use of bands of color also emphasizes horizontality.

Another distinctive feature is the steep curve of the nave vault. The ribs rise all the way from the triforium level. As a result, the clerestory gives the impression of being tucked away among the vaults. At Durham Cathedral, more than a

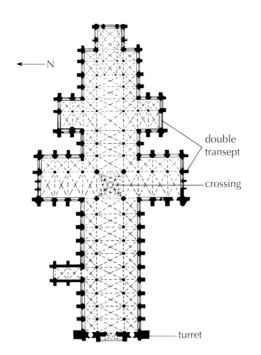

12.46. Plan of Salisbury Cathedral, England.
1220–1265

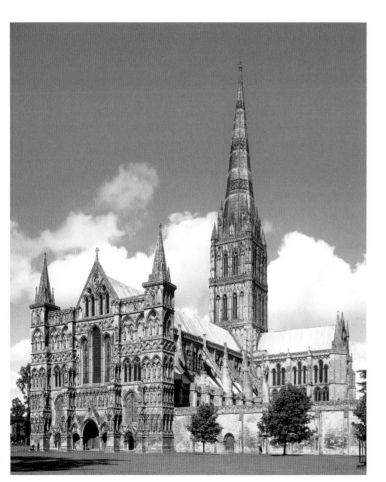

12.47. Salisbury Cathedral (from the southwest)
(spire ca. 1320–1330)

century earlier, the same treatment had been a technical necessity (see figs. 11.43, 11.44). Now it has become a matter of style, in keeping with the character of English Early Gothic as a whole. This character might be described as conservative in the positive sense. It accepts the French form but tones down its revolutionary aspects to maintain a strong sense of continuity with the Anglo-Norman past. In fact, French elements were integrated with a structure that was still based on thick walls with passages much like that found in Durham Cathedral. The contrast between the bold upward thrust of the fourteenth-century crossing tower at Salisbury and the leisurely horizontal progression throughout the rest of this thirteenth-century cathedral suggests that English Gothic had developed in a new direction during the intervening hundred years.

GLOUCESTER CATHEDRAL The change in the English Gothic becomes very clear if we compare the interior of Salisbury with the choir of Gloucester Cathedral, built in the

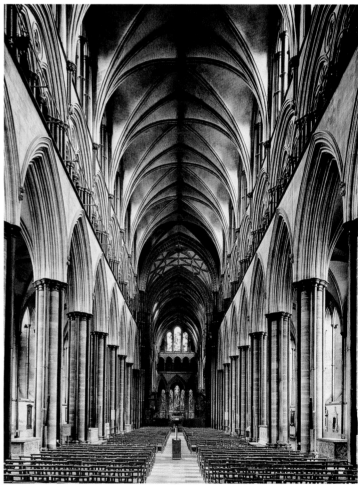

12.48. Nave, Salisbury Cathedral

bays so that the entire vault looks like one continuous surface. The ceiling reads as a canopy fluttering above the interior. This effect, in turn, emphasizes the unity of the interior space. Such elaboration of the classic four-part vault is characteristic of the Flamboyant style on the Continent as well (see pages 419–420), but the English started it earlier and carried it much further.

CHAPEL OF HENRY VII The Perpendicular Gothic style reaches its climax in the amazing hanging vault of Henry VII's Chapel at Westminster Abbey, built in the early years of the sixteenth century (fig. **12.50**). With its lanternlike knobs hanging from conical "fans," this chapel merges ribs and tracery patterns in a dazzling display of architectural pageantry. The complex vault patterns are unrelated to the structure of either the walls or the vaults themselves. Like the decorative features of Saint-Maclou in Rouen (see fig. 12.45), elaborate motifs obscure rather than clarify the architecture.

QUEEN MARY PSALTER As with Gothic architecture in England, manuscript illumination also shows an ambiguous relationship to French models. Some features are remarkably

12.49. Choir, Gloucester Cathedral, England. 1332–1357

second quarter of the fourteenth century (fig. **12.49**). Gloucester is an outstanding example of English Late Gothic, also called the *Perpendicular Gothic style*. The name certainly fits, since we now find a dominant vertical accent that was absent in the English Early Gothic style. Vertical continuity is most evident at Gloucester in the responds that run in an unbroken line from the floor to the vault. In this respect, Perpendicular Gothic is much closer to French sources, but it includes so many uniquely English features that it would look out of place on the Continent. The repetition of small uniform tracery panels recalls the bands of statuary on the west facade at Salisbury (see fig. 12.47). The square end repeats the apses of earlier English churches, and the upward curve of the vault is as steep as in the nave of Salisbury (see fig. 12.48).

The ribs of the vaults, on the other hand, have taken on a new role. They have been multiplied until they form an ornamental network that screens the boundaries between the

12.50. Chapel of Henry VII, Westminster Abbey, London, England. 1503–1519

12.51. *Jesus Teaching in the Temple* and *Hunting Scene,* from the *Queen Mary Psalter.* ca. 1310–1320. Ink, tempera, and gold leaf on vellum, $7 \times 4\frac{1}{2}''$ (17.9 × 11.5 cm). British Library, London. By permission of the British Library (ROY.2.B.VIIf151)

akin to those in French works, while others seem more concerned with continuing traditional English forms and manner of representation. The *Queen Mary Psalter* (fig. **12.51**) contains about 1,000 separate images, including Old and New Testament scenes, illustrations of saints' lives, and hunting scenes. The folio illustrating *Jesus Teaching in the Temple* combines two types of painting, which appear throughout the manuscript. The main scene is a full-color illumination, with a decorative gold background and an architectural framework, while the *bas-de-page* is a tinted

drawing. Despite the differences in technique, both scenes (and all the others in the manuscript) were created by a single artist, a remarkable achievement, particularly since this artist produced at least two other fully decorated books. Although scholars have suggested a general reliance on a French manner in the arrangement of the scenes, in the graceful, courtly sway of the figure, and in the inclusion of *bas-de-page* illustrations, the style of painting is more closely related to older English models. It is almost purely linear and there is very little evidence of shading.

12.52. Heinrich Parler the Elder and Peter Parler (?). Nave and Choir, Heiligenkreuz, Schwäbish-Gmünd, Germany. Begun 1317

The *bas-de-page* represents an elegant equestrian couple out hawking. A female attendant on horseback and a boy servant on foot accompany them. The lively scene, taken from the daily life of the nobility, is filled with naturalistic details, from the falcon attacking a duck at the lower left, to the way the male rider engages his female companion, both of them pointing at the hunt scene in front of them. Their forward movement is propelled by the active, wavelike lines of the horses' manes and the servant's gestures. In the main scene, line also conveys meaning with sensitivity and precision. The soft lines of hair and cloth that frame the face of the Virgin Mary contrast strongly with the sharply curved lines of the hair and beards of the Jews gathered in the Temple to hear her son teach.

The iconographic connection between the vignette in the bottom margin and the biblical scene is not clear. What is clear is that scenes from the courtly world are interwoven, or at least coexist, with biblical history, as they did in French manuscripts of the same period. In the English manuscript, however, the marginal illustrations are serial; they continue from one page to the next, just as does the cycle of biblical events. It is not known for whom this manuscript was made, although there is general agreement that it must have been produced between about 1310 and 1320 and, given its splendor, must have been a royal commission. The most convincing theory posits that King Edward II (r. 1307–1327) commissioned the book for his queen, Isabella of France. The name by which the manuscript is known today results from the fact that it was given to Queen Mary Tudor in the sixteenth century.

Germany

In Germany, Gothic architecture took root a good deal more slowly than in England. Until the mid-thirteenth century, the Romanesque tradition, with its persistent Ottonian elements, remained dominant, despite the growing acceptance of Early Gothic features. From about 1250 on, however, the High Gothic of the Île-de-France had a strong impact on the Rhineland. Cologne Cathedral (begun in 1248) is an ambitious attempt to carry the full-fledged French system beyond the stage of Amiens. However, it was not completed until modern times. Nor were any others like it ever built. While some German sculptors relied on French models, others pursued a more independent course, unlike German architects. German Gothic sculptures are sometimes dramatic, sometimes poignant, and sometimes lifelike, but they always express deep, if sometimes restrained, emotion.

HEILIGENKREUZ IN SCHWÄBISH-GMÜND Especially characteristic of German Gothic is the hall church, or *Hallenkirche*. This type of church, with aisles and nave of the same height, stems from Romanesque architecture (see fig. 11.24). Although also found in France, it is in Germany where its possibilities were explored fully. Heiligenkreuz (Holy Cross) in Schwäbish-Gmünd (fig. 12.52) is one of many examples from central Germany. Heinrich Parler the Elder began Heiligenkreuz in 1317, although it is perhaps his son Peter who is responsible for the

enlarged choir of 1351. (Heinrich had at least two other sons, two grandsons, and a great grandson who were also architects.) The space has a fluidity and expansiveness that enfolds us as if we were standing under a huge canopy, reminiscent of the effect at Gloucester Cathedral (see fig. 12.49). There is no clear sense of direction to guide us. And the unbroken lines of the pillars, formed by bundles of shafts that diverge as they turn into lacy ribs covering the vaults, seem to echo the continuous movement that we feel in the space itself.

NAUMBURG CATHEDRAL The growth of Gothic sculpture in Germany can be easily traced. From the 1220s on, German masters who had been trained in the sculpture workshops of the French cathedrals brought the new style back home. Because German architecture at that time was still mainly Romanesque, however, large statuary cycles like those at Chartres and Reims were not produced on facades, where they would have looked out of place. As a result, German Gothic sculpture tended to be less closely linked with its architectural setting. In fact, the finest work was often done for the interiors of churches.

This independence permitted a greater expressive freedom than in France. It is strikingly evident in the work of the Naumburg Master, an artist whose best-known work is the series of statues and reliefs made around 1255 for Naumburg Cathedral. The *Crucifixion* (fig. 12.53) forms the center of the choir screen; flanking it are statues of the *Virgin* and *John the Evangelist*. Enclosed by a deep, gabled porch, the three figures frame the opening that links the nave with the sanctuary. Rather than placing the group above the screen, as was usual, the sculptor brought the subject down to earth physically and emotionally. The suffering of Jesus thus becomes a human reality through the emphasis on the weight and volume of his body. Mary and John, pleading with the viewer, convey their grief more eloquently than ever before.

The pathos of these figures is heroic and dramatic, compared with the quiet lyricism of the Reims *Visitation* (see fig. 12.30). If the classical High Gothic sculpture of France may be compared with the calm restraint of Pheidias, the Naumburg Master embodies the temperamental counterpart of the strained physicality demonstrated in Hellenistic art (see fig. 5.72).

The same intensity dominates the Passion scenes, such as *The Kiss of Judas* (fig. 12.54), with its strong contrast between the meekness of Jesus and the violence of the sword-wielding St. Peter. Attached to the responds inside the choir are life-size statues of 12 nobles associated with the founding of the eleventh-century cathedral. The sculptures were made at a time when Bishop Dietrich II of Naumburg was attempting to raise funds to build a new choir for the cathedral. By highlighting the original building's generous benefactors, the bishop encouraged parishioners to support the new building campaign, to join the ranks of the cathedral's munificent sponsors. These men and women were not of the artist's own time—to him they were only names in a chronicle. Yet the pair *Ekkehard and Uta* (fig. 12.55) are as individual and realistic as if they had been portrayed from life. The gestures of their hands, the

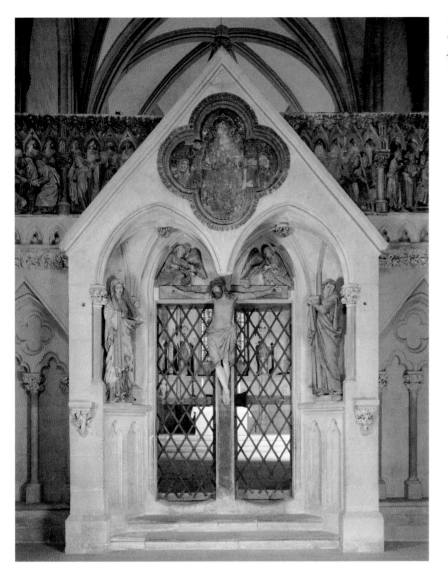

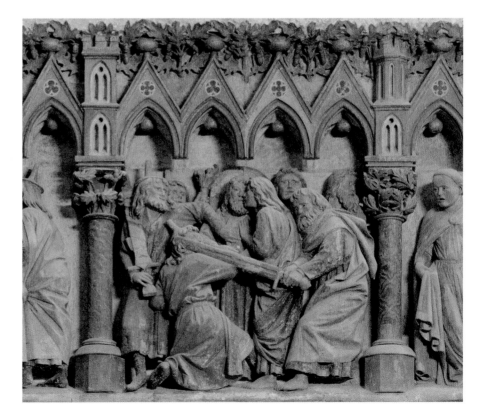

12.53. Naumburg Master. *Crucifixion,* on the choir screen, and the *Virgin* and *John the Evangelist*. ca. 1255. Stone. Naumburg Cathedral, Germany

12.54. Naumburg Master. *The Kiss of Judas,* on the choir screen. ca. 1255. Stone. Naumburg Cathedral

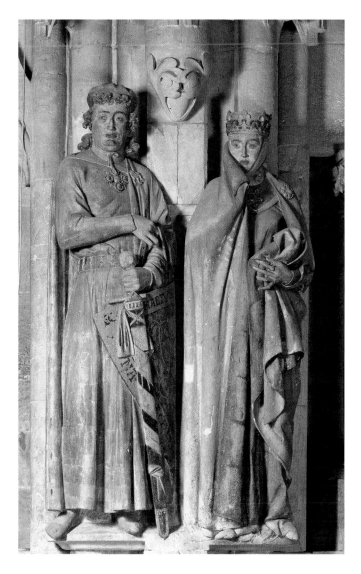

Primary Sources.) Originally designed for private devotion, it is often referred to by the German term **andachtsbild** (contemplation image), since Germany played the leading part in its development. The most widespread type was a representation of the Virgin grieving over the dead Christ. It is called a **Pietà** after an Italian word derived from the Latin *pietas*, the root word for both "pity" and "piety." No such scene occurs in the scriptural accounts of the Passion. We do not know where or when the *Pietà* was invented, but it portrays one of the Seven Sorrows of the Virgin. It thus forms a tragic counterpart to the motif of the Madonna and Child, one of her Seven Joys.

The *Roettgen Pietà* (fig. **12.56**) is carved of wood and vividly painted. Like most such groups, this large cult statue was meant to be placed on an altar. The style, like the subject, expresses the emotional fervor of lay religiosity, which emphasized a personal relationship with God as part of the tide of mysticism that swept over fourteenth-century Europe. Realism here is purely a means to enhance the work's impact. The faces convey unbearable pain and grief; the wounds are exaggerated

handling of their drapery, and their fixed gazes communicate human qualities with great subtlety. Their individuality and specificity reminds us that the concern for the personal identity of individuals signaled important social changes during the Gothic period. The trend toward realism is not unique here and is reminiscent of what occurred at Reims Cathedral (see figs. 12.30 and 12.31). The inclusion of historical figures within a sacred space is unusual, and it is perhaps the fact that the persons represented were long dead that made them appropriate for representation here.

The paint that is still visible on Naumburg's interior sculpture helps us appreciate how Gothic sculpture might have looked originally. Gothic interiors, as can be seen in the restored Sainte-Chapelle, were elaborately painted. Exterior sculpture was also painted, but that paint rarely survives today.

THE ROETTGEN PIETÀ Gothic sculpture, as we have come to know it so far, reflects a desire to give a greater emotional appeal to traditional themes of Christian art. Toward the end of the thirteenth century, this tendency gave rise to a new kind of religious image. (See end of Part II, *Additional*

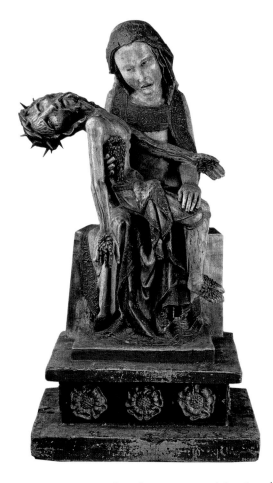

12.56. *Roettgen Pietà*. Early 14th century. Wood, height 34$\frac{1}{2}$″ (87.5 cm). Rheinisches Landesmuseum, Bonn

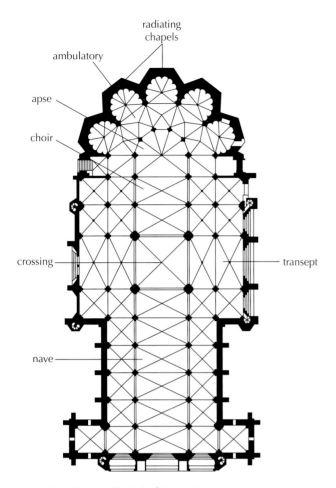

12.57. Plan, Cathedral of Santa María, León, Spain. Begun 1240s. (Drawing by Giroux after De los Rios)

Spain

During the Romanesque period Spanish artists had adopted the French manner of building and decoration in part to disassociate themselves from—and indeed to express their supremacy over—the Muslims with whom they shared the Iberian peninsula. This identification of French style with Christian conquest encouraged the reception of the Gothic style in Spain during the thirteenth century, when numerous Christian victories (principal among them the battle at Navas de Tolosa in 1212) drove the Muslims farther and farther south.

LEÓN The Cathedral of Santa María in León (figs. **12.57** and **12.58**), a city with a long history as a royal capital, recalls French High Gothic buildings associated with the monarchy, especially Reims Cathedral, the French coronation church (see pages 406–409). The east end of León, with its ambulatory and five radiating chapels, is particularly similar to the arrangement at Reims (see fig. 12.28), so much so that, although the specific identification of León's architect has been questioned, there has never been any doubt that he was French, nor that he knew the cathedral at Reims intimately. This reliance on a French model indicates a time lag, since León was not begun until the 1240s, some thirty years after Reims. León's elevation (fig. **12.59**) is

grotesquely; and the bodies and limbs are puppetlike in their thinness and rigidity. The purpose of the work clearly is to arouse so overwhelming a sense of horror and pity that the faithful will share in Christ's suffering and identify with the grief-stricken Mother of God. The ultimate goal of this emotional bond is a spiritual transformation that grasps the central mystery of God in human form through compassion (meaning "to suffer with").

At first glance, the *Roettgen Pietà* would seem to have little in common with *The Virgin of Paris* (see fig. 12.43), which dates from the same period. Yet they share a lean, "deflated" quality of form and exert a strong emotional appeal to a viewer. Both features characterize the art of northern Europe from the late thirteenth to the mid-fourteenth century. Only after 1350 do we again find an interest in weight and volume, coupled with a renewed desire to explore tangible reality as part of a change in religious outlook.

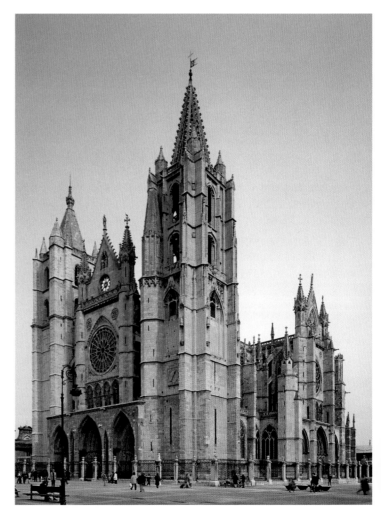

12.58. Exterior, Cathedral of Santa María, León

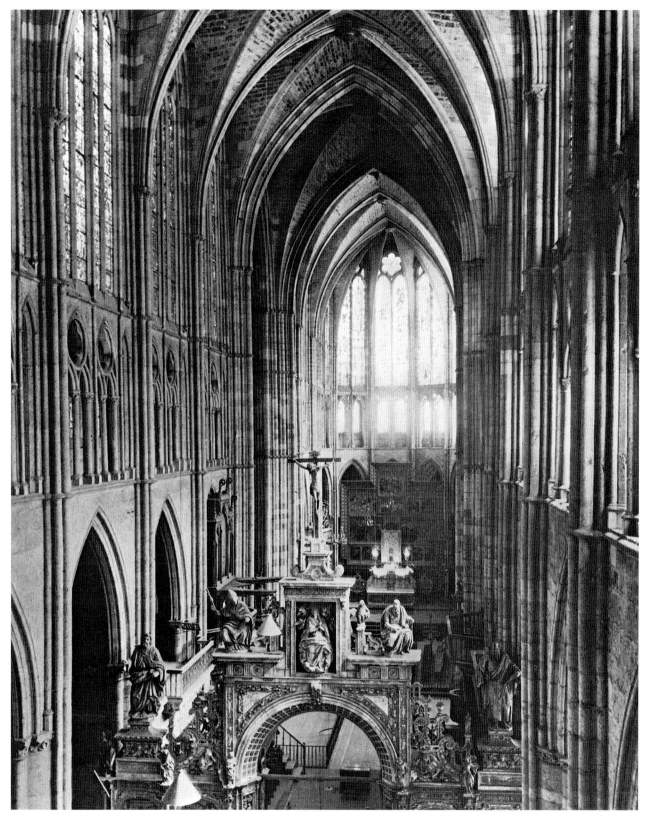

12.59. Interior, Cathedral of Santa María, León

more up to date and its tall, thin clerestory lancets recall Sainte-Chapelle (see fig. 12.34), completed in the same decade in which León was begun.

The association of León with French royal buildings is significant at this time. In 1230 Ferdinand III united the kingdoms of León and Castile. Despite unification, royal attentions continued to favor Burgos, capital of Castile, which had earlier been declared "mother and head" of all churches in the kingdom and where a Gothic cathedral in French style was begun in 1221. The Leónese promoted their historic rank as royal capital, more venerable than the rank of Burgos, through the building program of their new cathedral.

Although many of the jamb figures of the Cathedral of Santa María at León have been rearranged from their original locations, the sculptors' reliance on the French High Gothic manner of carving is clear. The figure of Simeon, the New Testament seer who recognized the infant Jesus as Redeemer (fig. **12.60**), carved in the last decades of the thirteenth century and placed on the right portal of the west facade, recalls sculptures from Reims (see figs. 12.30 and 12.31) in the elegant elongation of the body, the complicated and crisp folds of drapery, and the thick, wavy beard.

León is only one of a number of Spanish Gothic cathedrals that look to France for their inspiration. Toledo and Burgos, both cities with claims to royal status, also built buildings to designs that relied on French models and employed architects who undoubtedly came from France. Thus the royal origins of Gothic style were clearly not forgotten, even when the style was exported from France more than 100 years after it was conceived.

Italy: A Preview

In Italy, Gothic art was so distinctive as to stand apart from that of the rest of Europe. The growing concern for the individual that is expressed in the Gothic art we have studied so far will develop most fully in Italy and become the central focus of Gothic experimentations there. Gothic achievements in Italy are of such consequence in their own right and for the later development of Western art that they have been assigned their own chapter in this book, which follows. To some extent, there is an appealing symmetry in recognizing the strength of Italian contributions at the end of the Middle Ages. One of the defining differences in our discussion of the medieval world, as opposed to the ancient one, is that the center of gravity of European civilization had moved north of the Alps, to what had once been the northern boundaries of the Roman world. The shift north led to dramatic artistic interchanges during the early Middle Ages and throughout the Romanesque and Gothic periods. However, even as northern European art will continue to flourish in succeeding centuries, Italian art will once again occupy center stage.

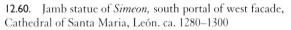

12.60. Jamb statue of *Simeon,* south portal of west facade, Cathedral of Santa Maria, León. ca. 1280–1300

SUMMARY

GOTHIC ART

Gothic style began in the vicinity of Paris in the mid-1100s. Within a hundred years, most of Europe had adopted the style. A general increase in population, expanding urban centers, and the growing importance of cathedrals are all features of the Gothic period. European princes and kings conquered increasingly large territories at the time, and conflicting claims over kingship led to a series of long battles between France and England known as the Hundred Years' War. In some areas of Europe, these wars interrupted the progress of art. By 1400 the Gothic area had begun to shrink, and by 1550 it had disappeared almost entirely, except in England.

EARLY GOTHIC ART IN FRANCE

Architecture played a dominant role in the formation of a coherent Gothic style, and therefore our study begins with an examination of the royal Abbey Church of Saint-Denis. Built just outside Paris in the first half of the twelfth century, the graceful architectural forms and large windows are a contrast to the massive solidity of the Romanesque style. The compact and unified plan of the Cathedral of Notre-Dame at Paris is another important example of the early Gothic style.

HIGH GOTHIC ART IN FRANCE

The political and economic stability of France during the thirteenth century was an ideal climate for producing monumental architecture with impressive sculptural programs. The rebuilding of Chartres Cathedral after a fire marks a crucial step in the development of Gothic architecture. The French cathedrals of Amiens and Reims—with an emphasis on verticality and translucency—are also significant exemplars of the High Gothic.

RAYONNANT OR COURT STYLE

The increasing importance of the French monarchy and the rising significance of Paris are reflected in King Louis IX's court chapel, Sainte-Chapelle. This phase of Gothic art is often called *rayonnant,* from a French word meaning "to radiate light." The style, closely associated with the French court, spread throughout the royal domain and then through much of Europe. Connections are also apparent between the building arts and elaborate devotional works of the period such as the *Bible moralisée.*

LATE GOTHIC ART IN FRANCE

During the period of Late Gothic art, artists felt free to deviate from previous patterns of development. Builders used elaborate arrangements to produce complex visual displays as seen in the undulating curves of the *Flamboyant* style. Late Gothic painting—such as the book of hours created for Jeanne d'Évreux by Jean Pucelle—indicates a new interest in representing spatial depth, and in sculpture, individual sculpted figures became prominent.

THE SPREAD OF GOTHIC ART

The royal French style of the Paris region was enthusiastically received abroad, where it was adapted to a variety of local conditions. Its influence in England can be seen in cathedrals built at Salisbury and elsewhere and in the *Queen Mary Psalter.* In Germany, its influence is witnessed in sculptures made for Naumburg Cathedral and in the *Roettgen Pietà.* And the Cathedral of Santa María in León is an example of the importation of the French High Gothic to Spain.

The Holy Bible

Exodus 20: 1–5

*Exodus, the second book of the Old Testament, is one of five books tradi-
tionally attributed to Moses (these five, called the Pentateuch, form the
Hebrew Torah). Exodus tells of the departure of the Jews from Egypt in the
thirteenth century BCE. In Chapter 20, God speaks to Moses on Mount
Sinai and gives him the Ten Commandments. The second commandment
pertains to images.*

And the Lord spoke all these words: I am the Lord thy God, who
brought thee out of the land of Egypt.

Thou shalt not have strange gods before me.

Thou shalt not make to thyself a graven thing, nor the likeness of
any thing that is in heaven above, or in the earth beneath, nor of
those things that are in the waters under the earth.

Thou shalt not adore them, nor serve them.

Pope Gregory I (r. 590–604)

From a letter to Serenus of Marseille

*Bishop Serenus apparently was moved to discourage excessive acts of devo-
tion to paintings in his church by having the images destroyed. In this letter
of 600 CE, Pope Gregory the Great reprimands him, reminding him that
images serve to teach those who cannot read. This remained the standard
defense of figural painting and sculpture in the Western church throughout
the Middle Ages.*

Word has reached us that you have broken the images of the saints
with the excuse that they should not be adored. And indeed we
heartily applaud you for keeping them from being adored, but for break-
ing them we reproach you. To adore images is one thing; to teach with
their help what should be adored is another. What Scripture is to the edu-
cated, images are to the ignorant, who see through them what they must
accept; they read in them what they cannot read in books. This is espe-
cially true of the pagans. And it particularly behooves you, who live
among pagans, not to allow yourself to be carried away by just zeal and so
give scandal to savage minds. Therefore you ought not to have broken
that which was placed in the church not in order to be adored but solely
in order to instruct the minds of the ignorant. It is not without reason that
tradition permits the deeds of the saints to be depicted in holy places.

SOURCE: CAECIIA DAVIS-WEYER, *EARLY MEDIEVAL ART 300–1150.* (ENGLEWOOD CLIFFS, NJ:
PRENTICE HALL, 1ST ED., 1971)

Nicholas Mesarites (ca. 1163–after 1214)

From *Description of the Church of the Holy Apostles*

*The Church of the Holy Apostles in Constantinople, destroyed in the fif-
teenth century, was decorated with mosaics by the artist Eulalios in the
twelfth century. This account of the mosaics was written by the poet
Constantinus Rhodius toward the end of his life. The description is
extremely lively, if slightly incomplete. (Certain standard subjects are
omitted.) It essentially describes the program of the Twelve Great Feasts
found in Middle and Late Byzantine mosaic and mural cycles.*

The whole inner space has been covered with a mixture of gold
and glass, as much as forms the domed roof and rise above the
hollowed arches, down to [the revetment of] multicolored marbles
and the second cornice. Represented here are the deeds and venerable
forms which narrate the abasement of the Logos [Divine Word, God]
and His presence among us mortals.

The first miracle is that of Gabriel bringing to a virgin maiden [the
tidings of] the incarnation of the Logos and filling her with divine joy.

The second is that of Bethlehem and the cave, the Virgin's giving
birth without pain, the Infant, wrapped in swaddling clothes, reclin-
ing—O wonder—in a poor manger, the angels singing divine hymns,
the rustic lyre of the shepherds sounding the song of God's nativity.

The third is the Magi hastening from Persia to do homage to the
all-pure Logos.

The fourth is Simeon, the old man, bearing the infant Christ in his
arms. And that strange old prophetess Anna foretelling for all to hear
the deeds which the infant was destined to accomplish [The Presenta-
tion in the Temple].

The fifth is the Baptism received from the hands of John by the
stream of Jordan; the Father testifying to the Logos from above, and
the Spirit coming down in the guise of a bird.

Sixth, you may see Christ ascending the thrice-glorious mount of
Tabor together with a chosen band of disciples and friends, altering
His mortal form; His face shining with rays more dazzling than those
of the sun, His garments a luminous white [The Transfiguration].

Next, you may see the widow's son, who had been brought on a bier
to his tomb, returning alive and joyful to his house [The Raising of the
Widow's Son of Nain].

Then again, Lazarus, who had been laid in his grave and had rotten
four days long leaping out of his tomb like a gazelle and returning
once more to mortal life after escaping corruption.

Next, Christ mounted on a colt proceeding to the city of the God-
slayers, the crowds, with branches and palm leaves acclaiming Him as
the Lord when he arrives at the very gates of Zion.

In addition to all the above wonders, you will see Judas, that
wretched man, betraying his Lord and teacher to be murdered by an
evil and abominable people.

The seventh [actually, the eleventh] spectacle you will see among all
these wonders is Christ's Passion [The Crucifixion]. Christ naked,
stretched out on the cross between two condemned criminals, his
hands and feet pierced with nails, hanging dead upon the wood of the
cross and this in the sight of His mother, the pure Virgin, and the dis-
ciple who is present at the Passion [St. Luke].

SOURCE: CYRIL MANGO, *THE ART OF THE BYZANTINE EMPIRE, 312–1453: SOURCES AND DOCUMENTS.*
(ENGLEWOOD CLIFFS, NJ: PRENTICE HALL, 1ST ED., 1972)

The Qur'an: God's Promise of Paradise to Good Muslims (Sura 55 ["The All-Merciful"]: 45–78)

*In this famous poetical passage from the Qur'an, with its dramatic repetition
of a rhetorical challenge to those who would deny God's word, Paradise is pic-
tured as a place where all of the sensual pleasures renounced by pious Muslims
on Earth will be enjoyed on a higher and more spiritual level in the heavenly
gardens that are promised to those who follow God's commandments.*

But such as fears the Station of his Lord,
for them shall there be two gardens—
O which of your Lord's bounties will you and you deny?
Abounding in branches—
O which of your Lord's bounties will you and you deny?
Therein two fountains of running water—
O which of your Lord's bounties will you and you deny?
therein of every fruit two kinds—
O which of your Lord's bounties will you and you deny?
reclining upon couches lined with brocade,
the fruits of the gardens night to gather—
O which of your Lord's bounties will you and you deny?
therein maidens restraining their glances,
untouched before them by any man or jinn—
O which of your Lord's bounties will you and you deny?
lovely as rubies, beautiful as coral—
O which of your Lord's bounties will you and you deny?
Shall the recompense of goodness be other than goodness?
O which of your Lord's bounties will you and you deny?
And besides these shall be two gardens—
O which of your Lord's bounties will you and you deny?
green, green pastures—
O which of your Lord's bounties will you and you deny?
therein two fountains of gushing water
O which of your Lord's bounties will you and you deny?
Therein fruits, and palm-trees, and pomegranates—
O which of your Lord's bounties will you and you deny?
therein maidens good and comely—
O which of your Lord's bounties will you and you deny?
houris clustered in cool pavilions—
O which of your Lord's bounties will you and you deny?
untouched before them by any man or jinn,
O which of your Lord's bounties will you and you deny?
reclining upon green cushions and lovely drugged
O which of your Lord's bounties will you and you deny?
Blessed by the name of thy Lord, majestic and splendid.

SOURCE: QUR'AN, SURA 55, TR. A. J. ARBERRY (NY: SIMON AND SCHUSTER, 1955)

St. Benedict of Nursia (ca. 480–ca. 553)

From *The Rule*

Monastic communities generally had a rule, or set of regulations, prescribing the discipline of their members' daily life. The Rule *written by St. Benedict for his community at Monte Cassino in southern Italy was admired by Pope Gregory the Great and by Charlemagne, who obtained an exact copy of it when he visited Monte Cassino in 787.* The Rule *requires complete renunciation of the world in order to maintain a routine of collective prayer and chanting seven times a day, plus about four hours of reading and meditating on the Bible, and some manual labor.*

Chapter 16: *The Day Office*

The prophet says: "Seven times daily I have sung Your praises" (Ps. 119:164). We will cleave to this sacred number if we perform our monastic duties at Lauds, Prime, Tierce, Sext, None, Vespers and Compline.

Chapter 17: *The number of psalms said in the Day Office*

Three psalms are to be chanted for Prime, each with a separate Gloria. An appropriate hymn is sung, before the psalms. . . . After the psalms a lesson from the apostle is recited, and the Hour is finished with the versicle, the Kyrie and dismissal. The Hours of Tierce, Sext and None are to be conducted in the same order.

Chapter 22: *How the monks are to sleep*

All the monks shall sleep in separate beds. . . . If possible they should all sleep in one room. However, if there are too many for this, they will be grouped in tens or twenties, a senior in charge of each group. Let a candle burn throughout the night. They will sleep in their robes, belted but with no knives, thus preventing injury in slumber. The monks then will always be prepared to rise at the signal and hurry to the Divine Office. But they must make haste with gravity and modesty.

The younger brothers should not be next to each other. Rather their beds should be interspersed with those of their elders. When they arise for the Divine Office, they ought encourage each other, for the sleepy make many excuses.

Chapter 48: *Daily manual labor*

Idleness is an enemy of the soul. Therefore, the brothers should be occupied according to schedule in either manual labor or holy reading. . . . From Easter to October, the brothers shall work at manual labor from Prime until the fourth hour. From then until the sixth hour they should read. After dinner they should rest (in bed) in silence. However, should anyone desire to read, he should do so without disturbing his brothers.

None should be chanted at about the middle of the eighth hour. Then everyone shall work as they must until Vespers. If conditions dictate that they labor in the fields (harvesting), they should not be grieved for they are truly monks when they must live by manual labor, as did our fathers and the apostles. Everything should be in moderation, though, for the sake of the timorous. . . .

All shall read on Saturdays except those with specific tasks. If anyone is so slothful that he will not or cannot read or study, he will be assigned work so as not to be idle.

Chapter 53: *The reception of guests*

The kitchen of the abbot and guests should be separate from that of the community so as not to disturb the brothers, for the visitors, of whom there are always a number, come and go at irregular hours. . . .

No one may associate or converse with guests unless ordered. If one meets or sees a guest, he is to greet him with humility . . . and ask a blessing. If the guest speaks, the brother is to pass on, telling the guest that he is not permitted to speak.

Chapter 55: *Clothing and shoes*

Each monk needs only two each of tunics and cowls, so he will be prepared for night wear and washing. Anything else is superfluous and should be banished. . . .

Bedding shall consist of a mattress, coverlet, blanket and pillow. The abbot will make frequent inspections of the bedding to prevent hoarding. Any infractions are subject to the severest discipline and, so that this vice of private ownership may be cut away at the roots, the abbot is to furnish all necessities: cowl, tunic, shoes, stockings, belt, knife, pen, needle, towel and writing tablet.

Chapter 57: *Artisans and craftsmen*

Craftsmen present in the monastery should practice their crafts with humility, as permitted by the abbot. But if anyone becomes proud of his skill and the profit he brings the community, he should be taken from his craft and work at ordinary labor. This will continue until he humbles himself and the abbot is satisfied. If any of the works of these craftsmen are sold, the salesman shall take care to practice no fraud. . . .

In pricing, they should never show greed, but should sell things below the going secular rate.

Chapter 66: *The porter of the monastery*

The monastery should be planned, if possible, with all the necessities—water, mill, garden, shops—within the walls. Thus the monks will not need to wander about outside, for this is not good for their souls.

SOURCE: ANTHONY C. MEISEL, *THE RULE OF ST. BENEDICT.* TR. M. L. DEL MASTRO. (DOUBLEDAY, A DIVISION OF RANDOM HOUSE, INC., 1975)

From Pilgrim's Guide to Santiago de Compostela

The Pilgrim's Guide, *written in the mid-twelfth century, describes notable sites along the routes to the shrine of the apostle James in Compostela (see map 11.2). The description of Sainte-Madeleine (the church of St. Mary Magdalen) at Vézelay recounts a medieval legend that Mary Magdalen journeyed to France after Christ's death and died in Aix-en-Provence.*

On the route that through Saint-Léonard stretches towards Santiago, the most worthy remains of the Blessed Mary Magdalene must first of all be rightly worshipped by the pilgrims. She is . . . that glorious Mary who, in the house of Simon the Leprous, watered with her tears the feet of the Savior, wiped them off with her hair, and anointed them with a precious ointment while kissing them most fervently. . . . It is she who, arriving after the Ascension of the Lord from the region of Jerusalem . . . went by sea as far as the country of Provence, namely the port of Marseille.

In that area she led for some years . . . a celibate life and, at the end, was given burial in the city of Aix. . . . But, after a long time, a distinguished man called Badilon, beatified in monastic life, transported her most precious earthly remains from that city to Vézelay, where they rest up to this day in a much honored tomb. In this place a large and most beautiful basilica as well as an abbey of monks were established. Thanks to her love, the faults of the sinners are here remitted by God, vision is restored to the blind, the tongue of the mute is untied, the lame stand erect, the possessed are delivered, and unspeakable benefices are accorded to many. Her sacred feast is celebrated on July 22.

SOURCE: *THE PILGRIM'S GUIDE TO SANTIAGO DE COMPOSTELA.* ED. AND TR. WILLIAM MELCZER. (NY: ITALICA PRESS, 1993)

Robert de Torigny (d. 1186)

From *Chronicle*

Chartres Cathedral burned twice in the twelfth century, in 1134 and 1194. This contemporary notice of the rebuilding of the west front (see fig. 12.4) in the 1140s stresses the participation of masses of lay volunteers. This kind of piety was later referred to as the "cult of the carts."

In this same year, primarily at Chartres, men began, with their own shoulders, to drag the wagons loaded with stone, wood, grain, and other materials to the workshop of the church, whose towers were then rising. Anyone who has not witnessed this will not see the like in our time. Not only there, but also in nearly the whole of France and Normandy and in many other places, [one saw] everywhere penance and the forgiveness of offenses, everywhere mourning and contrition. One might observe women as well as men dragging [wagons] through deep swamps on their knees, beating themselves with whips, numerous wonders occurring everywhere, canticles and hymns being offered to God.

SOURCE: *CHARTRES CATHEDRAL.* ED. ROBERT BRANNER. (NY: W.W. NORTON AND CO., 1969)

Villard De Honnecourt (13th Century)

From *Sketchbook*

The first inscription below addresses the user of Villard's Sketchbook *and suggests what the book might be for. The others appear on the leaves shown in figures 12.20 and 12.21.*

Villard de Honnecourt greets you and begs all who will use the devices found in this book to pray for his soul and remember him. For in this book will be found sound advice on the virtues of masonry and the uses of carpentry. You will also find strong help in drawing figures according to the lessons taught by the art of geometry.

Here is a lion seen from the front. Please remember that he was drawn from life. This is a porcupine, a little beast that shoots its quills when aroused. Here below are the figures of the Wheel of Fortune, all seven of them correctly pictured.

SOURCE: *THE SKETCHBOOK OF VILLARD HONNECOURT.* ED. THEODORE BOWIE. (BLOOMINGTON, IN: INDIANA UNIVERSITY, 1962)

Anonymous

From *Meditations on the Life of Christ*

This late thirteenth-century text, addressed to a Franciscan nun, represents a longstanding tendency to embellish the New Testament account of Christ's life with apocryphal detail. Unlike earlier such embellishments, this one dwells especially on the emotions of the participants in the story. From the twelfth century on, worshipers (especially women) were encouraged to experience Scripture through visualization and emotion rather than as words alone. In its purpose, the Meditations *is related to such representations as in figure 12.56.*

Attend diligently and carefully to the manner of the Deposition. Two ladders are placed on opposite sides of the cross. Joseph [of Arimathea] ascends the ladder placed on the right side and tries to extract the nail from His hand. But this is difficult and it does not seem possible to do it without great pressure on the hand of the Lord. The nail pulled out, John makes a sign to Joseph to extend the said nail to him, that the Lady [Virgin Mary] might not see it. Afterwards Nicodemus extracts the other nail from the left hand and similarly gives it to John. Nicodemus descends and comes to the nail in the feet. Joseph supported the body of the Lord: happy indeed is this Joseph, who deserves thus to embrace the body of the Lord! The nail

in the feet pulled out, Joseph descends part way, and all receive the body of the Lord and place it on the ground. The Lady supports the head and shoulders in her lap, the Magdalen the feet at which she had formerly found so much grace. The others stand about, all making a great bewailing over Him: all most bitterly bewail Him, as for a first-born son.

After some little time, when night approached, Joseph begged the Lady to permit them to shroud Him in linen cloths and bury Him. She strove against this, saying, "My friends, do not wish to take my Son so soon; or else bury me with Him." She wept uncontrollable tears; she looked at the wounds in His hands and side, now one, now the other; she gazed at His face and head and saw the marks of the thorns, the tearing of His beard, His face filthy with spit and blood, His shorn head; and she could not cease from weeping and looking at Him. The hour growing late, John said, "Lady, let us bow to Joseph and Nicodemus and allow them to prepare and bury the body of our Lord." She resisted no longer, but blessed Him and permitted Him to be prepared and shrouded. The Magdalen seemed to faint with sorrow. She gazed at the feet, so wounded, pierced, dried out, and bloody: she wept with great bitterness. Her heart could hardly remain in her body for sorrow; and it can well be thought that she would gladly have died, if she could, at the feet of the Lord.

SOURCE: *MEDITATIONS ON THE LIFE OF CHRIST.* TR. ISA RAGUSA. (PRINCETON, NJ: PRINCETON UNIVERSITY PRESS, 1961)

Art in Thirteenth- and Fourteenth-Century Italy

ALTHOUGH ITALIAN ARTISTS AND PATRONS SHARED CONCERNS WITH their contemporaries elsewhere in Europe, for geographic, historical, and economic reasons, the arts in Italy struck out in a different direction. Many of the innovations that would characterize the Italian Renaissance of the fifteenth and sixteenth centuries have their seeds in thirteenth and fourteenth-century Italy.

Throughout most of Europe in the thirteenth century, political and cultural power rested with landholding aristocrats. Products from their lands created wealth, and the land passed from one generation to the next. Although hereditary rulers controlled large regions, they usually owed allegiance to a king or to the Holy Roman emperor. But Italy had few viable kingdoms or strong central authorities. During most of the Middle Ages, Italian politics were dominated by the two international institutions of the Holy Roman Empire and the papacy. Usually, the emperors lived north of the Alps, and sheer distance limited their control in Italy. For much of the fourteenth century, Rome lacked a pope to command temporal power, as the papacy had moved to France. Hereditary rulers controlled southern Italy and the area around Milan, but much of Italy consisted of individual city-states, competing with each other for political influence and wealth. Among the most important of these were Florence, Siena, Pisa, and Venice.

Geography, particularly the long coastlines on the Mediterranean and Adriatic Seas, and long practice, had made Italy a trading center throughout the Middle Ages. By the thirteenth and fourteenth centuries, trade and paid labor for urban artisans had been long established. As the number of these new groups of merchants and artisans grew in the cities, their political power grew as well. The wealthiest and most influential cities, including Florence and Siena, were organized as representative republics. As a check on inherited power, some cities even excluded the landed aristocracy from participating in their political processes. Tensions erupted frequently between those who supported monarchical and aristocratic power, and thus supported the emperor, and those who supported the papacy and mercantile parties. In the cities of Florence, Venice, Pisa, and Siena, power tended to be concentrated in the hands of leading merchant families who had become wealthy through trade, manufacture, or banking. Members of these families would become the foremost patrons of artists in Italy.

Those artists developed their skills in a context that differed from the rest of Europe. Throughout the Middle Ages, Roman and Early Christian art served as an inspiration for Italian architects and sculptors, as is visible in such works as the Cathedral of Pisa (see fig. 11.33). In the mid-thirteenth century, the Holy Roman emperor Frederick II (1194–1250), who lived for a time in southern Italy, deliberately revived imperial Roman style to express his own political ambitions as heir to the Roman Empire. The other empire, Byzantium, kept a presence throughout Italy, too—through mosaics at Ravenna, Sicily, and Venice, and through the circulation of artists and icons such as the *Madonna Enthroned* (fig. 8.50). Added to these forces was the influence of the French Gothic style, introduced through the travels of artists and patrons.

Detail of figure 13.20, Giotto, *Christ Entering Jerusalem*

Map 13.1. Italy in the Thirteenth and Fourteenth Centuries

One of those travelers, the churchman, scholar, and poet Francesco Petrarch, exemplifies another aspect of fourteenth-century Italian culture: a growing interest in the creative works of individuals. Petrarch and his contemporaries, Dante Alighieri and Giovanni Boccaccio, belong to a generation of thinkers and writers who turned to the study of ancient works of literature, history, and art to seek out beautiful and correct forms. Petrarch also sought to improve the quality of written Latin, and thereby to emulate the works of the Roman authors Vergil and Cicero. This study of ancient thought and art led to a search for moral clarity and models of behavior, a mode of inquiry that came to be known as **humanism**. Humanists valued the works of the ancients, both in the literary and the visual arts, and they looked to the classical past for solutions to modern problems. They particularly admired Roman writers who championed civic and personal virtues, such as service to the state and stoicism in times of trouble. Humanists considered Roman forms the most authoritative, and, therefore, the most worthy of imitation, though Greek texts and ideas were also admired.

The study of the art of Rome and Greece would profoundly change the culture and the art of Europe by encouraging artists to look at nature carefully and to consider the human experience as a valid subject for art. These trends found encouragement in the ideals and theology of the mendicant orders, such as the Dominicans, who valued Classical learning, and the Franciscans, whose founder saw God in the beauty of Nature.

CHURCH ARCHITECTURE AND THE GROWTH OF THE MENDICANT ORDERS

International monastic orders, such as the Cistercians, made their presence felt in medieval Italy as in the rest of Europe. They were among the groups who helped to bring the technical and visual innovations of the French Gothic style to Italy. Italian Cistercian monasteries followed the practice, established in France, of building large, unadorned stone vaulted halls. These contrast starkly with the sumptuously adorned French Gothic cathedrals such as Reims (see fig. 12.29). Cistercians exercised control over the design of their monasteries to a great degree. The church of Fossanova, 60 miles south of Rome, represents the Cistercian plan transmitted to Italy (fig. **13.1**) from the headquarters churches in Burgundy. Consecrated in 1208, it is a vaulted basilica with somewhat abbreviated aisles that end in a squared chapel at the east end, as does the Cistercian church at Fontenay (fig. 11.23). Groin vaults cover the nave and the smaller spaces of the aisles, though the vaults are not ribbed as was the usual practice in Gothic buildings. Fossanova has no western towers and no tall spires. Interior spaces are spare and broadly proportioned rather than richly carved and narrow.

The simplicity of the architecture and the Cistercian reputation for reform made them an inspiration to the new mendicant movements that dominated Italy beginning in the thirteenth century and continuing through the Italian Renaissance. The

13.1. Nave and choir, Abbey Church of Fossanova, Italy. Consecrated 1208

two major mendicant groups were the Franciscans and the Dominicans. They established international "orders," as did their monastic brethren, although their missions took a different form from those of traditional monks. Both orders were founded to minister to the lay populations in the rapidly expanding cities; they did not retreat from the world, but engaged with it. Each order built churches in the cities where sermons could be preached to crowds of people. The Dominicans, founded by Dominic de Guzmán in 1216, were especially concerned with combatting heresy. The Franciscan order, founded by Francis of Assisi in 1209, worked in the cities to bring deeper spirituality and comfort to the poor. Taking vows of poverty, Franciscans were committed to teaching the laity and to encouraging them to pursue spiritual growth. Toward this goal, they told stories and used images to explain and affirm the teachings of the Church. Characteristically, Franciscans urged the faithful to visualize events such as the Nativity in tangible ways, including setting up Nativity scenes (crèches) in churches as an aid to devotion.

The Franciscans at Assisi

The charismatic Francis died in 1226 and was named a saint two years later. His home town was the site of a huge basilica built in his honor. Its construction was sponsored by the pope, and was begun shortly after Francis's canonization in 1228. This multistoried structure became a pilgrimage site within a few years of its completion. The expansive walls of its simple nave (fig. 13.2) were decorated with frescoes on Old and New Testament themes and a cycle that explained and celebrated the

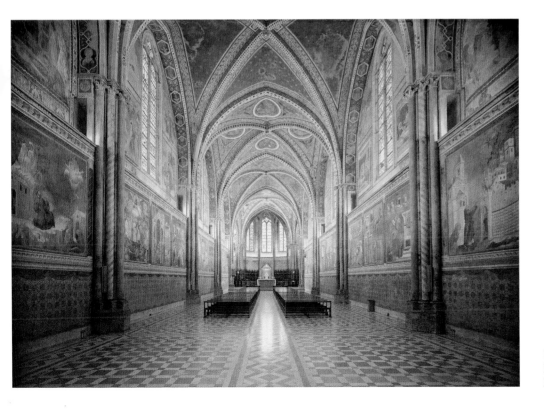

13.2. Interior of Upper Church, Basilica of San Francesco, Assisi. Begun 1228; consecrated 1253

achievements of Saint Francis. (See *Materials and Techniques*, page 442.) Scholars are still debating how many artists worked at Assisi from the 1290s to the early fourteenth century to complete this enormous cycle, but it appears that artists came here from Rome, Florence, Siena, and elsewhere. Assisi became a laboratory for the development of fourteenth-century Italian art. One of the most memorable of the many frescoes at Assisi depicts *Saint Francis Preaching to the Birds*, which was executed as part of a campaign of decoration in the church in the last decade of the thirteenth century or first part of the fourteenth century (fig. **13.3**). The whole cycle delineates Francis's life story based on a biography composed by his associates. One of the themes of Francis' life is his connection to Nature as a manifestation of God's workmanship; the story of Francis preaching to the birds exemplifies his attitude that all beings are connected. This fresco depicts Francis in his gray habit standing in a landscape and speaking to a flock of birds. To the astonished eyes of his companion, Francis appears to communicate to the birds, who gather at his feet to listen.

Trees establish the frame for the image as well as designate the location as outdoors; otherwise the background is a blue color, and little detail is provided. Francis and his companion are rendered naturalistically, as bulky figures in their

13.3. Anonymous. *Saint Francis Preaching to the Birds*. 1290s (?). Fresco from Basilica of San Francesco, Assisi

13.4. *Altarpiece of Saint Clare*. ca. 1280. Tempera on panel. 9 × 5½′ (2.73 × 1.65 m). Convent of Santa Chiara, Assisi

habits, as the artist describes light washing over their forms. Francis's figure becomes the focal point of the image, through his central position, the halo around his head, and his downward glance. His body language—the bent over stance, the movement of his hands—express his intense engagement with the birds as representatives of Nature. The simplicity of the composition makes the fresco easily legible and memorable.

The identity of the artist responsible for the frescoes in the nave of San Francesco is uncertain and controversial. One of the artists mentioned as a primary designer and painter is the Roman Pietro Cavallini, another is the Florentine Giotto di Bondone. But documentary evidence is lacking, and the opinions of connoisseurs fluctuate. Some scholars prefer to assign these frescoes to an anonymous master named for the paintings at Assisi. Whether through mutual influences or through competition with other artists, a new generation of painters comes of age at Assisi.

Franciscan women worshiped God through their vocations as nuns, though their convents and churches were less financially sound than many of the monasteries and churches of the friars. The nuns belonged to the branch of the Franciscans founded by his associate, Saint Clare, who was canonized in 1255. The church and convent she founded are still in service in Assisi, where an early example of an altarpiece to Saint Clare remains in place (fig. 13.4). A tall rectangle of wood, painted in tempera, the altarpiece was executed around 1280. It is dominated by the figure of Saint Clare, dressed in the habit of her order, standing frontally and holding the staff of an abbess. Rather than a portrait with specific features, Clare's face has the large eyes and geometric arrangement of a Byzantine Madonna (see fig. 8.37), while her figure seems to exist in one plane. She is flanked on either side by eight tiny narratives that tell the story of her life, death, and miracles. These vignettes demonstrate her commitment to her vocation, her obedience to Francis and the Church, and her service to her fellow nuns. The narratives make little pretense at three-dimensional form or spatial structure, keeping the focus on the figures and their actions to convey the story. Franciscan preachers wrote sermons and treatises addressed to religious women encouraging them to meditate on Scripture through visualizing the events in very physical terms. (See end of Part II, *Additional Primary Sources*.)

Churches and Their Furnishings in Urban Centers

Franciscan churches began to appear all over Italy as the friars ministered to the spiritual lives of city dwellers. A characteristic example in Florence is the church of Santa Croce (Holy Cross), begun around 1295 (fig. 13.5 and 13.6) The architect was probably the Tuscan sculptor Arnolfo di Cambio. Santa Croce shares some features with Gothic churches in Northern Europe, but has some distinctively Italian elements. This is a basilica with a mostly rectilinear eastern end, such as those found in Cistercian churches. Its proportions are broad and expansive rather than vertical. The nave arcade uses a Gothic pointed arch, while vertical moldings pull the eye up to the

13.5. Nave and choir, Santa Croce, Florence. Begun ca. 1295

13.6. Plan of Santa Croce

Fresco Painting and Conservation

Fresco is a technique for applying paint to walls that results in an image that is both durable and brilliant. Frescoed surfaces are built up in layers: Over the rough wall goes a layer of rough lime-based plaster called *arriccio*. The artist then draws preliminary drawings onto this layer of plaster. Because they are done in red, these drawings are called *sinopie* (an Italian word derived from ancient Sinope, in Asia Minor, which was famous as a source of red brick earth pigment). Then a finer plaster called *intonaco* is applied in areas just large enough to provide for a day's worth of painting—the *giornata* (from *giorno*, the Italian word for "day"). While the plaster is still wet, the artist applies pigments suspended in lime water. As the plaster dries, the pigments bind to it, creating a *buon fresco*, literally a "good fresco." Plaster dries in a day, so only the amount of wet plaster that can be painted during that time can be applied. The work has to be done on a scaffold, so it is carried out from top to bottom, usually in horizontal strips about 4 to 6 feet long. As each horizontal level is completed, the scaffolding is lowered for the next level. To prevent chemical interactions with the lime of the plaster, some colors have to be applied *a secco* or dry; many details of images are applied this way as well. *Fresco secco* does not bond to the plaster as surely as *buon fresco* does, so it tends to flake off over time. Consequently, some frescoes have been touched up with tempera paints.

Although durability is the key reason for painting in fresco, over the centuries wars and floods have caused damage. Modern conservators have developed techniques for removing frescoes from walls and installing them elsewhere. After the River Arno flooded in 1966, many Florentine frescoes were rescued in this way, not only preserving the artworks but greatly increasing the knowledge and technology for this task. When a fresco is removed, a series of cuts are made around the image. Then a supporting canvaslike material is applied to the frescoed surface with a water-soluble glue. The surface to which the canvaslike material has been glued can then be pulled off gently and transferred to a new support to be hung elsewhere, after which the canvas can be removed.

Such removals have exposed many *sinopie*, such as the one shown here. The fresco, attributed to Francesco Traini (see fig. 13.32), was badly damaged by fire in 1944 and had to be detached from the wall in order to save what was left of it. This procedure revealed the plaster underneath, on which the composition was sketched out. These drawings, of the same size as the fresco itself, are much freer-looking in style than the actual fresco. They often reveal the artist's personal style more directly than the painted version, which was carried out with the aid of assistants.

Anonymous (Francesco Traini?). Sinopia drawing for *The Triumph of Death* (detail). Camposanto, Pisa

ceiling. Where one might expect the moldings to support a vaulted ceiling, however, Santa Croce uses wooden trusses to span the nave. The only vaults are at the apse and several chapels at the ends of the transept.

The choice to cover the nave with wood seems deliberate, as no structural reason accounts for it. There may be a regional preference for wooden ceilings, as the great Romanesque cathedral of Pisa also has a wooden roof. Santa Croce's broad nave with high arches is also reminiscent of Early Christian basilicas, such as Old Saint Peter's or Santa Maria Maggiore (see figs. 8.6 and 8.15). The wood roof at Santa Croce may have sprung from a desire to evoke the simplicity of Early Christian basilicas and thus link Franciscan poverty with the traditions of the early church.

One function of the wide spaces at Santa Croce was to hold large crowds to hear the friars' sermons. For reading Scripture at services and preaching, churchmen often commissioned monumental pulpits with narrative or symbolic images carved onto them. Several monumental pulpits were made by members of a family of sculptors from Pisa, including Nicola Pisano (ca. 1220/25–1284) and his son Giovanni Pisano (1265–1314). Though the two men worked at various sites throughout Italy, they executed important pulpits for the cathedral and the baptistery of Pisa.

For the Pisan baptistery, Nicola Pisano carved a hexagonal marble pulpit that he finished around 1260 (fig. **13.7**) Rising to about 15 feet high, so the assembly could both see and hear the speaker, the six sides of the pulpit rest on colored marble columns supporting classically inspired capitals. Above the capitals, carved into leaf shapes, small figures symbolizing the virtues stand between scalloped shaped arches, while figures of the prophets sit in the spandrels of these arches. Surprisingly, one of these figures (fig. **13.8**) is a male nude with a lion cub on his shoulder and a lion skin over his arm. Both his form

and the lion skin identify him as Hercules, the Greek hero, who stands here for the Christian virtue of Fortitude. His anatomy, his proportions, and his stance are probably the product of Nicola Pisano's study of Roman and Early Christian sculpture. Pisano had worked for Frederick II and at Rome, so his knowledge of ancient forms was deep. The nudity is not meant to be lascivious, but serves rather to identify the figure.

Nicola's study of the Roman past informs many other elements in his pulpit, including the narratives he carved for the six rectangular sides of the pulpit itself. These scenes from the life of Christ are carved in relief. The Nativity in figure **13.9** is a densely crowded composition that combines the Annunciation with the Birth of Christ. The relief is treated as a shallow box filled with solid convex shapes in the manner of Roman sarcophagi, which Pisa's monumental cemetery preserved in good numbers. The figures could almost be copied from the

Ara Pacis procession; the Virgin has the dignity and bearing of a Roman matron (see fig. 7.22). Pisano probably knew Byzantine images of the Nativity, for his iconography reflects that tradition. As the largest and most central figure, the reclining Virgin overpowers all the other elements in the composition. Around her, the details of the narrative or setting, such as the midwives washing the child and Joseph's wondering gaze at the events, give the relief a human touch. Nicola uses broad figures, wrapped in classicizing draperies, to give the scene gravity and moral weight.

When his son Giovanni Pisano carved a pulpit about 50 years later for the Cathedral of Pisa, he chose a different emphasis. Though of the same size and material, his relief of the Nativity from the cathedral pulpit (fig. **13.10**) makes a strong contrast to his father's earlier work. Depicting the Nativity and the Annunciation to the shepherds, Giovanni Pisano dwells on the landscape and animal elements: Sheep and trees fill the right edge of

13.7. Nicola Pisano. Pulpit. 1259–1260. Marble. Height 15' (4.6 m). Baptistery, Pisa

13.8. *Fortitude,* detail of the pulpit by Nicola Pisano. 1260

13.9. *Nativity,* detail of the pulpit by Nicola Pisano

13.10. Giovanni Pisano. *The Nativity,* detail of pulpit. 1302–1310.
Marble. Pisa Cathedral

the composition, while the nativity itself takes place in a shallow cave. The Virgin still dominates the composition, but she is no longer a dignified matron. Instead, she is a young mother tending to her child. Her proportions are elongated rather than sturdy. Rather than echoing Roman or Classical models, Giovanni has studied contemporary French models to bring elegance and a detailed observation of nature to the image. Each of Giovanni's figures has its own pocket of space. Where Nicola's Nativity is dominated by convex, bulging masses, Giovanni's appears to be made up of cavities and shadows. The play of lights and darks in Giovanni's relief exhibits a dynamic quality that contrasts with the serene calm of his father's work.

Expanding Florence Cathedral

East of Pisa along the Arno, the increasing wealth of Florence inspired that town to undertake major projects for its cathedral and baptistery in order to compete with its neighbors. One of Nicola Pisano's students, Arnolfo di Cambio (ca. 1245–1302) was tapped to design a new cathedral for Florence to replace a smaller church that stood on the site. The cathedral was begun in 1296 (figs. **13.11**, **13.12**, and **13.13**). Such a project took the skills and energy of several generations, and the plan was modified more than once. Revisions of the plan were undertaken in 1357 by Francesco Talenti (active 1325–1369), who took over the project

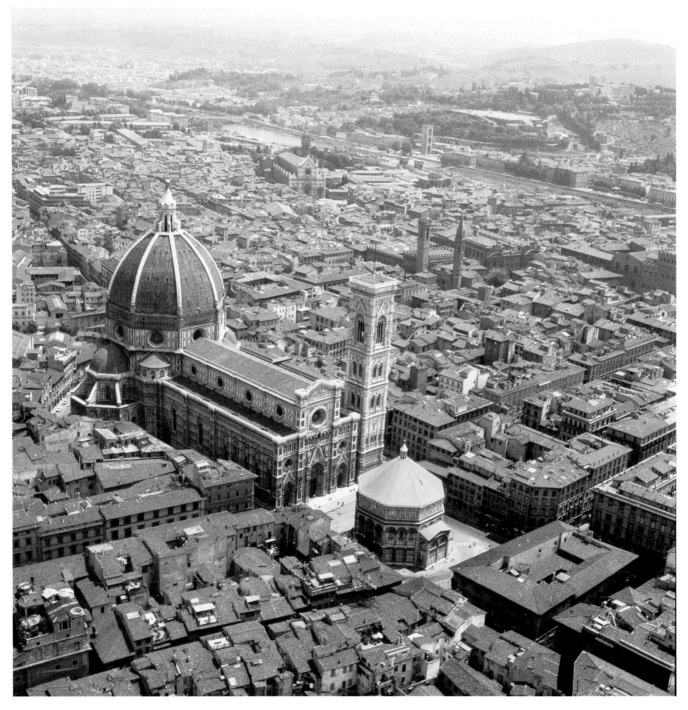

13.11. Florence Cathedral and Baptistery seen from the air. Cathedral begun 1296

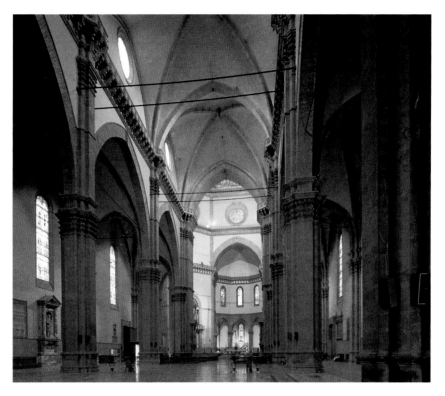

13.12. Nave and choir, Florence Cathedral

13.13. Plan of Florence Cathedral and Campanile

and dramatically extended the building to the east. By 1367, a committee of artists consulted by the overseers of the construction decided to cover the eastern zone with a high dome. The west facade and other portals continued to be adorned with sculpture throughout the Renaissance period, but the marble cladding on the building was not completed until the nineteenth century. Florence's *Duomo* was intended to be a grand structure that would not only serve as the spiritual center of the city, but as a statement of the city's wealth and importance.

Arnolfo's design was for a capacious basilica with a high arcade and broad proportions that contrast with contemporary Gothic structures in France (compare fig. 13.12 with fig. 12.26). The piers are articulated with leaf-shaped capitals and support flat moldings that rise to the clerestory level. Windows in the clerestory and aisles are relatively small, leaving much more wall surface than in French cathedrals. Although the original plan called for a trussed wooden roof in the Tuscan tradition,

by the mid-fourteenth century the plan had been altered to include ribbed groin vaults closer to the northern Gothic taste. The later plans enlarged the eastern zone to terminate in three faceted arms supporting an octagonal crossing that would be covered by a dome. (This design appears in the fresco in figure 13.33.) The scale of the proposed dome presented engineering difficulties that were not solved until the early fifteenth century. Instead of tall western towers incorporated into the facade, the cathedral has a *campanile* (bell tower) as a separate structure in the Italian tradition. The campanile is the work of the Florentine painter Giotto and his successors. If Florence's cathedral has Gothic elements in its vaults and arches, the foreign forms are tempered by local traditions.

In the heart of the city was the venerable Baptistery of Florence, built in the eleventh century on older foundations; the Florentines of the era believed it to be Roman and saw in its age the glory of their own past. Saint John the Baptist is the patron of Florence, so to be baptized in his baptistery meant that an individual not only became a Christian but also a citizen of Florence. In 1330, the overseers of the Baptistery commissioned another sculptor from Pisa, Andrea da Pisano (ca. 1295–1348; no relation to Nicola or Giovanni) to cast a new pair of bronze doors for the Baptistery. These were finished and installed in 1336 (fig. **13.14**). Cast of bronze and gilded, the project required 28 separate panels across the two panels of the door. They mostly represent scenes from the life of John the Baptist. Each vignette is framed by a Gothic quatrefoil, such as those found on the exteriors of French cathedrals. Yet within most of the four-lobed frames, Andrea provides a projecting ledge to support the figures and the landscape or architectural backgrounds. The relief of the Baptism of Christ demonstrates Andrea's clear compositional technique: Christ stands at the center, framed by

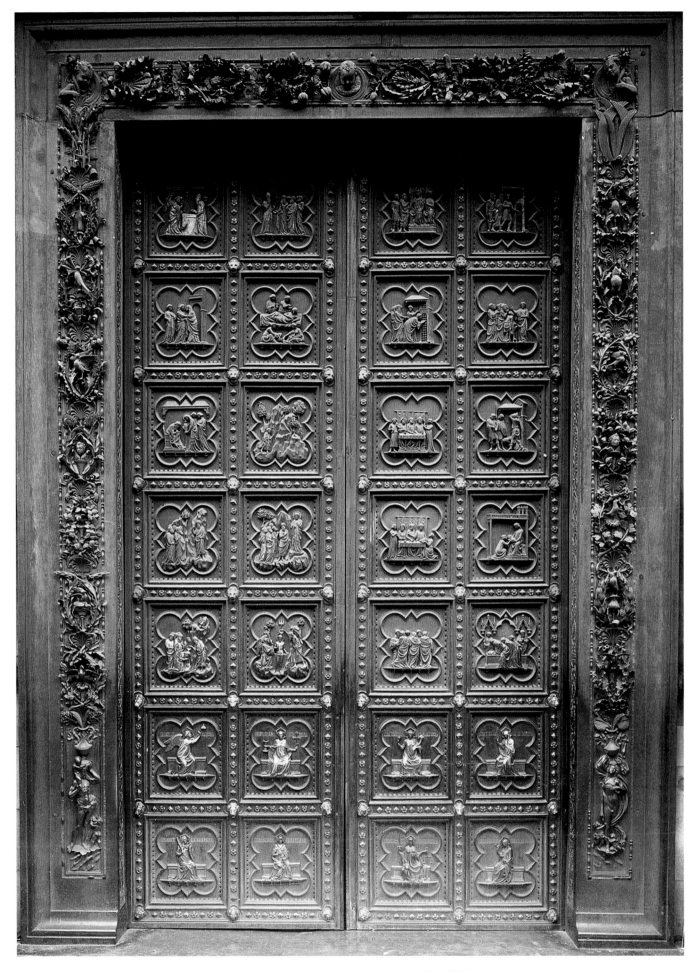

13.14. Andrea da Pisano. South doors, Baptistery of San Giovanni, Florence. 1330–1336. Gilt bronze

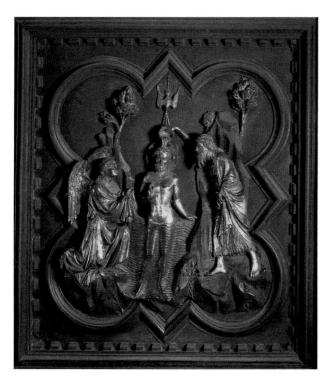

13.15. Andrea da Pisano. *The Baptism of Christ,* from the south doors, Baptistery of San Giovanni, Florence. 1330–1336. Gilt bronze

John on the right in the act of baptism and an angelic witness on the left (fig. **13.15**). The dove of the spirit appears above Christ's head. The emphasis is on the key figures, with little detail to distract from the main narrative; only a few small elements suggest the landscape context of the River Jordan.

Buildings for City Government: The Palazzo della Signoria

While the citizens of Florence were building the huge cathedral, the political faction that supported the papacy instead of the Holy Roman Empire consolidated its power in the city. The pro-papal party was largely composed of merchants who sought to contain the dynastic ambitions of aristocratic families who supported the emperor. The pro-papal group commissioned a large structure to house the governing council and serve as the symbol of the political independence of the city. The Palazzo della Signoria, also known as the *Palazzo Vecchio,* (fig. **13.16**) was probably also designed by Arnolfo di Cambio. It was begun in 1298 and completed in 1310, though it has been subject to later expansion and remodeling.

A tall, blocky, fortresslike structure, similar to fortified castles in the region, the Palazzo's stone walls are solid at the lowest level and rusticated for greater strength. The three stories of the structure are topped by heavy battlements and surmounted by a tall tower that serves not only as a symbol of civic pride, but as a defensive structure. It is slightly off-center for two reasons: The building rests on the foundations of an earlier tower, and its position makes it visible from a main street in the city. Boasting the highest tower in the city, the Palazzo della Signoria dominated the skyline of Florence and expressed the power of the communal good over powerful individual families.

PAINTING IN TUSCANY

As with other art forms in the thirteenth century, Italian painting's stylistic beginnings are different from those of the rest of Europe. Italy's ties to the Roman past and the Byzantine present would inspire Italian painters to render forms in naturalistic and monumental images. Throughout the Middle Ages, Byzantine mosaics and murals were visible to Italian artists. Venice had long-standing trading ties with the Byzantine Empire, and the Crusades had brought Italy in closer contact with Byzantium, including the diversion of the Fourth Crusade to Constantinople itself.

One result of the short-lived Latin occupation of Constantinople, from 1204 to 1261, was an infusion of Byzantine art forms and artists into Italy, which had a momentous effect on the development of Italian Gothic art. Later observers of the rapid changes that occurred in Italian painting from 1300 to 1550 described the starting point of these changes as the "Greek manner." Writing in the sixteenth century, Giorgio Vasari reported that in the mid-thirteenth century, "Some Greek painters were summoned to Florence by the government of the city for no other purpose than the revival of painting in their midst, since that art was not so much debased as altogether lost." Vasari assumes that medieval Italian painting was all but nonexistent and attributes to Byzantine art great influence over the development of Italian art in the thirteenth century. Italian artists were

13.16. Palazzo della Signoria (Palazzo Vecchio), Florence. Begun 1298

13.17. Cimabue. *Madonna Enthroned.* ca. 1280–1290. Tempera on panel, 12'7½" × 7'4" (3.9 × 2.2 m). Galleria degli Uffizi, Florence

able to absorb the Byzantine tradition far more thoroughly in the thirteenth century than ever before. When Gothic style began to influence artists working in this Byzantinizing tradition, a revolutionary synthesis of the two was accomplished by a generation of innovative and productive painters in Tuscan cities.

Cimabue and Giotto

One such artist was Cimabue of Florence (ca. 1250–after 1300), whom Vasari claimed had been apprenticed to a Greek painter. His large panel of the *Madonna Enthroned* (fig. **13.17**) was painted to sit on an altar in the Church of Santa Trinità in Florence; the large scale of the altarpiece—it is more than 12 feet high—made it the devotional focus of the church. Its composition is strongly reminiscent of Byzantine icons, such as the *Madonna Enthroned* (see fig. 8.50), but its scale and verticality are closer to the Saint Clare altarpiece (fig. 13.4) than to any Byzantine prototype. Mary and her son occupy a heavy throne of inlaid wood, which is supported by flanks of angels at either side and rests on a foundation of Old Testament prophets. The brilliant blue of the Virgin's gown against the gold leaf background makes her the focal point of the composition. Like Byzantine painters, Cimabue uses linear gold elements to enhance her dignity, but in his hands the network of gold lines follows her form more organically. The severe design and solemn expression is appropriate to the monumental scale of the painting.

ART IN TIME

1204—Fourth Crusade results in sacking of Constantinople

1226—Death of Francis of Assisi

1260—Nicola Pisano's Pisa Pulpit

1291—Turks expel Crusaders from Holy Land

Later artists in Renaissance Italy, such as Lorenzo Ghiberti (see chapter 15) and Giorgio Vasari (see chapter 16) claimed that Cimabue was the teacher of Giotto di Bondone (ca. 1267–1336/37), one of the key figures in the history of art. If so, Giotto learned the "Greek Manner" in which Cimabue worked. Many scholars believe Giotto was one of the artists working at Assisi, so he probably also knew the work of the Roman painter Pietro Cavallini. Giotto also worked in Rome where examples of both ancient and Early Christian art were readily available for study. Equally important, however, was the influence of the Pisani—Nicolo and Giovanni—with their blend of classicism and Gothic naturalism combined in an increased emotional content. (See figs. 13.9 and 13.10.)

We can see Giotto's relationship to, but difference from, his teacher Cimabue in a tall altarpiece of the *Madonna Enthroned*, which he painted around 1310 for the Church of All Saints (Ognissanti) in Florence (fig. **13.18**). Like Cimabue's Santa Trinità Madonna, Giotto depicts the Queen of Heaven and her son

13.18. Giotto. *Madonna Enthroned.* ca. 1310. Tempera on panel, 10'8" × 6'8" (3.3 × 2 m). Galleria degli Uffizi, Florence

enthroned among angels against a gold background. The Virgin's deep blue robe and huge scale bring a viewer's eye directly to her and to the Christ Child on her lap. All the other figures gaze at them, both signaling and heightening their importance. Unlike his teacher, Giotto renders the figures bathed in light, so that they appear to be solid, sculptural forms. Where Cimabue turns light into a network of golden lines, Giotto renders a gradual movement from light into dark, so that the figures are molded as three-dimensional objects.

The throne itself is based on Italian Gothic architecture, though here it has become a nichelike structure. It encloses the Madonna on three sides, setting her apart from the gold background. The possibility of space is further suggested by the overlapping figures, who seem to stand behind one another instead of floating around the throne. Its lavish ornamentation includes a feature that is especially interesting: the colored marble surfaces of the base and of the quatrefoil within the gable. Such illusionistic stone textures had been highly developed by ancient painters (see fig. 7.52), and its appearance here is evidence that Giotto was familiar with whatever ancient murals could still be seen in medieval Rome.

THE SCROVEGNI CHAPEL IN PADUA Giotto's innovations in the area of light and space were accompanied by a gift for storytelling, especially in the fresco cycles he completed. Although scholars are not certain that he was among the artists who painted the nave frescoes at Assisi, his fresco cycles share formal and narrative characteristics with those images. Of

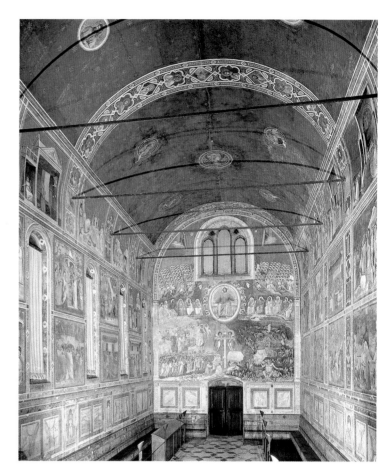

13.19. Interior, Arena (Scrovegni) Chapel. 1305–1306. Padua, Italy

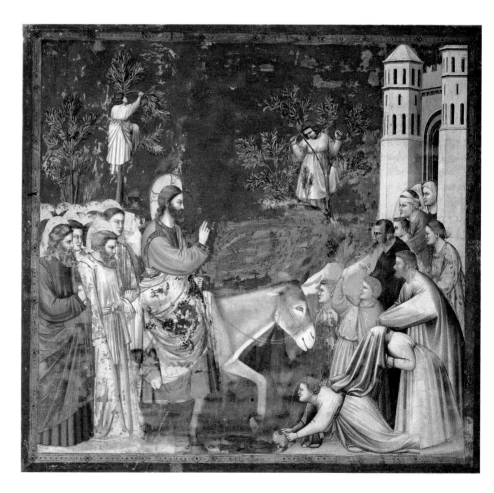

13.20. Giotto. *Christ Entering Jerusalem.* 1305–1306. Fresco. Arena (Scrovegni) Chapel. Padua, Italy

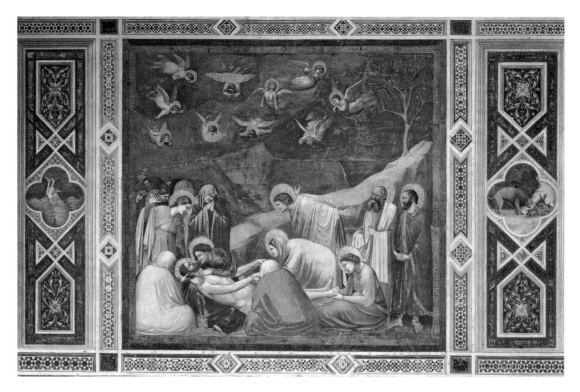

13.21. Giotto. *The Lamentation.* 1305–1306. Fresco. Arena (Scrovegni) Chapel. Padua, Italy

Giotto's surviving murals, those in the Scrovegni Chapel in Padua, painted in 1305 and 1306, are the best preserved and most famous. The chapel was built next to the palace of a Paduan banker, Enrico Scrovegni. (It is also known as the Arena Chapel because of its proximity to a Roman arena.) The structure itself is a one-room hall covered with a barrel vault. (fig. **13.19**)

Giotto and his workshop painted the whole chapel from floor to ceiling in the fresco technique. A blue field with gold stars symbolic of heaven dominates the barrel vault, below which the walls are divided into three registers or horizontal rows. Each register contains rectangular fields for narrative scenes devoted mainly to the life of Christ. The scenes begin at the altar end of the room with the Annunciation and culminate in the Last Judgment at the west end of the chapel. Along the length of the wall, the top register depicts stories of the early life of Mary and her parents; the center register focuses on stories of Christ's public life and miracles; and the lowest register depicts his Passion, Death, and Resurrection. Below the narratives the walls resemble marble panels interspersed with statues, but everything is painted.

Among the scenes from his public life is the *Christ Entering Jerusalem*, the event commemorated by Christians on Palm Sunday (fig. **13.20**). Giotto's handling of the scene makes a viewer feel so close to the event that his contemporaries must have had the sense of being a participant instead of an observer. He achieves this effect by having the entire scene take place in the foreground of his image, and by taking the viewer's position in the chapel into account as he designed the picture. Furthermore, Giotto gives his forms such a strong three-dimensional quality that they almost seem as solid as sculpture. The rounded forms create the illusion of space in which the actors exist.

Giotto gives very little attention to the setting for this event, except for the trees in which children climb and the gate of the

city on the right. His large simple forms, strong grouping of figures, and the limited depth of his stage give his scenes a remarkable coherence. The massed verticals of the block of apostles on the left contrast with the upward slope of the crowd welcoming Christ on the right; but Christ, alone in the center, bridges the gap between the two groups. His isolation and dignity, even as he rides the donkey toward the city where he will die, give the painting a solemn air.

Giotto's skill at perfectly matching composition and meaning may also be seen in the scenes on the lowest level register, which focus on the Passion. A viewer gazing at these frescoes sees them straight on, so the painter organizes these scenes to exploit that relationship. One of the most memorable of these paintings depicts the Lamentation, the moment of last farewell between Christ and his mother and friends (fig. **13.21**). Although this event does not appear in the gospels, by the end of the Middle Ages versions of this theme had appeared in both Byzantine and in Western medieval art.

The tragic mood of this Lamentation, found also in religious texts of the era, is created by the formal rhythm of the design as much as by the gestures and expressions of the participants. The low center of gravity and the hunched figures convey the somber quality of the scene as do the cool colors and bare sky. With extraordinary boldness, Giotto sets off the frozen grief of the human mourners against the frantic movement of the weeping angels among the clouds. It is as if the figures on the ground were restrained by their obligation to maintain the stability of the composition, while the angels, small and weightless as birds, are able to move—and feel—freely.

Once again the simple setting heightens the impact of the drama. The descending slope of the hill acts as a unifying element that directs attention toward the heads of Christ and the Virgin,

which are the focal point of the scene. Even the tree has a twin function. Its barrenness and isolation suggest that all of nature shares in the sorrow over Christ's death. Yet it also carries a more precise symbolic message: It refers to the Tree of Knowledge, which the sin of Adam and Eve had caused to wither and which was to be restored to life through Christ's sacrificial death.

Giotto's frescoes at the Arena Chapel established his fame among his contemporaries. In the *Divine Comedy*, written around 1315, the great Italian poet Dante Alighieri mentions the rising reputation of the young Florentine: "Once Cimabue thought to hold the field as painter, Giotto now is all the rage, dimming the luster of the other's fame." (See end of Part II, *Additional Primary Sources*.) Giotto continued to work in Florence for 30 years after completing the Arena Chapel frescoes, in 1334 being named the architect of the Florentine cathedral, for which he designed the *campanile* (bell tower) (see figs. 13.11 and 13.13). His influence over the next generation of painters was inescapable and had an effect on artists all over Italy.

Siena: Devotion to Mary in Works by Duccio and Simone

Giotto's slightly older contemporary, Duccio di Buoninsegna of Siena (ca. 1255–before 1319) directed another busy and influential workshop in the neighboring Tuscan town of Siena. The city of Siena competed with Florence on a number of fronts—military, economic, and cultural—and fostered a distinct identity and visual tradition. After a key military victory and the establishment of a republic directed by the *Nove* (the Nine), Siena took the Virgin Mary as its protector and patron, and dedicated its thirteenth-century cathedral to her. This cathedral, substantially completed by 1260, displays several features of the new style of Gothic architecture from France: Its arcade rests on compound piers like those in French cathedrals, and the ceiling was vaulted. Its facade (see fig. **13.22**) was entrusted to the sculptor Giovanni Pisano in 1284, though he left it incomplete when he departed in 1295. The facade reveals French elements, too, such as the pointed gables over tympanums defining the three portals, the blind arcades above the outer portals, and the sculpted figures of prophets and other figures who stand on platforms between the portals and on the turrets at the outer edges of the facade.

A fine example of Sienese devotion to Mary may be seen in a small panel of the *Virgin and Child* that Duccio painted around 1300 (fig. **13.23**). Still in its original frame, this wonderfully preserved painting has recently entered the Metropolitan Museum of Art in New York from a private collection. Small in scale, the painting depicts the Mother and son in a tender relationship: She supports the Christ

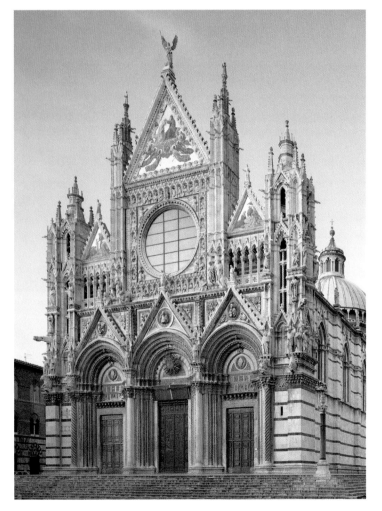

13.22. Siena Cathedral, completed ca. 1260. Facade. Lower sections ca. 1284–1299 by Giovanni Pisano

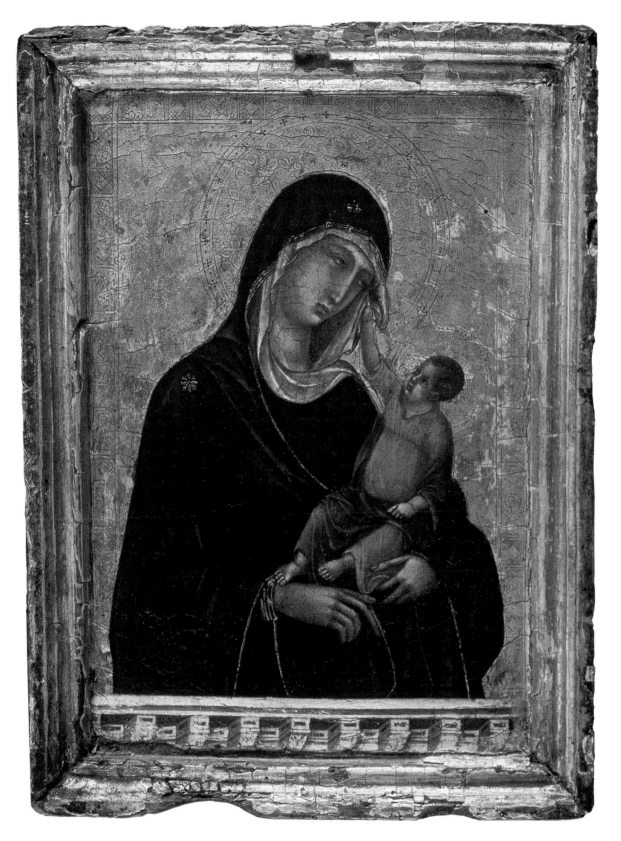

13.23. Duccio, *Virgin and Child*. ca. 1300. Tempera and gold on wood. 11 × 8¹/₄″ (28 × 20.8 cm) Metropolitian Museum of Art, New York. Purchase Rogers Fund, Walter and Lenore Annenberg Foundation Gift, Lila Acheson Wallace Gift, Annette de la Renta Gift, Harris Brisbane Dick, Fletcher, Louis V. Bell, and Dodge Funds, Joseph Pulitzer Bequest, several members of the Chairman's Council Gifts, Elaine L. Rosenberg and Stephenson Family Foundation Gifts, 2003 Benefit Fund, and other gifts and funds from various donors, 2004. (2004.442)

The Social Work of Images

The report of the celebrations held in Siena when Duccio's *Maestà* was installed in the cathedral attests to the importance of this painting for the entire community. It was a source of pride for the citizens of Siena, but also a powerful embodiment of the Virgin's protection of the city. Although modern audiences expect to find and react to works of art hanging in museums, art historians have demonstrated that art served different purposes in late medieval Europe. Few in the West today believe that a work of art can influence events or change lives. But in fourteenth-century Europe, people thought about images in much more active terms. Art could be a path to the sacred or a helper in times of trouble.

During a drought in 1354, for example, the city fathers of Florence paraded a miracle-working image of the Virgin from the village of Impruneta through the city in hopes of improving the weather. People with illness or health problems venerated a fresco of the Annunciation in the church of the Santissima Annunziata in Florence; they gave gifts to the image in hopes of respite from their problems. When the plague came to Florence, artists were commissioned to paint scenes depicting Saint Sebastian and other saints who were considered protectors against this deadly disease.

Images were also called upon for help outside the sacred space of the church. Continuing a tradition begun in the fourteenth century, street corners in Italy are often adorned with images of the Virgin to whom passersby may pray or show respect. Candles may be lit or gifts offered to such images in hopes of the Virgin's assistance. Art historians are also studying how works of art functioned among late medieval populations to forge bonds among social groups and encourage group identity. For example, outside the confines of monasteries, groups of citizens formed social organizations that were dedicated to a patron saint, whose image would be an important element of the group's identity.

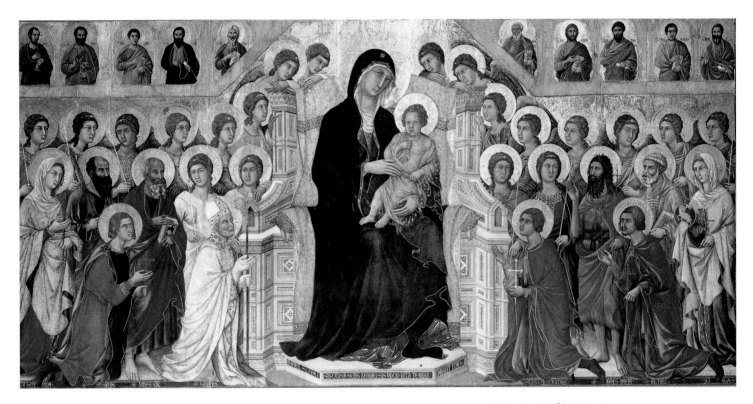

13.24. Duccio. *Madonna Enthroned,* center of the *Maestà Altar*. 1308–1311. Tempera on panel, height 6′10½″ (2.1 m). Museo dell'Opera del Duomo, Siena

Child in her arms as he reaches up to pull on her veil. His small scale in relation to his mother makes him seem very vulnerable. Duccio has washed both figures in a warm light that softens the contours and suggests three-dimensional forms, but he sets these figures against a brilliant gold background that contrasts vividly with the Virgin's blue gown. Her wistful glance at her tiny child gives the painting a melancholy effect.

Duccio was commissioned by the directors of Siena's cathedral to paint the large altarpiece for the high altar, called the *Maestà* as it depicts the Virgin and Child in majesty (fig. **13.24**). Commissioned in 1308, the *Maestà* was installed in the cathedral in 1311 amidst processions and celebrations in the city. (See *Primary Source,* page 456, and *The Art Historian's Lens,* above.) Duccio's signature at the base of the throne expresses his pride in the work: "Holy Mother of God,

be the cause of peace to Siena, and of life to Duccio because he has painted you thus."

In contrast to the intimate scale of the Metropolitan's *Virgin and Child*, here Duccio creates a regal image on a large scale. Members of her court surround the enthroned Virgin and Child in the *Maestà* in a carefully balanced arrangement of saints and angels. She is by far the largest and most impressive figure, swathed in the rich blue reserved for her by contemporary practice. Siena's other patron saints kneel in the first row, each gesturing and gazing at her figure. The Virgin may seem much like Cimabue's, since both originated in the Greek manner, yet Duccio relaxes the rigid, angular draperies of that tradition so that they give way to an undulating softness. The bodies, faces, and hands of the many figures seem to swell with three-dimensional life as the painter explores the fall of light on their forms. Clearly the heritage of Hellenistic-Roman illusionism that had always been part of the Byzantine tradition, however submerged, inspired Duccio to a profound degree. Nonetheless, Duccio's work also reflects contemporary Gothic sensibilities in the fluidity of the drapery, the appealing naturalness of the figures, and the glances by which the figures communicate with each other. The chief source of this Gothic influence was probably Giovanni Pisano, who was in Siena from 1285 to 1295 as the sculptor-architect in charge of the cathedral facade, although there is evidence that Duccio may have traveled to Paris, where he would have encountered French Gothic style directly.

In addition to the principal scene, the *Maestà* included on its front and on its back numerous small scenes from the lives of Christ and the Virgin. In these panels, Duccio's synthesis of Gothic and Byzantine elements gives rise to a major new development: a new kind of picture space and, with it, a new treatment of narrative. The *Annunciation of the Death of the Virgin* (fig. **13.25**), from the front of the altarpiece, represents two figures enclosed by an architectural interior implied by foreshortened walls and ceiling beams to create and define a space that the figures may inhabit. But Duccio is not interested simply in space for its own sake. The architecture is used to integrate the figures within the drama convincingly. In a parallel scene to the Annunciation (see fig. 13.27, for comparison), this panel depicts the angel Gabriel returning to the mature Virgin to warn her of her impending death. The architecture enframes the two figures separately, but places them in the same uncluttered room. Despite sharing the space, each figure is isolated. Duccio's innovative use of architecture to enhance the narrative of his paintings inspired his younger French contemporary Jean Pucelle, who adapted this composition for the *Annunciation* in the *Hours of Jeanne d'Évreux* (fig. 12.41).

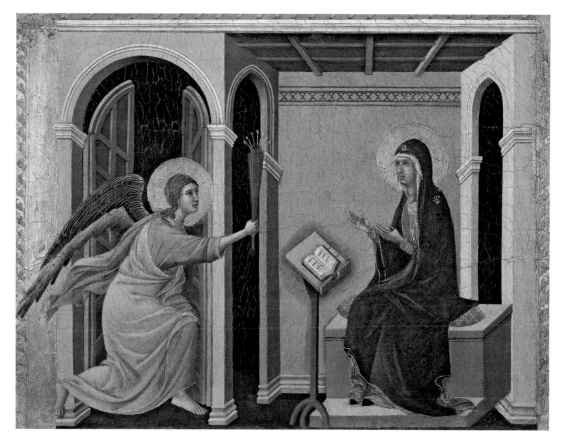

13.25. Duccio. *Annunciation of the Death of the Virgin,* from the *Maestà Altar*

Agnolo di Tura del Grasso

From his Chronicle

Duccio's Maestà *(fig. 13.24) stood on the main altar of Siena Cathedral until 1506, when it was removed to the transept. It was sawed apart in 1771, and some panels were acquired subsequently by museums in Europe and the United States. This local history of about 1350 describes the civic celebration that accompanied the installation of the altarpiece in 1311.*

These paintings [the *Maestà*] were executed by master Duccio, son of Nicolò, painter of Siena, the finest artist to be found anywhere at his time. He painted the altarpiece in the house of the Muciatti outside the gate toward Stalloreggi in the suburb of Laterino. On the 9th of June [1311], at midday, the Sienese carried the altarpiece in great devotion to the cathedral in a procession, which included Bishop Roger of Casole, the entire clergy of the cathedral, all monks and nuns of the city, and the Nine Gentlemen [Nove] and officials of the city such as the podestà and the captain, and all the people. One by one the worthiest, with lighted candles in their hands, took their places near the altarpiece. Behind them came women and children with great devotion. They accompanied the painting up to the cathedral, walking in procession around the Campo, while all the bells rang joyfully. All the shops were closed out of devotion, all through Siena many alms were given to the poor with many speeches and prayers to God and to his Holy Mother, that she might help to preserve and increase the peace and well being of the city and its jurisdiction, as she was the advocate and protection of said city, and deliver it from all danger and wickedness directed against it. In this way the said altarpiece was taken into the cathedral and placed on the main altar. The altarpiece is painted on the back with scenes from the Old Testament and the Passion of Jesus Christ and in front with the Virgin Mary and her Son in her arms and many saints at the sides, the whole decorated with fine gold. The alterpiece cost 3000 gold florins.

SOURCE: TERESA G. FRISCH, *GOTHIC ART 1140–C 1450.* (ENGLEWOOD CLIFFS, NJ: PRENTICE HALL, 1971.)

The architecture keeps its space-creating function even in the outdoor scenes on the back of the *Maestà,* such as in *Christ Entering Jerusalem* (fig. **13.26**), a theme that Giotto had treated only a few years before in Padua. Where Giotto places Christ at the center of two groups of people, Duccio places him closer to the apostles and on one side of the composition. He conveys the diagonal movement into depth not by the figures, which have the same scale throughout, but by the walls on either side of the road leading to the city, by the gate that frames the welcoming crowd, and by the buildings in the background. Where Giotto reduces his treatment of the theme to a few figures and a bare backdrop, Duccio includes not only detailed architectural elements but also many children climbing trees to gather palms leaves as well

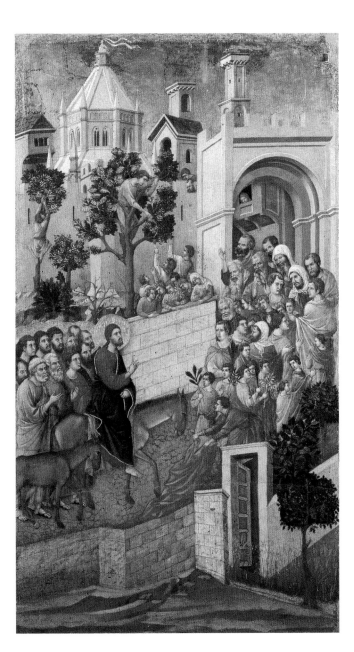

13.26. Duccio. *Christ Entering Jerusalem,* from the back of the *Maestà Altar.* 1308–1311. Tempera on panel, $40\frac{1}{2} \times 21\frac{1}{8}''$ (103 × 53.7 cm). Museo dell'Opera del Duomo, Siena

as figures peering at the crowd in the streets from their first-floor windows. Duccio gives a viewer a more complete description of the event than Giotto, whose work stresses the doctrinal and psychological import of the moment. The goals of the two painters differ, and so do the formal means they use to achieve them.

Duccio trained the next generation of painters in Siena. One distinguished disciple was Simone Martini (ca. 1284–1344), who also worked in Assisi but spent the last years of his life in Avignon, the town in southern France that served as the residence of the popes during most of the fourteenth century. In 1333 the directors of the Siena Cathedral commissioned Simone to make another altarpiece to complement Duccio's *Maestà*. His *Annunciation* (fig. **13.27**) preserves its original pointed and cusped arch format in its restored frame and suggests what has been lost in the dismemberment of the *Maestà*, which had a similar Gothic frame. Simone's altarpiece depicts the Annunciation flanked by two local saints set against a brilliant gold ground. To connect her visually to *Maestà*, Simone's Virgin sits in a similar cloth-covered throne and wears similar garments.

The angel Gabriel approaches Mary from the left to pronounce the words "*Ave Maria Gratia Plenum Dominus Tecum*" ("Hail Mary, full of grace, the Lord is with you"). Simone renders the words in relief on the surface of his painting, covering them in the same gold leaf that transforms the scene into a heavenly vision. Simone adds an element of doubt to this narrative, as the Virgin responds to her visitor with surprise and pulls away from him. The dove of the Holy Spirit awaits her momentous decision to agree to the charge given her to become the mother of the Christ Child and begin the process of Salvation. Like Giotto, Simone has reduced the narrative to its simplest terms, but like Duccio, his figures have a lyrical elegance that lifts them out of the ordinary and into the realm of the spiritual.

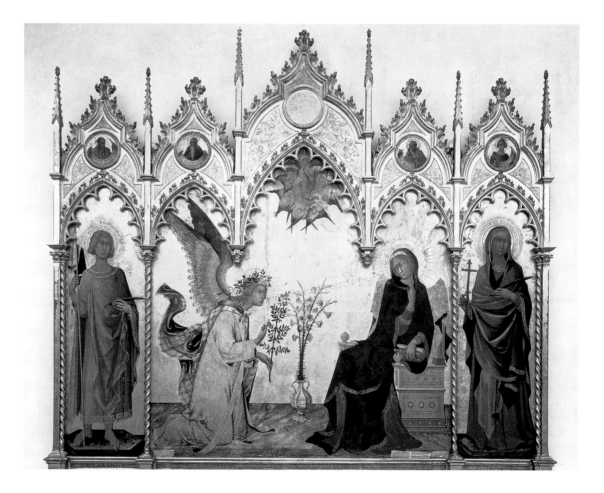

13.27. Simone Martini. *Annunciation*. ca. 1330. Tempera on panel. 10′ × 8′9″ (3 × 2.7 m). Galleria degli Uffizi, Florence.

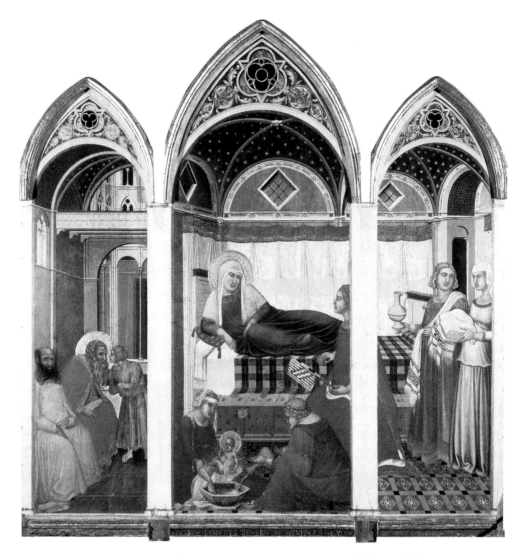

13.28. Pietro Lorenzetti. *Birth of the Virgin.* 1342. Tempera on panel, $6'1\frac{1}{2}'' \times 5'11\frac{1}{2}''$ (1.9 × 1.8 m). Museo dell'Opera del Duomo, Siena

Pietro and Ambrogio Lorenzetti

Another altarpiece commissioned for the cathedral at Siena takes a more down to earth approach. This is the *Birth of the Virgin* (fig. **13.28**) painted in 1342 by Pietro Lorenzetti (active ca. 1306–1348). Pietro and his brother Ambrogio (active ca. 1317–1348) learned their craft in Siena, though their work also shows the influence of Giotto. Pietro has been linked to work at Assisi, and Ambrogio went so far as to enroll in the painter's guild of Florence in the 1330s. Like Simone's, Pietro's altarpiece is a triptych though it has lost its original frame. In this triptych, the painted architecture has been related to the real architecture of the frame so closely that the two are seen as a single system. Moreover, the vaulted room where the birth takes place occupies two panels and continues unbroken behind the column that divides the center from the right wing. The left wing represents a small chamber leading to a Gothic courtyard. Pietro's achievement of spatial illusion here is the outcome of a development that began three decades earlier in the work of Duccio. Pietro treats the painting surface like a transparent window *through* which—not *on* which—a viewer experiences a space comparable to the real world. Following Duccio's example, Pietro uses the architecture in his painting to carve out boxes of space that his figures may inhabit, but he is also inspired by Giotto's technique of giving his figures such mass and weight that they seem to create their own space. His innovation served the narrative and liturgical needs of Siena Cathedral by depicting another key moment in the life of the Virgin, which was also an important feast day in the Church. Saint Anne rests in her childbed, while midwives attend the newly born Virgin and other women tend to the mother. The figure of the midwife pouring water for the baby's bath seems to derive from the figure seen from the back in Giotto's *Lamentation* (fig. 13.21). The father, Joachim, waits for a report of the birth outside this room. The architectural divisions separate the sexes in the same way the architecture in Duccio's *Annunciation of the Death of the Virgin* (fig. 13.25) separates the angel from Mary.

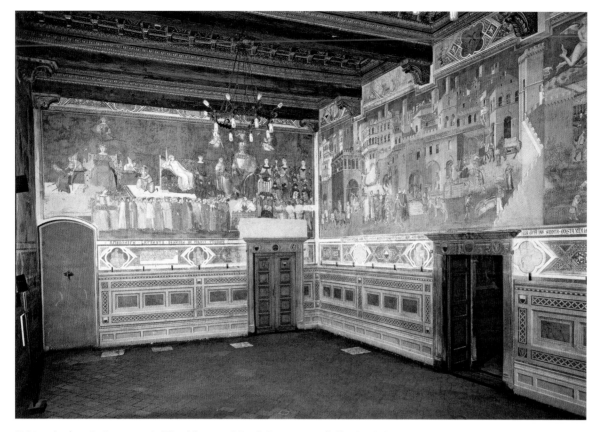

13.29. Ambrogio Lorenzetti. *The Allegory of Good Government* (left). *Good Government in the City,* and portion of *Good Government in the Country* (right). 1338–1340. Frescoes in the Sala della Pace, Palazzo Pubblico, Siena

13.30. Ambrogio Lorenzetti. *Good Government in the City*

GOOD AND BAD GOVERNMENT Pietro's brother, Ambrogio Lorenzetti, combined these same influences in a major project for the city hall of Siena, executed between 1338 and 1340. The ruling Council of Nine (Nove) commissioned for their meeting hall an allegorical fresco contrasting good and bad government. The aim of this project was to be salutary, for as they deliberated, they would see in these frescoes the effects of both. While the negative example of the effects of Bad Government has been severely damaged, the frescoes that depict the positive example of Good Government are remarkably well preserved (fig. **13.29**). On the short wall of the room, Ambrogio depicted the *Allegory of Good Government* as an assembly of virtues who support the large enthroned personification of the city. To the left another enthroned figure personifies Justice, who is inspired by Wisdom. Below the virtues stand 24 members of the Sienese judiciary under the guidance of Concord. On the long wall, the fresco of *Good Government in the City* (fig. **13.30**) bears an inscription praising Justice and the many benefits that derive from her. (See *Primary Source*, page 460.) Ambrogio paints an architectural portrait of the city of Siena in this fresco. To show the life of a well-ordered city-state, the artist fills the streets and houses with teeming activity. The bustling crowd gives the architectural vista its striking reality by introducing the human scale. On the right, outside the city walls, *Good Government in the Country* provides a view of the

Inscriptions on the Frescoes in the Palazzo Pubblico, Siena

The first inscription is painted in a strip below the fresco of Good Government (see figs. 13.29 and 13.30), which is dated between 1338 and 1340. The second is held by the personification of Security, who hovers over the landscape in figure 13.28.

Turn your eyes to behold her,
you who are governing, [Justice] who is portrayed here,
crowned on account of her excellence,
who always renders to everyone his due.
Look how many goods derive from her
and how sweet and peaceful is that life

of the city where is preserved
this virtue who outshines any other.
She guards and defends
those who honor her, and nourishes and feeds them.
From her light is born
Requiting those who do good
and giving due punishment to the wicked.

Without fear every man may travel freely
and each may till and sow,
so long as this commune
shall maintain this lady [Justice] sovereign,
for she has stripped the wicked of all power.

SOURCE: RANDOLPH STARN AND LOREN PARTRIDGE, *ARTS OF POWER: THREE HALLS OF STATE IN ITALY, 1300–1600*. (BERKELEY: UNIVERSITY OF CALIFORNIA PRESS, 1992)

Sienese farmland, fringed by distant mountains (fig. **13.31**) and overseen by a personification of Security. It is a true landscape—the first since ancient Roman times (see fig. 7.55). The scene is full of sweeping depth yet differs from Classical landscapes in its orderliness, which gives it a domesticated air. The people here have taken full possession of Nature: They have terraced the hillsides with vineyards and patterned the valleys with the geometry of fields and pastures. Ambrogio observes the peasants at their seasonal labors; this scene of rural Tuscan life has hardly changed during the past 600 years.

Artists and Patrons in Times of Crisis

Ambrogio's ideal vision of the city and its surroundings offers a glimpse at how the citizens of Siena imagined their government and their city at a moment of peace and prosperity. The first three decades of the fourteenth century in Siena, as in Florence, had been a period of political stability and economic expansion, as well as of great artistic achievement. In the 1340s, however, both cities suffered a series of catastrophes whose effects were to be felt for many years.

Constant warfare led scores of banks and merchants into bankruptcy; internal upheavals shook governments, and there were repeated crop failures and famine. Then, in 1348, the pandemic of bubonic plague—the Black Death—that spread throughout Europe wiped out more than half the population of the two cities. It was spread by hungry, flea-infested rats that swarmed into cities from the barren countryside in search of food. Popular reactions to these events were mixed. Many people saw them as signs of divine wrath, warnings to a sinful humanity to forsake the pleasures of this

earth. In such people, the Black Death intensified an interest in religion and the promise of heavenly rewards. To others, such as the merry company who entertain each other by telling stories in Boccaccio's *Decameron,* the fear of death intensified the desire to enjoy life while there was still time. (See end of Part II, *Additional Primary Sources*.)

Late medieval people were confronted often with the inevitability and power of death. A series of frescoes painted on the walls of the Camposanto, the monumental cemetery building next to Pisa Cathedral, offers a variety of responses to death. Because of its somber message, the fresco was once dated after the outbreak of the plague, but recent research has pushed it closer to the 1330s. The painter of this enormous fresco is not known, though some scholars attribute the work to a Pisan artist named Francesco Traini (documented ca. 1321–1363). The huge fresco cycle, which was damaged in 1944 as a result of bombings in the Second World War, included a powerful *Last Judgment* and an image called *The Triumph of Death*, which asserts that death comes to all, rich or poor, saint or sinner. In a particularly dramatic detail (fig. **13.32**), the elegantly costumed men and women on horseback have suddenly come upon three decaying corpses in open coffins. Even the animals are terrified by the sight and smell of rotting flesh. Only the hermit Saint Macarius, having renounced all earthly pleasures, points out the lesson of the scene. His scroll reads: "If your mind be well aware, keeping here your view attentive, your vainglory will be vanquished and you will see pride eliminated. And, again, you will realize this if you observe that which is written." As the hermits in the hills above make clear, the way to salvation is through renunciation of the world in favor of the

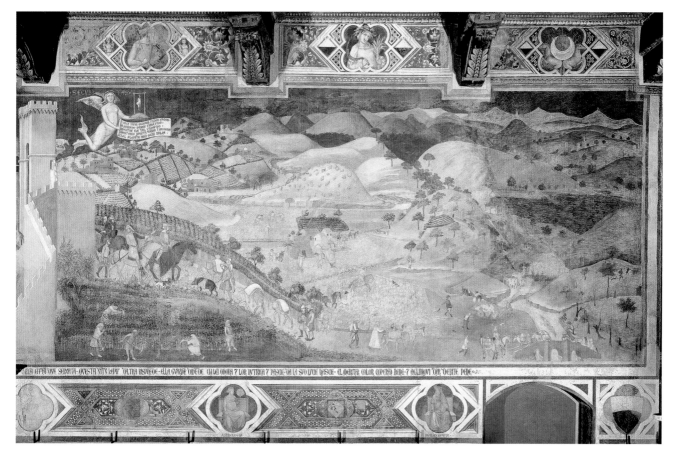

13.31. Ambrogio Lorenzetti. *Good Government in the Country*

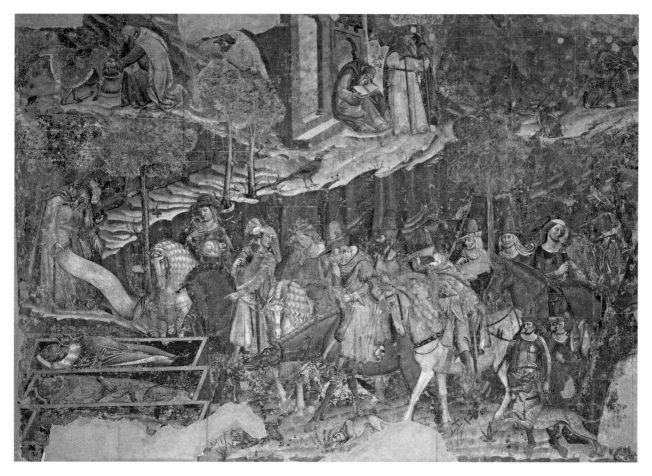

13.32. Anonymous (Francesco Traini?). *The Triumph of Death* (detail). ca. 1325–1350. Fresco. Camposanto, Pisa

spiritual life. In the center of the fresco lie dead and dying peasants who plead with Death, "the medicine for all pain, come give us our last supper." Further to the right are courtiers in a delightful landscape enjoying earthly pleasures as a figure of Death swoops down and angels and devils fight over the souls of the deceased in the sky overhead. The artist's style recalls the realism of Ambrogio Lorenzetti, although the forms are harsher and more expressive.

The Lorenzetti brothers were probably among the thousands of people throughout Tuscany who perished in the Black Death of 1348. Scholars have conjectured about the impact of the plague on the artists and patrons of works of art in the second half of the fourteenth century. We can assume that many painters died, so there weren't as many practitioners of this craft. Documentary research reveals that the number of endowed chapels, tombs, and funeral masses rose as people worried about their mortality. Many such burials and endowments were made in mendicant churches, such as the Franciscan Santa Croce and the Dominican Santa Maria Novella in Florence.

At Santa Maria Novella, a Florentine merchant named Buonamico Guidalotti, who died in 1355, provided funds in his will for a new chapter house for the Dominican community in which he could be buried. The chapel served as a meeting room for the friars and as such was painted with frescoes expressing the role of Dominicans in the struggle for salvation. A fresco on one of the walls of the Guidalotti chapel, painted by Andrea Bonaiuti (also known as Andrea da Firenze, active 1346–1379) between 1365 and 1367, depicts the actions of Dominicans to assure the access of the faithful to heaven, hence its title, *The Way of Salvation* (fig. **13.33**). In the lower section of the fresco, spiritual and temporal leaders gather before a representation of the then unfinished Cathedral of Florence. Groups of Dominicans preach to the laity and convert heretics, amidst black and white dogs (a punning reference to the order—the "Domini canes" or the dogs of the Lord). On the upper right some heedless aristocrats enjoy the pleasures of the senses, while at the center, a Dominican shows the more spiritually minded the path to heaven, whose gate is guarded by Saint Peter. Andrea's fresco reveals the influence both

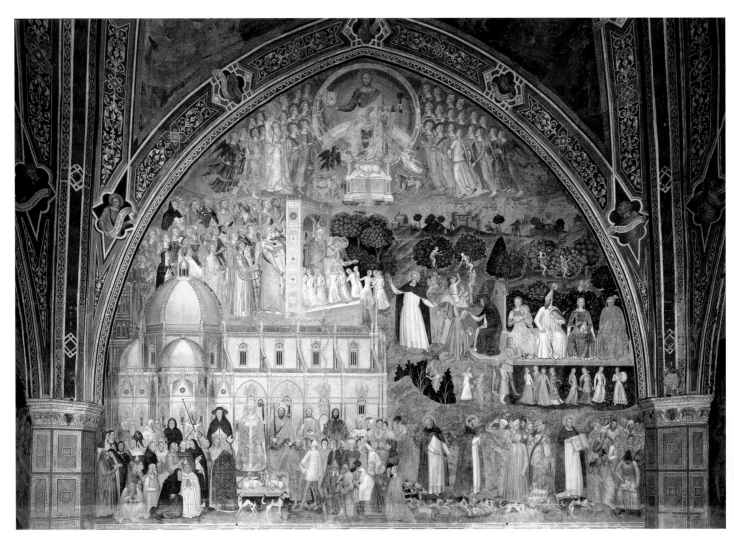

13.33. Andrea da Firenze, *Way of Salvation*. 1365–1367. Fresco. 38′ (11.6 m) wide. Guidalotti Chapel, Santa Maria Novella, Florence

of Ambrogio Lorenzetti's *Good Government* (see fig. 13.29) and the fresco on the walls of the cemetery near Pisa Cathedral (see fig. 13.32), but in its symmetry and sense of order, it seeks clarity rather than illusion and serenity rather than emotion.

Florence, however, did not complete its cathedral in the fourteenth century, and it was not to enjoy the calm atmosphere portrayed in Andrea's fresco. The plague returned in 1363, the political elite clashed with the papacy, and an uprising among the working classes created social and economic turmoil. The wealthier classes restored their power in 1381. Florence overcame these disasters to flourish in the fifteenth century as a center of economic energy, political astuteness, and cultural leadership. As the fifteenth century began, a new generation of Florentine artists would look to the art of Giotto and his contemporaries in their search for new forms of visual expression.

NORTHERN ITALY

Such political struggles did not distress the city of Venice in the fourteenth century. Unlike Florence, riven by warring factions, fourteenth-century Venice enjoyed political stability. Since 1297, the city had closed off membership in the merchant oligarchy that participated in government, and the city's leader (the Doge) was elected from this group. As a result, neither Venetian palaces nor their communal buildings required the defensive architecture seen in Florentine structures, such as the Palazzo della Signoria (fig. 13.16). A somewhat different atmosphere existed in Milan, west of Venice in Lombardy, where an aristocratic government lay in the hands of a single family with great dynastic

ambitions. In Lombardy, the political and cultural connections were with Northern Europe, with important results for the type and the style of art produced there.

Venice: Political Stability and Sumptuous Architecture

The differing political situations in Florence and Venice affected palace design. Whereas the Florentine palace was stolid and impenetrable, the palace in Venice is airy and open, full of windows and arcades that are anything but defensible. Venetian architects borrowed from Gothic and Islamic precedents in an elegant display of the city's wealth and security. When a larger meeting space was needed for the Great Council, the city decided to enlarge the Doge's Palace near San Marco in 1340 (fig. **13.34**). Work continued here until the mid-fifteenth century. In contrast to the fortresslike Palazzo della Signoria in Florence, the Doge's Palace is open at the base, the weight of its upper stories resting on two stories of pointed arcades. The lower arcade provides a covered passageway around the building, the

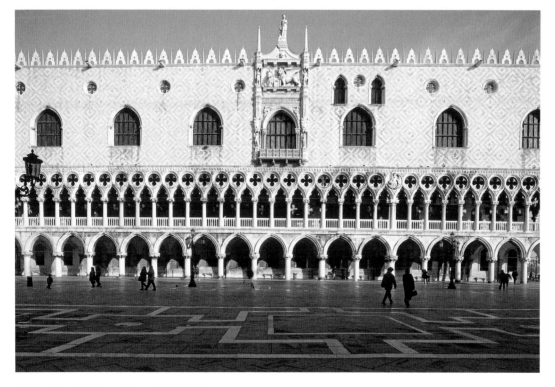

13.34. Doge's Palace. Begun 1340. Venice

13.35. Milan Cathedral. Begun 1386

upper a balcony. The lavish moldings and the quatrefoils of the arcades give the structure an ornamental feel that is accented by the doubling of the rhythm of the upper arcade. The walls of the structure are ornamented with stonework in a diamond pattern, making them both visually lighter and more ornate.

Milan: The Visconti Family and Northern Influences

To the West and North of Venice, Lombardy had a different political structure and a closer relationship with Gothic France, which found expression in its visual arts. In Lombardy, the Visconti family had acquired great wealth from the products of this richly agricultural region. Besides controlling Lombardy, the Visconti positioned themselves among the great families of Europe through marriage ties to members of the Italian and European nobility. By 1395, Giangaleazzo

Visconti had been named Duke of Milan, had married the daughter of the King of France, and wed their daughter to Louis, Duke of Orleans.

Fourteenth-century projects in Milan reflect these ties to Northern Europe. The city, its archbishop, and Giangaleazzo Visconti joined together to build a new cathedral in 1386, though it required more than a century to complete. Milan Cathedral is the most striking translation of French Gothic forms in Italy (fig. **13.35**). While local architects began the project, architects from France and Germany, who were experts in raising tall Gothic structures, were consulted about the design and its implementation. Yet the local preferences for wide interior spaces and solid structure resulted in double aisles and a rejection of flying buttresses. (Compare with figs. 12.15 and 12.17.) The facade defines the interior spaces: The stepped heights of the inner and outer aisles can be clearly read, despite the profusion of vertical moldings on the exterior. The continu-

ous solid mass of the aisle walls seems hardly diminished by the mass of triangular points and turrets along the roofline. Later in the fifteenth and sixteenth centuries more antique-inspired elements such as pediments and pilasters were set into the Gothic facade.

The authoritarian nature of Visconti rule in Milan may be seen in a commission of Giangaleazzo's uncle Bernabò Visconti for his tomb (fig. 13.36). Though now in a museum, Bernabò's *Equestrian Monument* originally stood over the altar of a church in Milan. Completed around 1363 by the local sculptor Bonino da Campione (active ca. 1357–1397), the marble structure includes a sarcophagus that supports a sculpted figure of Bernabò on horseback. The figure stands rather than sits on the horse, forcefully commanding the space over the high altar of the church. The idea of the equestrian image of a ruler goes back to antiquity, with the equestrian portrait of Marcus Aurelius (fig. 7.21) visible in Rome throughout the Middle Ages.

ART IN TIME

1271–1295—Marco Polo travels to China

1277—Visconti control Milan

1386—Milan Cathedral begun

13.36. Tomb of Bernabò Visconti. Before 1363. Marble. 19'8" (6 m). Castello Sforzesco, Milan

The aristocracy of Europe claimed for themselves the prerogative of equestrian imagery. In this sculpture, Bernabò is rigid and formal in his bearing; originally the figure was covered with silver and gold leaf to further enhance its impressiveness. Yet Bonino's treatment of the horse, with its sensitive proportions and realistically observed anatomy, point to a Lombard interest in the natural depiction of form, which may be a result of Lombard contact with contemporary French art.

While promoting the building of Milan Cathedral and during his own campaign to be named duke, Giangaleazzo Visconti commissioned illuminated manuscripts, as did his French peers. His *Book of Hours* was painted around 1395 by Giovannino dei Grassi (active ca. 1380–1398) with numerous personal representations and references to the duke. The page in figure **13.37** opens one of David's Psalms with an illuminated initial D wherein King David appears. David is both the author of the

text and a good biblical exemplar of a ruler. An unfurling ribbon ornamented with the French *fleur-de-lis* forms the D; shields at the corners bear the Visconti emblem of the viper. Below the text appears a portrait of Giangaleazzo in the profile arrangement that was familiar from ancient coins. Although this portrait is naturalistic, it is set into an undulating frame that supports the rays of the sun, another Visconti emblem. Around the portrait Giovannino has painted images of stags and a hunting dog, with great attention to the accurate rendering of these natural forms. Such flashes of realism set amidst the splendor of the page reflect both the patron and the artist's contribution to the developing International Gothic style. Commissioning such lavish books was an expression of the status and power that Giangaleazzo attempted to wield. His ambition to bring most of northern Italy under his control would profoundly affect the arts in Tuscany in the early fifteenth century.

13.37. Giovannino dei Grassi, *Hours of Giangaleazzo Visconti*. ca. 1395. Tempera and gold on parchment. 9³⁄₄″ × 6⁷⁄₈″ (24.7 × 17.5 cm). Banco Rari, Biblioteca Nazionale, 397 folio 115/H, Florence

SUMMARY

Thirteenth- and fourteenth-century Italian art had its roots in both Byzantine forms and Italian artists' contacts with Roman and Early Christian precedents. It is often the product of commissions by mercantile communities and urban patriciates rather than great aristocratic patrons. The activity of the mendicant orders inspired a new spirituality in these urban centers; their vivid preaching accompanied commissions of narrative imagery to speak more directly to their lay audience.

CHURCH ARCHITECTURE AND THE GROWTH OF THE MENDICANT ORDERS

One product of the mendicants' mission to preach was the building of large urban churches where sermons could be delivered. These structures took advantage of Northern Gothic innovations that allowed for large interior spaces and tall proportions, but often followed local preferences for wooden roofs, solid wall surfaces, and facades without towers. Inside these churches, sculpted forms enhanced worshipers' experience by representing sacred stories in direct and legible terms. On pulpits and on portals, sculptors in Italy made narrative scenes that drew inspiration from Roman art forms or from Northern Gothic styles. Inspired by mendicant ideas, they created memorable images of holy figures in human situations to stimulate the devotion of city dwellers.

PAINTING IN TUSCANY

For this same audience, painters developed new techniques to represent the natural world. Starting from the close study of Byzantine painting traditions that were themselves rooted in ancient styles, thirteenth- and fourteenth-century Italian painters explored ways to create images that more closely reflected nature than had earlier medieval art. This generation of artists explored techniques for consistently representing the fall of light on three-dimensional forms and for creating the illusion of space within their paintings. These techniques were used to enhance the spiritual impact of the sacred figures they painted and to tell sacred stories more effectively. The innovations of fourteenth-century painters like Giotto and Duccio provided a visual language of naturalism from which artists all over Europe could profit.

NORTHERN ITALY

The northern Italian centers of Venice and Milan developed individual forms of Gothic art. Venice's political situation and mercantile connections with the Far East and Middle East brought to that city a taste for architectural forms with sumptuous surfaces and open arcades. Ruled by an ambitious dynasty, Milan looked more to Northern Europe. Its cathedral reflects a closer study of French Gothic architecture than any other in Italy, and the artistic commissions of their rulers imitate the tastes of the French aristocracy.

Glossary

ABACUS. A slab of stone at the top of a Classical capital just beneath the architrave.

ABBEY. (1) A religious community headed by an abbot or abbess. (2) The buildings that house the community. An abbey church often has an especially large choir to provide space for the monks or nuns.

ACADEMY. A place of study, the word coming from the Greek name of a garden near Athens where Plato and, later, Platonic philosophers held philosophical discussions from the 5th century BCE to the 6th century CE. The first academy of fine arts was the Academy of Drawing, founded 1563 in Florence by Giorgio Vasari. Later academies were the Royal Academy of Painting and Sculpture in Paris, founded 1648, and the Royal Academy of Arts in London, founded 1768. Their purpose was to foster the arts by teaching, by exhibitions, by discussion, and occasionally by financial aid.

ACANTHUS. (1) A Mediterranean plant having spiny or toothed leaves. (2) An architectural ornament resembling the leaves of this plant, used on moldings, friezes, and Corinthian capitals.

ACROTERION (pl. **ACROTERIA**). Decorative ornaments placed at the apex and the corners of a pediment.

ACRYLIC. A plastic binder medium for pigments that is soluble in water. Developed about 1960.

ACTION PAINTING. In Abstract art, the spontaneous and uninhibited application of paint, as practiced by the avant-garde from the 1930s through the 1950s.

AERIAL PERSPECTIVE. See *perspective*.

AISLE. The passageway or corridor of a church that runs parallel to the length of the building. It often flanks the nave of the church but is sometimes set off from it by rows of piers or columns.

ALBUMEN PRINT. A process in photography that uses the proteins found in eggs to produce a photographic plate.

ALLA PRIMA. A painting technique in which pigments are laid on in one application with little or no underpainting.

ALTAR. A mound or structure on which sacrifices or offerings are made in the worship of a deity. In a Catholic church, a tablelike structure used in celebrating the Mass.

ALTARPIECE. A painted or carved work of art placed behind and above the altar of a Christian church. It may be a single panel or a *triptych* or a *polytych*, both having hinged wings painted on both sides. Also called a reredos or retablo.

ALTERNATE SYSTEM. A system developed in Romanesque church architecture to provide adequate support for a *groin-vaulted nave* having *bays* twice as long as the side-aisle bays. The *piers* of the nave *arcade* alternate in size; the heavier *compound piers* support the main nave vaults where the *thrust* is concentrated, and smaller, usually cylindrical, piers support the side-aisle vaults.

AMAZON. One of a tribe of female warriors said in Greek legend to dwell near the Black Sea.

AMBULATORY. A covered walkway. (1) In a basilican church, the semicircular passage around the apse. (2) In a central-plan church, the ring-shaped aisle around the central space. (3) In a cloister, the covered colonnaded or arcaded walk around the open courtyard.

AMPHITHEATER. A double theater. A building, usually oval in plan, consisting of tiers of seats and access corridors around the central theater area.

AMPHORA (pl. **AMPHORAE**). A large Greek storage vase with an oval body usually tapering toward the base. Two handles extend from just below the lip to the shoulder.

ANDACHTSBILD. German for "devotional image." A picture or sculpture with imagery intended for private devotion. It was first developed in Northern Europe.

ANIMAL STYLE. A style that appears to have originated in ancient Iran and is characterized by stylized or abstracted images of animals.

ANNULAR. From the Latin word for "ring." Signifies a ring-shaped form, especially an annular barrel vault.

ANTA (pl. **ANTAE**). The front end of a wall of a Greek temple, thickened to produce a pilasterlike member. Temples having columns between the antae are said to be "*in antis*."

APOCALYPSE. The Book of Revelation, the last book of the New Testament. In it, St. John the Evangelist describes his visions, experienced on the island of Patmos, of Heaven, the future of humankind, and the Last Judgment.

APOSTLE. One of the twelve disciples chosen by Jesus to accompany him in his lifetime and to spread the gospel after his death. The traditional list includes Andrew, Bartholomew, James the Greater (son of Zebedee), James the Lesser (son of Alphaeus), John, Judas Iscariot, Matthew, Peter, Philip, Simon the Canaanite, Thaddaeus (or Jude), and Thomas. In art, however, the same twelve are not always represented, since "apostle" was sometimes applied to other early Christians, such as St. Paul.

APSE. A semicircular or polygonal niche terminating one or both ends of the nave in a Roman basilica. In a Christian church, it is usually placed at the east end of the nave beyond the transept or choir. It is also sometimes used at the end of transept arms.

APSIDIOLE. A small apse or chapel connected to the main apse of a church.

AQUATINT. A print processed like an etching, except that the ground or certain areas are covered with a solution of asphalt, resin, or salts that, when heated, produces a granular surface on the plate and rich gray tones in the final print. Etched lines are usually added to the plate after the aquatint ground is laid.

AQUEDUCT. Latin for "duct of water." (1) An artificial channel or conduit for transporting water from a distant source. (2) The overground structure that carries the conduit across valleys, rivers, etc.

ARCADE. A series of arches supported by piers or columns. When attached to a wall, these form a blind arcade.

ARCH. A curved structure used to span an opening. Masonry arches are generally built of wedge-shaped blocks, called *voussoirs*, set with their narrow sides toward the opening so that they lock together. The topmost *voussoir* is called the *keystone*. Arches may take different shapes, such as the pointed Gothic arch or the rounded Classical arch.

ARCHBISHOP. The chief bishop of an ecclesiastic district.

ARCHITECTURAL ORDER. An architectural system based on the column and its entablature, in which the form of the elements themselves (capital, shaft, base, etc.) and their relationship to each other are specifically defined. The five Classical orders are the Doric, Ionic, Corinthian, Tuscan, and Composite.

ARCHITRAVE. The lowermost member of a classical entablature, such as a series of stone blocks that rest directly on the columns.

ARCHIVOLT. A molded band framing an arch, or a series of such bands framing a tympanum, often decorated with sculpture.

ARCUATION. The use of arches or a series of arches in building.

ARIANISM. Early Christian belief, initiated by Arius, a 4th-century CE priest in Alexandria. It was later condemned as heresy and suppressed, and it is now largely obscure.

ARRICCIO. A coating of rough plaster over a stone or cement wall that is used as a smooth base or ground (support) in fresco painting.

ART BRUT. Meaning "raw art" in French, *art brut* is the direct and highly emotional art of children and the mentally ill that served as an inspiration for some artistic movements in Modern art.

ASHLAR MASONRY. Carefully finished stone that is set in fine joints to create an even surface.

ATRIUM. (1) The central court or open entrance court of a Roman house. (2) An open court, sometimes colonnaded or arcaded, in front of a church.

ATTIC. A low upper story placed above the main cornice or entablature of a building and often decorated with windows and pilasters.

AUTOCHROME. A color photograph invented by Louis Lumière in 1903 using a glass plate covered with grains of starch dyed in three colors to act as filters and then a silver bromide emulsion.

AUTOMATIC DRAWING. A technique of drawing in Modern art whereby the artist tries to minimize his or her conscious and intellectual control over the lines or patterns drawn, relying instead on subconscious impulses to direct the drawing.

AVANT-GARDE. Meaning "advance force" in French, the artists of the avant-garde in 19th- and 20th-century Europe led the way in innovation in both subject matter and technique, rebelling against the established conventions of the art world.

BACCHANT (fem. **BACCHANTE**). A priest or priestess of the wine god, Bacchus (in Greek mythology, Dionysus), or one of his ecstatic female followers, who were sometimes called maenads.

BALDACCHINO. A canopy usually built over an altar. The most important one is Bernini's construction for St. Peter's in Rome.

BALUSTRADE. (1) A railing supported by short pillars called balusters. (2) Occasionally applied to any low parapet.

BANQUET PIECE. A variant of the still life, the banquet piece depicts an after-meal scene. It focuses more on tableware than food and typically incorporates a vanitas theme.

BAPTISTRY. A building or a part of a church in which the sacrament of baptism is administered. It is

often octagonal in design, and it contains a baptismal *font*, or a receptacle of stone or metal that holds the Holy Water for the rite.

BARREL VAULT. A vault formed by a continuous semicircular arch so that it is shaped like a half-cylinder.

BAR TRACERY. A style of tracery in which glass is held in place by relatively thin membranes.

BAS-DE-PAGE. Literally "bottom of the page." An illustration or decoration that is placed below a block of text in an illuminated manuscript.

BASE. (1) The lowermost portion of a column or pier, beneath the shaft. (2) The lowest element of a wall, dome, or building or occasionally of a statue or painting.

BASILICA. (1) In ancient Roman architecture, a large, oblong building used as a public meeting place and hall of justice. It generally includes a nave, side aisles, and one or more apses. (2) In Christian architecture, a longitudinal church derived from the Roman basilica and having a nave, an apse, two or four side aisles or side chapels, and sometimes a narthex. (3) Any one of the seven original churches of Rome or other churches accorded the same religious privileges.

BATTLEMENT. A parapet consisting of alternating solid parts and open spaces designed originally for defense and later used for decoration. See *crenelated*.

BAY. A subdivision of the interior space of a building. Usually a series of bays is formed by consecutive architectural supports.

BELVEDERE. A structure made for the purpose of viewing the surroundings, either above the roof of a building or freestanding in a garden or other natural setting.

BENEDICTINE ORDER. Founded at Monte Cassino in 529 CE by St. Benedict of Nursia (ca. 480–ca. 553). Less austere than other early orders, it spread throughout much of western Europe and England in the next two centuries.

BIBLE MORALISÉE. A type of illustrated Bible in which each page typically contains four pairs of illustrations representing biblical events and their related lessons.

BISHOP. The spiritual overseer of a number of churches or a diocese. His throne, or cathedra, placed in the principal church of the diocese, designates it as a cathedral.

BLACK-FIGURED. A style of ancient Greek pottery decoration characterized by black figures against a red background. The black-figured style preceded the red-figured style.

BLIND ARCADE. An arcade with no openings. The arches and supports are attached decoratively to the surface of a wall.

BLOCK BOOKS. Books, often religious, of the 15th century containing woodcut prints in which picture and text were usually cut into the same block.

BODEGÓNES. Although in modern Spanish *bodegón* means "still life," in 17th-century Spain, *bodegónes* referred to genre paintings that included food and drink, as in the work of Velázquez.

BOOK COVER. The stiff outer covers protecting the bound pages of a book. In the medieval period, they were frequently covered with precious metal and elaborately embellished with jewels, embossed decoration, etc.

BOOK OF HOURS. A private prayer book containing the devotions for the seven canonical hours of the Roman Catholic church (matins, vespers, etc.), liturgies for local saints, and sometimes a calendar. They were often elaborately illuminated for persons of high rank, whose names are attached to certain extant examples.

BRACKET. A stone, wooden, or metal support projecting from a wall and having a flat top to bear the weight of a statue, cornice, beam, etc. The lower part may take the form of a scroll; it is then called a scroll bracket.

BROKEN PEDIMENT. See *pediment*.

BRONZE AGE. The earliest period in which bronze was used for tools and weapons. In the Middle East, the Bronze Age succeeded the Neolithic period in ca. 3500 BCE and preceded the Iron Age, which commenced ca. 1900 BCE.

BRUSH DRAWING. See *drawing*.

BUON FRESCO. See *fresco*.

BURIN. A pointed metal tool with a wedged-shaped tip used for engraving.

BUTTRESS. A projecting support built against an external wall, usually to counteract the lateral thrust of a vault or arch within. In Gothic church architecture, a *flying buttress* is an arched bridge above the aisle roof that extends from the upper nave wall, where the lateral thrust of the main vault is greatest, down to a solid pier.

BYZANTIUM. City on the Sea of Marmara, founded by the ancient Greeks and renamed Constantinople in 330 CE. Today called Istanbul.

CAESAR. The surname of the Roman dictator, Caius Julius Caesar, subsequently used as the title of an emperor; hence, the German Kaiser and the Russian czar (tsar).

CALLIGRAPHY. From the Greek word for "beautiful writing." (1) Decorative or formal handwriting executed with a quill or reed pen or with a brush. (2) A design derived from or resembling letters and used to form a pattern.

CALOTYPE. Invented in the 1830s, calotype was the first photographic process to use negatives and positive prints on paper.

CALVARY. The hill outside Jerusalem where Jesus was crucified, also known as *Golgotha*. The name *Calvary* is taken from the Latin *calvaris*, meaning skull; the word *Golgotha* is the Greek transliteration of the word for "skull" in Aramaic. The hill was thought to be the spot where Adam was buried and was thus traditionally known as "the place of the skull." See *Golgotha*.

CAMEO. A low relief carving made on agate, seashell, or other multilayered material in which the subject, often in profile view, is rendered in one color while the background appears in another, darker color.

CAMERA OBSCURA. Latin for "dark room." A darkened enclosure or box with a small opening or lens on one wall through which light enters to form an inverted image on the opposite wall. The principle had long been known but was not used as an aid in picture making until the 16th century.

CAMES. Strips of lead in stained-glass windows that hold the pieces of glass together.

CAMPAGNA. Italian word for "countryside." When capitalized, it usually refers to the countryside near Rome.

CAMPANILE. From the Italian word *campana*, meaning "bell." A bell tower that is either round or square and is sometimes free-standing.

CAMPOSANTO. Italian word for "holy field." A cemetery near a church, often enclosed.

CANON. A law, rule, or standard.

CANOPY. In architecture, an ornamental, rooflike projection or cover above a statue or sacred object.

CAPITAL. The uppermost member of a column or pillar supporting the architrave.

CARDINAL. In the Roman Catholic church, a member of the Sacred college, the ecclesiastical body that elects the pope and constitutes his advisory council.

CARMELITE ORDER. Originally a 12th-century hermitage claimed to descend from a community of hermits established by the prophet Elijah on Mt. Carmel, Palestine. In the early 13th century it spread to Europe and England, where it was reformed by St. Simon Stock and became one of the three great mendicant orders.

CARTHUSIAN ORDER. An order founded at Chartreuse, France, by Saint Bruno in 1084; known for its very stringent rules. See *Chartreuse*.

CARTOON. From the Italian word *cartone*, meaning "large paper." (1) A full-scale drawing for a picture or design intended to be transferred to a wall, panel, tapestry, etc. (2) A drawing or print, usually humorous or satirical, calling attention to some action or person of popular interest.

CARVING. (1) The cutting of a figure or design out of a solid material such as stone or wood, as contrasted to the additive technique of modeling. (2) A work executed in this technique.

CARYATID. A sculptured female figure used in place of a column as an architectural support. A similar male figure is an *atlas* (pl. *atlantes*).

CASEMATE. A chamber or compartment within a fortified wall, usually used for the storage of artillery and munitions.

CASSONE (pl. *CASSONI*). An Italian dowry chest often highly decorated with carvings, paintings, inlaid designs, and gilt embellishments.

CASTING. A method of duplicating a work of sculpture by pouring a hardening substance such as plaster or molten metal into a mold.

CAST IRON. A hard, brittle iron produced commercially in blast furnaces by pouring it into molds where it cools and hardens. Extensively used as a building material in the early 19th century, it was superseded by steel and ferroconcrete.

CATACOMBS. The underground burial places of the early Christians, consisting of passages with niches for tombs and small chapels for commemorative services.

CATALOGUE RAISONNÉ. A complete list of an artist's works of art, with a comprehensive chronology and a discussion of the artist's style.

CATHEDRA. The throne of a bishop, the principal priest of a diocese. See *cathedral*.

CATHEDRAL. The church of a bishop; his administrative headquarters. The location of his *cathedra* or throne.

CELLA. (1) The principal enclosed room of a temple used to house an image. Also called the *naos*. (2) The entire body of a temple as distinct from its external parts.

CENTERING. A wooden framework built to support an arch, vault, or dome during its construction.

CENTRAL-PLAN CHURCH. (1) A church having four arms of equal length. The crossing is often covered with a dome. Also called a Greek-cross church. (2) A church having a circular or polygonal plan.

CHAMPLEVÉ. An enameling method in which hollows are etched into a metal surface and filled with enamel.

CHANCEL. The area of a church around the altar, sometimes set off by a screen. It is used by the clergy and the choir.

CHAPEL. (1) A private or subordinate place of worship. (2) A place of worship that is part of a church but separately dedicated.

CHARTREUSE. French word for a Carthusian monastery (in Italian, Certosa). The Carthusian Order was founded by St. Bruno (ca. 1030–1101) at Chartreuse near Grenoble in 1084. It is an eremitic order, the life of the monks being one of silence, prayer, and austerity.

CHASING. (1) A technique of ornamenting a metal surface by the use of various tools. (2) The procedure used to finish a raw bronze cast.

CHÂTEAU (pl. **CHÂTEAUS** or **CHÂTEAUX**). French word for "castle," now used to designate a large country house as well.

CHEVET. In Gothic architecture, the term for the developed and unified east end of a church, including choir, apse, ambulatory, and radiating chapels.

CHEVRON. A V-shaped decorative element that, when used repeatedly, gives a horizontal, zigzag appearance.

CHIAROSCURO. Italian word for "light and dark." In painting, a method of modeling form primarily by the use of light and shade.

CHOIR. In church architecture, a square or rectangular area between the apse and the nave or transept. It is reserved for the clergy and the singing choir and is usually marked off by steps, a railing, or a choir screen. Also called the *chancel*.

CHOIR SCREEN. A screen, frequently ornamented with sculpture and sometimes called a *rood screen*, separating the choir of a church from the nave or transept. In Orthodox Christian churches it is decorated with icons and thus called an *iconostasis*.

CHRISTOLOGICAL CYCLE. A series of illustrations depicting the life of Jesus Christ.

CIRE-PERDU PROCESS. The lost-wax process of casting. A method in which an original is modeled in wax or coated with wax, then covered with clay. When the wax is melted out, the resulting mold is filled with molten metal (often bronze) or liquid plaster.

CISTERCIAN ORDER. Founded at Cîteaux in France in 1098 by Robert of Molesme with the objective of reforming the Benedictine Order and reasserting its original ideals of a life of severe simplicity.

CITY-STATE. An autonomous political unit comprising a city and the surrounding countryside.

CLASSICISM. Art or architecture that harkens back to and relies upon the style and canons of the art and architecture of ancient Greece or Rome, which emphasize certain standards of balance, order, and beauty.

CLERESTORY. A row of windows in the upper part of a wall that rises above an adjoining roof. Its purpose is to provide direct lighting, as in a basilica or church.

CLOISONNÉ. An enameling method in which the hollows created by wires joined to a metal plate are filled with enamel to create a design.

CLOISTER. (1) A place of religious seclusion such as a monastery or nunnery. (2) An open court attached to a church or monastery and surrounded by an ambulatory. Used for study, meditation, and exercise.

CLUNIAC ORDER. Founded at Cluny, France, by Berno of Baume in 909. It had a leading role in the religious reform movement in the Middle Ages and had close connections to Ottonian rulers and to the papacy.

CODEX (pl. **CODICES**). A manuscript in book form made possible by the use of parchment instead of papyrus. During the 1st to 4th centuries CE, it gradually replaced the *rotulus*, or "scroll," previously used for written documents.

COFFER. (1) A small chest or casket. (2) A recessed, geometrically shaped panel in a ceiling. A ceiling decorated with these panels is said to be coffered.

COLLAGE. A composition made of cut and pasted scraps of materials, sometimes with lines or forms added by the artist.

COLONNADE. A series of regularly spaced columns supporting a lintel or entablature.

COLONNETTE. A small, often decorative, column that is connected to a wall or pier.

COLOPHON. (1) The production information given at the end of a book. (2) The printed emblem of a book's publisher.

COLOR-FIELD PAINTING. A technique of Abstract painting in which thinned paints are spread onto an unprimed canvas and allowed to soak in with minimal control by the artist.

COLOSSAL ORDER. Columns, piers, or pilasters in the shape of the Greek or Roman orders but that extend through two or more stories rather than following the Classical proportions.

COLUMN. An approximately cylindrical, upright architectural support, usually consisting of a long, relatively slender shaft, a base, and a capital. When imbedded in a wall, it is called an engaged column. Columns decorated with wraparound reliefs were used occasionally as freestanding commemorative monuments.

COMPOSITE IMAGE. An image formed by combining different images or different views of the subject.

COMPOUND PIER. A pier with attached pilasters or shafts.

CONCRETE. A mixture of sand or gravel with mortar and rubble invented in the ancient Near East and further developed by the Romans. Largely ignored during the Middle Ages, it was revived by Bramante in the early 16th century for St. Peter's.

CONTÉ CRAYON. A crayon made of graphite and clay used for drawing. Produces rich, velvety tones.

CONTINUOUS NARRATION. Portrayal of the same figure or character at different stages in a story that is depicted in a single artistic space.

CONTRAPPOSTO. Italian word for "set against." A composition developed by the Greeks to represent movement in a figure. The parts of the body are placed asymmetrically in opposition to each other around a central axis, and careful attention is paid to the distribution of weight.

CORBEL. (1) A bracket that projects from a wall to aid in supporting weight. (2) The projection of one course, or horizontal row, of a building material beyond the course below it.

CORBEL VAULT. A vault formed by progressively projecting courses of stone or brick, which eventually meet to form the highest point of the vault.

CORINTHIAN STYLE. An ornate Classical style of architecture, characterized in part by columns combining a fluted shaft with a capital made up of carved acanthus leaves and scrolls (*volutes*).

CORNICE. (1) The projecting, framing members of a classical pediment, including the horizontal one beneath and the two sloping or "raking" ones above. (2) Any projecting, horizontal element surmounting a wall or other structure or dividing it horizontally for decorative purposes.

COUNTER-REFORMATION. The movement of self-renewal and reform within the Roman Catholic church following the Protestant Reformation of the early 16th century and attempting to combat its influence. Also known as the Catholic Reform. Its principles were formulated and adopted at the Council of Trent, 1545–1563.

COURT STYLE. See *Rayonnant*.

CRENELATED. Especially in medieval Europe, the up-and-down notched walls (*battlements*) of fortified buildings and castles; the *crenels* served as openings for the use of weapons and the higher *merlons* as defensive shields.

CROMLECH. From the Welsh for "concave stone." A circle of large upright stones probably used as the setting for ritual ceremonies in prehistoric Britain.

CROSSHATCHING. In drawing and etching, parallel lines drawn across other parallel lines at various angles to represent differences in values and degrees of shading. See also *hatching*.

CROSSING. The area in a church where the transept crosses the nave, frequently emphasized by a dome or crossing tower.

CROSS SECTION. (1) In architecture, a drawing that shows a theoretical slice through a building along an imagined plane in order to reveal the design of the structure. (2) An imagined slice through any object along an imagined plane in order to reveal its structure.

CRYPT. A space, usually vaulted, in a church that sometimes causes the floor of the choir to be raised above that of the nave; often used as a place for tombs and small chapels.

CUNEIFORM. The wedge-shaped characters made in clay by the ancient Mesopotamians as a writing system.

CURTAIN WALL. A wall of a modern building that does not support the building; the building is supported by an underlying steel structure rather than by the wall itself, which serves the purpose of a facade.

CYCLOPEAN. An adjective describing masonry with large, unhewn stones, thought by the Greeks to have been built by the Cyclopes, a legendary race of one-eyed giants.

DAGUERREOTYPE. Originally, a photograph on a silver-plated sheet of copper, which had been treated with fumes of iodine to form silver iodide on its surface and then after exposure developed by fumes of mercury. The process, invented by L. J. M. Daguerre and made public in 1839, was modified and accelerated as daguerreotypes gained popularity.

DECALCOMANIA. A technique developed by the artist Max Ernst that uses pressure to transfer paint to a canvas from some other surface.

DEËSIS. From the Greek word for "entreaty." The representation of Christ enthroned between the Virgin Mary and St. John the Baptist, frequent in Byzantine mosaics and depictions of the Last Judgment. It refers to the roles of the Virgin Mary and St. John the Baptist as intercessors for humankind.

DENTIL. A small, rectangular, tooth-like block in a series, used to decorate a classical entablature.

DIKKA. An elevated, flat-topped platform in a mosque used by the muezzin or cantor.

DIORITE. An igneous rock, extremely hard and usually black or dark gray in color.

DIPTYCH. (1) Originally a hinged, two-leaved tablet used for writing. (2) A pair of ivory carvings or panel paintings, usually hinged together.

DIPYLON VASE. A Greek funerary vase with holes in the bottom through which libations were poured to the dead. Named for the cemetery near Athens where the vases were found.

DISGUISED SYMBOLISM. "Hidden" meaning in the details of a painting that carry a symbolic message.

DOLMEN. A structure formed by two or more large, upright stones capped by a horizontal slab. Thought to be a prehistoric tomb.

DOME. A true dome is a vaulted roof of circular, polygonal, or elliptical plan, formed with hemispherical or ovoidal curvature. May be supported by a circular wall or drum and by pendentives or related constructions. Domical coverings of many other sorts have been devised.

DOME VAULT. The arched sections of a dome that, joined together, form the rounded shape of a dome. See *dome, vault,* and *arch*.

DOMINICAN ORDER. Founded as a mendicant order by St. Dominic in Toulouse in 1220.

DOMUS. Latin word for "house." A detached, one-family Roman house with rooms frequently grouped around two open courts. The first court, called the *atrium*, was used for entertaining and conducting business. The second court, usually with a garden and surrounded by a *peristyle* or colonnade, was for the private use of the family.

DONOR. The patron or client at whose order a work of art was executed; the donor may be depicted in the work.

DORIC STYLE. A simple style of Classical architecture, characterized in part by smooth or fluted column shafts and plain, cushionlike capitals, and a frieze of *metopes* and *triglyphs*.

DRAWING. (1) A work in pencil, pen and ink, charcoal, etc., often on paper. (2) A similar work in ink or wash, etc., made with a brush and often called a brush drawing. (3) A work combining these or other techniques. A drawing may be large or small, a quick sketch or an elaborate work. Among its various forms are a record of something seen, a study for another work, an illustration associated with a text, and a technical aid.

DRESSED STONE. A masonry technique in which exposed stones are finished, or dressed, to produce a surface that is smooth and formal.

DRÔLERIES. French word for "jests." Used to describe the lively animals and small figures in the margins of late medieval manuscripts and in wood carvings on furniture.

DRUM. (1) A section of the shaft of a column. (2) A circular-shaped wall supporting a dome.

DRYPOINT. A type of *intaglio* printmaking in which a sharp metal needle is use to carve lines and a design into a (usually) copper plate. The act of drawing pushes up a burr of metal filings, and so, when the plate is inked, ink will be retained by the burr to create a soft and deep tone that will be unique to each print. The burr can only last for a few printings. Both the print and the process are called drypoint.

EARTHWORKS. Usually very large scale, outdoor artwork that is produced by altering the natural environment.

ECHINUS. In the Doric or Tuscan Order, the round, cushionlike element between the top of the shaft and the abacus.

ELEVATION. (1) An architectural drawing presenting a building as if projected on a vertical plane parallel to one of its sides. (2) Term used in describing the vertical plane of a building.

EMBLEM BOOK. A reference book for painters of Christian subjects that provides examples of objects and events associated with saints and other religious figures.

EMBOSSING. A metalworking technique in which a relief design is raised by hammering into the back side of a metal sheet.

EMPIRICISM. The philosophical and scientific idea that knowledge should be attained through observation and the accumulation of evidence through repeatable experiments.

ENAMEL. (1) Colored glassy substances, either opaque or translucent, applied in powder form to a metal surface and fused to it by firing. Two main techniques developed: champlevé (from the French for "raised field"), in which the areas to be treated are dug out of the metal surface; and cloisonné (from the French for "partitioned"), in which compartments or cloisons to be filled are made on the surface with thin metal strips. (2) A work executed in either technique.

ENCAUSTIC. A technique of painting with pigments dissolved in hot wax.

ENGAGED COLUMN. A column that is joined to a wall, usually appearing as a half-rounded vertical shape.

ENGRAVING. (1) A means of embellishing metal surfaces or gemstones by incising a design on the surface. (2) A print made by cutting a design into a metal plate (usually copper) with a pointed steel tool known as a burin. The burr raised on either side of the incised line is removed. Ink is then rubbed into the V-shaped grooves and wiped off the surface. The plate, covered with a damp sheet of paper, is run through a heavy press. The image on the paper is the reverse of that on the plate. When a fine steel needle is used instead of a burin and the burr is retained, a drypoint engraving results, characterized by a softer line. These techniques are called, respectively, engraving and drypoint.

ENTABLATURE. (1) In a classical order, the entire structure above the columns; this usually includes architrave, frieze, and cornice. (2) The same structure in any building of a classical style.

ENTASIS. A swelling of the shaft of a column.

ENVIRONMENT. In art, environment refers to the Earth itself as a stage for Environmental art, works that can be enormously large yet very minimal and abstract. These works can be permanent or transitory. The term Earth art is also used to describe these artworks.

ETCHING. (1) A print made by coating a copperplate with an acid-resistant resin and drawing through this ground, exposing the metal with a sharp instrument called a *stylus*. The plate is bathed in acid, which eats into the lines; it is then heated to remove the resin and finally inked and printed on paper. (2) The technique itself is also called etching.

EUCHARIST. (1) The sacrament of Holy Communion, the celebration in commemoration of the Last Supper. (2) The consecrated bread and wine used in the ceremony.

EVANGELISTS. Matthew, Mark, Luke, and John, traditionally thought to be the authors of the Gospels, the first four books of the New Testament, which recount the life and death of Christ. They are usually shown with their symbols, which are probably derived from the four beasts surrounding the throne of the Lamb in the Book of Revelation or from those in the vision of Ezekial: a winged man or angel for Matthew, a winged lion for Mark, a winged ox for Luke, and an eagle for John. These symbols may also represent the evangelists.

FACADE. The principle face or the front of a building.

FAIENCE. (1) A glass paste fired to a shiny opaque finish, used in Egypt and the Aegean. (2) A type of earthenware that is covered with a colorful opaque glaze and is often decorated with elaborate designs.

FATHERS OF THE CHURCH. Early teachers and defenders of the Christian faith. Those most frequently represented are the four Latin fathers: St. Jerome, St. Ambrose, and St. Augustine, all of the 4th century, and St. Gregory of the 6th.

FERROCONCRETE. See *reinforced concrete*.

FERROVITREOUS. In 19th-century architecture, the combining of iron (and later steel) with glass in the construction of large buildings (e.g., railway stations, exhibition halls, etc.).

FIBULA. A clasp, buckle, or brooch, often ornamented.

FILIGREE. Delicate decorative work made of intertwining wires.

FINIAL. A relatively small, decorative element terminating in a gable, pinnacle, or the like.

FLAMBOYANT GOTHIC. A style of Late Gothic architecture in which the bar tracery supporting the strained glass windows is formed into elaborate pointed, often flamelike, shapes.

FLUTING. In architecture, the ornamental grooves channeled vertically into the shaft of a column or *pilaster*. They may meet in a sharp edge, as in the Doric style, or be separated by a narrow strip or fillet, as in the Ionic, Corinthian, and composite styles.

FLYING BUTTRESS. An arch or series of arches on the exterior of a building, connecting the building to detached pier buttresses so that the thrust from the roof vaults is offset.

FOLIO. A leaf of a manuscript or a book, identified so that the front and the back have the same number, the front being labeled *recto* and the back *verso*.

FONT. (1) In printing, a complete set of type in which the letters and numbers follow a consistent design and style. (2) The stone or metal container that holds the Holy Water in a baptistry.

FORESHORTENING. A method of reducing or distorting the parts of a represented object that are not parallel to the picture plane in order to convey the impression of three dimensions as perceived by the human eye.

FORMALISM. The emphasis in art on form; i.e, on line, shape, color, composition, etc. rather than on subject matter. Hence, art from any era may be judged on the basis of its formal elements alone.

FORUM (pl. **FORA**). In an ancient Roman city, the main public square, which was a public gathering place and the center of judicial and business activity.

FOUR-IWAN MOSQUE. A mosque with a rectangular interior courtyard designed with a large vaulted chamber or recess open to the courtyard on each side.

FRANCISCAN ORDER. Founded as a mendicant order by St. Francis of Assisi (Giovanni de Bernardone, ca. 1181–1226). The order's monks aimed to imitate the life of Christ in its poverty and humility, to preach, and to minister to the spiritual needs of the poor.

FRESCO. Italian word for "fresh." Fresco is the technique of painting on plaster with pigments ground in water so that the paint is absorbed by the plaster and becomes part of the wall itself. *Buon fresco* is the technique of painting on wet plaster; *fresco secco* is the technique of painting on dry plaster.

FRIEZE. (1) A continuous band of painted or sculptured decoration. (2) In a Classical building, the part of the entablature between the architrave and the cornice. A Doric frieze consists of alternating triglyphs and metopes, the latter often sculptured. An Ionic frieze is usually decorated with continuous relief sculpture.

FRONTALITY. Representation of a subject in a full frontal view.

FROTTAGE. The technique of rubbing a drawing medium, such as a crayon, over paper that is placed over a textured surface in order to transfer the underlying pattern to the paper.

GABLE. (1) The triangular area framed by the cornice or eaves of a building and the sloping sides of a pitched roof. In Classical architecture, it is called a *pediment*. (2) A decorative element of similar shape, such as the triangular structures above the portals of a Gothic church and sometimes at the top of a Gothic picture frame.

GALLERY. A second story placed over the side aisles of a church and below the clerestory. In a church with a four-part elevation, it is placed below the triforium and above the nave arcade.

GENIUS. A winged semi-nude figure, often purely decorative but frequently personifying an abstract concept or representing the guardian spirit of a person or place.

GENRE. The French word for "kind" or "sort." In art, a genre scene is a work of art, usually a painting, depicting a scene from everyday, ordinary life.

GEOMETRIC ARABESQUE. Complex patterns and designs usually composed of polygonal geometric forms, rather than organic flowing shapes; often used as ornamentation in Islamic art.

GESSO. A smooth mixture of ground chalk or plaster and glue used as the basis for tempera painting and for oil painting on panel.

GESTURE PAINTING. A technique in painting and drawing where the actual physical movement of the artist is reflected in the brush stroke or line as it is seen in the artwork. The artist Jackson Pollock is particularly associated with this technique.

GIGANTOMACHY. From Greek mythology, the battle of the gods and the giants.

GILDING. (1) A coat of gold or of a gold-colored substance that is applied mechanically or chemically to surfaces of a painting, sculpture, or architectural decoration. (2) The process of applying this material.

GIORNATA. Because fresco painting dries quickly, artists apply only as much wet plaster on the wall as can be painted in one day. That amount of work is called the *giornata*, from the Italian word *giorno*, meaning "day." So, *giornata* means "one day's work."

GISANT. In a tomb sculpture, a recumbent effigy or representation of the deceased. At times, the gisant may be represented in a state of decay.

GLAZE. (1) A thin layer of translucent oil color applied to a painted surface or to parts of it in order to modify the tone. (2) A glassy coating applied to a piece of ceramic work before firing in the kiln as a protective seal and often as decoration.

GLAZED BRICK. Brick that is baked in a kiln after being painted.

GLORIOLE (or **GLORY**). The circle of radiant light around the heads or figures of God, Christ, the Virgin Mary, or a saint. When it surrounds the head only, it is called a *halo* or *nimbus*; when it surrounds the entire figure with a large oval, it is called a *mandorla* (the Italian word for "almond"). It indicates divinity or holiness, though originally it was placed around the heads of kings and gods as a mark of distinction.

GOLD LEAF. (1) Gold beaten into very thin sheets or "leaves" and applied to illuminated manuscripts and panel paintings, to sculpture, or to the back of the glass tesserae used in mosaics. (2) *Silver leaf* is also used, though ultimately it tarnishes. Sometimes called gold foil, silver foil.

GOLGOTHA. From the word in Aramaic meaning "skull," Golgotha is the hill outside Jerusalem where the Crucifixtion of Jesus Christ took place; it is also known as Calvary. See *Calvary*.

GORGON. In Greek mythology, one of three hideous female monsters with large heads and snakes for hair. Their glance turned men to stone. Medusa, the most famous of the Gorgons, was killed by Perseus only with help from the gods.

GOSPEL. (1) The first four books of the New Testament. They tell the story of Christ's life and death and are ascribed to the evangelists Matthew, Mark, Luke, and John. (2) A copy of these, usually called a Gospel Book, often richly illuminated.

GRANULATION. A technique of decoration in which metal granules, or tiny metal balls, are fused to a metal surface.

GRATTAGE. A technique in painting whereby an image is produced by scraping off paint from a canvas that has been placed over a textured surface.

GREEK CROSS. A cross with four arms of equal length arranged at right angles.

GREEK-CROSS CHURCH. A church designed using the shape of an equal-armed Greek cross; it has a central room with four equally sized rooms extending outward from the main room.

GRISAILLE. A monochrome drawing or painting in which only values of black, gray, and white are used.

GRISAILLE GLASS. White glass painted with gray designs.

GROIN VAULT. A vault formed by the intersection of two barrel vaults at right angles to each other. A groin is the ridge resulting from the intersection of two vaults.

GROUND-LINE. The line, actual or implied, on which figures stand.

GROUND PLAN. An architectural drawing presenting a building as if cut horizontally at the floor level. Also called a *plan*.

GUTTAE. In a Doric entablature, small peglike projections above the frieze; possibly derived from pegs originally used in wooden construction.

HALL CHURCH. See *hallenkirche*.

HALLENKIRCHE. German word for "hall church." A church in which the nave and the side aisles are of the same height. The type was developed in Romanesque architecture and occurs especially frequently in German Gothic churches.

HALO. In painting, the circle or partial circle of light depicted surrounding the head of a saint, angel, or diety to indicate a holy or sacred nature; most common in medieval paintings but also seen in more modern artwork. Also called a *nimbus*.

HAPPENING. A type of art that involves visual images, audience participation, and improvised performance, usually in a public setting and under the loose direction of an artist.

HATAIJI STYLE. Meaning literally "of Cathay" or "Chinese"; used in Ottoman Turkish art to describe an artistic pattern consisting of stylized lotus blossoms, other flowers, and sinuous leaves on curving stems.

HATCHING. A series of parallel lines used as shading in prints and drawings. When two sets of crossing parallel lines are used, it is called *crosshatching*.

HERALDIC COMPOSITION. A design that is symmetrical around a central axis.

HIERATIC SCALE. An artistic technique in which the importance of figures is indicated by size, so that the most important figure is depicted as the largest.

HIEROGLYPH. A symbol, often based on a figure, animal, or object, standing for a word, syllable, or sound. These symbols form the early Egyptian writing system, and are found on ancient Egyptian monuments as well as in Egyptian written records.

HIGH RELIEF. See *relief*.

HÔTEL. French word for "hotel" but used also to designate an elegant town house.

HOUSE CHURCH. A place for private worship within a house; the first Christian churches were located in private homes that were modified for religious ceremonies.

HUMANISM. A philosophy emphasizing the worth of the individual, the rational abilities of humankind, and the human potential for good. During the Italian Renaissance, humanism was part of a movement that encouraged study of the classical cultures of Greece and Rome; often it came into conflict with the doctrines of the Catholic church.

HYPOSTYLE. A hall whose roof is supported by columns.

ICON. From the Greek word for "image." A panel painting of one or more sacred personages, such as Christ, the Virgin, or a saint, particularly venerated in the Orthodox Christian church.

ICONOCLASM. The doctrine of the Christian church in the 8th and 9th centuries that forbade the worship or production of religious images. This doctrine led to the destruction of many works of art. The iconoclastic controversy over the validity of this doctrine led to a division of the church. Protestant churches of the 16th and 17th centuries also practiced iconoclasm.

ICONOGRAPHY. (1) The depicting of images in art in order to convey certain meanings. (2) The study of the meaning of images depicted in art, whether they be inanimate objects, events, or personages. (3) The content or subject matter of a work of art.

ILLUSIONISM. In artistic terms, the technique of manipulating pictorial or other means in order to cause the eye to perceive a particular reality. May be used in architecture and sculpture, as well as in painting.

IMPASTO. From the Italian word meaning "to make into a paste"; it describes paint, usually oil paint, applied very thickly.

IN ANTIS. An architectural term that indicates the position of the columns on a Greek or Roman building when those columns are set between the junction of two walls.

INCISION. A cut made into a hard material with a sharp instrument.

INLAID NIELLO. See *niello*.

INSULA (pl. **INSULA**). Latin word for "island." (1) An ancient Roman city block. (2) A Roman "apartment house": a concrete and brick building or chain of buildings around a central court, up to five stories high. The ground floor had shops, and above were living quarters.

INTAGLIO. A printing technique in which the design is formed from ink-filled lines cut into a surface. Engraving, etching, and drypoint are examples of intaglio.

INTONACO. The layer of smooth plaster on which paint is applied in fresco painting.

IONIC STYLE. A style of Classical Greek architecture that is characterized in part by columns that have fluted shafts, capitals with volutes (scrolls), and a base; a continuous frieze is also characteristic.

IWAN. A vaulted chamber in a mosque or other Islamic structure, open on one side and usually opening onto an interior courtyard.

JAMBS. The vertical sides of an opening. In Romanesque and Gothic churches, the jambs of doors and windows are often cut on a slant outward, or "splayed," thus providing a broader surface for sculptural decoration.

JAPONISME. In 19th-century French and American art, a style of painting and drawing that reflected the influence of the Japanese artworks, particularly prints, that were then reaching the West.

JESUIT ORDER. The "Society of Jesus" was founded in 1534 by Ignatius of Loyola (1491–1556) and was especially devoted to the service of the pope. The order was a powerful influence in the struggle of the Catholic Counter-Reformation with the Protestant Reformation and was also very important for its missionary work, disseminating Christianity in the Far East and the New World. The mother church in Rome, Il Gesù, conforms in design to the preaching aims of the new order.

KEEP. (1) The innermost and strongest structure or central tower of a medieval castle, sometimes used as living quarters, as well as for defense. Also called a donjon. (2) A fortified medieval castle.

KEYSTONE. The highest central stone or voussoir in an arch; it is the final stone to be put in place, and its weight holds the arch together.

KITSCH. A German word for "trash," in English *kitsch* has come to describe a sensibility that is vulgar and sentimental, in contrast to the refinement of "high" art or fine art.

KORE (pl. **KORAI**). Greek word for "maiden." An Archaic Greek statue of a standing, draped female.

KOUROS (pl. **KOUROI**). Greek word for "male youth." An Archaic Greek statue of a standing, nude youth.

KRATER. A Greek vessel, of assorted shapes, in which wine and water are mixed. A *calyx krater* is a bell-shaped vessel with handles near the base; a *volute krater* is a vessel with handles shaped like scrolls.

KUFIC. One of the first general forms of Arabic script to be developed, distinguished by its angularity; distinctive variants occur in various parts of the Islamic worlds.

KUNSTKAMMEN (German, pl. **KUNSTKAMMERN**; in Dutch, **KUNSTKAMER**). Literally this is a room of art. Developed in the 16th century, it is a forerunner of the museum—a display of paintings and objects of natural history (shells, bones, etc.) that formed an encyclopedic collection.

KYLIX. In Greek and Roman antiquity, a shallow drinking cup with two horizontal handles, often set on a stem terminating in a foot.

LABORS OF THE MONTHS. The various occupations suitable to the months of the year. Scenes or figures illustrating these were frequently represented in illuminated manuscripts. Sometimes scenes of the labors of the months were combined with signs of the zodiac.

LAMASSU. An ancient Near Eastern guardian of a palace; often shown in sculpture as a human-headed bull or lion with wings.

LANCET. A tall, pointed window common in Gothic architecture.

LANDSCAPE. A drawing or painting in which an outdoor scene of nature is the primary subject.

LANTERN. A relatively small structure crowning a dome, roof, or tower, frequently open to admit light to an enclosed area below.

LAPITH. A member of a mythical Greek tribe that defeated the Centaurs in a battle, scenes from which are frequently represented in vase painting and sculpture.

LATIN CROSS. A cross in which three arms are of equal length and one arm is longer.

LAY BROTHER. One who has joined a monastic order but has not taken monastic vows and therefore belongs still to the people or laity, as distinguished from the clergy or religious.

LEKYTHOS (pl. **LEKYTHOI**). A Greek oil jug with an ellipsoidal body, a narrow neck, a flanged mouth, a curved handle extending from below the lip to the shoulder, and a narrow base terminating in a foot. It was used chiefly for ointments and funerary offerings.

LIBERAL ARTS. Traditionally thought to go back to Plato, they comprised the intellectual disciplines considered suitable or necessary to a complete education and included grammar, rhetoric, logic, arithmetic, music, geometry, and astronomy. During the Middle Ages and the Renaissance, they were often represented allegorically in paintings, engravings, and sculpture.

LINTEL. In architecture, a horizontal beam of any material that is held up by two vertical supports.

LITHOGRAPH. A print made by drawing a design with an oily crayon or other greasy substance on a porous stone or, later, a metal plate; the design is then fixed, the entire surface is moistened, and the printing ink that is applied adheres only to the oily lines of the drawing. The design can then be transferred easily in a press to a piece of paper. The technique was invented ca. 1796 by Aloys Senefelder and quickly became popular. It is also widely used commercially, since many impressions can be taken from a single plate.

LOGGIA. A covered gallery or arcade open to the air on at least one side. It may stand alone or be part of a building.

LONGITUDINAL SECTION. A cross section of a building or other object that shows the lengthwise structure. See *cross section*.

LOUVERS. A series of overlapping boards or slats that can be opened to admit air but are slanted so as to exclude sun and rain.

LOW RELIEF. See *relief*.

LUNETTE. (1) A semicircular or pointed wall area, as under a vault, or above a door or window. When it is above the portal of a medieval church, it is called a *tympanum*. (2) A painting, relief sculpture, or window of the same shape.

MADRASA. An Islamic religious college.

MAESTÀ. Italian word for "majesty," applied in the 14th and 15th centuries to representations of the Madonna and Child enthroned and surrounded by her celestial court of saints and angels.

MAGICO-RELIGIOUS. In art, subject matter that deals with the supernatural and often has the purpose of invoking those powers to achieve human ends, e.g., prehistoric cave paintings used to ensure a successful hunt.

MAGUS (pl. **MAGI**). (1) A member of the priestly caste of ancient Media and Persia. (2) In Christian literature, one of the three Wise Men or Kings who came from the East bearing gifts to the newborn Jesus.

MANDORLA. A representation of light surrounding the body of a holy figure.

MANIERA. In painting, the "Greek style" of the 13th century that demonstrated both Italian and Byzantine influences.

MANUSCRIPT ILLUMINATION. Decoration of handwritten documents, scrolls, or books with drawings or paintings. Illuminated manuscripts were often produced during the Middle Ages.

MAQSURA. A screened enclosure, reserved for the ruler, often located before the *mihrab* in certain important royal Islamic mosques.

MARTYRIUM (pl. **MARTYRIA**). A church, chapel, or shrine built over the grave of a Christian martyr or at the site of an important miracle.

MASTABA. An ancient Egyptian tomb, rectangular in shape, with sloping sides and a flat roof. It covered a chapel for offerings and a shaft to the burial chamber.

MATRIX. (1) A mold or die used for shaping a ceramic object before casting. (2) In printmaking, any surface on which an image is incised, carved, or applied and from which a print may be pulled.

MAUSOLEUM. (1) The huge tomb erected at Halikarnassos in Asia Minor in the 4th century BCE by King Mausolos and his wife Artemisia. (2) A generic term for any large funerary monument.

MEANDER. A decorative motif of intricate, rectilinear character applied to architecture and sculpture.

MEDIUM (pl. **MEDIUMS**). (1) The material or technique in which an artist works. (2) The vehicle in which pigments are carried in paint, pastel, etc.

MEGALITH. From the Greek *mega*, meaning "big," and *lithos*, meaning "stone." A huge stone such as those used in cromlechs and dolmens.

MEGARON (pl. **MEGARONS** or **MEGARA**). From the Greek word for "large." The central audience hall in a Minoan or Mycenaean palace or home.

MENHIR. A megalithic upright slab of stone, sometimes placed in rows by prehistoric peoples.

MESOLITHIC. Transitional period of the Stone Age between the Paleolithic and the Neolithic.

METOPE. The element of a Doric frieze between two consecutive triglyphs, sometimes left plain but often decorated with paint or relief sculpture.

MIHRAB. A niche, often highly decorated, usually found in the center of the *qibla* wall of a mosque, indicating the direction of prayer toward Mecca.

MINARET. A tower on or near a mosque, varying extensively in form throughout the Islamic world, from which the faithful are called to prayer five times a day.

MINBAR. A type of staircase pulpit, found in more important mosques to the right of the mihrab, from which the Sabbath sermon is given on Fridays after the noonday prayer.

MINIATURE. (1) A single illustration in an illuminated manuscript. (2) A very small painting, especially a portrait on ivory, glass, or metal.

MINOTAUR. In Greek mythology, a monster having the head of a bull and the body of a man who lived in the Labyrinth of the palace of Knossos on Crete.

MODEL. (1) The preliminary form of a sculpture, often finished in itself but preceding the final casting or carving. (2) Preliminary or reconstructed form of a building made to scale. (3) A person who poses for an artist.

MODELING. (1) In sculpture, the building up of a figure or design in a soft substance such as clay or wax. (2) In painting and drawing, producing a three-dimensional effect by changes in color, the use of light and shade, etc.

MODULE. (1) A segment of a pattern. (2) A basic unit, such as the measure of an architectural member. Multiples of the basic unit are used to determine proportionate construction of other parts of a building.

MOLDING. In architecture, any of various long, narrow, ornamental bands having a distinctive profile that project from the surface of the structure and give variety to the surface by means of their patterned contrasts of light and shade.

MONASTIC ORDER. A religious society whose members live together under an established set of rules.

MONOTYPE. A unique print made from a copper plate or other type of plate from which no other copies of the artwork are made.

MOSAIC. Decorative work for walls, vaults, ceilings, or floors composed of small pieces of colored materials, called *tesserae*, set in plaster or concrete. Romans, whose work was mostly for floors, used shaped pieces of colored stone. Early Christians used pieces of glass with brilliant hues, including gold, and slightly irregular surfaces, producing an entirely different glittering effect.

MOSQUE. A building used as a center for community prayers in Islamic worship; it often serves other functions including religious education and public assembly.

MOTIF. A visual theme, a motif may appear numerous times in a single work of art.

MOZARAB. Term used for the Spanish Christian culture of the Middle Ages that developed while Muslims were the dominant culture and political power on the Iberian peninsula.

MUQARNAS. A distinctive type of Islamic decoration consisting of multiple nichelike forms usually arranged in superimposed rows, often used in zones of architectural transition.

MURAL. From the Latin word for wall, *murus*. A large painting or decoration either executed directly on a wall (fresco) or done separately and affixed to it.

MUSES. In Greek mythology, the nine goddesses who presided over various arts and sciences. They are led by Apollo as god of music and poetry and usually include Calliope, muse of epic poetry; Clio, muse of history; Erato, muse of love poetry; Euterpe, muse of music; Melpomene, muse of tragedy; Polyhymnia, muse of sacred music; Terpsichore, muse of dancing; Thalia, muse of comedy; and Urania, muse of astronomy.

MUTULES. A feature of Doric architecture, mutules are flat rectangular blocks found just under the cornice.

NAOS. See *cella*.

NARTHEX. The transverse entrance hall of a church, sometimes enclosed but often open on one side to a preceding atrium.

NATURALISM. A style of art that aims to depict the natural world as it appears.

NAVE. (1) The central aisle of a Roman basilica, as distinguished from the side aisles. (2) The same section of a Christian basilican church extending from the entrance to the apse or transept.

NECROPOLIS. Greek for "city of the dead." A burial ground or cemetery.

NEOLITHIC. The New Stone Age, thought to have begun ca. 9000–8000 BCE. The first society to live in settled communities, to domesticate animals, and to cultivate crops, it saw the beginning of many new skills, such as spinning, weaving, and building.

NEW STONE AGE. See *neolithic*.

NIELLO. Dark metal alloys applied to the engraved lines in a precious metal plate (usually made of gold or silver) to create a design.

NIKE. The ancient Greek goddess of victory, often identified with Athena and by the Romans with Victoria. She is usually represented as a winged woman with windblown draperies.

NIMBUS. See *halo*.

NOCTURNE. A painting that depicts a nighttime scene, often emphasizing the effects of artificial light.

NONOBJECTIVE PAINTING. In Abstract art, the style of painting that does not strive to represent objects, including people, as they would appear in everyday life or in the natural world.

OBELISK. A tall, tapering, four-sided stone shaft with a pyramidal top. First constructed as *megaliths* in ancient Egypt, certain examples have since been exported to other countries.

OCULUS. The Latin word for "eye." (1) A circular opening at the top of a dome used to admit light. (2) A round window.

ODALISQUE. Turkish word for "harem slave girl" or "concubine."

OIL PAINTING. (1) A painting executed with pigments mixed with oil, first applied to a panel prepared with a coat of gesso (as also in tempera painting), and later to a stretched canvas primed with a coat of white paint and glue. The latter method has predominated since the late 15th century. Oil painting also may be executed on paper, parchment, copper, etc. (2) The technique of executing such a painting.

OIL SKETCH. A work in oil painting of an informal character, sometimes preparatory to a finished work.

OLD STONE AGE. See *paleolithic*.

OPTICAL IMAGES. An image created from what the eye sees, rather than from memory.

ORANT. A standing figure with arms upraised in a gesture of prayer.

ORCHESTRA. (1) In an ancient Greek theater, the round space in front of the stage and below the tiers of seats, reserved for the chorus. (2) In a Roman theater, a similar space reserved for important guests.

ORTHODOX. From the Greek word for "right in opinion." The Eastern Orthodox church, which broke with the Western Catholic church during the 5th century CE and transferred its allegiance from the pope in Rome to the Byzantine emperor in Constantinople and his appointed patriarch. Sometimes called the Byzantine church.

ORTHOGONAL. In a perspective construction, an imagined line in a painting that runs perpendicular to the picture plane and recedes to a vanishing point.

ORTHOSTATS. Upright slabs of stone constituting or lining the lowest courses of a wall, often in order to protect a vulnerable material such as mud-brick.

PALAZZO (pl. **PALAZZI**). Italian word for "palace" (in French, palais). Refers either to large official buildings or to important private town houses.

PALEOLITHIC. The Old Stone Age, usually divided into Lower, Middle, and Upper (which began about 35,000 BCE). A society of nomadic hunters who used stone implements, later developing ones of bone and flint. Some lived in caves, which they decorated during the latter stages of the age, at which time they also produced small carvings in bone, horn, and stone.

PALETTE. (1) A thin, usually oval or oblong board with a thumbhole at one end, used by painters to hold and mix their colors. (2) The range of colors used by a particular painter. (3) In Egyptian art, a slate slab, usually decorated with sculpture in low relief. The small ones with a recessed circular area on one side are thought to have been used for eye makeup. The larger ones were commemorative objects.

PANEL. (1) A wooden surface used for painting, usually in tempera, and prepared beforehand with a layer of gesso. Large altarpieces require the joining together of two or more boards. (2) Recently, panels of Masonite or other composite materials have come into use.

PANTHEON. From *pan*, Greek for "all," and *theos*, Greek for "god." A Hellenistic Greek or Roman temple dedicated to all of the gods; in later years, often housing tombs or memorials for the illustrious dead of a nation.

PANTOCRATOR. A representation of Christ as ruler of the universe that appears frequently in the dome or apse mosaics of Byzantine churches.

PAPYRUS. (1) A tall aquatic plant that grows abundantly in the Near East, Egypt, and Abyssinia. (2) A paperlike material made by laying together thin strips of the pith of this plant and then soaking, pressing, and drying the whole. The resultant sheets were used as writing material by the ancient Egyptians, Greeks, and Romans. (3) An ancient document or scroll written on this material.

PARCHMENT. From Pergamon, the name of a Greek city in Asia Minor where parchment was invented in the 2nd century BCE. (1) A paperlike material made from bleached animal hides used extensively in the Middle Ages for manuscripts. Vellum is a superior type of parchment made from calfskin. (2) A document or miniature on this material.

PASSION. (1) In ecclesiastic terms, the events of Jesus' last week on earth. (2) The representation of these events in pictorial, literary, theatrical, or musical form.

PASTEL. (1) A soft, subdued shade of color. (2) A drawing stick made from pigments ground with chalk and mixed with gum water. (3) A drawing executed with these sticks.

PEDESTAL. An architectural support for a statue, vase, column, etc.

PEDIMENT. (1) In Classical architecture, a low gable, typically triangular, framed by a horizontal cornice below and two raking cornices above; frequently filled with sculpture. (2) A similar architectural member used over a door, window, or niche. When pieces of the cornice are either turned at an angle or interrupted, it is called a *broken pediment*.

PELIKE. A Greek storage jar with two handles, a wide mouth, little or no neck, and resting on a foot.

PENDENTIVE. One of the concave triangles that achieves the transition from a square or polygonal opening to the round base of a dome or the supporting drum.

PERFORMANCE ART. A type of art in which performance by actors or artists, often interacting with the audience in an improvisational manner, is the primary aim over a certain time period. These artworks are transitory, perhaps with only a photographic record of some of the events.

PERIPTERAL. An adjective describing a building surrounded by a single row of columns or colonnade.

PERISTYLE. (1) In a Roman house or *domus*, an open garden court surrounded by a colonnade. (2) A colonnade around a building or court.

PERPENDICULAR STYLE. The third style of English Gothic architecture, in which the bar tracery uses predominantly vertical lines. The fan vault is also used extensively in this style.

PERSPECTIVE. A system for representing spatial relationships and three-dimensional objects on a flat two-dimensional surface so as to produce an effect similar to that perceived by the human eye. In *atmospheric* or *aerial* perspective, this is accomplished by a gradual decrease in the intensity of color and value and in the contrast of light and dark as objects are depicted as farther and farther away in the picture. In color artwork, as objects recede into the distance, all colors tend toward a light bluish-gray tone. In *scientific* or *linear* perspective, developed in Italy in the 15th century, a mathematical system is used based on orthogonals receding to vanishing points on the horizon. Transversals intersect the orthogonals at right angles at distances derived mathematically. Since this presupposes an absolutely stationary viewer and imposes rigid restrictions on the artist, it is seldom applied with complete consistency. Although traditionally ascribed to Brunelleschi, the first theoretical text on perspective was Leon Battista Alberti's *On Painting* (1435).

PHILOSOPHES. Philosophers and intellectuals of the Enlightenment, whose writings had an important influence upon the art of that time.

PHOTOGRAM. A shadowlike photograph made without a camera by placing objects on light-sensitive paper and exposing them to a light source.

PHOTOGRAPH. The relatively permanent or "fixed" form of an image made by light that passes through the lens of a camera and acts upon light-sensitive substances. Often called a print.

PHOTOMONTAGE. A photograph in which prints in whole or in part are combined to form a new image. A technique much practiced by the Dada group in the 1920s.

PIAZZA (pl. **PIAZZE**). Italian word for "public square" (in French, place; in German, platz).

PICTURE PLANE. The flat surface on which a picture is painted.

PICTURESQUE. Visually interesting or pleasing, as if resembling a picture.

PIER. An upright architectural support, usually rectangular and sometimes with capital and base. When columns, pilasters, or shafts are attached to it, as in many Romanesque and Gothic churches, it is called a compound pier.

PIETÀ. Italian word for both "pity" and "piety." A representation of the Virgin grieving over the dead Christ. When used in a scene recording a specific moment after the Crucifixion, it is usually called a Lamentation.

PIETRA SERENA. A limestone, gray in color, used in the Tuscany region of Italy.

PILASTER. A flat, vertical element projecting from a wall surface and normally having a base, shaft, and capital. It has generally a decorative rather than a structural purpose.

PILGRIMAGE CHOIR. The unit in a Romanesque church composed of the apse, ambulatory, and radiating chapels.

PILGRIMAGE PLAN. The general design used in Christian churches that were stops on the pilgrimage routes throughout medieval Europe, characterized by having side aisles that allowed pilgrims to ambulate around the church. See *pilgrimage choir*.

PILLAR. A general term for a vertical architectural support that includes columns, piers, and pilasters.

PILOTIS. Pillars that are constructed from *reinforced concrete* (*ferroconcrete*).

PINNACLE. A small, decorative structure capping a tower, pier, buttress, or other architectural member. It is used especially in Gothic buildings.

PLAN. See *ground plan*.

PLATE TRACERY. A style of tracery in which pierced openings in an otherwise solid wall of stonework are filled with glass.

PLEIN-AIR. Sketching outdoors, often using paints, in order to capture the immediate effects of light on landscape and other subjects. Much encouraged by the Impressionists, their *plein-air* sketches were often taken back to the studio to produce finished paintings, but many *plein-air* sketches are considered masterworks.

PODIUM. (1) The tall base upon which rests an Etruscan or Roman temple. (2) The ground floor of a building made to resemble such a base.

POLYTYCH. An altarpiece or devotional work of art made of several panels joined together, often hinged.

PORCH. General term for an exterior appendage to a building that forms a covered approach to a doorway.

PORTA. Latin word for "door" or "gate."

PORTAL. A door or gate, usually a monumental one with elaborate sculptural decoration.

PORTICO. A columned porch supporting a roof or an entablature and pediment, often approached by a

number of steps. It provides a covered entrance to a building and a connection with the space surrounding it.

POST AND LINTEL. A basic system of construction in which two or more uprights, the posts, support a horizontal member, the lintel. The lintel may be the topmost element or support a wall or roof.

POUNCING. A technique for transferring a drawing from a cartoon to a wall or other surface by pricking holes along the principal lines of the drawing and forcing fine charcoal powder through them onto the surface of the wall, thus reproducing the design on the wall.

POUSSINISTES. Those artists of the French Academy at the end of the17th century and the beginning of the 18th century who favored "drawing," which they believed appealed to the mind rather than the senses. The term derived from admiration for the French artist Nicolas Poussin. See *Rubénistes*.

PREDELLA. The base of an altarpiece, often decorated with small scenes that are related in subject to that of the main panel or panels.

PREFIGURATION. The representation of Old Testament figures and stories as forerunners and foreshadowers of those in the New Testament.

PRIMITIVISM. The appropriation of non-Western (e.g., African, tribal, Polynesian) art styles, forms, and techniques by Modern era artists as part of innovative and avant-garde artistic movements; other sources were also used, including the work of children and the mentally ill.

PRINT. A picture or design reproduced, usually on paper and often in numerous copies, from a prepared wood block, metal plate, stone slab, or photograph.

PRONAOS. In a Greek or Roman temple, an open vestibule in front of the *cella*.

PRONK. A word meaning ostentatious or sumptuous; it is used to refer to a still life of luxurious objects.

PROPYLAEUM (pl. **PROPYLAEA**). (1) The often elaborate entrance to a temple or other enclosure. (2) The monumental entry gate at the western end of the Acropolis in Athens.

PROVENANCE. The place of origin of a work of art and related information.

PSALTER. (1) The book of Psalms in the Old Testament, thought to have been written in part by David, king of ancient Israel. (2) A copy of the Psalms, sometimes arranged for liturgical or devotional use and often richly illuminated.

PULPIT. A raised platform in a church from which the clergy delivers a sermon or conducts the service. Its railing or enclosing wall may be elaborately decorated.

PUTTO (pl. **PUTTI**). A nude, male child, usually winged, often represented in classical and Renaissance art. Also called a cupid or amoretto when he carries a bow and arrow and personifies Love.

PYLON. Greek word for "gateway." (1) The monumental entrance building to an Egyptian temple or forecourt consisting either of a massive wall with sloping sides pierced by a doorway or of two such walls flanking a central gateway. (2) A tall structure at either side of a gate, bridge, or avenue marking an approach or entrance.

QIBLA. The direction toward Mecca, which Muslims face during prayer. The qibla wall in a mosque identifies this direction.

QUADRANT VAULT. A half-barrel vault designed so that instead of being semicircular in cross-section, the arch is one-quarter of a circle.

QUADRA RIPORTATE. Painted scenes depicted in panels on the curved ceiling of a vault.

QUATREFOIL. An ornamental element composed of four lobes radiating from a common center.

RADIATING CHAPELS. Term for chapels arranged around the ambulatory (and sometimes the transept) of a medieval church.

RAYONNANT. The style of Gothic architecture, described as "radiant," developed at the Parisian court of Louis IX in the mid-13th century. Also referred to as *court style*.

READYMADE. An ordinary object that, when an artist gives it a new context and title, is transformed into an art object. Readymades were important features of the Dada and Surrealism movements of the early 20th century.

RED-FIGURED. A style of ancient Greek ceramic decoration characterized by red figures against a black background. This style of decoration developed toward the end of the 6th century BCE and replaced the earlier *black-figured* style.

REFECTORY. (1) A room for refreshment. (2) The dining hall of a masonry, college, or other large institution.

REFORMATION. The religious movement in the early 16th century that had for its object the reform of the Catholic church and led to the establishment of Protestant churches.

REGISTER. A horizontal band containing decoration, such as a relief sculpture or a fresco painting. When multiple horizontal layers are used, registers are useful in distinguishing between different visual planes and different time periods in visual narration.

REINFORCED CONCRETE. Concrete that has been made stronger, particularly in terms of tensile strength, by the imbedding of steel rods or steel mesh. Introduced in France ca. 1900. Many large modern buildings are only feasible through the use of reinforced concrete.

RELIEF. (1) The projection of a figure or part of a design from the background or plane on which it is carved or modeled. Sculpture done in this manner is described as "high relief" or "low relief" depending on the height of the projection. When it is very shallow, it is called *schiacciato*, the Italian word for "flattened out." (2) The apparent projection of forms represented in a painting or drawing. (3) A category of printmaking in which lines raised from the surface are inked and printed.

RELIQUARY. A container used for storing or displaying relics.

RESPOND. (1) A half-pier, pilaster, or similar element projecting from a wall to support a lintel or an arch whose other side is supported by a free-standing column or pier, as at the end of an arcade. (2) One of several pilasters on a wall behind a colonnade that echoes or "responds to" the columns but is largely decorative. (3) One of the slender shafts of a compound pier in a medieval church that seems to carry the weight of the vault.

RHYTON. An ancient drinking or pouring vessel made from pottery, metal, or stone, and sometimes designed in a human or animal form.

RIB. A slender, projecting, archlike member that supports a vault either transversely or at the groins, thus dividing the surface into sections. In Late Gothic architecture, its purpose is often primarily ornamental.

RIBBED VAULT. A style of vault in which projecting surface arches, known as ribs, are raised along the intersections of segments of the vault. Ribs may provide architectural support as well as decoration to the vault's surface.

ROMANESQUE. (1) The style of medieval architecture from the 11th to the 13th centuries that was based upon the Roman model and that used the Roman rounded arch, thick walls for structural support, and relatively small windows. (2) Any culture or its artifacts that are "Roman-like."

ROOD SCREEN. A partition in a church on which a crucifix (rood) is mounted and that separates the public nave area from the choir. See also *choir screen*.

ROSE WINDOW. A large, circular window with stained glass and stone tracery, frequently used on facades and at the ends of transepts in Gothic churches.

ROSTRUM (pl. **ROSTRA**). (1) A beaklike projection from the prow of an ancient warship used for ramming the enemy. (2) In the Roman forum, the raised platform decorated with the beaks of captured ships from which speeches were delivered. (3) A platform, stage, or the like used for public speaking.

ROTULUS (pl. **ROTULI**). The Latin word for scroll, a rolled written text.

RUBBING. A reproduction of a relief surface made by covering it with paper and rubbing with pencil, chalk, etc. Also called frottage.

RUBÉNISTES. Those artists of the French Academy at the end of the 17th century and the beginning of the 18th century who favored "color" in painting because it appealed to the senses and was thought to be true to nature. The term derived from admiration for the work of the Flemish artist Peter Paul Rubens. See *Poussinistes*.

RUSTICATION. A masonry technique of laying rough-faced stones with sharply indented joints.

SACRA CONVERSAZIONE. Italian for "holy conversation." A composition of the Madonna and Child with saints in which the figures all occupy the same spatial setting and appear to be conversing or communing with one another.

SACRISTY. A room near the main altar of a church, or a small building attached to a church, where the vessels and vestments required for the service are kept. Also called a *vestry*.

SALON. (1) A large, elegant drawing or reception room in a palace or a private house. (2) Official government-sponsored exhibition of paintings and sculpture by living artists held at the Louvre in Paris, first biennially, then annually. (3) Any large public exhibition patterned after the Paris Salon.

SANCTUARY. (1) A sacred or holy place or building. (2) An especially holy place within a building, such as the cella of a temple or the part of a church around the altar.

SARCOPHAGUS (pl. **SARCOPHAGI**). A large coffin, generally of stone, and often decorated with sculpture or inscriptions. The term is derived from two Greek words meaning "flesh" and "eating."

SATYR. One of a class of woodland gods thought to be the lascivious companions of Dionysos, the Greek god of wine (or of Bacchus, his Roman counterpart). They are represented as having the legs and tail of a goat, the body of a man, and a head with horns and pointed ears. A youthful satyr is also called a faun.

SAZ. Meaning literally "enchanted forest," this term describes the sinuous leaves and twining stems that are a major component of the *hatayi* style under the Ottoman Turks.

SCHIACCIATO. Italian for "flattened out." Describes low relief sculpture used by Donatello and some of his contemporaries.

SCIENTIFIC PERSPECTIVE. See *perspective*.

SCRIPTORIUM (pl. **SCRIPTORIA**). A workroom in a monastery reserved for copying and illustrating manuscripts.

SCROLL. (1) An architectural ornament with the form of a partially unrolled spiral, as on the capitals of the Ionic and Corinthian orders. (2) A form of written text.

SCUOLA. Italian word for school. In Renaissance Venice it designated a fraternal organization or confraternity dedicated to good works, usually under ecclesiastic auspices.

SECCO (or *A SECCO*). See *fresco secco* under *fresco*.

SECTION. An architectural drawing presenting a building as if cut across the vertical plane at right angles to the horizontal plane. A *cross section* is a cut along the

transverse axis. A *longitudinal section* is a cut along the longitudinal axis.

SELECTIVE WIPING. The planned removal of certain areas of ink during the etching process to produce changes in value on the finished print.

SEXPARTITE VAULT. See *vault.*

SFUMATO. Italian word meaning "smoky." Used to describe very delicate gradations of light and shade in the modeling of figures. It is applied especially to the work of Leonardo da Vinci.

SGRAFFITO ORNAMENT. A decorative technique in which a design is made by scratching away the surface layer of a material to produce a form in contrasting colors.

SHAFT. In architecture, the part of a column between the base and the capital.

SIBYLS. In Greek and Roman mythology, any of numerous women who were thought to possess powers of divination and prophecy. They appear on Christian representations, notably in Michelangelo's Sistine ceiling, because they were believed to have foretold the coming of Christ.

SIDE AISLE. A passageway running parallel to the nave of a Roman basilica or Christian church, separated from it by an arcade or colonnade. There may be one on either side of the nave or two, an inner and outer.

SILENI. A class of minor woodland gods in the entourage of the wine god, Dionysos (or Bacchus). Like Silenus, the wine god's tutor and drinking companion, they are thick-lipped and snub-nosed and fond of wine. Similar to satyrs, they are basically human in form except for having horses' tails and ears.

SILKSCREEN PRINTING. A technique of printing in which paint or ink is pressed through a stencil and specially prepared cloth to produce a previously designed image. Also called serigraphy.

SILVER LEAF. See *gold leaf.*

SILVERPOINT. A drawing instrument (stylus) of the 14th and 15th centuries made from silver; it produced a fine line and maintained a sharp point.

SILVER SALTS. Compounds of silver—bromide, chloride, and iodide—that are sensitive to light and are used in the preparation of photographic materials. This sensitivity was first observed by Johann Heinrich Schulze in 1725.

SINOPIA (pl. *SINOPIE*). Italian word taken from "Sinope," the ancient city in Asia Minor that was famous for its brick-red pigment. In fresco paintings, a full-sized, preliminary sketch done in this color on the first rough coat of plaster or *arriccio.*

SITE-SPECIFIC ART. Art that is produced in only one location, a location that is an integral part of the work and essential to its production and meaning.

SKETCH. A drawing, painting, or other artwork usually done quickly, as an aid to understanding and developing artistic skills; sometimes a sketch may lead to a more finished work of art.

SOCLE. A portion of the foundation of a building that projects outward as a base for a column or some other device.

SPANDREL. The area between the exterior curves of two adjoining arches or, in the case of a single arch, the area around its outside curve from its springing to its keystone.

SPHINX. (1) In ancient Egypt, a creature having the head of a man, animal, or bird and the body of a lion; frequently sculpted in monumental form. (2) In Greek mythology, a creature usually represented as having the head and breasts of a woman, the body of a lion, and the wings of an eagle. It appears in classical, Renaissance, and Neoclassical art.

SPIRE. A tall tower that rises high above a roof. Spires are commonly associated with church architecture and are frequently found on Gothic structures.

SPOLIA. Latin for "hide stripped from an animal." Term used for (1) spoils of war and (2) fragments of architecture or sculpture reused in a secondary context.

SPRINGING. The part of an arch in contact with its base.

SQUINCHES. Arches set diagonally at the corners of a square or rectangle to establish a transition to the round shape of the dome above.

STANZA (pl. **STANZE**). Italian word for "room."

STEEL. Iron modified chemically to have qualities of great hardness, elasticity, and strength.

STELE. From the Greek word for "standing block." An upright stone slab or pillar, sometimes with a carved design or inscription.

STEREOBATE. The substructure of a Classical building, especially a Greek temple.

STEREOSCOPE. An optical instrument that enables the user to combine two photographs taken from points of view corresponding to those of the two eyes. The combined single image has the depth and solidity of ordinary binocular vision. First demonstrated by Sir Charles Wheatstone in 1838.

STILL LIFE. A term used to describe paintings (and sometimes sculpture) that depict familiar objects such as household items and food.

STILTS. Term for pillars or posts supporting a superstructure; in 20th-century architecture, these are usually of ferroconcrete. Stilted, as in stilted arches, refers to tall supports beneath an architectural member.

STOA. In Greek architecture, a covered colonnade, sometimes detached and of considerable length, used as a meeting place or promenade.

STOIC. A member of a school of philosophy founded by Zeno about 300 BCE and named after the stoa in Athens where he taught. Its main thesis is that man should be free of all passions.

STRUCTURAL STEEL. Steel used as an architectural building material either invisibly or exposed.

STUCCO. (1) A concrete or cement used to coat the walls of a building. (2) A kind of plaster used for architectural decorations, such as cornices and moldings, or for sculptured reliefs.

STUDY. A preparatory sketch, drawing, painting, or other artwork that is used by an artist to explore artistic possibilities and solve problems before a more finished work is attempted. Often studies come to be regarded as finished works of art.

STYLOBATE. A platform or masonry floor above the stereobate forming the foundation for the columns of a Greek temple.

STYLUS. From the Latin word "stilus", the writing instrument of the Romans. (1) A pointed instrument used in ancient times for writing on tablets of a soft material such as clay. (2) The needlelike instrument used in drypoint or etching.

SUBLIME. In 19th-century art, the ideal and goal that art should inspire awe in a viewer and engender feelings of high religious, moral, ethical, and intellectual purpose.

SUNKEN RELIEF. Relief sculpture in which the figures or designs are modeled beneath the surface of the stone, within a sharp outline.

SUPERIMPOSED ORDERS. Two or more rows of columns, piers, or pilasters placed above each other on the wall of a building.

SYMPOSIUM. In ancient Greece, a gathering, sometimes of intellectuals and philosophers to discuss ideas, often in an informal social setting, such as at a dinner party.

TABERNACLE. (1) A place or house of worship. (2) A canopied niche or recess built for an image. (3) The portable shrine used by the ancient Jews to house the Ark of the Covenant.

TABLEAU VIVANT. A scene, usually derived from myth, the Bible, or literary sources, that is depicted by people standing motionless in costumes on a stage set.

TABLINUM. The Latin word meaning "writing tablet" or "written record." In a Roman house, a room at the far end of the atrium, or between the atrium and the second courtyard, used for keeping family records.

TEMPERA PAINTING. (1) A painting made with pigments mixed with egg yolk and water. In the 14th and 15th centuries, it was applied to panels that had been prepared with a coating of gesso; the application of gold leaf and of *underpainting* in green or brown preceded the actual tempera painting. (2) The technique of executing such a painting.

TENEBRISM. The intense contrast of light and dark in painting.

TERRA COTTA. Italian word for "baked earth." (1) Earthenware, naturally reddish-brown but often glazed in various colors and fired. Used for pottery, sculpture, or as a building material or decoration. (2) An object made of this material. (3) Color of the natural material.

TESSERA (pl. **TESSERAE**). A small piece of colored stone, marble, glass, or gold-backed glass used in a mosaic.

THEATER. In ancient Greece, an outdoor place for dramatic performances, usually semicircular in plan and provided with tiers of seats, the orchestra, and a support for scenery.

THEATINE ORDER. Founded in Rome in the 16th century by members of the recently dissolved Oratory of Divine Love. Its aim was to reform the Catholic church, and its members pledged to cultivate their spiritual lives and to perform charitable works.

THERMAE. A public bathing establishment of the ancient Romans that consisted of various types of baths and social gymnastic facilities.

THOLOS. A building with a circular plan, often with a sacred nature.

THRUST. The lateral pressure exerted by an arch, vault, or dome that must be counteracted at its point of greatest concentration either by the thickness of the wall or by some form of buttress.

TONDO. A circular painting or relief sculpture.

TRACERY. (1) Ornamental stonework in Gothic windows. In the earlier or plate tracery, the windows appear to have been cut through the solid stone. In bar tracery, the glass predominates, the slender pieces of stone having been added within the windows. (2) Similar ornamentation using various materials and applied to walls, shrines, façades, etc.

TRANSEPT. A cross arm in a basilican church placed at right angles to the nave and usually separating it from the choir or apse.

TRANSVERSALS. In a perspective construction, transversals are the lines parallel to the picture plane (horizontally) that denote distances. They intersect orthogonals to make a grid that guides the arrangement of elements to suggest space.

TREE OF KNOWLEDGE. The tree in the Garden of Eden from which Adam and Eve ate the forbidden fruit that destroyed their innocence.

TREE OF LIFE. A tree in the Garden of Eden whose fruit was reputed to give everlasting life; in medieval art it was frequently used as a symbol of Christ.

TRIBUNE. A platform or walkway in a church constructed overlooking the *aisle* and above the *nave.*

TRIFORIUM. The section of a nave wall above the arcade and below the clerestory. It frequently consists of a blind arcade with three openings in each bay. When the gallery is also present, a four-story elevation results, the triforium being between the gallery and clerestory. It may also occur in the transept and the choir walls.

TRIGLYPH. The element of a Doric frieze separating two consecutive metopes and divided by grooves into three sections.

TRIPTYCH. An altarpiece or devotional picture, either carved or painted, with one central panel and two hinged wings.

TRIUMPHAL ARCH. (1) A monumental arch, sometimes a combination of three arches, erected by a Roman emperor in commemoration of his military exploits and usually decorated with scenes of these deeds in relief sculpture. (2) The great transverse arch at the eastern end of a church that frames altar and apse and separates them from the main body of the church. It is frequently decorated with mosaics or mural paintings.

TROIS CRAYONS. The use of three colors, usually red, black, and white, in a drawing; a technique popular in the 17th and 18th centuries.

TROMPE L'OEIL. Meaning "trick of the eye" in French, it is a work of art designed to deceive a viewer into believing that the work of art is reality, an actual three-dimensional object or scene in space.

TROPHY. (1) In ancient Rome, arms or other spoils taken from a defeated enemy and publicly displayed on a tree, pillar, etc. (2) A representation of these objects, and others symbolic of victory, as a commemoration or decoration.

TRUMEAU. A central post supporting the lintel of a large doorway, as in a Romanesque or Gothic portal, where it is frequently decorated with sculpture.

TRUSS. A triangular wooden or metal support for a roof that may be left exposed in the interior or be covered by a ceiling.

TURRET. (1) A small tower that is part of a larger structure. (2) A small tower at a corner of a building, often beginning some distance from the ground.

TUSCHE. An inklike liquid containing crayon that is used to produce solid black (or solid color) areas in prints.

TYMPANUM. (1) In Classical architecture, a recessed, usually triangular area often decorated with sculpture. Also called a *pediment*. (2) In medieval architecture, an arched area between an arch and the lintel of a door or window, frequently carved with relief sculpture.

TYPOLOGY. The matching or pairing of pre-Christian figures, persons, and symbols with their Christian counterparts.

UNDERPAINTING. See *tempera painting*.

VANISHING POINT. The point at which the orthogonals meet and disappear in a composition done with scientific perspective.

VANITAS. The term derives from the book of Ecclesiastes I:2 ("Vanities of vanities, …") that refers to the passing of time and the notion of life's brevity and the inevitability of death. The vanitas theme found expression especially in the Northern European art of the 17th century.

VAULT. An arched roof or ceiling usually made of stone, brick, or concrete. Several distinct varieties have been developed; all need buttressing at the point where the lateral thrust is concentrated. (1) A barrel vault is a semicircular structure made up of successive arches. It may be straight or annular in plan. (2) A groin vault is the result of the intersection of two barrel vaults of equal size that produces a bay of four compartments with sharp edges, or groins, where the two meet. (3) A ribbed groin vault is one in which ribs are added to the groins for structural strength and for decoration. When the diagonal ribs are constructed as half-circles, the resulting form is a domical ribbed vault. (4) A sexpartite vault is a ribbed groin vault in which each bay is divided into six compartments by the addition of a transverse rib across the center. (5) The normal Gothic vault is quadripartite with all the arches pointed to some degree. (6) A fan vault is an elaboration of a ribbed groin vault, with elements of tracery using cone-like forms. It was developed by the English in the 15th century and was employed for decorative purposes.

VEDUTA (pl. **VEDUTE**). A view painting, generally a city landscape.

VELLUM. See *Parchment*.

VERISTIC. From the Latin *verus*, meaning "true." Describes a hyperrealistic style of portraiture that emphasizes individual characteristics.

VESTRY. A chamber in a church where the vestments (clerical garbs) and sacramental vessels are maintained. Also called a *sacristy*.

VICES. Often represented allegorically in conjunction with the seven virtues, they include Pride, Envy, Avarice, Wrath, Gluttony, Lust, and Sloth, though others such as Injustice and Folly are sometimes substituted.

VILLA. Originally a large country house but in modern usage a lso a detached house or suburban residence.

VIRTUES. The three theological virtues, Faith, Hope, and Charity, and the four cardinal ones, Prudence, Justice, Fortitude, and Temperance, were frequently represented allegorically, particularly in medieval manuscripts and sculpture.

VOLUTE. A spiraling architectural element found notably on Ionic and Composite capitals but also used decoratively on building façades and interiors.

VOTIVE. A devotional image used in the veneration or worship of a deity or saint.

VOUSSOIR. A wedge-shaped piece of stone used in arch construction.

WASH. A thin layer of translucent color or ink used in watercolor painting and brush drawing, and occasionally in oil painting.

WATERCOLOR PAINTING. Painting, usually on paper, in pigments suspended in water.

WEBS. Masonry construction of brick, concrete, stone, etc. that is used to fill in the spaces between groin vault ribs.

WESTWORK. From the German word *Westwerk*. In Carolingian, Ottonian, and German Romanesque architecture, a monumental western front of a church, treated as a tower or combination of towers and containing an entrance and vestibule below and a chapel and galleries above. Later examples often added a transept and a crossing tower.

WING. The side panel of an altarpiece that is frequently decorated on both sides and is also hinged, so that it may be shown either open or closed.

WOODCUT. A print made by carving out a design on a wooden block cut along the grain, applying ink to the raised surfaces that remain, and printing from those.

WROUGHT IRON. A comparatively pure form of iron that is easily forged and does not harden quickly, so that it can be shaped or hammered by hand, in contrast to molded cast iron.

WUNDERKAMMER (pl. **WUNDERKAMMERN**). Literally a "room of wonders." This forerunner of the museum developed in the 16th century. Such rooms displayed wonders of the world, often from exotic, far off places. The objects displayed included fossils, shells, coral, animals (bones, skins, etc.), and gems in an effort to form an encyclopedic collection. See *kunstkammen*.

ZIGGURAT. From the Assyrian word *ziqquratu*, meaning "mountaintop" or "height." In ancient Assyria and Babylonia, a pyramidal mound or tower built of mud-brick forming the base for a temple. It was often either stepped or had a broad ascent winding around it, which gave it the appearance of being stepped.

ZODIAC. An imaginary belt circling the heavens, including the paths of the sun, moon, and major planets and containing twelve constellations and thus twelve divisions called signs, which have been associated with the months. The signs are Aries, the ram; Taurus, the bull; Gemini, the twins; Cancer, the crab; Leo, the lion; Virgo, the virgin; Libra, the balance; Scorpio, the scorpion; Sagittarius, the archer; Capricorn, the goat; Aquarius, the waterbearer; and Pisces, the fish. They are frequently represented around the portals of Romanesque and Gothic churches in conjunction with the Labors of the Months.

Books for Further Reading

This list is intended to be as practical as possible. It is therefore limited to books of general interest that were printed over the past 20 years or have been generally available recently. However, certain indispensable volumes that have yet to be superseded are retained. This restriction means omitting numerous classics long out of print, as well as much specialized material of interest to the serious student. The reader is thus referred to the many specialized bibliographies noted below.

REFERENCE RESOURCES IN ART HISTORY

I. BIBLIOGRAPHIES AND RESEARCH GUIDES

Arntzen, E., and R. Rainwater. *Guide to the Literature of Art History*. Chicago: American Library, 1980.

Barnet, S. *A Short Guide to Writing About Art*. 8th ed. New York: Longman, 2005.

Ehresmann, D. *Architecture: A Bibliographical Guide to Basic Reference Works, Histories, and Handbooks*. Littleton, CO: Libraries Unlimited, 1984.

———. *Fine Arts: A Bibliographical Guide to Basic Reference Works, Histories, and Handbooks*. 3d ed. Littleton, CO: Libraries Unlimited, 1990.

Freitag, W. *Art Books: A Basic Bibliography of Monographs on Artists*. 2d ed. New York: Garland, 1997.

Goldman, B. *Reading and Writing in the Arts: A Handbook*. Detroit, MI: Wayne State Press, 1972.

Kleinbauer, W., and T. Slavens. *Research Guide to the History of Western Art*. Chicago: American Library, 1982.

Marmor, M., and A. Ross, eds. *Guide to the Literature of Art History 2*. Chicago: American Library, 2005.

Sayre, H. M. *Writing About Art*. New ed. Upper Saddle River, NJ: Pearson Prentice Hall, 2000.

2. DICTIONARIES AND ENCYCLOPEDIAS

Aghion, I. *Gods and Heroes of Classical Antiquity*. Flammarion Iconographic Guides. New York: Flammarion, 1996.

Boström, A., ed. *Encyclopedia of Sculpture*. 3 vols. New York: Fitzroy Dearborn, 2004.

Brigstocke, H., ed. *The Oxford Companion to Western Art*. New York: Oxford University Press, 2001.

Burden, E. *Illustrated Dictionary of Architecture*. New York: McGraw-Hill, 2002.

Carr-Gomm, S. *The Hutchinson Dictionary of Symbols in Art*. Oxford: Helicon, 1995.

Chilvers, I., et al., eds. *The Oxford Dictionary of Art*. 3d ed. New York: Oxford University Press, 2004.

Congdon, K. G. *Artists from Latin American Cultures: A Biographical Dictionary*. Westport, CT: Greenwood Press, 2002.

Cumming, R. *Art: A Field Guide*. New York: Alfred A. Knopf, 2001.

Curl, J. *A Dictionary of Architecture*. New York: Oxford University Press, 1999.

The Dictionary of Art. 34 vols. New York: Grove's Dictionaries, 1996.

Duchet-Suchaux, G., and M. Pastoureau. *The Bible and the Saints*. Flammarion Iconographic Guides. New York: Flammarion, 1994.

Encyclopedia of World Art. 14 vols., with index and supplements. New York: McGraw-Hill, 1959–1968.

Fleming, J., and H. Honour. *The Penguin Dictionary of Architecture and Landscape Architecture*. 5th ed. New York: Penguin, 1998.

———. *The Penguin Dictionary of Decorative Arts*. New ed. London: Viking, 1989.

Gascoigne, B. *How to Identify Prints: A Complete Guide to Manual and Mechanical Processes from Woodcut to Inkjet*. New York: Thames & Hudson, 2004.

Hall, J. *Dictionary of Subjects and Symbols in Art*. Rev. ed. London: J. Murray, 1996.

———. *Illustrated Dictionary of Symbols in Eastern and Western Art*. New York: HarperCollins, 1995.

International Dictionary of Architects and Architecture. 2 vols. Detroit, MI: St. James Press, 1993.

Langmuir, E. *Yale Dictionary of Art and Artists*. New Haven: Yale University Press, 2000.

Lever, J., and J. Harris. *Illustrated Dictionary of Architecture, 800–1914*. 2d ed. Boston: Faber & Faber, 1993.

Lucie-Smith, E. *The Thames & Hudson Dictionary of Art Terms*. New York: Thames & Hudson, 2004.

Mayer, R. *The Artist's Handbook of Materials and Techniques*. 5th ed. New York: Viking, 1991.

———. *The HarperCollins Dictionary of Art Terms & Techniques*. 2d ed. New York: HarperCollins, 1991.

Murray, P., and L. Murray. *A Dictionary of Art and Artists*. 7th ed. New York: Penguin, 1998.

———. *A Dictionary of Christian Art*. New York: Oxford University Press, 2004, © 1996.

Nelson, R. S., and R. Shiff, eds. *Critical Terms for Art History*. Chicago: University of Chicago Press, 2003.

Pierce, J. S. *From Abacus to Zeus: A Handbook of Art History*. 7th ed. Englewood Cliffs, NJ: Pearson Prentice Hall, 2004.

Reid, J. D., ed. *The Oxford Guide to Classical Mythology in the Arts 1300–1990*. 2 vols. New York: Oxford University Press, 1993.

Shoemaker, C., ed. *Encyclopedia of Gardens: History and Design*. Chicago: Fitzroy Dearborn, 2001.

Steer, J. *Atlas of Western Art History: Artists, Sites, and Movements from Ancient Greece to the Modern Age*. New York: Facts on File, 1994.

West, S., ed. *The Bulfinch Guide to Art History*. Boston: Little, Brown, 1996.

———. *Portraiture*. Oxford History of Art. New York: Oxford University Press, 2004.

3. INDEXES, PRINTED AND ELECTRONIC

ARTbibliographies Modern. 1969 to present. A semiannual publication indexing and annotating more than 300 art periodicals, as well as books, exhibition catalogues, and dissertations. Data since 1974 also available electronically.

Art Index. 1929 to present. A standard quarterly index to more than 200 art periodicals. Also available electronically.

Avery Index to Architectural Periodicals. 1934 to present. 15 vols., with supplementary vols. Boston: G. K. Hall, 1973. Also available electronically.

BHA: Bibliography of the History of Art. 1991 to present. The merger of two standard indexes: *RILA* (*Répertoire International de la Littérature de l'Art/International Repertory of the Literature of Art*, vol. 1. 1975) and *Répertoire d'Art et d'Archéologic* (vol. 1. 1910). Data since 1973 also available electronically.

Index Islamicus. 1665 to present. Multiple publishers. Data since 1994 also available electronically.

The Perseus Project: An Evolving Digital Library on Ancient Greece and Rome. Medford, MA: Tufts University, Classics Department, 1994.

4. WORLDWIDE WEBSITES

Visit the following websites for reproductions and information regarding artists, periods, movements, and many more subjects. The art history departments and libraries of many universities and colleges also maintain websites where you can get reading lists and links to other websites, such as those of museums, libraries, and periodicals.

http://www.aah.org.uk/welcome.html Association of Art Historians

http://www.amico.org Art Museum Image Consortium

http://www.archaeological.org Archaeological Institute of America

http://archnet.asu.edu/archnet Virtual Library for Archaeology

http://www.artchive.com

http://www.art-design.umich.edu/mother/ Mother of all Art History links pages, maintained by the Department of the History of Art at the University of Michigan

http://www.arthistory.net Art History Network

http://artlibrary.vassar.edu/ifla-idal International Directory of Art Libraries

http://www.bbk.ac.uk/lib/hasubject.html Collection of resources maintained by the History of Art Department of Birkbeck College, University of London

http://classics.mit.edu The Internet Classics Archive

http://www.collegeart.org College Art Association

http://www.constable.net

http://www.cr.nps.gov/habshaer Historic American Buildings Survey

http://www.getty.edu Including museum, five institutes, and library

http://www.harmsen.net/ahrc/ Art History Research Centre

http://icom.museum/ International Council of Museums

http://www.icomos.org International Council on Monuments and Sites

http://www.ilpi.com/artsource

http://www.siris.si.edu Smithsonian Institution Research Information System

http://whc.unesco.org/ World Heritage Center

5. GENERAL SOURCES ON ART HISTORY, METHOD, AND THEORY

Andrews, M. *Landscape and Western Art*. Oxford History of Art. New York: Oxford University Press, 1999.

Barasch, M. *Modern Theories of Art: Vol. 1, From Winckelmann to Baudelaire. Vol. 2, From Impressionism to Kandinsky*. New York: 1990–1998.

———. *Theories of Art: From Plato to Winckelmann*. New York: Routledge, 2000.

Battistini, M. *Symbols and Allegories in Art*. Los Angeles: J. Paul Getty Museum, 2005.

Baxandall, M. *Patterns of Intention: On the Historical Explanation of Pictures*. New Haven: Yale University Press, 1985.

Bois, Y.-A. *Painting as Model*. Cambridge, MA: MIT Press, 1993.

Broude, N., and M. Garrard. *The Expanding Discourse: Feminism and Art History*. New York: Harper & Row, 1992.

———., eds. *Feminism and Art History: Questioning the Litany*. New York: Harper & Row, 1982.

Bryson, N., ed. *Vision and Painting: The Logic of the Gaze*. New Haven: Yale University Press, 1983.

———., et al., eds. *Visual Theory: Painting and Interpretation*. New York: Cambridge University Press, 1991.

Chadwick, W. *Women, Art, and Society*. 3d ed. New York: Thames & Hudson, 2002.

D'Alleva, A. *Methods & Theories of Art History*. London: Laurence King, 2005.

Freedberg, D. *The Power of Images: Studies in the History and Theory of Response*. Chicago: University of Chicago Press, 1989.

Gage, J. *Color and Culture: Practice and Meaning from Antiquity to Abstraction*. Berkeley: University of California Press, 1999.

Garland Library of the History of Art. New York: Garland, 1976. Collections of essays on specific periods.

Goldwater, R., and M. Treves, eds. *Artists on Art, from the Fourteenth to the Twentieth Century*. 3d ed. New York: Pantheon, 1974.

Gombrich, E. H. *Art and Illusion*. 6th ed. New York: Phaidon, 2002.

Harris, A. S., and L. Nochlin. *Women Artists, 1550–1950*. New York: Random House, 1999.

Holly, M. A. *Panofsky and the Foundations of Art History*. Ithaca, NY: Cornell University Press, 1984.

Holt, E. G., ed. *A Documentary History of Art: Vol. 1, The Middle Ages and the Renaissance. Vol. 2, Michelangelo and the Mannerists. The Baroque and the Eighteenth Century. Vol. 3, From the Classicists to the Impressionists*. 2d ed. Princeton, NJ: Princeton University Press, 1981. Anthologies of primary sources on specific periods.

Johnson, P. *Art: A New History*. New York: HarperCollins, 2003.

Kemal, S., and I. Gaskell. *The Language of Art History*. Cambridge Studies in Philosophy and the Arts. New York: Cambridge University Press, 1991.

Kemp, M., ed. *The Oxford History of Western Art*. New York: Oxford University Press, 2000.

Kleinbauer, W. E. *Modern Perspectives in Western Art History: An Anthology of Twentieth-Century Writings on the Visual Arts*. Reprint of 1971 ed. Toronto: University of Toronto Press, 1989.

Kostof, S. A. *History of Architecture: Settings and Rituals*. 2d ed. New York: Oxford University Press, 1995.

Kruft, H. W. *A History of Architectural Theory from Vitruvius to the Present*. Princeton, NJ: Princeton Architectural Press, 1994.

Kultermann, U. *The History of Art History*. New York: Abaris Books, 1993.

Langer, C. *Feminist Art Criticism: An Annotated Bibliography*. Boston: G. K. Hall, 1993.

Laver, J. *Costume and Fashion: A Concise History*. 4th ed. The World of Art. London: Thames & Hudson, 2002.

Lavin, I., ed. *Meaning in the Visual Arts: Views from the Outside: A Centennial Commemoration of Erwin Panofsky (1892–1968)*. Princeton, NJ: Institute for Advanced Study, 1995.

Minor, V. H. *Art History's History*. Upper Saddle River, NJ: Pearson Prentice Hall, 2001.

Nochlin, L. *Women, Art, and Power, and Other Essays*. New York: HarperCollins, 1989.

Pächt, O. *The Practice of Art History: Reflections on Method*. London: Harvey Miller, 1999.

Panofsky, E. *Meaning in the Visual Arts*. Reprint of 1955 ed. Chicago: University of Chicago Press, 1982.

Penny, N. *The Materials of Sculpture*. New Haven: Yale University Press, 1993.

Pevsner, N. *A History of Building Types*. Princeton, NJ: Princeton University Press, 1976.

Podro, M. *The Critical Historians of Art*. New Haven: Yale University Press, 1982.

Pollock, G. *Differencing the Canon: Feminist Desire and the Writing of Art's Histories*. New York: Routledge, 1999.

———. *Vision and Difference: Femininity, Feminism, and the Histories of Art*. New York: Routledge, 1988.

Prettejohn, E. *Beauty and Art 1750–2000*. New York: Oxford University Press, 2005.

Preziosi, D., ed. *The Art of Art History: A Critical Anthology*. New York: Oxford University Press, 1998.

Rees, A. L., and F. Borzello. *The New Art History*. Atlantic Highlands, NJ: Humanities Press International, 1986.

Roth, L. *Understanding Architecture: Its Elements, History, and Meaning*. New York: Harper & Row, 1993.

Sedlmayr, H. *Framing Formalism: Riegl's Work*. Amsterdam: G+B Arts International, © 2001.

Smith, P., and C. Wilde, eds. *A Companion to Art Theory*. Oxford: Blackwell, 2002.

Sources and Documents in the History of Art Series. General ed. H. W. Janson. Englewood Cliffs, NJ: Prentice Hall. Anthologies of primary sources on specific periods.

Sutton, I. *Western Architecture*. New York: Thames & Hudson, 1999.

Tagg, J. *Grounds of Dispute: Art History, Cultural Politics, and the Discursive Field*. Minneapolis: University of Minnesota Press, 1992.

Trachtenberg, M., and I. Hyman. *Architecture: From Prehistory to Post-Modernism*. 2d ed. New York: Harry N. Abrams, 2002.

Watkin, D. *The Rise of Architectural History*. Chicago: University of Chicago Press, 1980.

Wolff, J. *The Social Production of Art*. 2d ed. New York: New York University Press, 1993.

Wölfflin, H. *Principles of Art History: The Problem of the Development of Style in Later Art*. Various eds. New York: Dover.

Wollheim, R. *Art and Its Objects*. 2d ed. New York: Cambridge University Press, 1992.

PART TWO: THE MIDDLE AGES

GENERAL REFERENCES

Alexander, J. J. G. *Medieval Illuminators and Their Methods of Work*. New Haven: Yale University Press, 1992.

———., ed. *A Survey of Manuscripts Illuminated in the British Isles*. 6 vols. London: Harvey Miller, 1975–1996.

Avril, F., and J. J. G. Alexander, eds. *A Survey of Manuscripts Illuminated in France*. London: Harvey Miller, 1996.

Bartlett, R., ed. *Medieval Panorama*. Los Angeles: J. Paul Getty Museum, 2001.

Cahn, W. *Studies in Medieval Art and Interpretation*. London: Pindar Press, 2000.

Calkins, R. G. *Medieval Architecture in Western Europe: From A.D. 300 to 1500*. New York: Oxford University Press, 1998.

Cassidy, B., ed. *Iconography at the Crossroads*. Princeton, NJ: Princeton University Press, 1993.

De Hamel, C. *The British Library Guide to Manuscript Illumination: History and Techniques.* Toronto: University of Toronto Press, 2001.

———. *A History of Illuminated Manuscripts.* Rev. and enl. 2d ed. London: Phaidon Press, 1994.

Duby, G. *Art and Society in the Middle Ages.* Polity Press; Malden, MA: Blackwell Publishers, 2000.

Hamburger, J. *Nuns as Artists: The Visual Culture of a Medieval Convent.* Berkeley: University of California Press, 1997.

Katzenellenbogen, A. *Allegories of the Virtues and Vices in Medieval Art.* Reprint of 1939 ed. Toronto: University of Toronto Press, 1989.

Kazhdan, A. P. *The Oxford Dictionary of Byzantium.* 3 vols. New York: Oxford University Press, 1991.

Kessler, H. L. *Seeing Medieval Art.* Peterborough, Ont. and Orchard Park, NY: Broadview Press, 2004.

Pächt, O. *Book Illumination in the Middle Ages: An Introduction.* London: Harvey Miller, 1986.

Pelikan, J. *Mary Through the Centuries: Her Place in the History of Culture.* New Haven: Yale University Press, 1996.

Ross, L. *Artists of the Middle Ages.* Westport, CT: Greenwood Press, 2003.

———. *Medieval Art: A Topical Dictionary.* Westport, CT: Greenwood Press, 1996.

Schütz, B. *Great Cathedrals.* New York: Harry N. Abrams, 2002.

Sears, E., and T. K. Thomas, eds. *Reading Medieval Images: The Art Historian and the Object.* Ann Arbor: University of Michigan Press, 2002.

Sekules, V. *Medieval Art.* New York: Oxford University Press, 2001.

Snyder, J. *Medieval Art: Painting, Sculpture, Architecture, 4th–14th Century.* New York: Harry N. Abrams, 1989.

Stokstad, M. *Medieval Art.* Boulder, CO: Westview Press, 2004.

Tasker, E. *Encyclopedia of Medieval Church Art.* London: Batsford, 1993.

Watson, R. *Illuminated Manuscripts and Their Makers: An Account Based on the Collection of the Victoria and Albert Museum.* London and New York: V & A Publications; Dist. by Harry N. Abrams, 2003.

Wieck, R. S. *Painted Prayers: The Book of Hours in Medieval and Renaissance Art.* New York: George Braziller in association with the Pierpont Morgan Library, 1997.

Wixom, W. D. *Mirror of the Medieval World.* Exh. cat. New York: Metropolitan Museum of Art; Dist. by Harry N. Abrams, 1999.

CHAPTER 8. EARLY CHRISTIAN AND BYZANTINE ART

Beckwith, J. *Studies in Byzantine and Medieval Western Art.* London: Pindar Press, 1989.

Bowersock, G. W., ed. *Late Antiquity: A Guide to the Postclassical World.* Cambridge, MA: Belknap Press of Harvard University Press, 1999.

Demus, O. *Studies in Byzantium, Venice and the West.* 2 vols. London: Pindar Press, 1998.

Drury, J. *Painting the Word: Christian Pictures and Their Meanings.* New Haven and London: Yale University Press in association with National Gallery Publications, 1999.

Durand, J. *Byzantine Art.* Paris. Terrail, 1999.

Evans, H. C., ed. *Byzantium: Faith and Power, 1261–1557.* Exh. cat. New York and New Haven: Metropolitan Museum of Art; Yale University Press, 2004.

Galavaris, G. *Colours, Symbols, Worship: The Mission of the Byzantine Artist.* London: Pindar, 2005.

Grabar, A. *Christian Iconography: A Study of Its Origins.* Princeton, NJ: Princeton University Press, 1968.

Henderson, G. *Vision and Image in Early Christian England.* New York: Cambridge University Press, 1999.

Kalavrezou, I. *Byzantine Women and Their World.* Exh. cat. Cambridge, MA and New Haven: Harvard University Art Museums; Yale University Press, © 2003.

Kleinbauer, W. *Early Christian and Byzantine Architecture: An Annotated Bibliography and Historiography.* Boston: G. K. Hall, 1993.

Krautheimer, R., and S. Curcic. *Early Christian and Byzantine Architecture.* 4th ed. Pelican History of Art. New Haven: Yale University Press, 1992.

Lowden, J. *Early Christian and Byzantine Art.* London: Phaidon, 1997.

Maguire, H. *Art and Eloquence in Byzantium.* Princeton, NJ: Princeton University Press, 1981.

Mango, C. *The Art of the Byzantine Empire, 312–1453: Sources and Documents.* Reprint of 1972 ed. Toronto: University of Toronto Press, 1986.

Mark, R., and A. S. Çakmak, eds. *Hagia Sophia from the Age of Justinian to the Present.* New York: Cambridge University Press, 1992.

Matthews, T. *Byzantium from Antiquity to the Renaissance.* New York: Harry N. Abrams, 1998.

———. *The Clash of Gods: A Reinterpretation of Early Christian Art.* Princeton, NJ: Princeton University Press, 1993.

Milburn, R. *Early Christian Art and Architecture.* Berkeley: University of California Press, 1988.

Rodley, L. *Byzantine Art and Architecture: An Introduction.* New York: Cambridge University Press, 1994.

Simson, O. G. von. *Sacred Fortress: Byzantine Art and Statecraft in Ravenna.* Reprint of 1948 ed. Princeton, NJ: Princeton University Press, 1987.

Webster, L., and M. Brown, eds. *The Transformation of the Roman World A.D. 400–900.* Berkeley: University of California Press, 1997.

Weitzmann, K. *Late Antique and Early Christian Book Illumination.* New York: Braziller, 1977.

CHAPTER 9. ISLAMIC ART

Asher, C. E. B. *Architecture of Mughal India.* New Cambridge History of India, Cambridge, England. New York: Cambridge University Press, 1992.

Atil, E. *The Age of Sultan Süleyman the Magnificent.* Exh. cat. Washington, DC: National Gallery of Art; New York: Harry N. Abrams, 1987.

———. *Renaissance of Islam: Art of the Mamluks.* Exh. cat. Washington, DC: Smithsonian Institution Press, 1981.

Behrens-Abouseif, D. *Beauty in Arabic Culture.* Princeton, NJ: Markus Wiener, 1998.

Bierman, I., ed. *The Experience of Islamic Art on the Margins of Islam.* Reading, England: Ithaca Press, 2005.

Blair, S., and J. Bloom. *The Art and Architecture of Islam 1250–1800.* Pelican History of Art. New Haven: Yale University Press, 1994.

Brookes, J. *Gardens of Paradise: The History and Design of the Great Islamic Gardens.* New York: New Amsterdam, 1987.

Burckhardt, T. *Art of Islam: Language and Meaning.* London: World of Islam Festival, 1976.

Creswell, K. A. C. *A Bibliography of the Architecture, Arts, and Crafts of Islam.* Cairo: American University in Cairo Press, 1984.

Denny, W. B. *The Classical Tradition in Anatolian Carpets.* Washington, DC: Textile Museum, 2002.

Dodds, J. D., ed. *al-Andalus: The Art of Islamic Spain.* Exh. cat. New York: Metropolitan Museum of Art; Dist. by Harry N. Abrams, 1992.

Erdmann, K. *Oriental Carpets: An Essay on Their History.* Fishguard, Wales: Crosby Press, 1976, © 1960.

Ettinghausen, R., O. Grabar, and M. Jenkins-Madina. *Islamic Art and Architecture, 650–1250.* 2d ed. Pelican History of Art. New Haven: Yale University Press, 2001.

Frishman, M., and H. Khan. *The Mosque: History, Architectural Development and Regional Diversity.* London: Thames & Hudson, 2002, © 1994.

Goodwin, G. *A History of Ottoman Architecture.* New York: Thames & Hudson, 2003, © 1971.

Grabar, O. *The Formation of Islamic Art.* Rev. and enl. ed. New Haven: Yale University Press, 1987.

Hillenbrand, R. *Islamic Architecture: Form, Function, and Meaning.* New York: Columbia University Press, 1994.

Komaroff, L., and S. Carboni, eds. *The Legacy of Genghis Khan: Courtly Art and Culture in Western Asia, 1256–1353.* Exh. cat. New York: Metropolitan Museum of Art; New Haven: Yale University Press, 2002.

Lentz, T., and G. Lowry. *Timur and the Princely Vision: Persian Art and Culture in the Fifteenth Century.* Exh. cat. Los Angeles: Los Angeles County Museum of Art; Washington, DC: Arthur M. Sackler Gallery; Smithsonian Institution Press, 1989.

Lings, M. *The Quranic Art of Calligraphy and Illumination.* 1st American ed. New York: Interlink Books, 1987, © 1976.

Necipoğlu, G. *The Age of Sinan: Architectural Culture in the Ottoman Empire.* Princeton, NJ: Princeton University Press, 2005.

———. *The Topkapı Scroll: Geometry and Ornament in Islamic Architecture.* Topkapı Palace Museum Library MS H. 1956. Santa Monica, CA: Getty Center for the History of Art and the Humanities, 1995.

Pope, A. U. *Persian Architecture: The Triumph of Form and Color.* New York: Braziller, 1965.

Robinson, F. *Atlas of the Islamic World Since 1500*. New York: Facts on File, 1982.

Ruggles, D. F. *Gardens, Landscape, and Vision in the Palaces of Islamic Spain*. University Park: Pennsylvania State University Press, 2000.

———., ed. *Women, Patronage, and Self-Representation in Islamic Societies*. Albany: State University of New York Press, 2000.

Tabbaa, Y. *The Transformation of Islamic Art During the Sunni Revival*. Seattle: University of Washington Press, 2001.

Thompson, J., ed. *Hunt for Paradise: Court Arts of Safavid Iran, 1501–1576*. Milan: Skira; New York: Dist. in North America and Latin America by Rizzoli, 2003.

———. *Oriental Carpets from the Tents, Cottages, and Workshops of Asia*. New York: Dutton, 1988.

Vernoit, S., ed. *Discovering Islamic Art: Scholars, Collectors and Collections, 1850–1950*. London and New York: I. B. Tauris; Dist. by St. Martin's Press, 2000.

Welch, S. C. *Imperial Mughal Painting*. New York: Braziller, 1978.

———. *A King's Book of Kings: The Shahnameh of Shah Tahmasp*. New York: Metropolitan Museum of Art; Dist. by New York Graphic Society, 1972.

CHAPTER 10. EARLY MEDIEVAL ART

Backhouse, J. *The Golden Age of Anglo-Saxon Art, 966–1066*. Bloomington: Indiana University Press, 1984.

———. *The Lindisfarne Gospels: A Masterpiece of Book Painting*. London: British Library, 1995.

Barral i Altet, X. *The Early Middle Ages: From Late Antiquity to A.D. 1000*. Taschen's World Architecture. Köln and New York: Taschen, © 1997.

Conant, K. *Carolingian and Romanesque Architecture, 800–1200*. 4th ed. Pelican History of Art. New Haven: Yale University Press, 1992.

Davis-Weyer, C. *Early Medieval Art, 300–1150: Sources and Documents*. Reprint of 1971 ed. Toronto: University of Toronto Press, 1986.

Diebold, W. J. *Word and Image: An Introduction to Early Medieval Art*. Boulder, CO: Westview Press, 2000.

Dodwell, C. R. *Anglo-Saxon Art: A New Perspective*. Ithaca, NY: Cornell University Press, 1982.

———. *The Pictorial Arts of the West, 800–1200*. New ed. Pelican History of Art. New Haven: Yale University Press, 1993.

Graham-Campbell, J. *The Viking-age Gold and Silver of Scotland, A.D. 850–1100*. Exh. cat. Edinburgh: National Museums of Scotland, 1995.

Harbison, P. *The Golden Age of Irish Art: The Medieval Achievement, 600–1200*. New York: Thames & Hudson, 1999.

Henderson, G. *The Art of the Picts: Sculpture and Metalwork in Early Medieval Scotland*. New York: Thames & Hudson, 2004.

Kitzinger, E. *Early Medieval Art, with Illustrations from the British Museum*. Rev. ed. Bloomington: Indiana University Press, 1983.

Lasko, P. *Ars Sacra, 800–1200*. 2nd ed. Pelican History of Art. New Haven: Yale University Press, 1994.

Mayr-Harting, M. *Ottonian Book Illumination: An Historical Study*. 2 vols. London: Harvey Miller, 1991–1993.

Megaw, M. R. *Celtic Art: From Its Beginnings to the Book of Kells*. New York: Thames & Hudson, 2001.

Mosacati, S., ed. *The Celts*. Exh. cat. New York: Rizzoli, 1999.

Nees, L. *Early Medieval Art*. Oxford History of Art. New York: Oxford University Press, 2002.

Ohlgren, T. H., comp. *Insular and Anglo-Saxon Illuminated Manuscripts: An Iconographic Catalogue, c. A.D. 625 to 1100*. New York: Garland, 1986.

Rickert, M. *Painting in Britain: The Middle Ages*. 2d ed. Pelican History of Art. Harmondsworth, England: Penguin, 1965.

Stalley, R. A. *Early Medieval Architecture*. Oxford History of Art. New York: Oxford University Press, 1999.

Stone, L. *Sculpture in Britain: The Middle Ages*. 2d ed. Pelican History of Art. Harmondsworth, England: Penguin, 1972.

Webster, L., and J. Backhouse, eds. *The Making of England: Anglo-Saxon Art and Culture, A.D. 600–900*. Exh. cat. London: Published for the Trustees of the British Museum and the British Library Board by British Museum Press, 1991.

CHAPTER 11. ROMANESQUE ART

Bizzarro, T. *Romanesque Architectural Criticism: A Prehistory*. New York: Cambridge University Press, 1992.

Boase, T. S. R. *English Art, 1100–1216*. Oxford History of English Art. Oxford: Clarendon Press, 1953.

Cahn, W. *Romanesque Bible Illumination*. Ithaca, NY: Cornell University Press, 1982.

Davies, M. *Romanesque Architecture: A Bibliography*. Boston: G. K. Hall, 1993.

Focillon, H. *The Art of the West in the Middle Ages*. Ed. J. Bony. 2 vols. Reprint of 1963 ed. Ithaca, NY: Cornell University Press, 1980.

Hearn, M. F. *Romanesque Sculpture: The Revival of Monumental Stone Sculpture*. Ithaca, NY: Cornell University Press, 1981.

Mâle, E. *Religious Art in France, the Twelfth Century: A Study of the Origins of Medieval Iconography*. Bollingen series, 90:1. Princeton, NJ: Princeton University Press, 1978.

Minne-Sève, V. *Romanesque and Gothic France: Architecture and Sculpture*. New York: Harry N. Abrams, 2000.

Nichols, S. *Romanesque Signs: Early Medieval Narrative and Iconography*. New Haven: Yale University Press, 1983.

O'Keeffe, T. *Romanesque Ireland: Architecture and Ideology in the Twelfth Century*. Dublin and Portland, OR: Four Courts, 2003.

Petzold, A. *Romanesque Art*. Perspectives. New York: Harry N. Abrams, 1995.

Platt, C. *The Architecture of Medieval Britain: A Social History*. New Haven: Yale University Press, 1990.

Sauerländer, W. *Romanesque Art: Problems and Monuments*. 2 vols. London: Pindar, 2004.

Schapiro, M. *Romanesque Art*. New York: Braziller, 1977.

Stoddard, W. *Art and Architecture in Medieval France*. New York: Harper & Row, 1972, © 1966.

Stones, A., and J. Krochalis. *The Pilgrim's Guide to Santiago de Compostela: A Critical Edition*. 2 vols. London: Harvey Miller, 1998.

Toman, R. *Romanesque Architecture, Sculpture, Painting*. Cologne: Könemann, 1997.

Zarnecki, G. *Further Studies in Romanesque Sculpture*. London: Pindar, 1992.

CHAPTER 12. GOTHIC ART

Barnes, C. F. *Villard de Honnecourt, the Artist and His Drawings: A Critical Bibliography*. Boston: G. K. Hall, 1982.

Belting, H. *The Image and Its Public: Form and Function of Early Paintings of the Passion*. New Rochelle, NY: Caratzas, 1990.

Blum, P. *Early Gothic Saint-Denis: Restorations and Survivals*. Berkeley: University of California Press, 1992.

Bony, J. *French Gothic Architecture of the Twelfth and Thirteenth Centuries*. Berkeley: University of California Press, 1983.

Camille, M. *Gothic Art: Glorious Visions*. Perspectives. New York: Harry N. Abrams, 1997.

———. *The Gothic Idol: Ideology and Image Making in Medieval Art*. New York: Cambridge University Press, 1989.

———. *Sumptuous Arts at the Royal Abbeys of Reims and Braine*. Princeton, NJ: Princeton University Press, 1990.

Cennini, C. *The Craftsman's Handbook (Il Libro dell'Arte)*. New York: Dover, 1954.

Coldstream, N. *Medieval Architecture*. Oxford History of Art. New York: Oxford University Press, 2002.

Erlande-Brandenburg, A. *Gothic Art*. New York: Harry N. Abrams, 1989.

Frankl, P. *Gothic Architecture*. Rev. by P. Crossley. Pelican History of Art. New Haven, CT: Yale University Press, 2001.

Frisch, T. G. *Gothic Art, 1140–c. 1450: Sources and Documents*. Reprint of 1971 ed. Toronto: University of Toronto Press, 1987.

Grodecki, L. *Gothic Architecture*. New York: Electa/Rizzoli, 1985.

———. *Gothic Stained Glass, 1200–1300*. Ithaca, NY: Cornell University Press, 1985.

Hamburger, J. F. *The Visual and the Visionary: Art and Female Spirituality in Late Medieval Germany*. Zone Books. Cambridge, MA: MIT Press, 1998.

Jantzen, H. *High Gothic: The Classic Cathedrals of Chartres, Reims, Amiens*. Reprint of 1962 ed. Princeton, NJ: Princeton University Press, 1984.

Kemp, W. *The Narratives of Gothic Stained Glass*. New York: Cambridge University Press, 1997.

Limentani Virdis, C. *Great Altarpieces: Gothic and Renaissance*. New York: Vendome Press; Dist. by Rizzoli, 2002.

Mâle, E. *Religious Art in France, the Thirteenth Century: A Study of Medieval Iconography and Its Sources*. Ed. H. Bober. Princeton, NJ: Princeton University Press, 1984.

Marks, R., and P. Williamson, eds. *Gothic: Art for England 1400–1547*. Exh. cat. London

and New York: Victoria & Albert Museum; Dist. by Harry N. Abrams, 2003.

Murray, S. *Beauvais Cathedral: Architecture of Transcendence*. Princeton, NJ: Princeton University Press, 1989.

Panofsky, E. ed. and trans. *Abbot Suger on the Abbey Church of Saint-Denis and Its Art Treasures*. 2d ed. Princeton, NJ: Princeton University Press, 1979.

———. *Gothic Architecture and Scholasticism*. Reprint of 1951 ed. New York: New American Library, 1985.

Parnet, P., ed. *Images in Ivory: Precious Objects of the Gothic Age*. Exh. cat. Detroit, MI: Detroit Institute of Arts, © 1997.

Sandler, L. *Gothic Manuscripts, 1285–1385*. Survey of Manuscripts Illuminated in the British Isles. London: Harvey Miller, 1986.

Scott, R. A. *The Gothic Enterprise: A Guide to Understanding the Medieval Cathedral*. Berkeley: University of California Press, 2003.

Simson, O. von. *The Gothic Cathedral: Origins of Gothic Architecture and the Medieval Concept of Order*. 3d ed. Princeton, NJ: Princeton University Press, 1988.

Toman, R., ed. *The Art of Gothic: Architecture, Sculpture, Painting*. Cologne: Könemann, 1999.

Williamson, P. *Gothic Sculpture, 1140–1300*. New Haven: Yale University Press, 1995.

Wilson, C. *The Gothic Cathedral*. New York: Thames & Hudson, 1990.

PART THREE: THE RENAISSANCE THROUGH THE ROCOCO

GENERAL REFERENCES AND SOURCES

Campbell, L. *Renaissance Portraits: European Portrait-Painting in the 14th, 15th, and 16th Centuries*. New Haven: Yale University Press, 1990.

Chastel, A., et al. *The Renaissance: Essays in Interpretation*. London: Methuen, 1982.

Cloulas, I. *Treasures of the French Renaissance*. New York: Harry N. Abrams, 1998.

Cole, A. *Art of the Italian Renaissance Courts: Virtue and Magnificence*. London: Weidenfeld & Nicolson, 1995.

Gascoigne, B. *How to Identify Prints: A Complete Guide to Manual and Mechanical Processes from Woodcut to Inkjet*. New York: Thames & Hudson, 2004.

Grendler, P. F., ed. *Encyclopedia of the Renaissance*. 6 vols. New York: Scribner's, published in association with the Renaissance Society of America, 1999.

Gruber, A., ed. *The History of Decorative Arts: Vol. 1, The Renaissance and Mannerism in Europe. Vol. 2, Classicism and the Baroque in Europe*. New York: Abbeville Press, 1994.

Harbison, C. *The Mirror of the Artist: Northern Renaissance Art in its Historical Context*. New York: Harry N. Abrams, 1995.

Harris, A. S. *Seventeenth-Century Art and Architecture*. Upper Saddle River, NJ: Pearson Prentice Hall, 2005.

Hartt, F., and D. Wilkins. *History of Italian Renaissance Art*. 6th ed. Upper Saddle River, NJ: Pearson Prentice Hall, 2007.

Hopkins, A. *Italian Architecture: from Michelangelo to Borromini*. World of Art. New York: Thames & Hudson, 2002.

Hults, L. *The Print in the Western World*. Madison: University of Wisconsin Press, 1996.

Impey, O., and A. MacGregor, eds. *The Origins of Museums: The Cabinet of Curiosities in Sixteenth- and Seventeenth-Century Europe*. New York: Clarendon Press, 1985.

Ivins, W. M., Jr. *How Prints Look: Photographs with a Commentary*. Boston: Beacon Press, 1987.

Landau, D., and P. Parshall. *The Renaissance Print*. New Haven: Yale University Press, 1994.

Lincoln, E. *The Invention of the Italian Renaissance Printmaker*. New Haven: Yale University Press, 2000.

Martin, J. R. *Baroque*. Harmondsworth, England: Penguin, 1989.

Millon, H. A., ed. *The Triumph of the Baroque: Architecture in Europe, 1600–1750*. New York: Rizzoli, 1999.

Minor, V. H. *Baroque & Rococo: Art & Culture*. New York: Harry N. Abrams, 1999.

Norberg-Schultz, C. *Late Baroque and Rococo Architecture*. New York: Harry N. Abrams, 1983.

Olson, R. J. M. *Italian Renaissance Sculpture*. The World of Art. New York: Thames & Hudson, 1992.

Paoletti, J., and G. Radke. *Art in Renaissance Italy*. 3d ed. Upper Saddle River, NJ: Pearson Prentice Hall, 2006.

Payne, A. *Antiquity and Its Interpreters*. New York: Cambridge University Press, 2000.

Pope-Hennessy, J. *An Introduction to Italian Sculpture: Vol. 1, Italian Gothic Sculpture. Vol. 2, Italian Renaissance Sculpture. Vol. 3, Italian High Renaissance and Baroque Sculpture*. 4th ed. London: Phaidon Press, 1996.

Smith, J. C. *The Northern Renaissance*. Art & Ideas. London: Phaidon, 2004.

Snyder, J. *Northern Renaissance Art: Painting, Sculpture, the Graphic Arts, from 1350–1575*. 2d ed. New York: Harry N. Abrams, 2005.

Tomlinson, J. *From El Greco to Goya: Painting in Spain 1561–1828*. Perspectives. New York: Harry N. Abrams, 1997.

Turner, J. *Encyclopedia of Italian Renaissance & Mannerist Art*. 2 vols. New York: Grove's Dictionaries, 2000.

Vasari, G. *The Lives of the Artists*. Trans. with an introduction and notes by J. C. Bondanella and P. Bondanella. New York: Oxford University Press, 1998.

Welch, E. *Art in Renaissance Italy, 1350–1500*. New ed. Oxford: Oxford University Press, 2000.

Wiebenson, D., ed. *Architectural Theory and Practice from Alberti to Ledoux*. 2d ed. Chicago: University of Chicago Press, 1983.

Wittkower, R. *Architectural Principles in the Age of Humanism*. 5th ed. New York: St. Martin's Press, 1998.

CHAPTER 13. ART IN THIRTEENTH- AND FOURTEENTH-CENTURY ITALY

Bellosi, L. *Duccio, the Maestà*. New York: Thames & Hudson, 1999.

Bomford, D. *Art in the Making: Italian Painting Before 1400*. Exh. cat. London: National Gallery of Art, 1989.

Cole, B. *Studies in the History of Italian Art, 1250–1550*. London: Pindar, 1996.

Derbes, A. *The Cambridge Companion to Giotto*. New York: Cambridge University Press, 2004.

Kemp, M. *Behind the Picture: Art and Evidence in the Italian Renaissance*. New Haven: Yale University Press, 1997.

Maginnis, H. B. J. *The World of the Early Sienese Painter*. With a translation of the Sienese Breve dell'Arte del pittori by Gabriele Erasmi. University Park: Pennsylvania State University Press, 2001.

Meiss, M. *Painting in Florence and Siena after the Black Death: The Arts, Religion, and Society in the Mid-Fourteenth Century*. Princeton, NJ: Princeton University Press, 1978, © 1951.

Norman, D., ed. *Siena, Florence, and Padua: Art, Society, and Religion 1280–1400*. New Haven: Yale University Press in association with the Open University, 1995.

Schmidt, V., ed. *Italian Panel Painting of the Duecento and Trecento*. Washington, DC: National Gallery of Art; New Haven: Dist. by Yale University Press, 2002.

Stubblebine, J. H. *Assisi and the Rise of Vernacular Art*. New York: Harper & Row, 1985.

———. *Dugento Painting: An Annotated Bibliography*. Boston: G. K. Hall, 1983.

White, J. *Art and Architecture in Italy, 1250–1400*. 3d ed. Pelican History of Art. New Haven: Yale University Press, 1993.

Credits

Index

NOTES

NOTES

NOTES

NOTES